Material Culture
of the American Freemasons

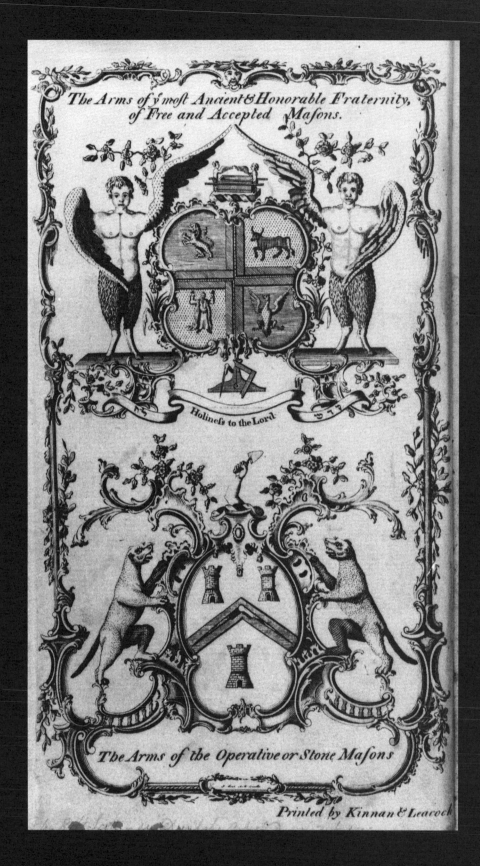

The Arms of ye most Ancient & Honorable Fraternity, of Free and Accepted Masons.

Holiness to the Lord.

The Arms of the Operative or Stone Masons

Printed by Kinnan & Leacock

Material Culture
of the American Freemasons

John D. Hamilton

Museum of Our National Heritage
Lexington, Massachusetts
1994

Distributed by University Press of New England
Hanover and London

ISBN 0-87451-971-3

Material Culture of the American Freemasons
was produced by the Scottish Rite Masonic Museum
and Library, Inc., Lexington, Massachusetts
and edited by Bronwyn M. Mellquist

Designed by Woodworth Associates, Portland, Maine.

Typeset in Caslon 540.

An edition of 1500 was printed by Penmor Lithographers,
Lewiston, Maine. Black and white pages printed on
Mohawk Superfine, color plates printed on Karma, and dust
jacket printed on Lustro Offset Enamel Gloss.

Photographs by David Bohl, John Miller, and
Bill Wasserman.

FRONTISPIECE

*Arms of the Ancients
and Operative Stone Masons*
Frontispiece: *Ahiman Rezon, Abridged and Digested...*
Robert Scot, engraver
Philadelphia, 1783.
Library Collection, 17.9782 .P415

Contents

Forward

One of the most satisfying accomplishments of my tenure as the founding director of the Museum of Our National Heritage had been the development of the museum's collection of Masonic fraternal objects and memorabilia. We presented our first exhibition, "Masonic Symbols in American Decorative Arts," in September 1975. Our small holdings at the time came primarily from the existing collection of the Supreme Council of the Scottish Rite Masons in the Northern Jurisdiction of the United States, the sponsors of the new museum and library. To do the exhibit, we found it necessary to borrow substantially from other museums, Masonic organizations, and private individuals. The catalog, published in 1976, was the first extended statement about the importance of these materials as American decorative art objects. Both exhibit and catalog helped document the significant role Freemasonry has played in this nation's social and cultural life.

The scope of our holdings in this field since that first exhibit opened seventeen years ago has expanded dramatically. In all probability, today the Museum of Our National Heritage has the most comprehensive and best preserved, documented collection of Masonic objects in the United States.

Building the collection was a team effort, but responsibility for much of the research and gathering rested with Curator John Hamilton. Not only does John's network of friends and collectors place him in a unique position to locate and acquire objects, his encyclopedic mind retains the most detailed information about collecting and the objects being collected. He is the author of this comprehensive catalog, the fourth in our series. The first three catalogs, with skilled interpretive essays by Barbara Franco, include *Masonic Symbols in American Decorative Arts* (1976); *Bespangled, Painted & Embroidered: Decorated Masonic Aprons in America, 1790-1850* (1980); and *Fraternally Yours: A Decade of Collecting* (1986). Like its predecessors, this volume is published to record a major exhibit, "The Oblong Square; Lodge Furnishings and Paraphernalia in America Since 1733" (June 13, 1993 - February 20, 1994). The exhibit and catalog gave John an opportunity to display his extensive knowledge of the Masonic holdings in the museum's collection.

Clement M. Silvestro
Founding Director (1974-1992)

Preface

The founding of the Museum of Our National Heritage by the Northern Jurisdiction of the Ancient Accepted Scottish Rite of Freemasonry inspired the creation of a specialized collection of Americana that would provide scholars with a unique focus for the study of fraternalism in American society and the impact of Masonic symbolism on a broad range of American decorative arts.

In 1976 the Museum exposed its infant Masonic collection to the general public in an exhibit and catalog titled *Masonic Symbols in American Decorative Arts*. This first broad effort was heavily augmented by loans from private collections and public institutions, yet it served to arouse interest in objects of our material culture that had been decorated with Masonic symbols. As the Museum's unique collecting efforts intensified, the first exhibit was followed in 1980 by an exhibit and catalog titled *Bespangled Painted & Embroidered, Decorated Masonic Aprons in America 1790-1850*. This second effort spotlighted Masonic aprons as works of art, illustrating that within each area of the Masonic decorative arts lay uncharted depths for research and collecting interest. It also brought to light the fact that many of the artists and engravers that produced this form of mini-art were inspired in their work by membership in the Masonic fraternity. In 1986 a number of Masonic artifacts in the collection were placed in juxtaposition with objects generated for members of other fraternal societies, in an explorative attempt to examine the larger scope and context of the American fraternal movement. That exhibit and catalog was titled *Fraternally Yours, A Decade of Collecting*.

Now, in cycle with past exhibitions, an attempt is made here to present yet another facet to the Museum's Masonic collection. The focus of this effort has been to explore the workings of the Masonic Lodge, Royal Arch Chapter, Knights Templar Commandery, and Scottish Rite Valley in order to explain the regalia and furnishings of Freemasonry in a working context.

In describing the significance of items in the collection, a fine distinction has been made between providing meaningful information for those outside Freemasonry, and in not breaking faith with the confidentiality of ritual. Fortunately for the progress of this work, a very extensive body of exposures and alleged revelations of archaic Masonic ritual already exist in published and graphic form. One should also bear in mind that the game of titillating the public with revelations such as T. Payne's publication of "*The Grand Mys-*

tery of Free-Masons Discover'd..." (London, 1724), began almost as soon as there was ritual to expose, and that the process has always been carried on with varying degrees of fidelity to reality and truth. Additionally, an incredible wealth of information concerning Freemasonry's workings and lore is to be found in the century-long run of *Ars Quatuor Coronatorum, or the transactions of the Quatuor Coronati Lodge No. 2076, London* (the premier lodge of Masonic research), which has been in continuous publication since 1886, with the approbation of the United Grand Lodge of England. In the United States, the American Lodge of Research has been publishing similar Masonic scholarly works for the past 63 years.

The work of researching the artifacts and tracing their ownership has often been hampered by the fact that many Masonic records are no longer in existence. A number of Grand Lodges were found to have suffered not one, but a series of disastrous fires that repeatedly destroyed records, regalia, and memorabilia. It is suspected that these conflagrations were often caused by the careless use of gas lighting systems that were introduced into Lodges and Temples during the 19th century. It is truly fortunate that faithful brethren and their descendants have often replenished those loses.

The objects illustrated herein represent Masonic related artifacts from the Museum collection; and manuscripts, documents and books from the Archives of the Supreme Council of the Scottish Rite, Northern Jurisdiction. A more broad perspective on these holdings was sought by examining and comparing similar materials contained in other Masonic collections, particularly those maintained by the Grand Lodges of Massachusetts, New York, and Pennsylvania.

Many administrative personnel attached to the offices of various Grand Lodge Secretaries have been extremely helpful in tracking down membership records of long deceased brethren and other equally elusive information. I wish to thank them all for their patient efforts. I also wish to thank Bronwyn M. Mellquist for editing the manuscript and bringing order out of chaos; and Brother S. Brent Morris, 33rd Degree, for his review of the book's Masonic content.

John D. Hamilton
Curator

Chapter 1

Origins of Freemasonry

AHIMAN REZON:

OR,

A Help to a Brother;

Shewing the

EXCELLENCY of SECRECY,

And the firſt Cauſe, or Motive, of the Inſtitution of

FREE-MASONRY;

THE

PRINCIPLES of the CRAFT,

And the

Benefits ariſing from a ſtrict Obſervance thereof;
What Sort of MEN ought to be initiated into the MYSTERY,
And what Sort of MASONS are fit to govern LODGES,
With their Behaviour in and out of the Lodge.

Likewiſe the

Prayers uſed in the *Jewiſh* and *Chriſtian* Lodges,

The Ancient Manner of

Conſtituting new Lodges, with all the Charges, &c.

Alſo the

OLD and NEW REGULATIONS,

The Manner of Chuſing and Inſtalling *Grand-Maſter* and *Officers*,
and other uſeful Particulars too numerous here to mention.

To which is added,

The greateſt Collection of MASONS SONGS ever preſented to
public View, with many entertaining PROLOGUES and EPILOGUES;

Together with

SOLOMON'S TEMPLE an ORATORIO,

As it was performed for the Benefit of

FREE-MASONS.

By Brother LAURENCE DERMOTT, Sec.

LONDON:
Printed for the EDITOR, and ſold by Brother *James Bedford*, at the
Crown in St. *Paul's Church-Yard*.

MDCCLVI.

Origins of Freemasonry

FREEMASONRY EVOLVED IN ENGLAND AS A PHILOSOPHICAL FRATERNAL BROTH- erhood deriving its ceremonies and symbolism from the rules and craftsmanship of the ancient stonemason's guilds. From roots in a guild sys- tem dating back to Edward III (1327-1377), the operative stonemasons governed themselves and their craft by a set of regulations known as the "Old Charges," which were contained in their *constitutions*. The guilds, meeting in groups called lodges, began in the late 17th century to confer honorary membership on influential members of the nobility who were referred to as "Speculative Masons."[1]

ILLUSTRATION: 1.07, FACING SEE DESCRIPTION ON PAGE 12

By the time of Queen Anne's reign (1702-1714), the number of speculative members who were interested in the philosophical aspects of craft masonry began to outnumber the operative members. The accepted or speculative members included many gentle- men, merchants, and eventually noblemen, who identified with the prevailing age of intellectual enlightenment. The métier of masonry shifted to a moralistic and philosophical experience, imparted through the rituals of the "Craft" and strengthened by fraternal bonding. Commencing in 1717, Freemasonry's organization, regulation, and continuity was destined to be administered by a Grand Lodge, headed by a Grand Master. The found- ing of a Grand Lodge in England was later followed by the establishment of Grand Lodges in Ireland and Scotland.

Between 1717 and 1725, reassessment of the old rituals resulted in a revision of the "Ancient Charges" or regulations that governed the Craft. In 1722 the antiquated guild regulations were digested and compiled by James Anderson (1680-1739) into a new set of regulations titled *The Constitutions of the Free Masons*. Thereafter, several decades of internal debate over departures from the Ancient Charges culminated in 1751 with the founding of a rival Grand Lodge whose members were dedicated to preserving intact the old rituals.

William Preston (1742-1818), England's leading Masonic ritualist and lecturer, strove to create a constructive intellectual approach, a unified, better arranged and expressed ritual that could be used in all lodges. Laurence Dermott (1720-1791), Grand Secretary of the "Ancient's" Grand Lodge (1752-1771), denounced Preston's work as introducing too many innovations and neglecting many of the ancient ways. Dermott labeled the revisionists "Moderns." Both the traditionalists, or "Ancients," and the revisionists, or

"Moderns," planted lodges in America, but it was Preston's work in the field of ritual, published as *Illustrations of Masonry* (London, 1772) that was generally adopted in America. *(See "Ancients" and "Moderns" section under Jewels and Medals.)*

British Freemasons who emigrated or traveled to the American colonies and the West Indies carried the Craft with them. Once sufficient numbers of brethren had assembled in a town, application could be made to a Grand Lodge in Britain for a charter to form a lodge and "work" the Craft: elect officers, conduct ritual, and initiate new members. Provincial Grand Lodges were established in the more populous colonies, under suzerainty of either the Grand Lodge of England, Ireland, or Scotland. Freemasons chart their activity in America from the duly constituted founding of First Lodge at Boston, Massachusetts in 1733. Thereafter, Freemasonry spread throughout the western hemisphere.

An understanding of Freemasonry is imparted to initiates through an ascending series of steps or degrees by which the candidate receives a higher condition of knowledge. The first three degrees in Freemasonry are known as "symbolic" degrees. They are lessons concealed from outsiders but unfolded to initiates by secret ceremonies in terms of symbols derived from the science, craft, and tools of ancient stonemasons who, according to biblical traditions, were employed in the building of King Solomon's Temple. Higher levels of instruction are known as the "temple" or Royal Arch degrees (Cryptic and Capitular), which center around legends concerning the second, or Temple of Zerubbabel; "chivalric" degrees, which are based on historic lore surrounding the Order of Knights Templar; and "philosophic" degrees of the Ancient and Accepted Scottish Rite, which are based on moral lessons common to many philosophies.

Key to the development of the American Masonic system was a modification of the English Masonic degrees that separated the Royal Arch Degree from the Master Mason's Degree. From its introduction into the North American colonies prior to the American Revolution, the Royal Arch Degree continued to be conferred in Craft lodges until the late 1790s. After that period, independent Chapter and Grand Chapter jurisdictions became established to administer the four degrees of the Capitular Rite, i.e., the Mark Master, Past Master, Most Excellent Master, and Royal Arch Degree. The Cryptic Rite, consisting of the Royal Master and Select Master Degrees, was also worked in America during the 1760s, but its development remained subject to shifting control until formally organized early in the 19th century under authorities known as Councils and Grand Councils.

By 1830 the series of three ancient degrees that had existed in early 18th-century England had decidedly been restructured by the American brethren. America's pioneer ritualist and premier Masonic lecturer, Thomas Smith Webb (1771-1819), condensed *Preston's*

Illustrations of Masonry to better suit the needs of American lodges. Webb's *Freemason's Monitor and Illustration of Freemasonry* (1797) contained little that was original, but it did embellish, abbreviate, and rearrange what was already accepted ritual. Later editions of Webb's work included the Capitular, Cryptic, and Chivalric rites as well as some of the Scottish Rite degrees. Upon Webb's death, Jeremy L. Cross (1783-1861) became America's leading Masonic lecturer after publication of his *The True Masonic Chart and Hieroglyphic Monitor* (New Haven, 1819) in which numerous illustrations provided an approved vernacular of Masonic emblems and symbols. Because of the imagery it contained, Cross's book became the best selling and most influential source of Masonic symbolism.

In the second half of the 18th century, American Masons began to work the Chivalric or Templar Rite, which was derived from the English Masonic Templars who established encampments at Bristol, London, Bath, York, and Salisbury. This rite included the Knights Templar degree and its appendant orders of Knight of the Red Cross and Knights of Malta. In 1805 the Grand Encampment of the United States was established as a supreme authority over the American order that operated under various regional jurisdictions. In 1820, Cross published *The Templar Chart* as a monitor for the degrees of the encampment.

As early as 1762 the degrees of the Ancient Accepted Scottish Rite were being propagated in America and the West Indies by individuals who held Letters of Patent issued by a Sovereign Council from the Chapter of Clermont at Paris, France, which acted as supreme authority of the Scottish Rite in both hemispheres.[2] In 1801 four of these patent holders, or Deputy Inspector Generals, established a Supreme Council at Charlestown, South Carolina to exercise dogmatic guardianship over the Scottish Rite in the western hemisphere. In 1813 a second jurisdiction was established at New York to administer the rite in the northern United States.

A place has been made in Freemasonry for social participation by the female relatives of Masons. In France, the Rite of Adoption filled this need, but failed to gain popularity in America. It was replaced by unofficial or "side" degrees that are referred to as "Ladies Masonry." Like the Rite of Adoption, these degrees are androgynous, or conferred on both men and women. Although the androgynous degrees in no manner admit recipients into the Masonic Order, they do provide separate ceremonies and rituals in keeping with the spirit of Freemasonry. The catalog of such androgynous degrees includes the "Mason's Wife" (eligible to Master Masons and their wives, widowed mothers, unmarried sisters and daughters); Knight and Heroine of Jericho (Royal Arch Masons, their wives and daughters); and Good Samaritan (Royal Arch Masons and their wives). In 1855 an initiation ceremony and five degrees were created for wives, daughters, and sisters of Masons. Originally called the "Star of the East," it later came to be better known as the Order of the Eastern Star.

In the last quarter of the 19th century a number of socially oriented Masonic orders were developed to provide what has been referred to as the "Playground of Masonry." Notable among these organizations are the Ancient Arabic Order Nobles of the Mystic Shrine, or "Shriners"; the Mystic Order Veiled Prophets of the Enchanted Realm, or "Grotto"; Tall Cedars of Lebanon, and the Royal Order of Jesters. The initiation ceremonies of these orders are more frivolous in nature and they are not considered to be true Masonic degrees. Youth organizations such as Job's Daughters, Rainbow Girls, and the Order of De Molay (founded in 1919) receive sponsorship from a variety of Masonic orders and extend the precepts of Freemasonry to nearly all age levels. A complete list of real and pseudo degrees and orders would be quite lengthy; according to Henry Wilson Coil's *Masonic Encyclopedia* (1961), there have been more than 1,100 such Masonic related degrees documented.

1. The 17th century custom of conferring honorary membership is documented only in Scotland.

2. Stephen Morin was granted a patent in 1761 to propagate the Rite of Perfection (25th degree) in America.

Illustrations

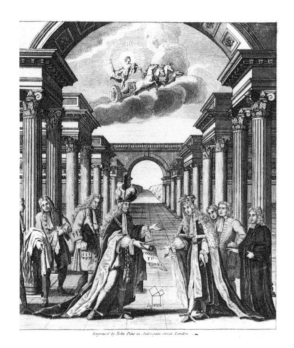

I.01

The Constitutions of the Free Masons
James Anderson (c. 1680-1739), compiler
John Senex, publisher
John Pine (1690-1756), engraver
London, 1723
Library, 88-346sc

The first published edition of the history, laws, ancient charges, and regulations of the Masonic fraternity. Included are a selection of Masonic songs appropriate for each of the degrees. The frontispiece depicts John, Duke of Montagu, Grand Master of England in 1721, handing a roll of the constitutions to his successor, Philip, Duke of Wharton. Behind each Grand Master are his respective officers. With Montagu at left stand his Deputy Grand Master Dr. John Beal, and Wardens Josias Villeneau and Thomas Morris. On the right, behind Wharton, are Deputy Grand Master Dr. John Theophilus Desaguliers in cleric robes and Wardens Joshua Timson and William Hawkins.

 In 1721 the Grand Lodge ordered Grand Warden Dr. James Anderson to "digest the old Gothic Consti-

tutions in a new and better method." Anderson was assisted by the Rev. John Theophilus Desaguliers (1683-1744) who investigated and assembled the old records. Anderson also prepared a second edition in 1738. Engraver John Pine's imprint appears only on the frontispiece to this first edition.

I.02

The Constitutions of the Free Masons
James Anderson (c.1680-1739), compiler
Benjamin Franklin (1706-1790), printer
Philadelphia, 1734
Acquired through the generosity of Mount Lebanon Lodge, Boston; St. Andrew's Lodge, Boston; and Kane Lodge Foundation, New York
Library, 88-339

The first book on Freemasonry printed in America. The first edition of Anderson's *Constitutions* (London, 1723) went out of print in 1734, and this edition was

THE

CONSTITUTIONS

OF THE

FREE-MASONS.

CONTAINING THE

History, Charges, Regulations, &c.
of that moſt Ancient and Right
Worſhipful FRATERNITY.

By Mr. James Anderson, M.A.

For the Uſe of the LODGES.

LONDON Printed; *Anno* 5723.
Re-printed in *Philadelphia* by ſpecial Order, for the Uſe
of the Brethren in NORTH-AMERICA.
In the Year of Maſonry 5734, *Anno Domini* 1734.

reprinted from the original "by special order, for the Use of the Brethren in North America." Six months later Franklin was elected Grand Master of the Grand Lodge of Pennsylvania. This copy appears with the autograph signature of American geographer Lewis Evans and the date "1741" in the upper margin of page 30.

Franklin's account books reveal that only 127 copies were sold, of which all but 8 were bound. Customers in Boston received 70 copies and 25 copies went to Carolina. The exact number that was actually printed is not known, but less than twenty copies have been located. This edition lacks the engraved frontispiece of the original, omits the frequent passages set in Hebrew, and prints in italic the passages set originally in black letter. Franklin's edition also omits the musical notation for the songs but adds the text of a "new song" not present in the London printing.

The *Pennsylvania Gazette*, published by Franklin, in numbers 284, 285, and 286, May 9, 1734, contained this advertisement:

<div align="center">

Just Published
The CONSTITUTIONS of the Freemasons:
Containing the History, Charges, Regulations, etc.,
of that most ancient and Right Worshipful Fraternity,
London printed, Reprinted by B. Franklin,
in the year of Masonry 5734.
Price stitch'd 2s.6, bound 4s.

</div>

References: Voorhis 1931, 1953. Harris 1947

1.03

*The Constitutions of
the Antient and Honourable Fraternity
of Free and Accepted Masons*
Revised by John Entick (1703-1773)
Louis Peter Boitard (fl. 1750), artist
Benjamin Cole (fl. 1728-1767), engraver
London, 1756
Library, 75-445

A revision ordered by the Grand Lodge of the third edition of Anderson's *Constitutions*. The Grand Lodge determined in 1754 that a new edition was required of Anderson's *Constitutions* and entrusted the revision to John Entick. Five hundred copies were printed and the new edition was brought out in 1756.

In 1775 many of the Entick editions remained unsold. It was determined to print an appendix containing principle proceedings of the Grand Lodge since 1756 and annex it to the unsold remaining copies. By 1782 all of the annexed copies were reported sold.

The engraved frontispiece is an allegorical scene of Britannia enthroned with the Arms of the Freemasons. At her feet are the jewels of the Master and Wardens

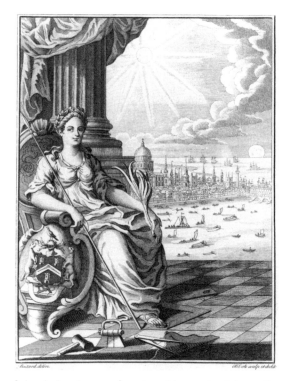

[plumb, level, square], and working tools of the craft: a mallet, compasses, and a lewis [iron lifting ring]. London and the River Thames are shown in the background. Beyond the city lies the ocean horizon, alluding to foreign lands in which Freemasonry will thrive in the future. The design probably suggested a similar scene found as a vignette beneath the portrait of John Entick on the frontispiece to his "*A New and Accurate History and Survey of London*" (London, 1766). The frontispiece was drawn by Burgoss and engraved by Benoist.
Reference: Hawkins 1908

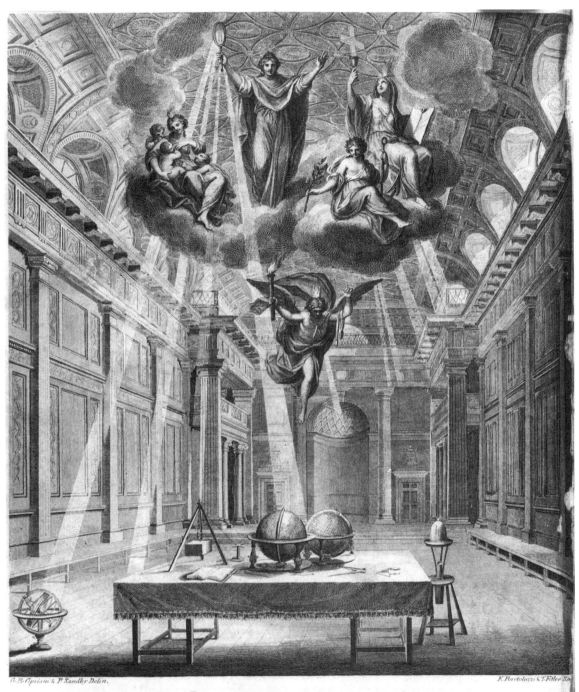

G.B. Cipriani & P. Sandby Delin.

F. Bartolozzi & T. Fitler Sc.

Publish'd as the Act directs

By the SOCIETY of FREE MASONS

at their HALL in GREAT QUEEN STREET LINCOLNS INN FIELDS 1786

1.04

*Constitutions of the Antient Fraternity
of Free and Accepted Masons*
Revised by John Noorthouck (c. 1746-1816)
Drawn by Giovanni Battista Cipriani (1727-1785)
and Paul Sandby (1725-1809)
Engraved by Francisco Bartolozzi (1727-1815)
and James Fittler (1758-1835)
London, 1784
Library, 90-190

The fifth edition of Anderson's *Constitutions*. A special
note describes the plate as follows:

EXPLANATION OF THE FRONTISPIECE
The architectural part represents the inside of
Free-Masons' Hall. The uppermost figure is TRUTH;
holding a mirror [*sic*], which reflects its rays on
divers ornaments of the Hall, and also on the Globes
and other Masonic Furniture and Implements of
the Lodge. TRUTH is attended by the three
Theological Virtues FAITH, HOPE, and CHARITY:
under these, the GENIUS OF MASONRY,
commissioned by TRUTH and her Attendants, is
descending into the Hall, bearing a lighted
Tourch; she is decorated with some of the Masonic
Emblems, and on her arm hangs a ribbon with a
Medal pendant, with which she is to invest
the GRAND MASTER, in token of the Divine
approbation of a Building sacred to Charity
and Benevolence.

The background of the picture shows the interior of
the first Freemason's Hall, London, 1776, the architect
of which was Thomas Sandby, elder brother of water-
color artist Paul Sandby.

1.05

*The Pocket Companion
And History of Free-Masons*
Jonathan Scott, publisher
London, 1764 (3rd edition)
Library

An unofficial edition of Anderson's *Constitutions* con-
taining a history of Freemasonry, collections of
Freemasons' songs, and a list of duly constituted
lodges.
 Copies of the first quarto edition of Anderson's *Con-
stitutions* had completely sold out by 1734. A second
version was printed in 1728/9 and again in 1731 by en-
graver Benjamin Cole. Cole's second edition (1731) was
beautifully engraved on copperplates. These editions
were large, heavy, and expensive. In response to persis-
tent demands of the brethren, William Smith pub-
lished yet another version of the *Constitutions* that was
both cheap and portable. Although a pirated octavo

THE
POCKET COMPANION
AND
HISTORY
OF
FREE-MASONS.
CONTAINING THEIR
Origin, Progress, and present State:

An ABSTRACT of their LAWS, CONSTITUTIONS,
CUSTOMS, CHARGES, ORDERS, and REGULA-
TIONS, for the Instruction and Conduct of the
BRETHREN:

A CONFUTATION of Dr. *PLOT's* False
INSINUATIONS:

An APOLOGY occasioned by their PERSECUTION
in the Canton of *Berne*, and in the Pope's Dominions:

And a Collection of SONGS; a List of all the
LODGES, in a new, yet easy Method; and other
Particulars, for the Use of the SOCIETY.

The THIRD EDITION,
Revised and Corrected, and greatly enlarged throughout,
and continued down to this Time in all its Parts.

Per bonam famam et infamiam.

LONDON,
Printed for R. BALDWIN, W. JOHNSTON, B. LAW and Co.
and J. SCOTT. MDCCLXIV.

1764

version of the official *Constitutions*, its popularity was
such that between 1735 and 1799, the *Pocket Compan-
ion* was republished in more than forty editions.
 The compilation of a list of lodges included those at
Boston; Norfolk and Yorktown, Virginia; New York (St.
John's No. 2.); Quebec (The Merchant's Lodge); Beau-
fort (Port Royal Lodge) and Charlestown (Union
Lodge and A Master's Lodge), South Carolina; Savan-
nah, Georgia (St. Mark's Lodge); and Wilmington,
North Carolina (Cape Fear River).
Reference: Adams 1932

1.06

*The Complete Free Mason,
or Multa Paucis for Lovers of Secrets*
Author unidentified
Peter Larken (fl. 1760), engraver
London, 1764
Library, 77-642

An unofficial history of the development of Freema-
sonry, based on Entick's 1756 revision of the
Constitutions. The engraved title page contains a scene
inspired by John Pine's frontispiece to the first edition
of *Constitutions*, showing the Duke of Montagu holding
a document labeled "Constitution." In Larken's ver-

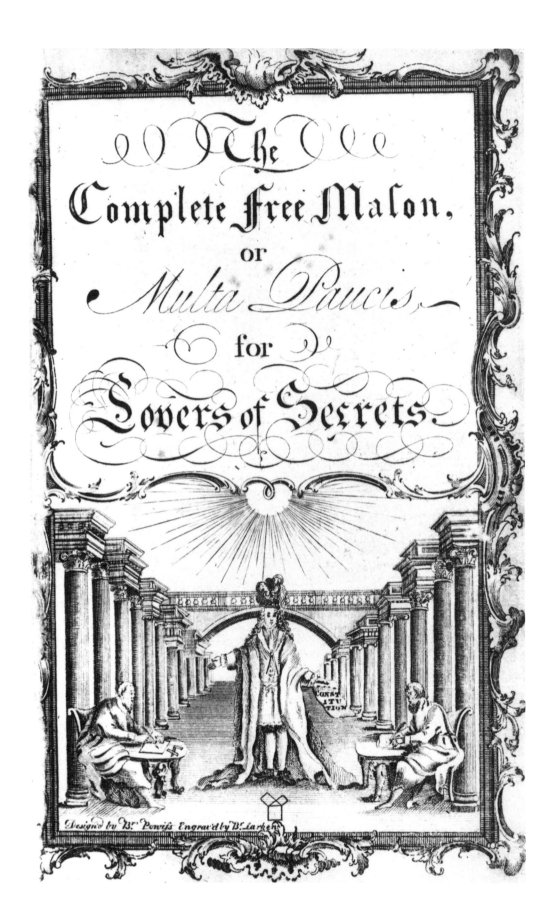

The
Complete Free Mason,
or
Multa Paucis,
for
Lovers of Secrets.

CONST
ITU
TION

Design'd by Br. Penris. Engrav'd by Br. Larken.

sion, designed by "Br. Powiss," the document is being presented to the scribes of Freemasonry, reflecting the Duke of Wharton's fall to disfavor as a result of his role in the Gormagons and his Jacobite support for the Pretender (2.15). The contents also include a list of lodges and a selection of Masonic songs.

1.07 SEE ILLUSTRATION ON PAGE 2

Ahiman Rezon, or a help to all that are (or would be) Free and Accepted Masons, containing the quintessence of all that has been published on the subject of Freemasonry
Laurence Dermott (1720-1791)
London, 1756
Library, 31.3 D 435

In 1751, independent of any higher authority or control, six lodges whose members were mostly Irish formed themselves into a collective body under the title of the Grand Lodge "of the Old Institution." Their purpose was to preserve certain features of the ancient Craft that had been altered by the Premier Grand Lodge of England. It was noted that the two Grand Lodges (Ancients and Moderns) "differ exceedingly in makings, ceremonies, knowledge, masonical language, and installations."

Published by Brother Isaiah Thomas 1798.

Laurence Dermott, serving as Grand Secretary of the "Ancients," drafted a new set of regulations and orders to augment and in some cases supplant Anderson's *Constitutions*. In drafting the new work, Dermott used as his model the *Constitutions* compiled by Edward Spratt (Dublin, 1751), Jonathan Scott's *Pocket Companion* (London, 1754), and Fiefield D'Assigny's *A Serious Enquiry...* (Dublin, 1744).

Although quarto in size, the 8 x 5-inch pages were much smaller than the *Constitutions* and hence more popular. Dermott's dedication contains a reminder that young brethren should conduct their actions "still keeping the ancient Land-Marks in View," and the preface contained sarcastic references to other current "histories" of the Craft.

In North America many lodges under the Ancient's Grand Lodge made use of Dermott's *Ahiman Rezon* as their official Book of Constitutions. The first *Ahiman Rezon* to be published in the United States was issued in 1783 in Philadelphia. This edition is derived from the English second edition of 1764 and is dedicated to George Washington.
Reference: Adams 1933.

1.08

The Constitutions of the Ancient and Honourable Fraternity of Free and Accepted Masons: containing their History, Charges, Addresses, &c. Collected and Digested from Their Old Records, faithful Traditions, and Lodge Books
Thaddeus Mason Harris (1767-1842), compiler
Isaiah Thomas (1749-1831), printer
S. Seymour, engraver
Worcester, Massachusetts, 1792
Library, 17.9763 M414

Seymour's frontispiece consists of an oval scene of the three ancient Grand Masters — Solomon, Hiram of Tyre and Hiram Abif — conferring over plans of the Temple. In the background is a view of the temple under construction.

Isaiah Thomas served as Master of Trinity Lodge, Lancaster; Charter Master of Morning Star Lodge, Worcester; and Grand Master of the Grand Lodge of Massachusetts from 1803 to 1805, and again in 1809.

Rev. Thaddeus Harris served as Deputy Grand Master, Grand Chaplain, and Corresponding Grand Secretary of the Grand Lodge of Massachusetts. This edition is sometimes referred to as the "Harris Constitutions." Brother Harris also published a collection of essays under the title of *Discourses in Favor of Freemasonry*. (Boston, 1803).
Reference: Denslow 1959, 2:190.

Chapter 2

The Lodge: The Oblong Square
Floorings & Floor Cloths
Tracing Boards & Charts

JACHIN AND BOAZ;

OR, AN
AUTHENTIC KEY
To the DOOR of
FREE-MASONRY,

Both ANTIENT and MODERN.

Calculated not only for the Inftruction of every New-made MASON; but alfo for the Information of all who intend to become BRETHREN.

CONTAINING,

I. A circumftantial Account of all the Proceedings in making a Mafon, with the feveral Obligations of an ENTERED APPRENTICE, FELLOWCRAFT, and MASTER; and alfo the Sign, Grip, and Pafs-Word of each Degree, with the Ceremony of the Mop and Pail.

II. The Manner of opening a Lodge, and fetting the Craft to Work.

III. The *Entered Apprentice, FellowCraft,* and *Mafter's Lectures,* verbatim, as delivered in all Lodges; with the Songs at the Conclufion of each Part.

IV. The Origin of Mafonry; Defcription of *Solomon's* Temple; Hiftory of the Murder of the Grand Mafter *Hiram* by the three Fellow-Crafts; the Manner of the Affaffins being difcovered, and their Punifhment; the Burial of *Hiram* by King *Solomon's* Order; with the Five Points of Fellowfhip, &c.

V. The Ceremony of the Inftalment of the Mafter of different Lodges on St. *John's* Day.

VI. A fafe and eafy Method propofed, by which a Man may obtain Admittance into any Lodge, without paffing through the Form required, and thereby fave a Guinea or two in his Pocket.

Illuftrated with

An Accurate Plan of the DRAWING on the Floor of a Lodge,

And Interfperfed with Variety of

NOTES and REMARKS,

Neceffary to explain and render the Whole clear to the meaneft Capacity.

To which is now added,

A New and Accurate LIST of all the Englifh Regular Lodges in the World, according to their Seniority, with the Dates of each Conftitution, and Days of Meeting.

By a GENTLEMAN belonging to the Jerufalem Lodge; a frequent Vifitor at the Queen's Arms, St. Paul's Church-Yard; the Horn, in Fleet-ftreet; Crown and Anchor, Strand; and the Salutation, Newgate-ftreet.

Try me; prove me.

THE SIXTH EDITION.

LONDON:

Printed for W. NICOLL, at the Paper Mill, St. Paul's Church-Yard.
MDCCLXVII.

1767

The Lodge: The Oblong Square

During American Freemasonry's formative years in the first half of the 18th century, few buildings were exclusively devoted to the holding of Masonic meetings. Following the example of their English brethren, American Masons usually met in public coffee houses and taverns or in the homes of members. This practice continued until the 19th century when lodges generally began to expand their membership and obtain enough revenue to acquire property.

ILLUSTRATION: 2.18, FACING

Masonic lodge buildings are termed "temples" because so much of speculative Masonry is connected with the legends surrounding the building of King Solomon's Temple and of the Second Temple by Zerubbabel. The temple built on Mount Moriah in Jerusalem by Solomon, King of Israel (1015 B.C.), forms the cornerstone of Masonic lore and is regarded by Masons as representing the symbolic language of spiritual man. To build such a structure, Solomon found it necessary to seek the assistance of Hiram, King of Tyre, whose subjects were particularly skilled in architectural construction. Among the army of stonemasons sent by Hiram was chief architect Hiram Abif, a lowly widow's son who had risen to the peak of his profession. At that time, Solomon, Hiram of Tyre, and Hiram Abif constituted the three Grand Masters of the Craft. The guild system and working tools of the ancient Tyrian stonemasons, as employed in construction of the temple, provide much of the symbolism of Freemasonry.

The chamber room in which Masonic meetings are held has come to be known as the "Oblong Square." A symbol consisting of a horizontal rectangle has even evolved as a substitute for the printed word "lodge." Chamber orientation is derived from Biblical descriptions of King Solomon's Temple. The Master presides from the chamber's eastern end, or what might be designated as such if the tavern, inn, or dwelling being used for meetings was not actually aligned along cardinal coordinates. The Senior Warden's station is opposite the Master, at the western end. The center of the floor is kept open for the conduct of ceremony and the working of ritual. The Junior Warden is placed as an intermediary between the Master and Senior Warden on the south side.

This arrangement is symbolic in that no sunlight was reputed to have penetrated the northern part of Solomon's Temple. The three principal officers of the lodge, who are considered its guiding lights, symbolically illuminate proceedings within the lodge. Seating for brethren and visitors who attend meetings is usually ranged along the southern and northern sidelines.

Externally, Masonic temples usually conformed to contemporary architectural design, but their interior treatment followed the primary function of providing a secure meeting hall, albeit enhanced with the symbols, badges, and signs of Freemasonry. The first Masonic temple built in the western hemisphere was erected at St. John's, Antigua in 1744.[1] The lodge room measured sixty feet long and thirty feet wide, the shape of a perfect "oblong square."

The Freemasons of Boston, Massachusetts claim the honor of holding the first Masonic lodge meeting in America. They met on July 30, 1733, at the house of Bro. Edward Lutwych, landlord of the Bunch of Grapes Tavern. Thereafter, brethren attending meetings of First Lodge at Lutwych's were advised to take their bearings from the Bunch of Grapes Tavern sign that hung at a nearby street corner.[2] Thus from earliest beginnings in New England, as well as in old England, tavern signs generally became identified as the signposts of Freemasonry.

In the process of establishing the early lodges, measures were occasionally taken to acquire buildings in which to meet. In 1759 a lottery was instituted in Newport, Rhode Island in order to obtain funds to build a Freemason's Hall. In 1764, Boston's Green Dragon Tavern (established in 1697) was purchased by Second and Third Lodges and renamed the "Free Masons' Arms." A large sign of the square and compasses was then prominently placed on the front of the building. In other major American cities where Freemasonry also thrived, such as New York, Philadelphia and Charleston, taverns remained the most popular, convenient, and economical locations for Masons to hold their meetings.

With expansion of the American post road and turnpike systems in the 18th and early 19th century, strategically located coaching inns were established to accommodate passenger traffic. As centers offering comfort for weary travelers and entertainment for local inhabitants, the inns often fitted upper level rooms with partitions that could be removed to create a spacious ballroom or meeting hall. With the exception of churches, these facilities often represented the largest building in a village and were ideal for holding Masonic meetings. Chambers regularly used for lodge meetings often became decorated with Masonic symbols that were frescoed or stenciled on ceilings and walls. A number of Masonic chambers in inns, taverns, and private dwellings throughout New England and New York have been located and recorded.[3]

A number of extant tavern signs prominently include the square and compasses in addition to the owner's name and the date his establishment was founded.[4] However, the appearance of the Masonic square and compasses on a public house sign was not necessarily intended to indicate that lodge meetings were held on the premises. It often served to indicate that the proprietor was a Mason and that his integrity as a Freemason could be relied upon to provide the weary traveler with safe accommodation at an honest price.

Until well into the 19th century, rural lodges were often peripatetic in nature, meeting in the home of one member or another. Paraphernalia that was needed to conduct ritual would be stored and transported from one location to another in trunks or chests designated for that purpose.

The farther westward lodges were established, the greater was the probability that meetings would be held in the upper levels of commercial buildings. This phenomenon, peculiar to American Masonry, resulted mainly from economic considerations that were more acutely felt in the agrarian communities of the Midwest than in the more affluent East. As Freemasonry emerged in the 1840s from a politically-induced "dark period," the incidence of acquiring property increased. Cooperative ownership, in conjunction with other Masonic bodies or compatible fraternal organizations such as the Independent Order of Odd Fellows, gave rise to a proliferation of Masonic temples throughout the country.

Much of what we know of early lodge rooms and their appearance comes from illustrations contained in the attempted exposures. During the 1720s and 1730s the sudden popularity of speculative Freemasonry among noblemen, gentlemen, clergymen, merchants, and respectable tradesmen aroused a lively curiosity among the general public. The public's obsession with discovering the "secret" nature of Masonic rituals prompted Matthew Birkhead (d. 1722) to compose "The Entered Apprentice's Song," in which the second stanza asserted:

> The world is in pain, our secrets to gain,
> But still let them wonder and gaze on,
> For they ne'er can devine,
> The Word or the Sign,
> Of a Free and an Accepted Mason.[5]

It became necessary to take certain precautions before a chamber was considered secure for the conduct of a meeting. A sentinel or Tyler (sometimes spelled "Tiler"), armed with an unsheathed sword, stood watch outside the door to the room to insure that the business conducted within was safe from intruders and cowans, or eavesdroppers. The lodge was thus said to be properly "Tiled."

Eavesdroppers would go to great lengths to satisfy their curiosity. During the late 18th century, when it became routine to hold Masonic meetings in a building's upper floor, even height above ground did not necessarily prevent eavesdropping. Minutes of a 1798 meeting of St. John's Lodge No. 2 at Middletown, Connecticut recorded that "During lodge hours this evening the shed adjoining the back side of this house fell down altogether, which made a very great crashing, supposed to be by the great weight of a number

of cowans who had climbed upon it to look in and see what we were doing."[6] In the 19th century a number of Masonic temples were constructed with an interior passageway that surrounded the meeting room and served as a buffer zone between interior chamber and a building's exterior walls.

Attempts to eavesdrop on Masonic meetings occasionally ended with humorous results. Concealment within a building was a method satirized with risque humor by engraver William Hogarth in 1754. Rarely, as in the case of Mrs. Elizabeth Aldworth (1693-1773), was concealment and discovery countered with initiation and celebrity.

Public curiosity led to the publication of a flood of exposures and catechisms, each purporting to reveal the true secrets of Freemasonry. The first exposures, *A Mason's Examination* (London, 1723) and *The Grand Mystery of Free-Masons Discovered* (London, 1724), professed to describe the ritual and ceremony of a Masonic lodge. However, Samuel Prichard's *Masonry Dissected* (London, 1730) was the first significant exposure that claimed to give full details of the Third Degree. One Masonic authority has postulated that the reason for its large number of editions and rare survival rate is that "they were used by the brethren of those days as rituals."[7] In 1754, Alexander Slade published *The Freemason Examined*, which bore little resemblance to Freemasonry, but is thought to have been intended as a satire to either discredit, or by its contradictions, to bewilder and confound the public. If Slade's niche in Masonic history was not established by his exposé, it was assured by his whimsical caricature titled *A Free Mason Form'd Out Of The Materials Of His Lodge*.[8]

During the period from 1730 to 1760 a number of exposures were published in France, with Abbe Larudan's *L'Ordre des Franc-Masons Trahi* (Paris, 1745) being one of the most detailed. The *Trahi* contained illustrations claiming to represent portions of the ceremonies as well as a plan of the lodge and the drawings on the floor, as did the Abbe Gabriel-Louis Perau's expose *Les Secrets de L'Ordre des Francs-Masons* (Amsterdam, Part I-1742, Part II-1745). Louis Travenol's *Nouveau Catechisme des Francs-Masons* (Paris, 1744) also included initiation scenes, floor cloths, and an illustration of a Masonic feast.[9]

In the 1760s England again took the lead in publishing Masonic exposures, of which the most important were *The Three Distinct Knocks* (1760), and *Jachin and Boaz* (1762). *The Three Distinct Knocks* documented the changes that had occurred in Masonic ceremony since 1730.[10] *Jachin and Boaz* — the title refers to the Hebrew names of the two brass pillars that stood on the portico of King Solomon's Temple and represent establishment and strength — contained ceremonies for the formal opening of the lodge, an installation of officers, and separate ritual for the three degrees. *Jachin and Boaz* was introduced with mixed messages: orginally as providing information for "those who intended to become brethren," but later as "A safe and easy method proposed by which a man may obtain

admittance into any Lodge without passing through the form required, and thereby save a guinea or two in his pocket." [11] After 1776, all editions of *Jachin and Boaz* were illustrated with a much copied "beautiful frontispiece of the regalia, Jewels and Emblematical Ornaments belonging to Masonry; and an accurate Plan of the drawing on the floor of a Lodge."

In America, events surrounding the publication in 1827 of William Morgan's exposure, *Illustrations of Masonry*, generated unparalleled action and reaction. Morgan (1776-c.1826) lived in Batavia, New York, and the brethren there, learning of his intention to publish an exposure on Freemasonry, attempted to burn his manuscript. After being incarcerated in Canandaigua on charges of indebtedness, he was kidnapped from jail and supposedly carried across the border into Canada. He was never seen again. Charges raised that he was murdered by Freemasons led to an hysterical outburst against Freemasonry. The matter became a political crusade to eradicate Freemasonry and secret societies in general. This anti-Masonic period lasted until the 1840s. Morgan's manuscript exposed all three symbolic degrees; later editions exposed the higher degrees as well.

1. Entick 1756. Minutes of the Grand Lodge of England, April 4, 1744.

2. First Lodge, instituted in 1734, was renamed St. John's Lodge. Two of the original carved wooden clusters of gilt grapes are owned by St. John's Lodge.

3. Little 1952. 114-116. Taverns, inns and private dwellings known to have frescoed or stenciled Masonic wall murals include the Joshua Eaton House, Bradford, NH, c. 1818; the Salem Towne House, Charlton, MA, c. 1797; the Solomon Smead House, Shelburne, MA; Hall Tavern, Cheshire, MA; the Hubbard House, Cromwell, CT, c. 1808-33; Fuller Tavern, Berlin, CT, c. 1791; Kelley Hotel, Woodbridge, CT, c. 1797-1821; Elisha Gilbert House, New Lebanon, NY, c. 1795-1850; the Stapleton House, Treadwell, NY, c.1810. Recent discoveries include taverns at Treadwell, NY, c. 1810; Meredith, Delaware Co., NY, c. 1813-34; and the Samuel B. French Tavern, Gilmanton, NH, c. 1799-1835.

4. J. Healy, Trapshire, NH, 1819; J. Hathorn, Thomaston, ME, 1816; A. Lawrence, NY or CT, c. 1800; Cobleigh Tavern, Sugar Hill, NH, 1824; Silas Cochran, Peru, Clinton Co., NY, c. 1810-40; Daniel Cheny, Chatham, CT, c. 1811; H. Rose, Coventry, CT, prior to 1822; P. Jones, Worcester, MA, c.1780; J. Williams, Jr., Ashfield, MA, 1816, M. Dow, South Ware, NH, 1824; J. Burt, E. Long Island, NY, 1824; J. Brooks, VT, 1818/1824; R. Decker, NY, c. 1815 (also owned by D. Beemer, c. 1828).

5. This is one of the oldest known English Masonic songs. The earliest record of it appeared as an undated manuscript suppliment to an early 18th century collection of songs in the British Library entitled *The Bottle Companion: a choice collection of merry drinking songs and healths consisting of loyalty, love and good fellowship.*
 The first appearance of the verses authored by singer/actor Matthew Birkhead (d.1722) were published in Read's *Weekly Journal* for December 1, 1722. (Haunch, T.O.-*Freemasonry In England*).
 Birkhead's verses, entitled "Enter'd 'PRENTICES SONG. By our late Brother Mr. Matthew Birkhead, deceas'd." were subsequently published in Anderson's *Book of Constitutions* (London, 1723), where it was "To be sung when all grave Business is over, and with the MASTER'S Leave". Birkhead was a member of Lodge of Friendship No. 6, London.

6. Secretary's Minute Book, December 26, 1798, St. John's Lodge No. 2, Middletown, Connecticut.

7. Spencer 1961, 142-145.

8. Slade's cariacture of a Freemason was first published by Wm. Tringham on August 15, 1754.

9. Drawings on the floor were often painted on canvas cloths that could be rolled up for storage. *See also* Floorings & Floor Cloths.

10. *The Three Distinct Knocks on the Door of the Most Ancient Freemasonry opening to all men, neither naked nor clothed, barefooted nor shod*. London, 1760.

11. *Jachin and Boaz, or an authentic key to the Door of Freemasonry, both Ancient and Modern, calculated not only for the instruction of every new made Mason, but also for the information of all who intend to become brethren*. London, 1762.

Illustrations

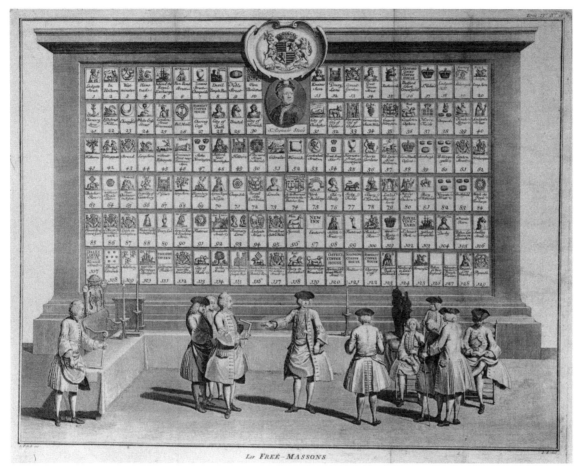

Les FREE-MASSONS

2.01

Les Free Massons
Claude Du Bosc, engraver
Amsterdam, 1735
Engraving
Special Acquisition Fund, 91.008.4

A scene of Freemasons congregating in front of a large panel listing 129 English lodges in numerical sequence with their identifying logos. In the upper center of the panel are shown the Arms of Weymouth and a oval portrait of Sir Richard Steele (1672-1729), second Grand Master of the Grand Lodge of England. Thomas, 2nd Viscount Weymouth, served as Grand Master in 1735.

Before English lodges adopted the use of distinctive names, they were simply known by the name of the inn, coffee house, or tavern at which they met. In the "Engraved Lists of Lodges" that were published annually from 1722 to 1778, they were identified, from 1729 onward, by a sequential number according to the date they were constituted, and by an illustration of the tavern sign or name of the coffee house where they met. Lodge Number 126 is listed as meeting at "Boston in New England."

The original 1734 issue of this engraving by John Pine (1690-1756) listed only 128 lodges. Bosc's un-dated copy of Pine's original version, listing 129 lodges, appeared in the fourth volume of J.F. Bernard's *Ceremonies et Coutumes Religienses de tous les Peuples du Monde* (Amsterdam, 1735), and in volume 6 (Plate 11) of the same title published in London by Bernard Picart in 1737. The imprint "L.F.D.B." (Le Frater Du Bosc) identifies Brother Claude Du Bosc as the artist.

In the chapter headed "A Dissertation on the Labadists," J.F. Bernard referred to "The Free-Masons who are so well known in England, that we need not give our readers any account of them. Besides, as it is not a religious society, it is out of the sphere of this work. But the ignorant or curious reader may consult the Book of the *Constitutions*, and the *Defense of Masonry*, occasioned by a pamphlet, called *Masonry Dissected*. The print here annexed represents Free-Masons."

A footnote to Bernard's description of the separatist movement founded by Jean de Labadie (1610-1674) and known as Labidists, or Quakers, advocated that the state exercise the same tolerance of their religion that was extended to Freemasons. Bernard upheld the Masons as "meetings of a society which is no ways offensive to religion, good manners, or political govern-ment, and has, and does still flourish in Great Britain, under the protection of the greatest men of that king-dom, even princes of the royal family."
Reference: Picart 6:203

2.02

*Plan of the Drawing on the Floor
At The Making of a Mason*
London, 1767
Copperplate engraving
Gift of Alphonse Cerza, Library Collection M19.J12 1767
h: 5 ¼" w: 3 ¼"

Floor plan drawn on the floor of the lodge during 18th-century initiation ceremonies. This illustration first ap-peared in the 1767 edition of *Jachin and Boaz; or, An Authentic Key to the Door of Free-Masonry, Both Antient [sic] and Modern*. The plan is described as "the exact form of the drawing on the floor at the making a Ma-son, according to most ancient custom, and is still retained in all regular lodges. It is most commonly drawn with chalk and charcoal; and as soon as the cer-emony of making is over, the new-made Mason (though ever so great a gentleman) must take a mop from a pail of water, and wash it out. In some lodges they use red tape and nails to form it, which prevents any marks or stain on the floor, as with chalk. After this figure is washed out, they sit at the table in the same form, as near as possible; the new member being placed the first night on the Master's right-hand."

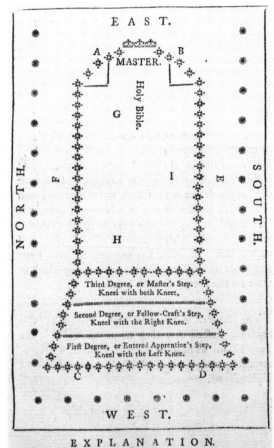

2.03

Front View of the Temple of Solomon...
John Senex (fl. 1717-1727), engraver
London, 1725
Engraving
Gift of Union Lodge, A.F.& A.M.,
Dorchester, Massachusetts, 75.46.16
h: 30" w: 40"

A view and comprehensive description of the many features of King Solomon's Temple.

The revival of Freemasonry in the 1720s was pro-moted by the circulation in England of two important architectural models of Solomon's Temple. The first version, built entirely of wood as a model for proposed construction, was 3 ½ feet deep, 7 feet wide, and 1 ½ feet high. It was created by the Dutch architec-tural scholar Rabbi Jacob Jehudah Leon in 1640. The

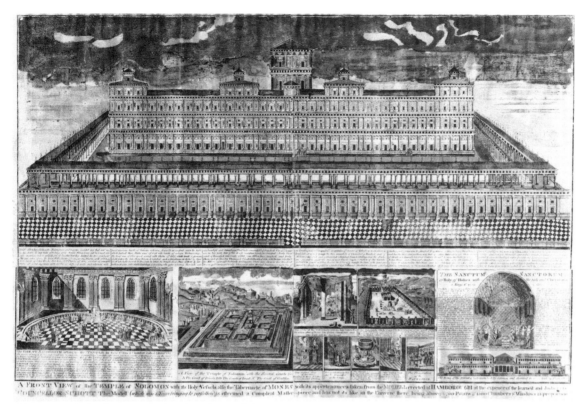

A FRONT VIEW of the TEMPLE of SOLOMON with its Holy Vessels also the Tabernacle of MOSES with its appurtenances taken from the MODELL erected at HAMBOROUGH at the expence of the learned and Judicious COUNSELLOR SCHOTT This Modell (which was if we can bring it to perfection) is esteemed a Compleat Master piece and has not its like in the Universe there being above 1300 Pillars 2000 Chambers & Windows as people observe

scheme was judged too expensive, but the model was placed on public exhibition in Paris, Vienna, and London where, under the patronage of William, Prince of Orange, the model was exhibited to King Charles II in 1675. A guide book, dedicated to Charles II, accompanied its exhibition in England.

A second, more magnificent model was built at the instigation of Gerhard Schott (1641-1702), a Counsellor of Hamburg and patron of Hamburg's opera house. Schott's project was inspired by scenery created for an opera about the destruction of Jerusalem. The 20-foot-square model, designed by Erasmus, was exhibited in Hamborough [*sic*] until 1710. In 1717 a wealthy Englishman brought both models to London, but they were not placed on public exhibition until 1724-1725, and again in 1729-1730.

John Senex (d. 1741), engraver, Junior Grand Warden, and publisher of the first *Book of Constitutions* (1723), copied the engraving contained in the guidebook of Schott's model and published this front elevation of the temple. The engraving received wide circulation among lodges where it was received as being semi-official. The minutes of Union Lodge, Dorchester, reflect that in 1799 this "View of King Solomon's Temple" was added to the Steward's Inventory of Lodge Furnishings.
References: Crawley 1899. Horne 1958.

2.04
An Exact Representation of Solomon's Temple
Alexander Anderson (1775-1870), engraver
New York, c. 1800
Engraving
Gift of Armen Amerigian, 90.19.10.1
h: 8 ¼" w: 13 ½"

View of Solomon's Temple copied from the original version engraved by John Senex in 1725.

2.05
The Temple of Solomon
Nathaniel Currier (1813-1888), publisher
New York, 1846
Lithograph
Gift of Armen Amerigian, 90.19.10.2
h: 8 ¾" w: 12 ¼"

Mid-19th-century version of Solomon's Temple. Currier continued to copy established and accepted views of the temple.

ILLUSTRATIONS:
2.04, TOP
2.05, BOTTOM

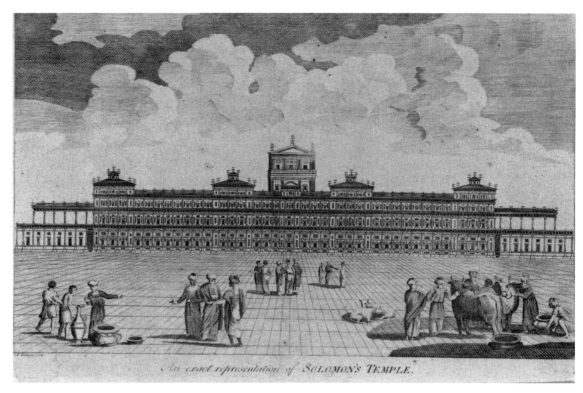

An exact representation of SOLOMON'S TEMPLE.

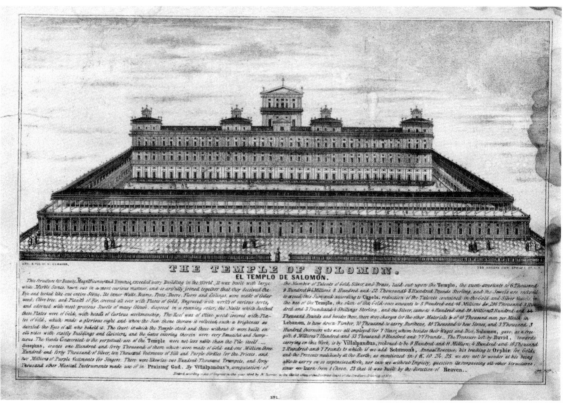

THE TEMPLE OF SOLOMON.
EL TEMPLO DE SALOMÓN.

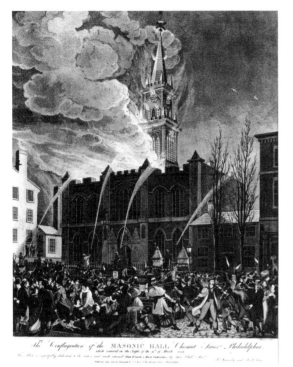

2.06

*The Conflagration of the Masonic
Hall Chestnut Street, Philadelphia*
John Hill (1770-1850), engraver
Kennedy and West, publishers
Philadelphia, 1819
Aquatint
Special Acquisition Fund, 79.42.2
h: 30 ½" w: 25"

Neo-Gothic building of the Grand Lodge of Pennsylva-
nia, designed by William Strickland (1787-1854) and
erected in 1809. The brick and marble-faced wood
structure burned as the result of a fire caused by a de-
fective chimney flue. During a lodge meeting on March
9, 1819, the chimney burst creating a shower of sparks
that ignited the interior stucco decorations and caused a
general conflagration. Crowds gathered in the snow to
watch the blazing spectacle as the 180 foot-high wooden
steeple caught fire. The roof and spire were destroyed
and the interior was gutted. Spectator figures of local
Freemasons were added to the original painting by art-
ist John L. Krimmell (1789-1821).
 The temple was rebuilt in 1820, but without a
steeple. It was the first public building in Philadelphia
to be lit by gas made in the building's own gas
manufactory.

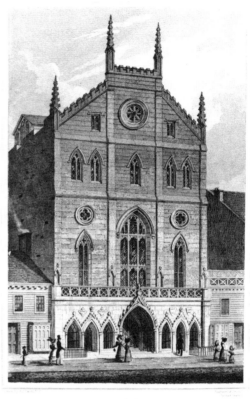

2.07

Masonic Hall, Broadway, N.Y.
Alexander Jackson Davis (1803-1892), artist
Fenner, Sears & Company, engravers
London, September 1, 1830
Engraving
Special Acquisition Fund, 76.26.9
h: 10 ⅞" w: 7 ¾"

The Masonic hall on Broadway was designed by archi-
tect Hugh Beinagle and the cornerstone was laid in
January 1826. Davis completed this plate while work-
ing in New York. The same view also appeared in the
American Magazine in 1834.

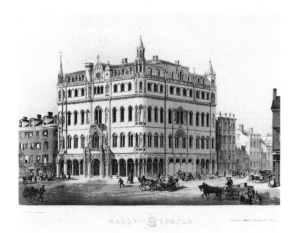

2.08 SEE COLOR PLATE PAGE 258

Grand Lodge Room of the New Masonic Hall, Chestnut Street, Philadelphia.
Louis N. Rosenthal, artist
Max Rosenthal, lithographer
Philadelphia, 1885
Chromolithograph
Special Acquisition Fund, 77.13.2
h: 21" w: 27"

Lodge room decorated in ornate Gothic style, designed by the architectural firm of Sloan and Stewart. Etcher and lithographer Max Rosenthal (1833-1918) was an early leader in the art of chromo-lithography. This view is considered an outstanding example of the visual effect that was achieved by the new color process.

2.09

The New Masonic Temple, Boston
Merrill G. Wheelock (1822-1866), artist
John H. Bufford, lithographer
Pollard and Leighton, publishers
Boston, 1865
Chromolithograph
Supreme Council Archives, 86.66
h: 17 ¼" w: 24 ½"

A Gothic-style building erected to replace a former Grand Lodge temple destroyed by fire in 1864. The replacement structure was dedicated on June 24, 1867, by Bro. Andrew Johnson (1808-1875), Seventeenth President of the United States (1865-69).

2.10

Architectural Rendering
Charles H. Dunbar Company
Boston, c. 1900
Watercolor on board
Gift of Ann M. Dowrick, 78.72
h: 16" w: 27 ¾"

Elevation view of mural decorations for a meeting room in the temple of the Grand Lodge of Massachusetts, Boston. A dias is shown with a Greek-style baldachino, or canopy, supported by Corinthian columns. Beneath the baldachino is seating for a Master and other officers of a lodge.

Entertainment by

J. HEALY.

1819

2.11 SEE ILLUSTRATION ON PAGE 27

Tavern Sign
Trapshire, New Hampshire, c. 1819
Chestnut, maple
Special Acquisition Fund, 92.003
h: 64" w: 34 ½"

An oval signboard painted in Prussian blue, inscribed in gilt on both sides "Entertainment by J. Healy. 1819," with Masonic square and compasses. The board is mortised and tenoned to a red painted rectangular frame having a broken arch pediment and turned stiles that terminate in egg-shaped finials.

The J. Healy Tavern was located in the vicinity of present day Trapshire, New Hampshire (three miles south of Charlestown). The tavern appeared under the notation "Sartles Tav.," on *A Topographical Map of the State of New Hampshire*, published by Samuel Holland in 1784. Jesse Healy (1769-1853) married Mrs. Dolly Sartwell (d. 1810), widow of the tavern's original owner, Simon Sartwell (Sartle). The Healys' first child was born in 1793.

Jesse Healy was raised a Master Mason on May 7, 1800, in Hiram Lodge No. 9 at Claremont, New Hampshire. That June the Grand Lodge of New Hampshire granted a charter to Freemasons in the Charlestown area to hold a lodge (Faithful Lodge No.12). On the occasion of installing Faithful's officers, Jesse Healey was listed as Senior Warden of the lodge. He served as Master in 1802-03, as Chaplain in 1812-14, and as Senior Warden again in 1815. Healey's name reoccurs in Faithful's annual membership returns until the year 1824, after which it fails to appear. There is no record of Faithful No. 12 having ever met at Healey's Tavern.
Reference: Frizzell 1955, 270. Saunderson 1876, 399. Proceedings, Grand Lodge of New Hampshire 1860, 66. *Membership Returns for Faithful Lodge No. 12, Charlestown, 1800-1830. Grand Lodge of New Hampshire, Manchester.*

2.12

Weather Vane
Pennsylvania, 19th century
Iron
Special Acquisition Fund, 78.1.3
h: 26" w: 19 ½"

Masonic square and compasses finial fixed above a rotating arrow-shaped directional vane. The circular base fitted with bracket ears for attachment.

Weather vanes served to proclaim a building's purpose or identify its owner, as well as indicate changing wind direction. The square and compasses that comprise the finial are Freemasonry's most universal logo. A Masonic temple with such a distinctive vane could be easily recognized. Since this vane was removed

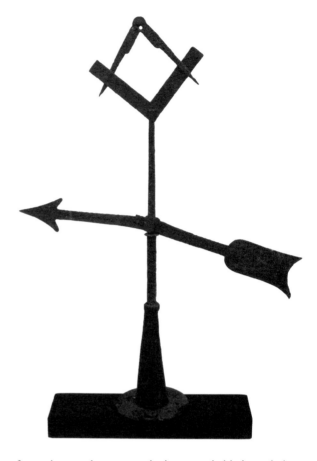

from a barn and not a temple, it was probably intended to identify the owner as a Freemason. This vane was removed from a barn in West Chester, Pennsylvania.

2.13

Door Latch
J. Cook
Plattsburgh, New York, dated 1825
Wrought Iron
Special Acquisition Fund, 88.44
h: 28" w: 6"

Monumental door latch composed of a forged grasp riveted to upper and lower cusped plates. The upper plate pierced with a keyhole and thumbpress, and deeply stamped with Masonic square and compasses, Jacob's ladder, crescent moon and seven stars, and the name "J. Cook" in a sunken cartouche. The lower plate stamped with Masonic pillars and letter "G" above the date "1825."

The latch was removed from the door of a stone grist mill located on the Au Sable River in the town of Keeseville, New York. Built in 1825 on the border between Essex and Clinton counties, the mill housed

meetings of Peru Lodge No. 319. The lodge was originally chartered in 1819 to hold meetings in the town of Peru (Clinton County), but it removed to Keeseville in 1825. The date of 1825 stamped on the latch was probably intended to commemorate this move. As Deputy Grand Steward in 1825, Timothy F. Cook of Plattsburgh was charged with inspection of lodge charters, and was in a position to assist the brethren in acquiring such a unique latch. His relationship to J. Cook, whose name appears on the latch, currently remains unresolved. The 1830 Census of Essex County lists a Joseph Cook, blacksmith, in Moriah (Crown Point).

Like many Masonic lodges in upstate New York, Peru Lodge was forced to surrender its charter in 1832 as a result of anti-Masonic public reaction to the Morgan Affair. As Freemasonry emerged in the 1840s from its Morgan-induced "dark period," the mill was again used as the meeting place of another Masonic lodge (Ausable River Lodge No. 149, chartered in 1849). The latch remained on the door of the mill until, as a section of Prescott Mills Plant No. 1, it was destroyed by fire on May 20, 1969.
References: Smith 1885, 518. U.S. Census 1830, New York, Essex County.

2.14 SEE ILLUSTRATION ON PAGE 30
A Freemason Form'd Out Of The Materials of His Lodge
Samuel King (1749-1819), artist
Newport, Rhode Island, 1763
Ink and watercolor on paper
On loan courtesy of St. Andrew's Lodge, A.F.& A.M.
Boston, Massachusetts
h: 19" w: 14"

Caricature of a Freemason. The figure is constructed of various Masonic symbols including square, compasses, level, plumb line, Book of Constitutions, radiant sun, apron, and the pillars of Solomon's Temple. The base of the pillars bear the date "1758." An inscription below the figure reads:

> Behold a Master Mason rare,
> Whose mistic Portrait does declare,
> The secrets of FreeMasonry
> Fair for all to read and see;
> But few there are to whom they're known,
> "Tho they so plainly here are shown.

It is signed and dated under the inscription, "S.King pinx, 1763."

The design was copied from an engraving by Alexander Slade that was published by W. Tringham in London on August 15, 1754. Slade also authored a spurious book of Masonic ritual titled *The Freemasons Examined* (London, 1754).

The artist Samuel King (1749-1819) was born in Newport, Rhode Island, and spent most of his life

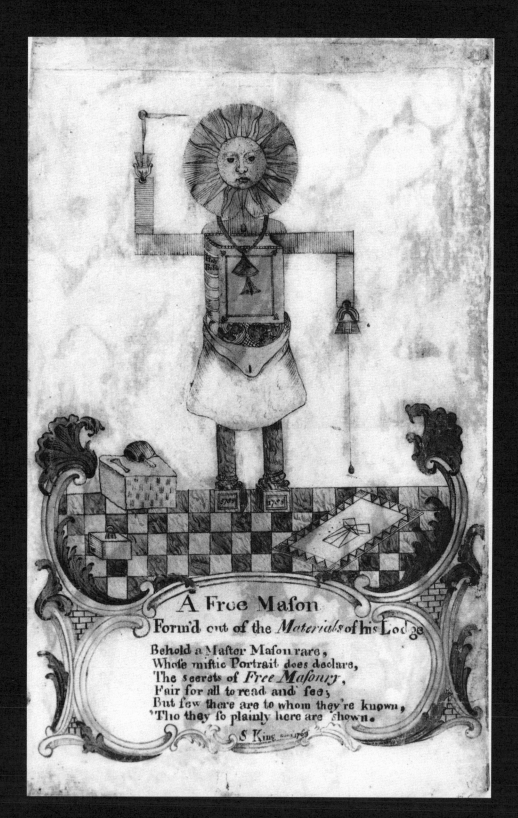

A Free Mason
Form'd out of the *Materials of his Lodge*

Behold a Master Mason rare,
Whose miftic Portrait does declare,
The secrets of *Free Mafonry*,
Fair for all to read and fee;
But few there are to whom they're known,
'Tho they fo plainly here are shown.

S King sin 1769

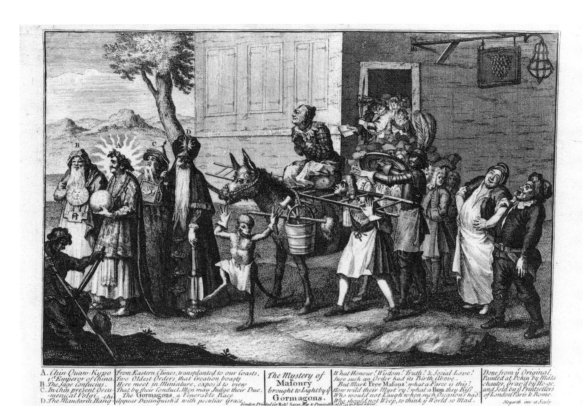

A. Chin Quan-Kypo / 1ᵗ Emperor of China. / From Eastern Climes, transplanted to our Coasts, / Two Oldest Orders that Creation boasts, / B. The Sage Confucius. / Here meet in Miniature, expos'd to view / That by their Conduct, Men may Judge their Due. / C. In Chin present Docu- / -mental Poteri, -th / The Gormogons, a Venerable Race / D. The Mandarin Hang / Appear Distinguish'd with peculiar Grace. | The Mystery of / Masonry / brought to Light by ye / Gormagons. | What Honour! Wisdom! Truth! & Social Love! / Sure such an Order had its Birth Above. / But Mark Free Masons! what a Farce is this? / How wild their Myst'ry! what a Kiss / Who would not Laugh when such Occasions had / Who should not Weep, to think ye World so Mad. | Done from ỹ Original, / Painted at Pekin by Maia / chauler, Grav'd by Hoage, / and Sold by ỹ Printsellers / of London Paris & Rome. / Hogarth inv et Sculp

London Printed for Robᵗ Sayer, Map & Printseller...

there as a nautical instrument maker and portrait and miniature painter. There is a tradition that he was sent to Boston to serve an apprenticeship as a house painter, but instead may have studied art under Thomas Johnston. This work was probably done for a member of St. Andrew's Lodge when King was fourteen and studying in Boston.

References: Thorp 1907

2.15

The Mystery of Masonry brought to Light by Ye Gormagons

William Hogarth (1697-1764), artist and engraver
Robert Sayer, publisher
London, April 27, 1742 (third state)
Engraving
Special Acquisitions Fund, 91.035
h: 16" w: 22"

A procession of Gormogons led by their mythical Emperor Chin Quan, followed by oriental sages, an ape wearing an apron signifying Masonry as aping the Gormogons, and an old gentleman sitting on a ladder carried by an ass. The beast's rider was probably intended to represent the Rev. John Theophilus

Desaguliers (1683-1744), the third Grand Master, and the beast itself represents the ancient craft of Masonry. The ladder is supported by a figure who is wearing gloves and an apron and is believed to be James Anderson, compiler of the *Constitutions*. In the background, issuing from a tavern door guarded by an armed Tyler, are the brethren of a lodge.

The Society of Gormogons was founded in 1724 as a small Jacobite Club to imitate and ridicule proceedings of the Freemasons. The Gormogons were begun for religious and political reasons by Philip, Duke of Wharton (1698-1731), a Roman Catholic, Jacobite, and Sixth Grand Master of Freemasons. For his seditious pro-Jacobite articles written in the *True Briton*, Wharton was outlawed in 1729 and denounced in Grand Lodge. Wharton is represented in the print as Chin Quan, leader of the Gormogons.

Hogarth, himself a Freemason and member of the lodge at the Hand and Appletree tavern in 1725, satirized the exclusivity and hermetic symbolism of the ritual. Many of the characterizations used by Hogarth in *The Mystery of Masonry...* were freely copied from figures in the *History of Don Quixote*, drawn by Charles Antoine Coypel (1694-1752) and published by T. Shelton (London, 1725). Early impressions of the plate were known to bear the words "Stolen from Coypel's Don Quixote." Hogarth's plate is generally supposed

The Lodge 31

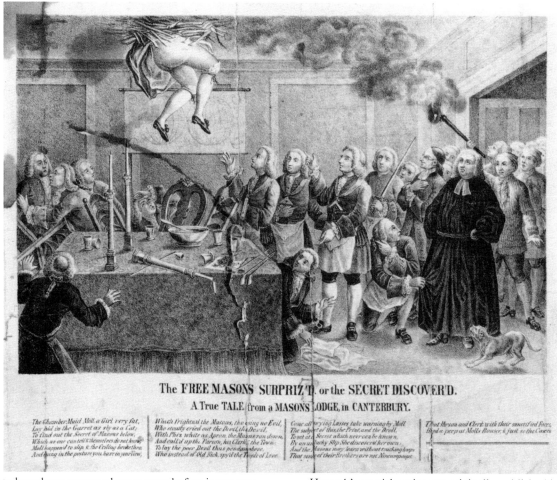

The FREE MASONS SURPRIZ'D, or the SECRET DISCOVER'D.

A True TALE, from a MASONS LODGE, in CANTERBURY.

The Chamber-Maid Moll a Girl very fat,	Which Frightned the Masons, tho' being no Evil,	Come all prying Lasses take warning by Moll	That Person and Clerk with their sanctified Faces,
Lay hid in the Garret as sly as a Cat;	Who stoutly cried out the Devil, the Devil,	The subject of this, the Print, and the Droll,	Had a peep at Molls Houses & just so the Casts
To find out the Secret of Masons below,	With Phix white as Apron, the Masons ran down,	To set at a Secret which never can be known,	
Which no one can tell & themselves do not know,	And call'd up the Parson, his Clerk, the Town,	By an unlucky Slip She discover'd her own,	
Moll happen'd to slip & the Ceiling broke thro,	To lay the poor Devil thus pendant above,	And the Masons may learn without racking toys	
And hung in the posture you have in your View,	Who instead of Old Nick, spy'd the Temple of Love.	That some of their Brothers are not Nincompoops	

to have been executed some years before it was actu-
ally put on the market in 1742.
Reference: Gould 1895, 114-115

2.16

*The Free Mason's Surpriz'd,
or the Secret Discovered...*
after William Hogarth
Robert Sayer, publisher
London, 1767
Stipple engraved
Gift of Pauline Tyrell, 87.42.2
h: 9 ½" w: 13 ½"

Lodge room scene in which the brethren gaze upwards
with consternation at a female chambermaid whose ex-
posed lower limbs protrude through a hole in their
ceiling. A table in the center of the room had been set
for refreshment.

Hogarth's roguish satire was originally published in
1754 to warn those who wish to discover Freemason's
secrets that they may end by uncovering their own.
The chambermaid Moll has inadvertently fallen par-
tially through the attic garret floor in her efforts to
eavesdrop on the lodge proceedings. By holding lodge
meetings in public houses, the opportunity for eaves-
dropping increased manyfold.

Painter and engraver William Hogarth (1697-1764)
was a member of the lodge at the Hand and Apple
Tree, Little Queen Street, Holborn, London, and of
Corner Stone Lodge. He served as Grand Steward
(1734-1735) and is reputed to have designed the Grand
Lodge jewel for that office.

The Honble. Mrs. Aldworth, The Female Freemason

John Cameron, artist
Macoy & Sickels, publisher
New York, 1865
Lithograph
Special Acquisition Funds, 83.53
h: 21 ½" w: 17"

Portrait of a lady wearing a Masonic apron and pointing to the square and compasses laying on an open book. On her right hand a ring in the form of a radiant sun, in the background a Masonic armchair.

Known as "The Lady Freemason," the Hon. Elizabeth St. Leger (1693-1773) was the daughter of Lord Duneraile of County Cork, Ireland. Her father was accustomed to holding lodge meetings in his home and, seized with curiosity about the mysteries of Freemasonry, Lady Elizabeth decided to eavesdrop on the proceedings. Discovered in her place of concealment, she was offered (after much deliberation) an invitation to initiation, which she willingly accepted. After her marriage to Richard Aldworth, she maintained her connection with the Craft; her name occurs among the subscribers to Dassingy's *Enquiry* of 1744, and it has even been stated that she presided as Master of her lodge.

An etching by Alexander Wilson of Mrs. Aldworth's original portrait was followed by Richard Jackson's mezzotint of the same view. Cameron drew upon one of these for his version.
Reference: Conder 1895, 16-23.

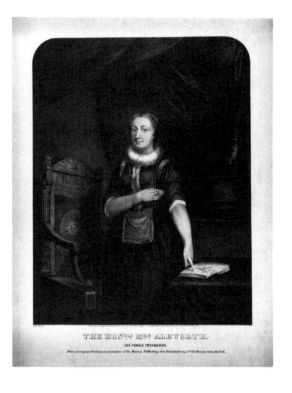

THE HON.^{BLE} M^{RS} ALDWORTH.
THE FEMALE FREEMASON.

2.18 SEE ILLUSTRATION ON PAGE 14

Jachin and Boaz; or an Authentic Key to the Door of Free-Masonry, Both Antient and Modern.

London, 1767 (sixth edition)
Gift of Alphonse Cerza,
Library Collection M19.J12 1767

Jachin and Boaz was the most widely reprinted alleged exposure of Masonic ritual. The first edition was published in London in 1762; the first American edition was printed in Albany in 1797. Public fascination with the secrets of Freemasonry fostered continued reprinting until well into the 20th century. The engraved illustrations of a *Description of the Regalia...* (4.46) and the *Plan of the Drawing on the Floor...* (2.02) underwent minuscule change at the hands of various publishers, but the outmoded text remained virtually unchanged.
Reference: Smith 1943, 10-14

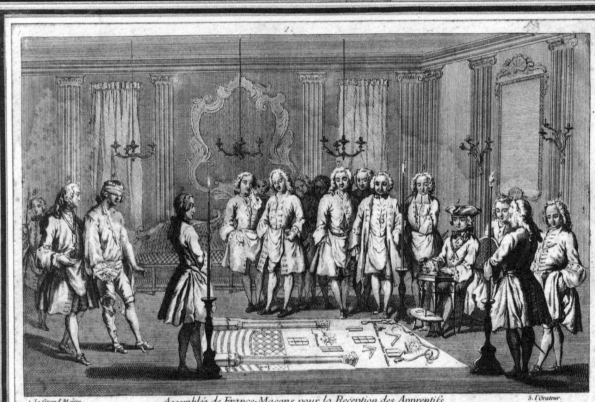

1. Le Grand Maître .
2. le 1er Surveillant .
3. le 2e Surveillant .
4. le Recipiendaire .

Assembleé de Francs-Maçons pour la Reception des Apprentifs.
Entrée du Recipiendaire dans la Loge .
Dedié au trés Galant, trés sincere et trés veridique Frere profane Leonard Gabanon, Auteur du Catechisme des Francs-Maçons.
Dessiné par Madame la Marquise de *** et Gravé par Mademoiselle ****.

5. l'Orateur .
6. le Secretaire .
7. le Tresorier .
8. le Frere Sentinelle .

Floorings & Floor Cloths

ILLUSTRATION:
2.19, FACING

PRIOR TO THE INITIATION OF A CANDIDATE, ONE OF THE TYLER'S DUTIES WAS TO "DRAW the lodge," or trace in chalk, crayon, or charcoal on the floor of the chamber symbols associated with the degree to be presented; the symbols were drawn within an indented "oblong square" border representing a plan of the lodge.[1] Referring to these symbols, the Master delivered a catechism on the moral and philosophical meaning of that specific degree. Upon completion of the ritual, the new member, regardless of his social rank, would be obliged with mop and pail to erase all traces of the chalked diagram. The design might also be drawn in sand or clay. Red tape and small nails were sometimes used to create the outline form of the lodge, which prevented the leaving of any mark or stain on the floor.[2] Metal cut-outs or actual tools could be used in lieu of drawn symbols.

It became a practice to paint the symbols on a canvas cloth that could be unrolled, laid down upon the floor like a carpet, and rolled up again for storage.[3] The earliest known floor cloth is the eighteen-foot-long Kirkwell Kilwinning Scroll, painted in oils on linen to illustrate the Degrees of the Symbolic Lodge, the Royal Arch Chapter, and the Red Cross of Babylon and the Knights Templar. The Lodge at Kirkwell in the Orkney Islands was founded in 1736.[4] The contents of early American lodge inventories reflect that rarely was more than one floor cloth mentioned. More often, as in the case of Union Lodge, Dorchester, Massachusetts, it was termed a "Flooring Compleat," indicating an all-purpose design applicable for all three Craft degrees.

During the period from 1730 to 1760 a number of exposures were published in France that revealed the appearance of Masonic floor cloths. Louis Travenol's *Nouveau Catechisme des Francs-Masons* (Paris, 1744) included a series of copperplate engravings that revealed the specific design and use of floor cloths during initiations. Abbot Larudan's *L'Ordre des Franc-Masons Trahi* (Paris, 1745), and the Abbe Gabriel-Louis Perau's expose *Les Secrets de L'Ordre des Francs-Masons* (Amsterdam, Part I-1742, Part II-1745), also contained illustrations claiming to represent portions of the ceremonies as well as the drawings on the floor.

American floor cloths that survive from the 18th century display relatively fewer Craft symbols than English examples. Within the prescribed oblong indented border will be found an all-seeing eye, radiant sun, crescent moon, and seven stars. These symbols nearly

always appear in the upper portion of the design. A black and white checkered mosaic pavement, representing the ground floor to King Solomon's Temple, forms a base for the design and usually displays a blazing star in the center.[5] One, two, or three steps, each representing a degree level, may lead to the mosaic pavement. Set upon the pavement are the two architectural pillars Jachin and Boaz, which are usually shown flanking an open Holy Bible. A number of stonemason's working tools, including square and compasses, plumb rule, level, chisel and mallet, and trowel are distributed around the periphery. Almost any symbol associated with the Entered Apprentice's Degree, such as a cable-tow (towline) or slipper, could also be added at the artist's discretion.

Throughout the remainder of the 18th century, floor cloths were mentioned in American lodge records with increased frequency. In 1768 the lodge in Fredericksburg, Virginia paid three pounds sterling to have two floor cloths painted and gilded.

1. The indented border was composed of alternating black and white dogtooth-shaped triangles.

2. *Jachin & Boaz* 1767.

3. The minute book of Old King's Arms Lodge No. 28 (London) records that "a proper delineation shall be made on canvas for use at initiations." The occasional inadvertent disclosure of a floor cloth was met with considerable opposition from conservative quarters. In the middle of the 18th century, their use was prohibited in France and Scotland.

4. Craven 1897, 79-91. The cloth is said to date from the time of the lodge's establishment.

5. A sun with blazing lines of heat and light radiating outward was first mentioned by Preston in *Illustrations of Masonry* (London, 1772) as an emblem of Divine Providence. The black and white squares of the mosaic pavement are said to represent good and evil forces in life.

Illustrations

2.19 SEE ILLUSTRATION ON PAGE 34

*Assemblee de Francs-Maçons
pour la Reception des Apprentiss*
C. Crepy, engraver
Jacques Chevreau (1688-1776), printer
Paris, 1744/1745
Copperplate engraving
Museum Collection, 84.69
h: 18" w: 13"

Scene of a hoodwinked, or blindfolded, candidate be-
ing led into the lodge chamber for initiation. On the
floor in front of the Master lies a floor cloth decorated
with symbols of the degree that will be used during
the ritual ceremony.

This is one of the earliest illustrations purporting to
reveal the initiation of a candidate for the Entered
Apprentice Degree. This scene (Plate I) is one in
a series of seven plates. Plates 1-4 and 6 were engraved
at "chez Crepy rue s. Jacques a S. Pierre"; Plates 5
and 7 were done at "chez J. Chereau." The floor cloth
design was also published as a "Plan de la Loge" in
Neaulme's exposé (Amsterdam, 1745), and Travenol's
(Paris, 1749).

An Anglicized version of this scene appeared in 1809
as part of a set of aquatints by Thomas Palser. Relative
positions of figures in the composition remained the
same, but clothing worn by the English brethren re-
flect changes in fashion that occurred during the sixty
years between publication dates.
Reference: Les Costumes des Francs-Maçons *1744/1745*.
Neaulme 1745.

2.20

Apprentice's Carpet
Louis Travenol
Paris, 1749
Copperplate engraving
Library & Archives, 81.274

Floor cloth design popular in French lodges of the mid
18th century.

Several symbols illustrated in this design are pecu-
liar to French ritual and include the broached thurnal
and the French style A-frame plumb-line level, or
niveau. The broached thurnal is represented as a cubi-

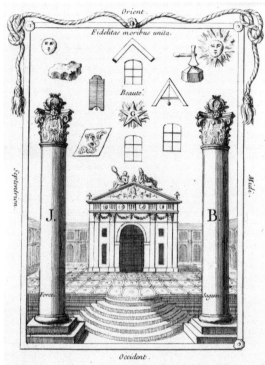

ILLUSTRATION:
2.20

Plan de la Loge de l'Aprentif-Compagnon.

cal ashlar, or dressed stone, with an axe imbedded in
its pyramidal apex. The three "lights of the lodge" are
represented by three window frames, or lights, rather
than the more common three standing candlesticks.
Reference: Travenol 1749

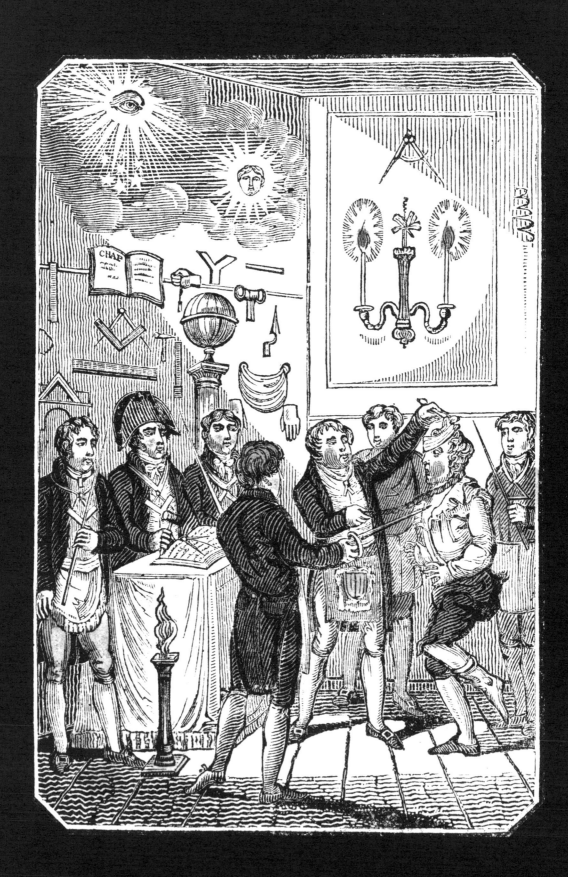

Tracing Boards & Charts

ILLUSTRATION:
2.21, FACING

✿ ✿ SURFACE CRACKING AND PAINT LOSS, RESULTING FROM NORMAL HANDLING IN THE
✿ ✿ ✿ lodge, eventually led to a more practical treatment of floorcloths. The can-
✿ ✿ vases experienced a better rate of survival when framed as works of art and
displayed on an easel or wall. The panel-mounted floor cloth with leather bound edging
and brass tack decoration, listed as a "tracing board" in the 1796 inventory of Union
Lodge, Dorchester, Massachusetts, suffered little damage in this more durable form.

Some frames were hinged so that the paintings could be folded, perhaps to be more
easily carried from one meeting location to another, but certainly also to be safe from
uninitiated eyes. The Royal Arch tracing board belonging to Hiram Lodge of Arlington,
Massachusetts (see 2.24) was framed in this manner. Other means were taken to insure
that tracing boards were not subjected to unwanted scrutiny. Elizur Barnes, a Middletown,
Connecticut cabinetmaker, noted in his accountbook on January 9, 1824, that he charged
chaise and carriage painters Jones & Bush "To a Fraim 4 by 5 feet for a Masonic Carpet-
$2.00." A month later, G.W. Bull paid for "...a Box 4 by 5 feet for Masonic Carpet painted
by Jones & Bush-$1.75." In 1816 artist John Ritto Penniman (1783-1841) painted a floor-
ing for Columbian Lodge of Boston. It was hung in Grand Lodge, where Columbian met,
but before much time had passed it was deemed necessary to suspend a curtain in front
of the painting.[1]

Inasmuch as Freemasonry is a system of morality veiled in allegory and illustrated
by symbols, the tracing board evolved as an ideal teaching aid for emphasizing its te-
nets. Together with the rough and polished ashlars, the tracing board is considered one
of the three Immovable Jewels of the Lodge. The tracing board has often been confused
with the trestle-board; "Trestle-board" is a term that A.G. Mackey in the *Encyclopaedia
of Freemasonry* defined as "a board laid upon a trestle or framework, upon which the Master
drew his diagrams or designs." It appeared frequently among the Masonic symbols that
decorated Chinese export punch bowls and cider jugs (see Refreshment).

At the beginning of the 19th century a tradition had been established in English lodges
to acquire painted tracing boards in sets of three, one for each of the degrees or symbolic
steps in Masonry: (1) Craft symbols within an oblong square (representing a floor plan
of the lodge) with a mosaic pavement and indented tesselated border for the Entered
Apprentice, or First Degree; (2) the portico to King Solomon's Temple and a winding

staircase leading to the sanctum sanctorum for the Fellow-craft, or Second Degree; and (3) what was referred to as a "mort board," depicting a coffin and occupant (Grand Master Hiram Abiff) in a shroud, which alluded to the Hiramic legend central to the Master Mason, or Third Degree.[2]

In the 19th century all-purpose tracing boards, or "Master's Carpet's" as they came to be called, became crowded with a pastiche of symbols from all Craft degrees. During visits to numerous American lodges as a Masonic lecturer, noted ritualist Jeremy Cross (1783-1861) observed much "improper classification" of Masonic symbols. In order to "obviate these inaccuracies," his *Masonic Chart* (New Haven, 1819) established an illustrated classification of Masonic symbols that gained rapid acceptance among American lodges. Rather than restricting their use of Masonic symbols, Cross's work provided artists with an expanded catalog of "approved" symbols from which to satisfy Masonic customers. Cross's illustrator, engraver Amos Doolittle (1754-1832), included vignettes depicting legends associated with the Royal Arch Degree, so Royal Arch symbols also became integrated into tracing board designs.

In the early decades of the 19th century the "Master's Carpet" became a stock in trade item for many house, sign, coach, and ornamental painters. A number of newspaper advertisements placed by these limners specifically listed Masonic paintings or carpets as part of their repertoire.[3] Brethren who were professional artists of considerable reputation such as Ezra Ames, John Penniman, and Thomas Savory advertised that they painted Masonic carpets or floorings. Unknown amateur artists such as the Rev. Thomas Tolman or Jonas Prentiss were more than willing to paint a Master's Carpet for their lodges, merely for the honor of the Craft.[4]

By mid-century Masonic tracing boards were commercially available in lithographed wall chart form. Designed by John Sherer in 1856, the "Sherer Charts" became standard lecture fixtures in lodge rooms until well into the 20th century.[5] The charts were printed on sheets suspended from spring rollers that were attached to the wall. When not in use they could be rolled up like a window curtain. By the 1880s and 1890s, the regalia industry offered tracing boards on glass plate slides (see 2.34) that could be projected in the lodge by a variety of gas-jet or carbon-arc "Magic Lanterns."

1. History of Columbian Lodge, Minutes of March 7, 1816. According to the Treasurers report dated September 6,1821, Penniman was paid $330 for his "emblamatic painting," and the curtain cost $59.

2. A number of artists and engravers responsible for codifying the symbols used on English tracing-boards have been identified, among whom were engravers John Cole and John Browne (1800-1810), artists Josiah Bowring (1800-1830), John Harris (1820s), and Arthur L. Thiselton (1830s). Surveys of their idiosyncratic work are contained in E.H. Dring 1916, and Haunch 1962.

3. See advertisement by John Leman in the *American Masonick Record and Albany Saturday Magazine*, May 17, 1828.

4. See Records of the Grand Lodge of F.& A.M. of the State of Vermont from 1794 to 1845 Inclusive. Burlington, 1879. According to a cash book entry in 1797, Rev. Bro. Tolman was paid 65 shillings for painting a Masters Carpet.

5. See The Pettibone Bros. Lodge Catalog No. 791, c. 1910. Bro. John Sherer copyrighted his design in Ohio in 1856.

Illustrations

2.21 SEE ILLUSTRATION ON PAGE 38

Interior of a Masonic Lodge, with the ceremony of making a Mason

J. Bailey, publisher
London, n.d.
Copperplate engraving
Archives 88-295

A purported depiction of the initiation of a candidate who has been prepared to receive the Entered Apprentice Degree.

This illustration is the frontispiece to W.O. Vernon's exposure of the English Craft system titled *The Three Distinct Knocks....* The "knocks" refer to the supposed mode by which escorted candidates gain entrance to the lodge (see Doorknockers). Symbols alluding to the moral precepts that are explained in the lecture given as part of the Entered Apprentice Degree appear on the wall behind the Master. The symbols might have been frescoed or might also have been actual three-dimensional articles fastened to the wall.
Reference: Vernon 1760.

2.22 SEE COLOR PLATE, PAGE 262

Emblematic Painting

English, 18th century
Oil on canvas
Special Acquisition Fund, 79.42.1
h: 21" w: 17"

Allegorical figures of Faith, Hope and Charity support a classic trestle board of slate chalked with an architectural sketch of a temple. Heraldric arms of the "Ancients" Grand Lodge illuminate a dedication statement.

2.23, SEE COLOR PLATE, PAGE 259, LEFT

Entered Apprentice Tracing Board

Boston, c.1796
Oil on canvas board
Gift of Union Lodge, A.F. & A.M.,
Dorchester, Massachusetts 75.46.17
h: 54 ½" w: 35 ¼"

A painted Masonic floor cloth mounted on pine board, in the form of a rectangle or "oblong square" with an "indented" border composed of alternating black and white triangles. The board is edged with leather tape under regularly spaced brass-headed tacks. Within the border are Masonic Craft symbols, some highlighted in gold leaf, that are associated with the Entered Apprentice Degree.

This painted floor cloth was identified as a "Flooring Compleat" in "An Inventory of Utencils & furniture belonging to the Union Lodge," first compiled on December 13, 1796. In 1818 it was listed on the annual inventory as the "Apprentices flooring." By 1820 it was listed as the "Eter.d apprentices flooring" and was joined by a "Masters Do. (Masters [flooring] ditto) and a "Draf.g Board" (Drafting [trestle] Board).

2.24, SEE COLOR PLATE, PAGE 260

Royal Arch Tracing Board

Jonas Prentiss (1777-1832), artist
West Cambridge, Massachusetts
dated February 18, 1818
Oil on canvas
Gift of Hiram Lodge, A.F. & A.M.,
Arlington, Massachusetts 91.048
h: 72" w: 48"

Masonic tracing board mounted on a hinged folding frame. The complex architectural design rendered in a flat chart-like style consists of two Corinthian columns in gold leaf, supporting a Doric pediment inscribed "SIT LUX ET LUX FUIT" [Let there be light, and there was light]. Beneath the pediment is a Royal Arch set on a squared mosaic pavement with a star in the center. Beyond the arch is a winding staircase leading to another Royal Arch doorway. Above the pediment, a vaulted heavenly canopy contains an all-seeing eye, a radiant sun in gold leaf, and a crescent moon in silver leaf encircled by seven stars. Symbols associated with the basic first three symbolic degrees, as well as those of the Holy Royal Arch Degree, fill the areas between the Royal Arch and the pediment columns. The architectural elements are highlighted in gold leaf, which no doubt made a dramatic effect in the candlelight used for illumination in the early lodges. The reverse of the canvas is inscribed "Painted by Jonas Prentiss West Cambridge, Feby 18th, 1818."

Jonas Prentiss (1777-1832) was raised a Master Mason in 1809 and became a member of Hiram Lodge in 1817. The Middlesex County probate records list Prentiss's occupation as that of a "Gentleman." The tracing board was probably painted for Hiram Lodge of

Menotomy (Arlington) in anticipation of the establishment of a Royal Arch Chapter in Arlington.

The Grand Royal Arch Chapter of Massachusetts (instituted in 1798) decreed that no degrees within Royal Arch could be conferred in other than a Royal Arch Chapter. In compliance with this requirement, certain members of Hiram Lodge petitioned the Grand Chapter on December 8, 1818, to charter a local chapter. Designated as St. Paul's Royal Arch Chapter, its officers were installed January 25, 1819.

Prentiss's flat chart-like composition was probably inspired by a design created by Edward Horsman (1775-1819) for an engraved Master Mason's apron (Franco, Fig.60). The Horsman design was given official sanction by the Grand Lodge of Massachusetts in 1814. Another tracing board of similar artistic technique, but less complex composition, is owned by Amicable Lodge of Cambridge, Massachusetts. The Minutes of Amicable Lodge (chartered in 1805) record that the lodge Stewards inventoried "2 Floorings" and "1 Tressel Board" on December 7, 1819.
Reference: Columbian Centinel (Boston) Feb. 27, 1807 and Aug. 25, 1832. Middlesex County Probate Records, case #17991. Franco 1980.

2.25, SEE COLOR PLATE, PAGE 259, RIGHT
Master's Carpet
Attributed to John Ritto Penniman (1782-1841), artist
Boston, Massachusetts
c. 1820-1825
Oil on linen
Special Acquisitions Fund 89.76
h: 65" w: 41"

A view of King Solomon's Temple rendered in neoclassical style. The two pillars Jachin and Boaz stand in the foreground courtyard accompanied by an array of symbols that include the beehive of industry, rough and smooth ashlars, a mallet and chisel, a lewis (lifting ring) for raising blocks of stone, an hourglass containing the sands of time, a 24-inch marking gauge to measure work, a trowel to spread the cement of brotherly love, and a slate board upon which the Grand Master draws his plans. In the center a Bible is surrounded by the three "lights" of Masonry accompanied by a square, plumb, and level that also allude to the three principal officers of the lodge. The seal of the Grand Lodge of Massachusetts is shown on the building's pediment. Statues of the allegorical figures of Faith, Hope, and Charity adorn the vestibule roof.

This tracing board, which was created as a well-designed architectural composition in perspective, was removed from King Solomon's Lodge Masonic temple located in Charlestown, Massachusetts. Penniman was initiated in St. John's Lodge, Boston in 1810 and is known to have completed many Masonic commissions in the Boston area. In March 1816 he completed a monumental emblematic painting for Columbian

Lodge titled *The Flooring*, for which he was paid $330.00. In 1821 he was chosen to decorate the interior of the New Masonic Hall in the Old State House, Boston.
Reference: Andrews 1981.

2.26, SEE COLOR PLATE, PAGE 261
Emblematic Chart
Attributed to New York State
c. 1840-1850
Oil on canvas
Special Acquisition Fund 90.20
h: 25 ½" w: 30 ¼"

A complex Masonic emblematic painting that combines symbols of Craft, Royal Arch, and Knights Templar. The Royal Arch, supported by two stout columns on a stark mosaic pavement, is inscribed "NZ. ABG. VN. ZNA. NAG. N. OEBGURE." Within a trianglar Templar table, surrounded by twelve candles or "lights," a book lies open to verses numbered 72 and 73, which are legible as "Stand therefore having your loins girded with Truth And having only a Brest [*sic*] plate of Rightiousnos [*sic*]" and "And this pray that your Love may abound yet more and more in Knowledge and in all Judgement." A robed figure kneels before a cubical stone with pyramidal apex, the several facets inscribed "RYBVZ." A square plate representing the "Breastplate of Judgement" bears initials of the twelve tribes of Israel. The letters "U" and "T" in the center of the plate represent the Urim and Thummim, or light and truth inherent in the concept of the Breastplate of Judgment.

The Breastplate of Judgment was worn by the High Priest in American Royal Arch Chapters as a vestment, symbolic of his responsibility to the laws and ordnances of Royal Arch Masonry. The plate was set with twelve colored stones, each representing one of the twelve tribes of Israel which were named after the sons of Jacob. The cubical stone with pyramidal apex, or broached thurnal, which was often depicted on French Entered Apprentice tracing boards, was replaced in American rites by the perfect ashlar.

The cryptic letter groups inscribed on the arch and thurnal were encoded in "Caesar's Cipher," a simple regular advance substitution cipher attributed to Julius Caesar (100-44 B.C.). The code groups decipher as "Am not I a man and a Brother" and "Elo[h]im" (one of the Hebrew names of God).
Reference: Jones 1957.

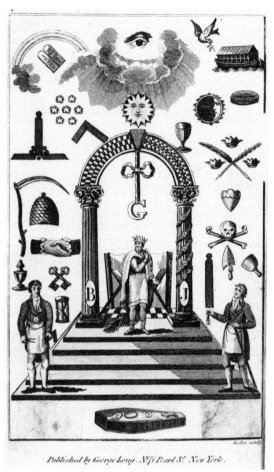

Published by George Long. N.º 71 Pearl St. New York.

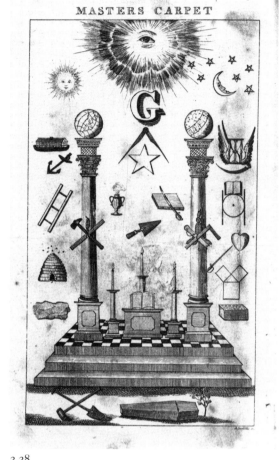

2.27

Masonic Chart
John Scoles (fl. 1793-1844), engraver
George Long, publisher
New York, 1818
Engraving
Archives

Frontispiece to *The New Freemason's Monitor*, with Royal Arch design.

2.28

Master's Carpet
Jeremy Cross, artist
Amos Doolittle, engraver
New Haven, Connecticut, 1819
Engraving
Archives

Chart of symbols from Cross's *The True Masonic Chart and Masonic Monitor* that are associated with the symbolic degrees.

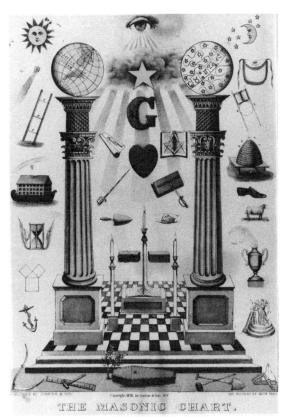

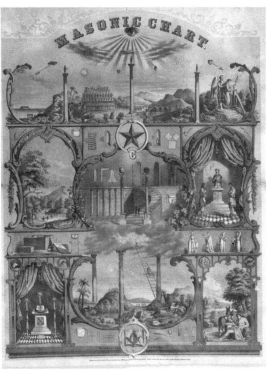

2.29

The Masonic Chart
Currier & Ives
New York, 1876
Lithograph
Special Acquisition Fund 74.8
h: 13 ⅜" w: 9 ⅞"

A rearrangement of the "Master's Carpet" designed by
Jeremy Cross and engraved by Amos Doolittle in 1819.
This version includes a symbol of mourning that was
introduced by Cross and is represented by a broken
column with the figures of Father Time and a weeping
virgin standing over a book. This symbol recalls the
Third Degree where it is interpreted as a symbol of
grief for the unfinished state of Solomon's Temple,
which was caused by Hiram Abif's death.
Reference: Mackey 1920.

2.30

Masonic Chart
Strobridge & Company
Cincinnati, Ohio
c. 1867
Chromolithograph
Gift of Armen Amerigian 90.19.37
h: 22 w: 17 ¼"

2.31 SEE ILLUSTRATION ON PAGE 46

The Oriental Guide
John Warren Currier, artist
Armstrong Company (fl. 1872-1897), publisher
Boston, Massachusetts
c. 1874
Chromolithograph
Special Acquisiton Fund 75.18.3
h: 28" w: 22"

2.32 SEE ILLUSTRATION ON PAGE 47

Masonic Chart
Lyman T. Moore, publisher
Hatch & Co., (fl. 1859-1875), lithographers
New York, 1865
Chromolithograph
Special Acquisition Fund 84.67
h: 26 w: 19 ¾"

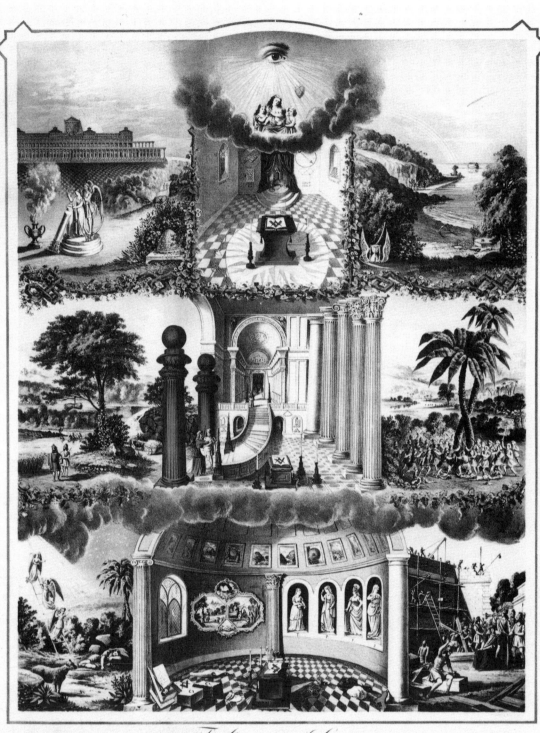

The Oriental Guide

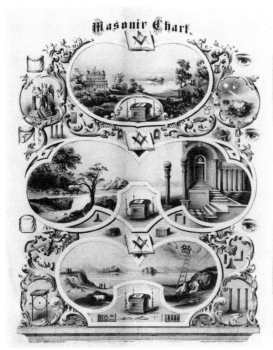

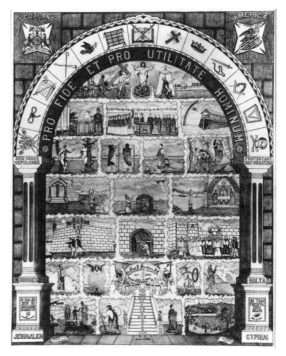

2.33 SEE ILLUSTRATION ON PAGE 48, TOP

Masonic Chart of the Scottish Rite
J.G. Nettles, artist
John H. Bufford (fl. 1869-1874), lithographer
Boston, Massachusetts, c. 1874
Chromolithograph
Gift of John M. Topham 92.020
h: 33" w: 33"

The dimensions of this chart are symbolic and allude
to the 33rd Degree in Scottish Rite Masonry.

2.34 SEE ILLUSTRATIONS ON PAGE 48, BOTTOM

Magic Lantern Slides
American
Late 19th century
Glass
Gift of Armen Amerigian, 90.19.8
h: 4" w: 3 ¼"

Portion of a large set of glass-plate slides used to
project images illustrating Masonic symbols. The im-
ages were of individual symbols such as the allegorical
figure of Charity, or charts of multiple symbols related
to specific degrees.

2.35

Knights of Malta Chart
Carl D. Willson, artist
William E. Willson, publisher
Providence, Rhode Island, 1901
Lithograph
Gift of Gerald Dallas Jencks Estate, 91.47.10
h: 24" w: 19"

Symbolic chart produced for the Knights of Malta,
decorated with vignettes showing Biblical events, Ma-
sonic sumbols, and Templar legend. The chart was
owned by Charles C. Purdum who was initiated in Fra-
ternity Commandry No. 371, Pawtucket, Rhode Island
in 1896.

The Lodge: Tracing Boards & Charts 47

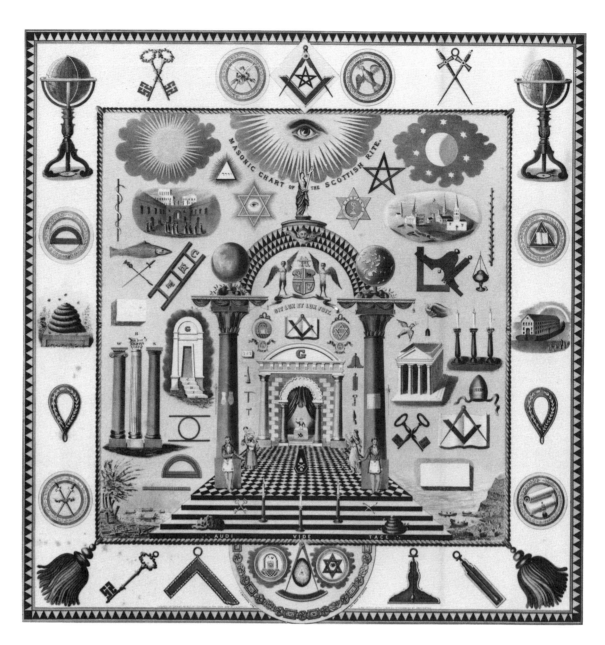

 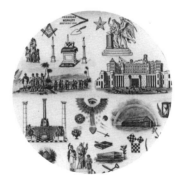 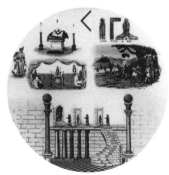

48 *The Lodge: Tracing Boards & Charts*

Chapter 3

Furnishings of the Lodge

"THE BIBLE, SQUARE AND COMPASSES ARE TECHNICALLY SAID TO CONSTITUTE THE furniture of a Lodge. But the lecture of the early part of the last century made the furniture consist of the Mosaic Pavement, Blazing Star, and the Indented Tarsel, while the Bible, square and compasses were considered as additional furniture." *A.G. Mackey Encyclopaedia of Freemasonry*

ILLUSTRATION: 3.04, FACING SEE DESCRIPTION ON PAGE 56

As soon as lodges began to acquire possessions in the form of regalia, furnishings and decorations, paraphernalia of ritual, and the means for serving refreshment, it was deemed necessary to provide for their accountability. Annual inventories, usually conducted by the Stewards at the beginning of the calendar year, were recorded in the minutes of a lodge and insured orderly replacement of damaged or lost items. The Stewards' inventories not only reveal the physical contents of lodges and priorities of acquisition, but also shed light on contemporary terminology in the formative years.

Union Lodge, A.F.& A.M. of Dorchester, Massachusetts was chartered in 1796, and its records include numerous inventories, commencing with "An Inventory of all the Utensils and Furniture belonging to the Union Lodge as exhibited by the Stewards Decbr. 29 A.L. 5796."

Charter & Case
1 Bible
1 *Constitution*[s] [Anderson]
Folio Journal
1 Bye Law Book
the Treasurers Acct. Book
Secretarys [account book]
Quarterage Book & Receipt
 Book
Pedestal and Steps
Flooring compleat
3 large Corrinthen Candle Stick
 & 5 brass candlesticks
10 Sashes & Jewels
2 pair of Compasses
1 Square
Columns for the Wardens
 [2 each]
1 Rule

Balloting Box & 41 Balls
2 benches whole and one
 broken one
5 pieces of Baze [baize cloth
 table covers]
2 Wands [for the Stewards]
1 Cushing [cushion]
11 Windowshutters
1 Chist [chest]
1 Table
7 Chairs
3 pair of Drawers [initiation
 trousers]
4 pair of Gloves
22 Tumblers [firing glasses]
24 wine Glasses
1 Ladle
1 candle Mould and 24 lb.
 of Candles

Thirty-two aprons were on hand at the time of the first inventory. A lodge seal was added in 1798. In 1799 an engraving of a "view of King Solomon's Temple" was framed and glazed for display within the lodge (see 2.03). Other items were added to subsequent inventories such as candle extinguishers, snuffers & trays, blank summonses and diplomas, two large punch pitchers (see 6.17), a Tyler's sword, and a "drop.g board" [dropping board].[1] The lodge's library of Masonic reference books expanded to include:

2 *Constitutions* [Anderson]	25 Harris & Lisle works
Masonick Minstrel [Vinton 1816]	7 Bently & Dix Do.
Masonic Register [Dunham 1802]	2 Gurney Do.
251 Harris' *Masonic Discourses* [Harris 1801]	Washington's Masonic tribute

In addition to ritual and ceremonial items, whenever possible lodges acquired furnishings that would provide the brethren with a degree of physical comfort to make attendance at the often lengthy meetings a pleasurable occasion. Whether the brethren were at labor or refreshment, they invariably surrounded themselves with the official and unofficial trappings of Freemasonry.

Seating

The Master's chair was easily the largest and most impressive piece of furniture owned by a Masonic lodge. Its importance was emphasized by being placed at the eastern end of the lodge room upon a dais with three symbolic steps, each representing one of the degrees in Craft Masonry. Often the product of local or regional craftsmanship, the Master's chair derived its distinctive Masonic character from a back rest that was invariably pierced, carved, inlaid, or painted with the square and compasses and additional symbols associated with Freemasonry. In candlelit meeting rooms of the 18th century, gilding was used to further enhance the dramatic effect created by such a monumental chair. In some instances it was even more impressive than chairs of state in colonial assemblies. The Master's chair from Unanimity Lodge No. 7, Edenton, North Carolina, c. 1766-1778, is without doubt the finest Masonic chair in America.

Armchairs of quality but lesser magnitude were obtained for the Senior and Junior Wardens. The level and plumb, symbols of their jewels of office, might be found worked into the design of the back. The Senior Warden's chair was placed opposite the Master's in the western end of the room on a two-step dais. The Junior Warden's less important chair was placed on a one-step dais on the south side of the room. The remaining brethren of a lodge seated themselves around the room on regular chairs or benches which might be simply decorated with painted or stenciled square and compasses. During the early

19th century, Windsor style chairs and benches provided economical lodge seating. Emerging from the anti-Masonic "dark period" (1831-1840), many rejuvenated lodges continued to acquire Windsor style seating.

The dramatic post-Civil War growth of the regalia industry induced major regalia manufacturers to rapidly add furniture to their inventory of fraternal lodge goods. Churning out matched sets of massive Gothic style walnut furniture, they were able to completely equip newly chartered lodges with everything deemed necessary to work the Craft. Fashions in lodge furnishings shifted completely to a Gothic style, which became *de rigueur* by the last decades of the century. The Arts and Crafts movement also influenced the design of lodge furniture. Plain, square, solid-oak seating provided a dramatic change from the over-upholstered Gothic behemoths. Under the guise of progress, lodges of long standing were induced by regalia industry hype to "modernize" their interiors. In the process, many historic chairs were often relegated to back rooms or to the town dump.

Chests & Boxes

In the 18th and early 19th century many rural Masonic meetings were held in the homes of various brethren. Jewels and regalia belonging to the lodge had to be stored safe from uninitiated eyes and transported from one meeting location to another. A chest or trunk was usually procured for this purpose. The proceedings of the Grand Lodge of Massachusetts for December 12, 1796, mention a vote "to procure a trunk and columns for the use of the Grand Lodge."

Lodge members pay dues to support the maintenance of their own lodge and of their respective Grand Lodge. Failure to pay dues resulted in being dropped from membership and was tantamount to withdrawing, or demitting from the fraternity. During the 18th century, dues were collected by the Treasurer on a quarterly basis (quarterlings) and safeguarded in a cash box. Lodges continued to use cash boxes until well into the 19th century despite the advent of banks.

Desks, Tables & Stands

Lodges recognized the convenience a small lap desk might afford such officers as the Treasurer or Secretary, or various committee members, during the performance of their duties. In 1812 the Grand Lodge of New York authorized the purchase of "a small portable writing desk" for the use of committee members.

Pillars

Two hollow brass pillars were erected on the porch of Solomon's Temple. Named Jachin and Boaz, they are contradictorily described in Scripture. They are first alluded to in the

Masonic catechisms of the 18th century as historical details rather than symbols. In 1772, William Preston (1742-1818) introduced the pillar symbolism into his system of lectures as an allusion to the strength and stability of the institution of Freemasonry. Shortly thereafter, William Hutchinson (1732-1814) included the pillars in the Masonic system along with the ornaments, furniture, and jewels of the lodge. According to Hutchinson, the pillars were not only ornamental, they also carried emblematic import in their names: Boaz being "strength" and Jachin, "it shall be established" or stability.

The pillars were rendered as visual images on the earliest surviving tracing boards dating from the last quarter of the 18th century, but are not mentioned as furnishings per se in lodge inventories from the same period. Many 18th-century representations of Jachin and Boaz on tracing boards and certificates depict the pillars with net-covered flat chapiter, but it was not until the first decade of the 19th century that artists began to place terrestial and celestial globes atop them. Thereafter the pillars are invariably illustrated as ornamented with globes.

About the middle of the 19th century, globed pillars become prominent features of most lodge interiors, usually standing at the west end of the meeting room and forming a portal of sorts through which candidates passed upon admission.

Door Knockers

In order to prevent unauthorized entry to the lodge during meetings, admittance is gained by a series of knocks exchanged between the Tyler, who is stationed on the outside, and the Junior Deacon on the inside. For this purpose the entrance door at the west end of the lodge is fitted with a knocker on both the inner and outer side. It is an old custom to give three distinct knocks at the door in order for candidates to gain admission into Freemasonry. Such a practice became the title of an early expose. This knocking proceedure is also used to announce the presence of distinguished visitors to the lodge and insure that they are properly received with all due ceremony.

1. A mobile recliner used during certain portions of the Master Mason's Degree initiation.

2. Gusler 1979, 75-79. Rauschenberg 1976, 1-23.

3. *Early History and Transactions* 1876, 1:514.

4. (Antiq., lib..I, cap. II); Exekiel 11:49; 1 Kings 7:15, 17,20,22; 2 Chronicles 3:15. In 1 Kings the dimensions of the pillars are given as being 18 cubits high (27 feet) and 12 cubits in circumfrence (18 feet). In 2 Chronicles they are described as being 52 feet high (excluding chapiter).

5. Preston 1772.

6. Hutchinson 1775.

7. Vernon 1760.

Illustrations

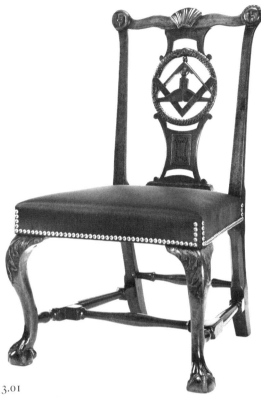

3.01
Side Chair
Boston/Salem, Massachusetts, c. 1760-1780
Mahogany, maple
Special Acquisition Fund. 92.001
h: 37" w: 24" d: 21 ½"

Chippendale style side chair. The crest rail with carved central shell terminates in rondels carved with a radiant sun and crescent man-in-the-moon. The pierced splat with upper and lower C-scroll brackets supports a carved central medallion of entwined square, compasses, and plumb level, encircled by an *Ouroboros*, or serpent, devouring its tail (symbol of eternity). The lower C-scroll support bracket with raised rectangular panel is incised with an "oblong square" (symbol for a lodge), outlined by thirty-four punched stars (representing members of the lodge).

The chair has cabriole legs, the knees shallow-carved with deep-slit long-tip acanthus leaves (Salem school) and ball and claw feet with rearward swept

talons. Outer corners of the leg posts terminate in peaked projections (Portsmouth, New Hampshire). The over-the-rail upholstered seat (New England) is outlined with a single row of brass tacks. The front and side rails are maple and the rear rail is mahogany. The foot of the splat rides in an open shoe. Triangular frame corner blocks are attached with hand wrought rose-head nails. Turned and block-ended side stretchers are mortised and tenoned to the legs (rectangular tenons), and the turned medial stretcher is doweled (Boston/Salem school).

This side chair appears to be closely related to a fine Masonic Royal Arch armchair in the Metropolitan Museum's Kaufman Collection, which has a Boston/Salem stylistic attribution and an oral history of use in an "unidentified New Hampshire Masonic lodge." Jobe cites seventeen furniture makers working in Salem in 1762, four of whom were chair makers and capable of such work.

The Gnostic *ouroboros* appears as a secular symbol within Masonry, in reptile form, alluding to the eternal cycle of life — a cyclic pattern that returns to its own beginning. It appeared on English Masonic certificates and summons in the 1750s and in America during the Revolution on newspaper mastheads (*New York Sentinel*) and Treasury notes (Massachusetts 1777-1780). During the struggle for American independence, the non-specific reptile form was transmorgified to a native American rattlesnake for political purposes.
References: Flanigan 1986, pl.4. Jobe and Kaye 1984, fig 110.

3.02 SEE COLOR PLATE, PAGE 263, TOP
Armchair
Pennsylvania, c.1797
Black walnut, yellow pine
Special Acquisition Fund. 88.43
h: 58" w: 28" d: 20"

Sheraton style high-backed armchair. Within the rear stiles is an openwork splat composed of a carved Masonic Royal Arch and pillars with a swag of drapery. At the base of the arch an altar supports a vertical arrangement of square, plumb rule, and level, representing the jewels of the Master and Wardens; compasses and quadrant arc of the Past Master; and triangle of Royal Arch Masonry. The arched crest rail has birch inlays of a chisel and mallet, representing working tools

of the Mark Master, and a central keystone. The center of the keystone is inscribed with a Mark Master's mark: a bar of music. The bowed front seat rail has over-the-rail leather upholstery and double row brass tack decoration.

The chair was presented by Archibald McCoy in 1798 to Lodge No. 76 which met at Newville, Cumberland County, Pennsylvania. Brother McCoy was a charter member of the lodge and its first Junior Warden. In 1805 the lodge was notified that its dues to the Grand Lodge of Pennsylvania were two years in arrears and, if not paid, its warrant would be suspended. After continued delinquency, the officers were ordered to return warrant, jewels, furniture, and funds to the Grand Lodge. The Grand Secretary reported (October 16, 1809) that these items had not been surrendered as demanded. The chair was returned to McCoy when the lodge vacated its charter in 1806.
References: Lyte 1895, vol.1. Randall 1966, 287.

3.03 SEE COLOR PLATE, PAGE 263, BOTTOM
Armchair
Eastern Massachusetts, c. 1790
Mahogany
Gift in part from Harold French, 86.40
h: 38 ¼" w: 24 ½" d: 19 ½"

Sheraton style shield-back armchair with molded seat rails and stretchers. The back splat with a circular open-work medallion is supported between C-scroll brackets. Within the medallion is a carved design of entwined Masonic square, compasses, and plumb level. Two carved rosettes provide additional points of support for the design. The frame of the horsehair-covered slip seat is inscribed in pencil: "Ben C. Bird/ Tyler/45 years/1862" and "Thomas J. Hatch/25 years/ 1865." The chair is also inscribed "Property of Union Lodge Dorchester Sept 20, 1864" and "Originally the property of Genl. Amasa Davis."

The minutes of Union Lodge, Dorchester, Massachusetts, September 20, 1864, contain the entry: "Bro. John Mears, Jr. presented the Lodge with an ancient Masonic Chair...." John Mears, Jr. of St. Andrews Lodge was the son of John Mears, Sr. (1796-1876) who was raised in Union Lodge 1817. The senior Mears served as secretary of Union Lodge during the anti-Masonic period from 1831 to 1846, when lodge meetings were held in the seclusion of his home. In January 1877, John Mears, Jr. was elected an honorary member of the lodge.

When Union Lodge moved from Friendship Hall to a new building at Field's Corner in 1864, new furniture was presented to the lodge. Bro. Mears' gift of the "ancient masonic chair" was placed outside the door to the lodge room and made available for use by successive Tylers. Benjamin Coolidge Bird (1826-1915) served as Tyler of Union Lodge from 1863 to 1865 and from 1867 to 1915. Thomas J. Hatch (1830-1919) was raised

a Master Mason in 1880 and served as Assistant Tyler from 1905 until 1909. General Amasa Davis (? -1825) was raised in Morning Star Lodge, Worcester, Massachusetts in 1796.
References: Upham 1877. Bernard & S. Dean Levy, Inc. Gallery Catalog VII, 1990. See a related Masonic side chair (p. 83).

3.04 SEE ILLUSTRATION ON PAGE 50
Armchair
Connecticut, c. 1770-1790
Pine, maple, hickory
Gift of Harmony Lodge No. 42 A.F.& A.M.,
Waterbury, Connecticut, 91.043
h: 39" W: 23 ¼" d: 21"

Comb-back Windsor style armchair. The crest rail terminates in an elongated upturned ear. The arms are braced by one short spindle placed between the turned support and the long back spindles. The bottom of the narrow shield-shaped seat is incised "HARMONY 1797."

This chair was part of the original furniture when Harmony Lodge No. 42 was chartered on November 7, 1797. The chair was removed from the lodge building in Waterbury, Connecticut when the building was sold. Santore identified a number of similar chairs.
References: Santore 1981, 1:72 (fig. 47). Correspondence, Stephen F. Brittain, Master, Harmony Lodge No. 42, March (n.d.) 1991.

3.05
Armchair
John Luker
Vinton County, Ohio, c. 1873
Pine, maple, painted and decorated
Estate of Mr. & Mrs. Charles V. Hagler, 85.20.1
h: 71" w: 29 ¼" d: 30"

An unusual and complex chair painted blue with red striping and decorated with numerous Masonic symbols. The x-shaped curule supports, based on early Roman chair forms, terminate in carved paw feet; the cross stretcher is inscribed " Manufd. by JOHN LUKER," and the left leg is inscribed "JHM HOUSTON'S." The curved rear stiles terminate in terrestial and celestial globes and are decorated with painted sabers. The crest rail, surmounted by the Masonic square and compasses enclosing a letter "G" encrusted with crushed lapus or blue glass, is decorated with painted candelabra flanking a Masonic apron with the all-seeing eye on its flap. The solid-shaped back splat is painted with a Royal Arch and columns, a keystone with a Mark Master's mark, square and compasses, indenting chisels and crossed mallets (working tools of the Mark Master); compasses and quadrant arc enclosing a radiant sun (jewel of the

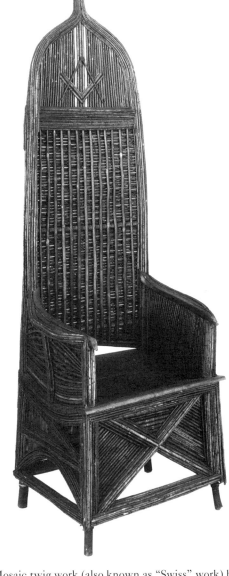

Past Master); and the square, level, and plumb (jewels of the Master and Wardens). The plank seat has a rolled front edge, and the splat shoe is decorated with a cabletow and slipper (symbols associated with the Entered Apprentice Degree). The shoe is dated 1873. Free-standing columns and candlesticks accompany the chair and were probably also made by Luker.

Swan Lodge No. 358, in the town of New Mt. Pleasant, Swan Township, Vinton County, Ohio, received its charter in 1866 and was suspended in 1902. A new hall for Swan Lodge was dedicated in 1871 during the tenure of J.H.M. Houston, who served as Master of Swan Lodge from 1867 to 1873. The Federal Population Census of 1860 listed a John Luker residing in Brown Township, Vinton County.
References: Reeves 1914, 2:163,168,172,204,212. Connell 1984, (Pl. 71). Franco 1976, (Fig. 79); Franco 1986, (Fig. 27).

3.06

Armchair

Attributed to Vermont, c. 1880-1920
Oak, willow, alder
Gift of Elizabeth V. Thomasy, 85.25
h: 82" w: 28" d: 20"

Mosaic twig work, gothic-form chair, constructed of wooden branches with applied mosaic twig work. The chair has a planed-oak plank seat, lancet arch-shaped back topped with cross-shaped finial and an applied letter "G." Under the point of the arch is an applied Masonic square and compasses. The back has joined and nailed twigs, the arms are made of branches, and the skirt has open and closed twig work.

Mosaic twig work (also known as "Swiss" work) became very popular in upstate New York and the back woods of New England in the 1870s. Camps and country retreats were furnished in what was considered appropriate furniture for the outdoor environment. Made by the same carpenters who built the camps, the furniture became known as Adirondack-type. It tended to be stiff and closely followed traditional furniture styles. Ceremonial furniture is rare but not unknown. Churches and Masonic lodges in the regions used this inexpensive type of furniture as well.
Reference: Stephenson 1979.

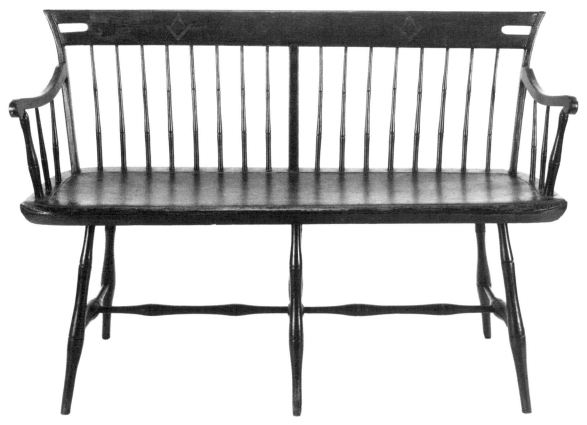

3.07
Settee
New England, c. 1800-1810
Birch, hickory
Gift in Memory of George S. Deffenbaugh, 87.38
h: 36" w: 56" d: 15"

Windsor style settee with curved side arms, painted
brick red and grained. A cock-bead molding is carved
around the back rest frame and two Masonic square
and compasses are painted in yellow on the back rail.
The corners of the rail are relieved with cutouts.

The coarse and somewhat unsophisticated quality of
the graining is believed to have been done during the
1850s or as late as the 1870s. A third paint layer of
black overpainted with butterflies was removed to re-
veal the grained layer with Masonic symbols. The use
of cock-beading on the frame and cutouts at the cor-
ners of the rail are regarded as characteristic of work
from Rhode Island or New Hampshire, but the use of
birch indicates a New Hampshire origin.

3.08
Side Chair
New England, c.1780-1800
Grained maple
Special Acquisition Fund, 80.39
h: 37 ¾" w: 19 ¾" d: 15"

Chippendale style side chair painted brick red and
grained in black. The back splat is pierced with carved
interlaced C-scrolls and entwined Masonic square and
compasses. The crest rail has carved ears and pierced
central fan. A cock-bead runs down the outer corner of
the square front legs. The seat frame is doweled to
blocks atop the front leg posts and to the rear stiles.
The upholstered seat is covered in leather, tooled to
simulate the original woven rush-work. There are two
sets of stretchers, the upper set turned and doweled to
the legs, the lower set rectangular and tenoned.

This unsophisticated style of chair is associated with
side chairs made in the Portsmouth, New Hampshire
area. The tooled leather seat is a seldom encountered
mid-19th-century upholstery technique.
Reference: Franco 1986, (Fig. 133).

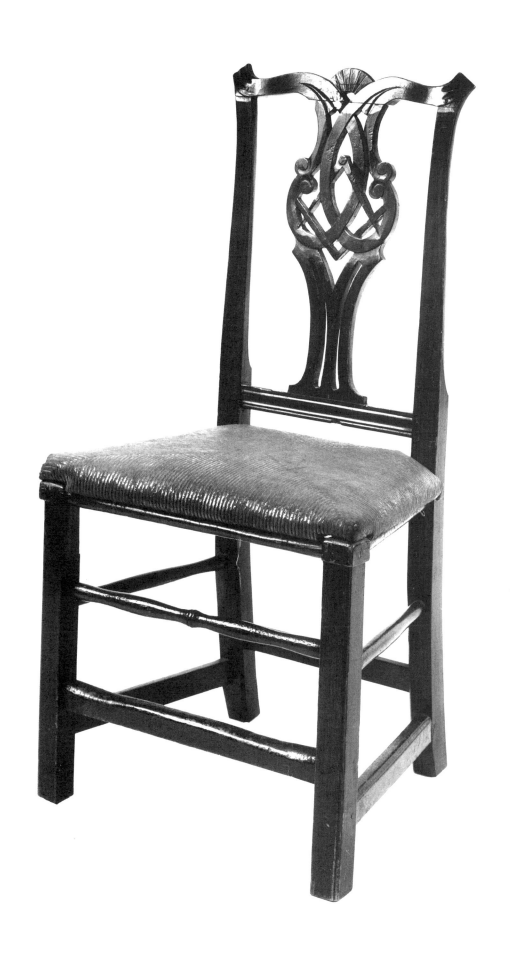

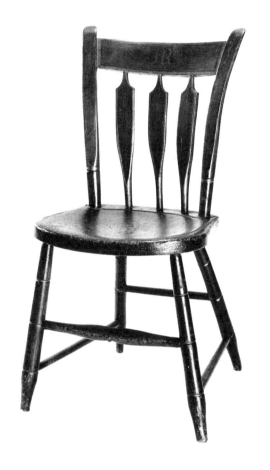
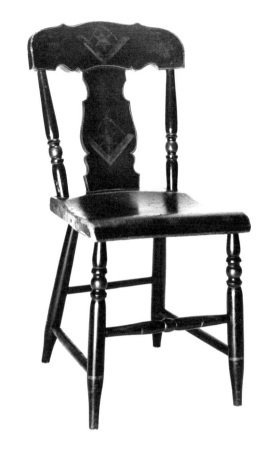

3.09
Side Chair
American, dated 1827
Pine, maple
Special Acquisition Fund, 79.79
h: 32" w: 15 ½" d: 17"

An arrow-back Windsor style chair with shield-shaped plank seat, painted red with yellow striping and banding. The concave seat is painted with a Masonic square and compasses enclosing the letter "G" and the date "1827." The crest rail is painted with the initials "J.R." A turned front stretcher is doweled to turned and tapered legs. The initials "J.R." probably denote the name of the lodge in which the chair was used, or the name of chair's donor.

3.10
Side Chair (Set of six)
American, mid-19th century
Grained and stenciled maple
Special Acquisition Fund, 76.34
h: 31 ¾" w: 14" d: 13 ½"

A Victorian style chair with curved plank seat, grained with yellow striping and stenciling. The shaped back splat and crest rail are stenciled with the Masonic square and compasses enclosing a radiant sun. The rear stiles, front legs, and stretcher have pronounced turnings.

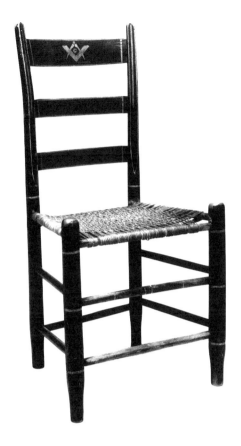

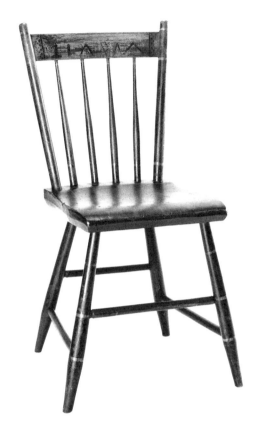

3.11
Side Chair (Set of four)
American, mid-19th century
Maple
Special Acquisition Fund, 83.15.1
h: 35" w: 18 ½" d: 14 ¼"

A ladder-back chair with woven twine seat. The leg
posts and turned stretchers have yellow banding and
striping. The crest rail is painted with a Masonic
square and compasses enclosing the letter "G."

3.12
Side Chair (Set of six)
American, mid-19th century
Pine, maple
Special Acquisition Fund, 88.45
h: 31" w: 15" d: 13"

A late Windsor style chair with curved plank seat,
painted green and grained, with yellow banding. The
crest rail is stenciled with Masonic level, plumb, mark-
ing gauge, compasses and square.

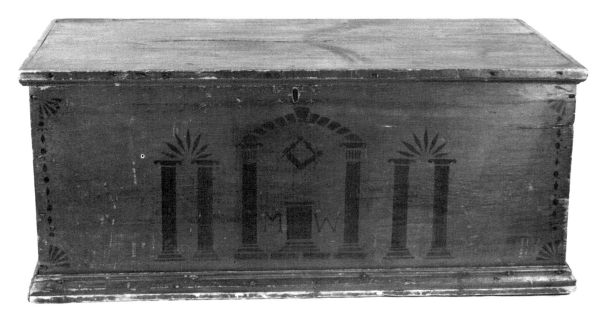

3.13
Chest
New England, c. 1800-1820
Pine
Special Acquisition Fund, 75.28
h: 17" w: 40" d: 18"

Six-board lift-top chest painted red and stenciled with black Masonic symbols. The front is decorated with a Masonic Royal Arch encompassing entwined square and compasses above an altar flanked by the initials "MW"; the arch is flanked by pairs of columns. The ends are stenciled with a Royal Arch enclosing a radiant sun and the Greek letters alpha and omega above an altar.

Repeated use of the Royal Arch symbol would indicate that the chest belonged to a Royal Arch Chapter rather than a symbolic "Blue" lodge. As the first and last letters of the Greek alphabet, alpha and omega also represent the beginning and end of creation and serve here to delineate not only the the physical confines of the chest but also the philosophical scope of its Masonic contents.
Reference: Franco 1976, Fig. 82.

3.14
Cash Box
Pennsylvania, dated 1861
Walnut, sulphur inlay
Special Acquisition Fund. 90.3
h: 9" w: 11 ½" d: 8"

Walnut box with hinged lid and compartmented interior tray. The exterior surfaces are covered with sulphur-inlaid Masonic symbols and illustrations. Molten sulphur has been poured into carved areas, allowed to solidify, polished off level with the surface of the wood, and detailed with pen and ink. The rear edge of the lid is inscribed "A.D.1861.YEAR OF THE ORDER 2395."

The inlaid Masonic symbols and illustrations were copied from the sixteenth edition of Jeremy Cross's *The True Masonic Chart, or Hieroglyphic Monitor* (New York, 1851). The entire vernacular of Cross's symbols were employed, including his explicit illustrations pertaining to legends associated with degrees of the Royal Arch. The compartmented interior tray is fitted for coins and banknotes, indicating probable use as a cash box for the Treasurer of a Masonic Royal Arch Chapter. The inscription "year of the order" incorrectly refers to the dating era adopted by Knights Templars. The Royal Arch dating era, A..Inv.. (Year of Discovery), computes correctly. (See Appendix IV).

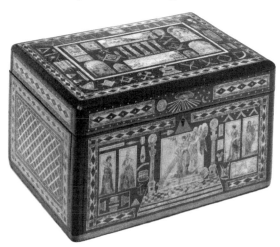

A sewing box made for "Fanny Loud" (Acc.# 77.27.7), decorated with sulphur inlaid Masonic symbols and applied carved flowers, is sufficiently similar in technique to have been executed by the same hand. Monroe Fabian attributes introduction of the sulphur inlay technique to Pennsylvania cabinetmakers working in the 1780s.
Reference: Fabian 1978, 51.

3.15 SEE COLOR PLATE, PAGE 264, TOP
Cash Box
New England, 19th century
Walnut, tortoise shell, nacre
Special Acquisition Fund. 82.48
h: 6 ½" w: 15 ½" d: 10 ½"

Top inlaid with blank nameplate, Masonic square and compasses, radiant sun and cresent moon, and five-pointed star within a circle. The lid is framed with triple stringing and a border of alternating nacre and tortoise shell demi-lunes.

The marine origin of the tortoise shell and nacre inlay materials would imply that this box was the work of a mariner or craftsman working in a seafaring environment.

3.16
Altar
Massachusetts, c. 1796
Pine
Gift of Union Lodge, A.F.& A.M.,
Dorchester, Massachusetts, 75.46.20
h: 29 ¾" w: 30 ¼" d: 18 ½"

Grain-painted altar with gilded dentil moldings, pull-out grained writing surface, and a large door. The front

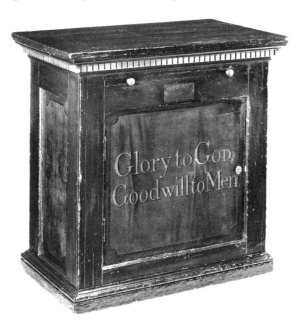

panel is decorated with letters in gold leaf which read "Glory to God, Goodwill to Men."

An altar is placed in the center of the lodge room and serves as a focal point for many ceremonies. During meetings the Bible and Masonic square and compasses are displayed on top of it, and candidates affirm their Masonic obligations while kneeling at it. The altar is illuminated by candlesticks representing the Three Lights of Masonry.

ILLUSTRATIONS:
3.16, LEFT
3.17, RIGHT

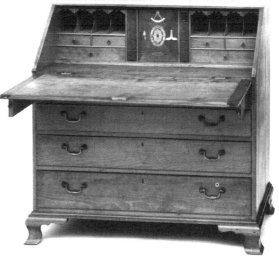

3.17
Desk
New England, 18th century
Cherry
Special Acquisition Fund. 87.25
h: 43 ½" w: 46 ½" d: 22"

Slant-lid desk of Chippendale style with four graduated drawers, brass bail pulls, and Ogee-bracket feet. The center of the lid is inlaid with Masonic square and compasses. The interior is fitted on each side of a central prospect door with slip-case drawers that have pseudo-book spines, four valenced pidgeon-holes, and three flat drawers. The center door is inlaid with a paterae surrounded by symbols representing a trowel, level, coffin, and compasses and quadrant (jewel of the Past Master).

3.18
Desk
Attributed to Joseph Rawson (1760-1835)
Providence, Rhode Island, c. 1810-1820
Cherry, pine, oak
Special Acquisition Fund. 84.81
h: 44" w: 38 ¾" d: 19 ¾"

Slant-lid desk of Hepplewhite style with four graduated drawers inlaid with rosewood banding, black-

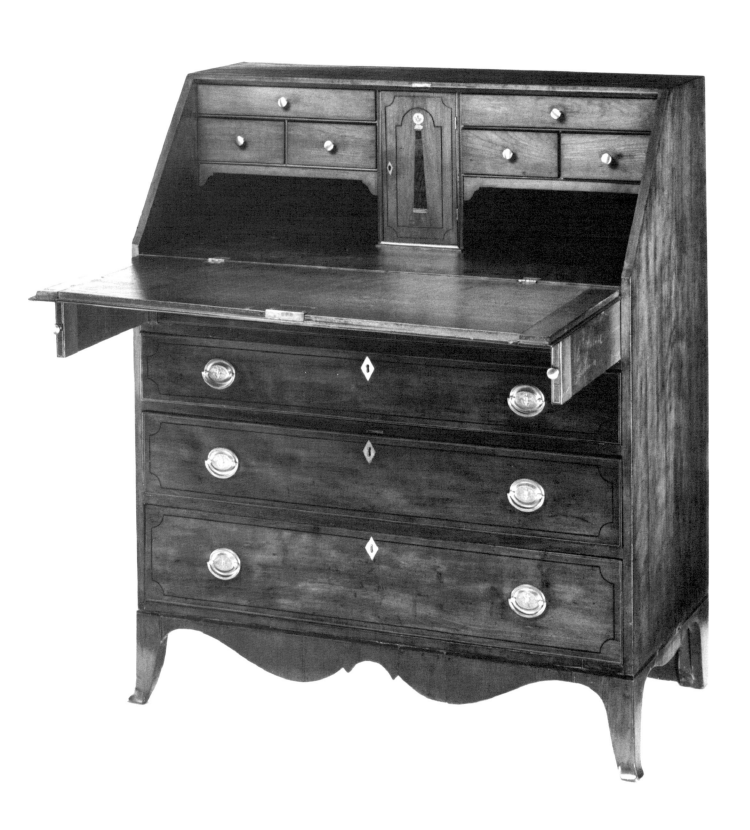

painted striping in imitation of ebony stringing, and diamond-shaped ivory escutcheons. Sheraton style fire-gilt drawer pulls are stamped with an American eagle and the motto "E Pluribus Unum." The bail handles are stamped "HJ." The base has splayed bracket feet and a cupid's bow shaped apron. The interior is fitted with two sets of three flat drawers that flank a central prospect door. The door is painted to represent two stringed panels enclosing a tapered architectural pillar surmounted by a globe inscribed with a Masonic square and compasses.

This desk has an oral history of having been re-moved from Harmony Lodge, Pawtucket, Rhode Island for safekeeping during the Anti-Masonic period in the 1830s. The brass drawer pulls stamped "HJ" were manufactured by Thomas Hands and William Jenkins of Birmingham, England while in partnership from 1791 to 1803.
Reference: Fennimore 1991.

ILLUSTRATIONS:
3.18, FACING
3.20, TOP
3.21, BOTTOM

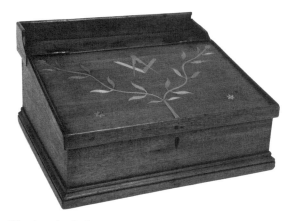

The interior is fitted with seven valanced and gradu-ated pigeonholes above three shallow drawers. The lid was originally fitted with a mortise-lock.

3.19 SEE COLOR PLATE, PAGE 265, TOP & BOTTOM
Desk
New York State, c. 1870
Cherry
Special Acquisition Fund, 91.012.2
h: 64" w: 42" d: 22"

Inlaid rolltop desk with turned and carved columns and mirrored gallery top. Below two full-width hori-zontal drawers is a cupboard door inlaid with a vignette of a Worshipful Master wearing a top hat and apron and standing on a three-step dias under a Royal Arch. In the center of the panel, within a radiant circle, is an altar and three "lights." At the panel's base is a Ma-sonic square and compasses with the letter "G." The points of the compass are joined by a chain of three links. A globed pillar stands at each corner of the panel.

The scene of the Master standing in his lodge was derived from an illustration contained in mid-19th-cen-tury editions of Jeremy Cross's *The True Masonic Chart....* The three links connecting the compass points denote an affiliation with the Independent Order of Odd Fellows whose primary symbol is the chain of good fellowship, composed of links that represent faith, love and truth.

3.20
Portable Desk
New Hampshire
Walnut and spruce
Special Acquisition Fund, 78.44
h:8" w: 15 ⅜" d: 12 ½"

Lap desk with dovetailed corners and gallery rail. The walnut lid is inlaid with Masonic square and com-passes, a tree-of-life pattern, and two six-pointed stars.

3.21
Table
Attributed to New York State
mid-19th century
Cherry, maple
86.57.1
h: 30 ¼" w: 23" d: 22 ½"

One-drawer table with Masonic square and compasses inlaid on the top. The cherry top is edged and diago-nally banded with bird's eye maple and the ring-turned legs are of tiger maple. The straight skirt of the frame conceals a drawer front.

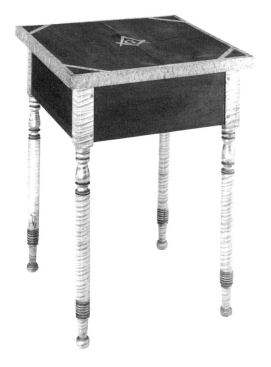

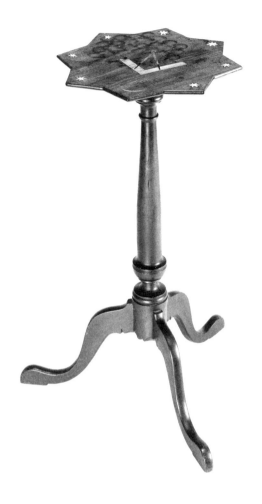

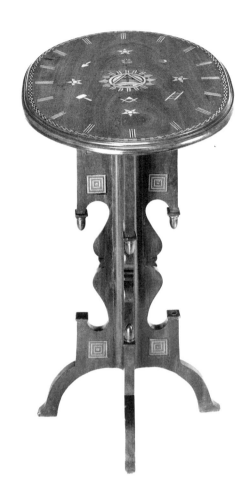

3.22

Candlestand

New Hampshire, c. 1800
Walnut
Acquired through the generosity of
Lodge of St. Andrew, A.F. & A.M., Boston, Massachu-
setts, 84.1.1
h: 30" w: 16" d: 16"

Three-legged candlestand with stationary inlaid top in
the form of an eight-pointed star. The top is inlaid
with Masonic square and compasses surrounded by
seven stars and a crescent moon. The snake-foot legs
are dovetailed to the turned shaft and reinforced with a
hand-forged, y-shaped iron brace. The stand has an
oral tradition of having been removed from a Masonic
lodge in Keene, New Hampshire, possibly Rising Sun
Lodge No. 3, which was chartered in 1784 and dis-
solved in 1805. When early lodges were dissolved the
members often appropriated the furnishings rather
than surrender them to the Grand Lodge.

3.23

Candlestand

Concord, New Hampshire, c. 1873
Walnut
Special Acquisiton Fund, 87.18
h: 31" w: 24" d: 18"

Gothic style candlestand with stationary marquetry top
inlaid with Masonic symbols and the Anno Lucis date
"5873." It was formerly the property of Blazing Star
Lodge No. 11, Concord, New Hampshire. Blazing Star
lodge was chartered in 1799. The A.L. date (1873)
probably commemorates the year the stand was ac-
quired by the lodge.

3.24
Wall Clock
E. Howard & Co.
Boston, Massachusetts, c. 1864
Marble, brass
Gift of Union Lodge, A.F. & A.M.,
Dorchester, Massachusetts, 75.46.18
h: 41" w: 24"

Banjo style "Hall" model wall clock with white marble dial having a star-shaped aperture in the pendent to view motion of the brass pendulum bob. The marble face is inscribed "Presented to Union Lodge by Brother Albert Howard." The eight-day brass movement is weight-driven. A recessed lever in the bottom of the case is used to start pendulum motion; a knob at the top of the case is used to "rate" the pendulum (adjust length) by raising or lowering the suspension spring.

The minutes of Union Lodge record that in February 1864 the lodge leased a new meeting hall located at Field's Corner and that various members donated gifts of furniture and other articles to furnish the rooms. On October 10, 1864, "An unanimous vote of thanks was passed for the beautiful Clock adorning the Lodge Room, presented by Bro. Albert Howard." The Howard Clock Co. of Roxbury, Massachusetts was formed by Edward Howard (1813-1904) in 1858 in association with his younger cousin Albert.

Albert Howard (1833-1893) completed an apprenticeship in his cousin's clockmaking firm (Howard & Davis) in 1856, and remained with the Howard Watch

& Clock Company throughout his life. He served as company president in 1861 and director in 1862. Upon reorganization of the company in October 1862, Albert assumed the position of treasurer in addition to being supervisor of the Boston office and store. Albert was raised in Union Lodge on September 20, 1864. He served as general superintendent of the company from 1881 until his death on January 1, 1893.
Reference: Minutes - Union Lodge, October 10, 1864. Hackett 1962.

ILLUSTRATIONS:
3.24, LEFT
3.25, RIGHT

3.25
Lodge Pillars
Ohio
c. 1840
Pine
Special Acquisitions Fund, 89.47
h: 89" w: 17" d: 17"

Solid pillars of wood plank-laminated construction, surmounted by plank-laminated balls painted to represent celestial and terrestial globes. The pedestal base of one pillar bears the letter "J" (Jachin) on two adjacent sides, the other bears the letter "B" (Boaz) in similar fashion.

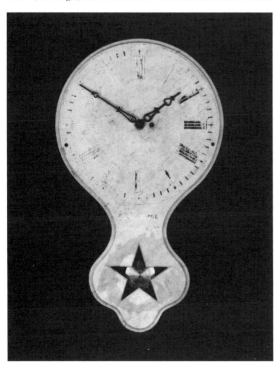

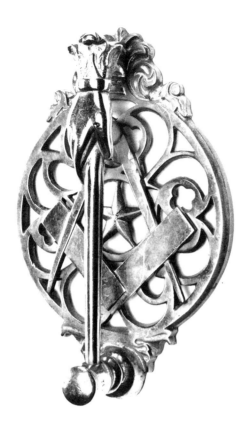

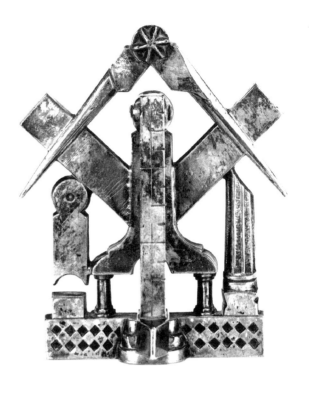

3.26
Lodge Door Knocker
Ames Sword Company
Chicopee, Massachusetts
c. 1890
Plated brass
Special Acquisitions Fund, 79.21.1
h:8" w: 6" d: 2"

Fretwork design capable of being adapted to display
the logo of other fraternal organizations. Knockers are
also known as "alarms."

3.27
Lodge Door Knocker
Ames Sword Company
Chicopee, Massachusetts
c. 1890
Silver plated brass
Special Acquisitions Fund, 79.21.2
h: 6" w: 5" d: 2"

Knocker in the form of a hammer attached to a plumb
level resting on the three "lights" of Masonry. The
knocker design was derived from Masonic working
tools and architectural elements. The composition in-
cludes a Masonic square and compasses supported by a
plumb and a broken column. The base represents a
mosaic pavement with three steps alluding to the three
Craft degrees.

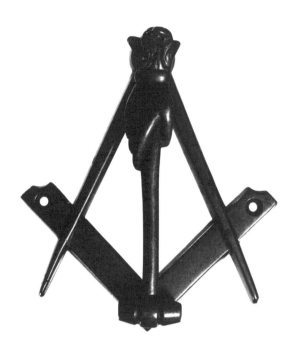

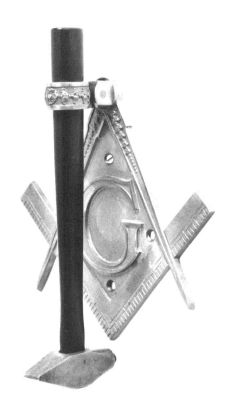

3.28
Lodge Door Knocker
American
c. 1900
Brass
Gift of Gilbert T. Singleton, 75.63
h: 6" w: 5" d: 2"

Knocker in the form of a hand grasping a mallet.

3.29
Lodge Door Knocker
American
c. 1880
Brass, ebony
Special Acquisitions Fund, 88.42.149
h: 9" w: 7" d: 3"

Knocker in the form of a blacksmith's cross-peen hammer. The reference to the art of blacksmithing is intentional. The name of Tubal Cain, biblical founder of all forms of metal smithing, is significant in Masonic ritual.

Heating (Fireplaces & Stoves)

NUMEROUS IRON FURNACES IN 18TH-CENTURY AMERICA PRODUCED A WIDE VARI-
ety of utilitarian wares for home and commercial use. Among the more inter-
esting surviving examples of the colonial ironmaster's skill are the cast-iron
firebacks and stove plates that were used for home heating and cooking. Patterned after
16th-century grave slabs, firebacks were mounted at the rear of a fireplace in order to
protect the soft brick from disintegration. Stove plates were bolted together to form a
portable six-sided fire box or draft stove that was used to heat rooms.

ILLUSTRATION: 3.34, FACING SEE DESCRIPTION ON PAGE 73

Yet, of the many new designs ironmasters selected to decorate their work, only three
are known to have included Masonic motifs: they can be found on firebacks cast for Joseph
Webb of Boston, c. 1765; stove-plates by "Baron" Henry Stiegel of Pennsylvania, dated
1768; and stove-plates by Henry Miller and Mark Bird, cast in Virginia and dated 1775.

Illustrations

ILLUSTRATIONS:
3.30, LEFT
3.31, RIGHT

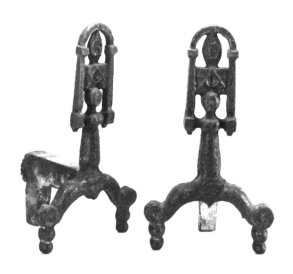

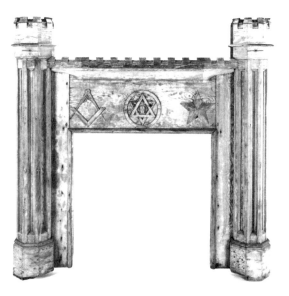

3.30
Andirons
Attributed to the Shenandoah Valley, c. 1820
Cast Iron
Special Acquisition Fund, 76.27.1
h: 17" d: 10"

Pair of andirons, cast with a female figure supporting a Masonic Royal Arch enclosing the letter "G" and an open Bible with square and compasses.

3.31
Fireplace Mantel
Virginia, c. 1870
Yellow pine
Special Acquisition Fund, 86.45
h: 66 ½" w: 72" d: 12"

Removed from a Masonic Temple in Albermarle County, Virginia. The mantel head is decorated with applied insignia of Masonic bodies that met in the temple, including Royal Arch and Eastern Star. The crenelated and turreted design alludes to the Knights Templars.

3.32
Fireback
Massachusetts, c. 1756-1787
Cast Iron
Gift of Mr. & Mrs. Howard W. Johnson, 83.26
h: 25" w: 26 ¼"

Heavy iron plate cast with design of heraldric arms of the Grand Lodge of Freemasons in Massachusetts, identified by an inscription on the upper border "The·Free·Masons·Arms" and the motto "Follow·Reason" below. Across the base the inscription reads "Sold to Joseph Webb, Boston."

A Boston merchant and ship chandler, Joseph Webb (1734 -1787) was Master of St. Andrews Lodge 1765-1766, Grand Marshal in 1769, and Grand Master of the Massachusetts Grand Lodge from 1777 to 1780 and again from 1784 to 1786.

A similar Masonic fireback, once in the John Cabot House in Beverly, Massachusetts, is said to have been part of the cargo of a British East India Company vessel that was captured by an American privateer. Examples of this fireback pattern are also in the collections of the Museum of Fine Arts in Boston and at the Henry Francis Du Pont Winterthur Museum in Delaware.
Reference: Massey 1896, 48.

3.33

Stove Plate
Massey Creek Furnace
Staunton, Virginia, 1775
Cast Iron
Special Acquisition Fund, 79.57
h: 23 ¼" w: 26 ¾"

Heavy iron plate cast with raised central design of a
Masonic Past Master's jewel flanked by birds in flight,
and the inscription, "Bird & Miller Massey Creek
Fornace [sic] 1775."
 Ironmasters Henry Miller and Mark Bird operated
Massey Creek iron furnace on the headwaters of the
south branch of the Shenandoah River in Augusta
County, fourteen miles north-west of Staunton, Vir-
ginia. The furnace was built about 1760 and remained
in operation until it burned in 1841.
Reference: Mercer, 1961.

3.34 SEE ILLUSTRATION ON PAGE 70

Stove Plate
Elizabeth Furnace
Brickerville, Pennsylvania, c. 1769
Cast Iron
Special Acquisition Fund, 90.26
h: 23" w: 27"

Heavy iron plate cast with design of laureated portrait
bust of King George III (1738-1820), an entwined Ma-
sonic plumb level and square, and a 24-inch marking
gauge and compasses. The upper portion of the plate is
inscribed "H W Stiegel. Elizabeth Furnace" and the
date "1769."
 Elizabeth Furnace was originally established in
1750 near Brickerville, Pennsylvania by ironmaster
Jacob Huber. It was subsequently reorganized in 1757
by Henry Wilhelm Stiegel (1729-1785) who married
Huber's daughter Elizabeth and renamed the furnace
in her honor. George III was not a Freemason, but
a majority of the male members of his immediate fam-
ily were.
Reference: Mercer 1961.

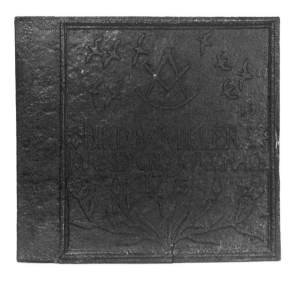

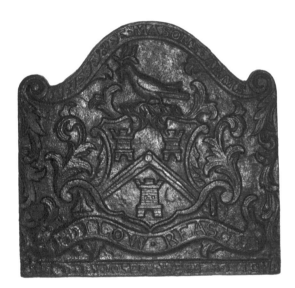

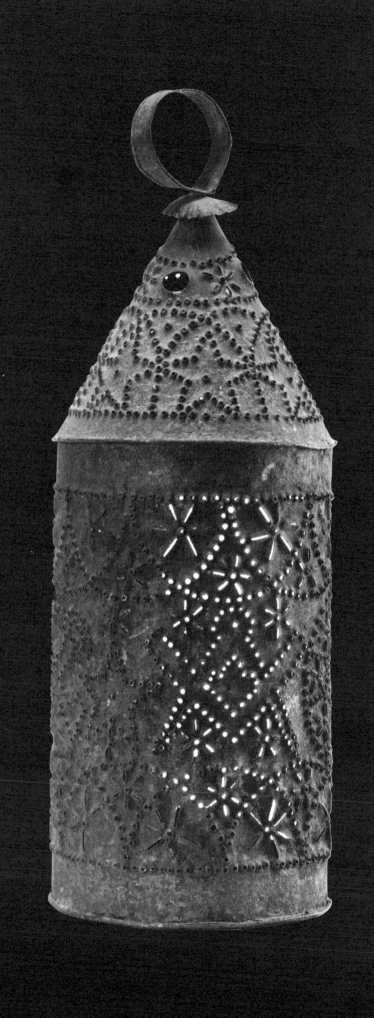

Lighting

ILLUSTRATION: 3.37, FACING SEE DESCRIPTION ON PAGE 78

A DISCUSSION OF LIGHTING USED IN THE LODGE SHOULD NOT PROCEED WITHout first clarifying the distinctions Masons make between philosophical and actual illumination. In the lore of Freemasonry there is reference to three triads of lights. In two of those instances the lights are philosophical in nature with the most important being the three "Great Lights" of Masonry. This triad is symbolized by the Holy Bible, the square, and the compasses whose moral lessons are said to be seen only by the aid of the "Lesser Lights" represented by the sun, the moon, and the Master. Both allusions infer that the light of Freemasonry, or its moral precepts, may be seen, or learned, through instruction given by the three principal officers of the lodge.

The third traid of lights are the "Lights of the Lodge," referred to in 18th-century lectures as the "Fixed Lights." They are three lighting devices, or standing candlesticks, placed in various arrangements around the altar. Many 18th-century lodge inventories included three large Masonic candlesticks. The appelative "*Masonic*" was presumably reserved for the ceremonial candle holders or "lights" that were placed around the altar. The three "lights" owned by Union Lodge, Dorchester, were described in 1796 as "large Corinthian Candlesticks."[1]

In addition to providing general illumination in early Masonic lodges, candlelight was also used to create special lighting of ceremonial significance. Twelve candles set in a triangular arrangement are said to represent the twelve original points of Masonry that formed the basis of the system of ceremony and initiation in the English lecture system. They were in use prior to the Grand Union of 1813, but were never introduced per se into the American rite.

A golden candelabra of seven branches is part of the furniture of a Royal Arch Chapter. Its form is derived from the holy candelabra that Moses was instructed to construct of beaten gold for use in the tabernacle and represents the temporary tabernacle that was erected near the ruins of the first temple.

Whether used for ceremony or illumination, candlelight played an important role in creating a theatrically contrived atmosphere conducive to the performance of ritual. The Stewards' inventories disclose that lodges maintained large supplies of candles as well as candle molds, snuffers and extinguishers, brass and iron candlesticks of various sizes, and tin wall sconces.

During the 19th century a number of fuel oil lighting devices were specifically designed for use in lodges. One of the first lamps made for lodge use was Strong's Patent Masonic Lamp.[2] Manufactured by Butler & Whittaker of Boston in the 1840s, it was described as being suitable for parlor (mounted on pedestals), hanging, and shadeless hand-held use and capable of burning the most common oil. According to Strong's advertising, the most important advantage to his lamp was that it was supposedly impossible to spill by careless carrying.

About 1880 a pressed glass kerosene lamp was produced by Dalzell, Gilmore & Leighton Co. of Findlay, Ohio that catered to Royal Arch Masons. The unique design consisted of a fuel reservoir, or font, mounted above an arch supported by two glass pillars.[3] A third known form of Masonic hand lamp has a small flat mold-blown font of deep amethyst color and large applied loop handle. The font sides bear alternating motifs of an all-seeing eye and Masonic square and compasses. The origin of manufacture of this lamp remains to be identified, but it is likely that it was produced in the Midwest.

Natural gas lighting was introduced in America prior to 1820, but gas lighting fixtures were generally not installed in Masonic lodges until the 1850s (see 3.38). Glass globes that enclosed the gas jets and prevented flames from being accidentally extinguished were either acid-etched or wheel-cut to display Masonic symbols. Gas was a dangerous method of illumination and one that often contributed to the destruction of Masonic temples. Between 1840 and 1880, Masonic buildings experienced a very high incidence of fires. The advent of electrical lighting replaced gas as a means of lodge illumination and significantly contributed to the survival rate of Masonic buildings.

1. Minutes of Union Lodge, A.F.& A.M., Dorchester, Massachusetts; December 13, 1796.

2. Advertisement appeared in *The Freemason's Monthly Magazine*, Vol. VI, No. VII, May 1, 1847.

3. Thuro, Katherine M.V. *The Kerosene Era in North America: Oil Lamps*. Des Moines, 1976. 1:248.

Illustrations

ILLUSTRATION:
3.36, LEFT

3.35 SEE ILLUSTRATION ON PAGE 78
Candlesticks
Rhode Island, 19th century
Pine
Gift of St. John's Lodge No. 1, A.F.& A.M.,
Newport, Rhode Island 93.038
h: 42 ½" w: 9" d: 9"

Set of three tall candlesticks. The turned vasiform
shafts have triple-stepped square bases and silvered
bobeche. This set of "Fixed Lights" was used in St.
John's Lodge to illuminate the Masonic altar.

3.36
Candle Box
American, 19th century
Cocobola, bone
Special Acquisition Fund, 78.1.1
h: 3 ½" w: 10 ⅛" d: 6"

Sliding beveled top inlaid with a bone plaque in-
scribed with the initials "J.B.," a Masonic square and
compasses, and a trowel. Corners of the box are dove-
tailed. A raised plaque, carved with an American eagle,
is applied to one end.
 The initials "J.B." could denote the name of the
lodge but probably represent Jachin and Boaz, the
names given the two brass pillars said to have been
erected on the portico of King Solomon's temple.
Reference: Flayderman 1972, 158.

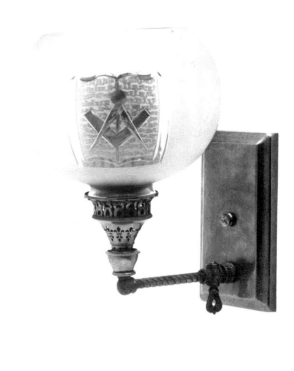

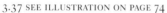

3.37 SEE ILLUSTRATION ON PAGE 74

Lantern
American, c. 1840
Tin
Gift of the Estate of Charles V. Hagler, 85.20.3
h: 13" dia.: 5"

Candle-lit punched-tin design of Masonic square and
compasses and crossed keys.

3.38
Gas Lamp
American, c. 1870
Brass
Gift of Harriet Ward, 89.21
h: 9 ½" dia.: 7"

Wall-mounted gas jet fixture with a frosted glass globe
decorated with wheel-cut Masonic symbols.

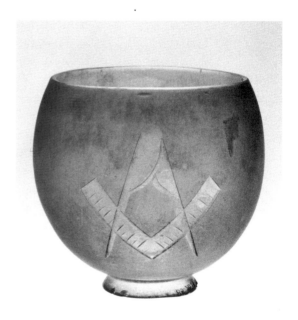

3.39
Lamp Globe
American, c. 1860
Glass
Gift of the Estate of Charles V. Hagler, 85.20.19
h: 7" dia.: 8"

Frosted smoke shade for a kerosene lamp; sides etched
with Masonic square and compasses, plumb and level.

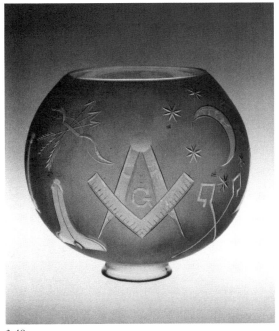

3.40

Lamp Globe
American, c. 1870
Glass
Special Acquisiton Fund, 84.57
h: 7 ½" dia.: 9"

Gas jet globe decorated with a Masonic square and compasses and level, and the three links of fellowship and other Odd Fellow symbols. It was common practice, particularly in the Midwest, for Freemasons to jointly own buildings or occupy meeting rooms in conjunction with other sympathetic fraternal organizations such as the Independent Order of Odd Fellows. Under such circumstances, the furnishings were often decorated with symbols of both organizations.

3.41

Reading Lamp
Louis E. Stilz & Brothers Company
Philadelphia, c. 1915
Tin
Gift of the estate of Gerald Dallas Jencks, 90.5.13
h: 8 ½" w: 2 ½" d: 2"

Black enamelled candle lamp with flat base and adjustable hooded visor. A metal cannister insert filled with paraphin fuel provided sufficient light for reading. The Stilz company illustrated these lamps, complete with stand, in their 1915 regalia catalog for the Knights of Malta degree. Lecturers used them in darkened chambers to read the narrative scripts of rituals. A low-priced version, known as the Acme Ritual Lamp, could be attached to a hand-held book. The Stilz family was in the regalia business from 1885 until 1936.

ILLUSTRATIONS:
3.40, LEFT
3.41, BOTTOM

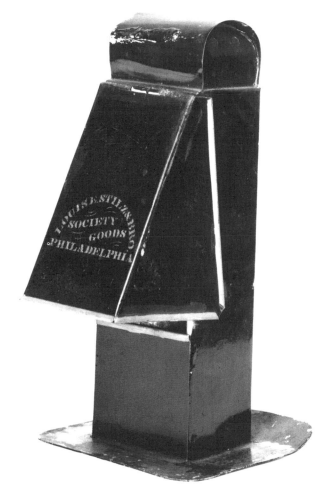

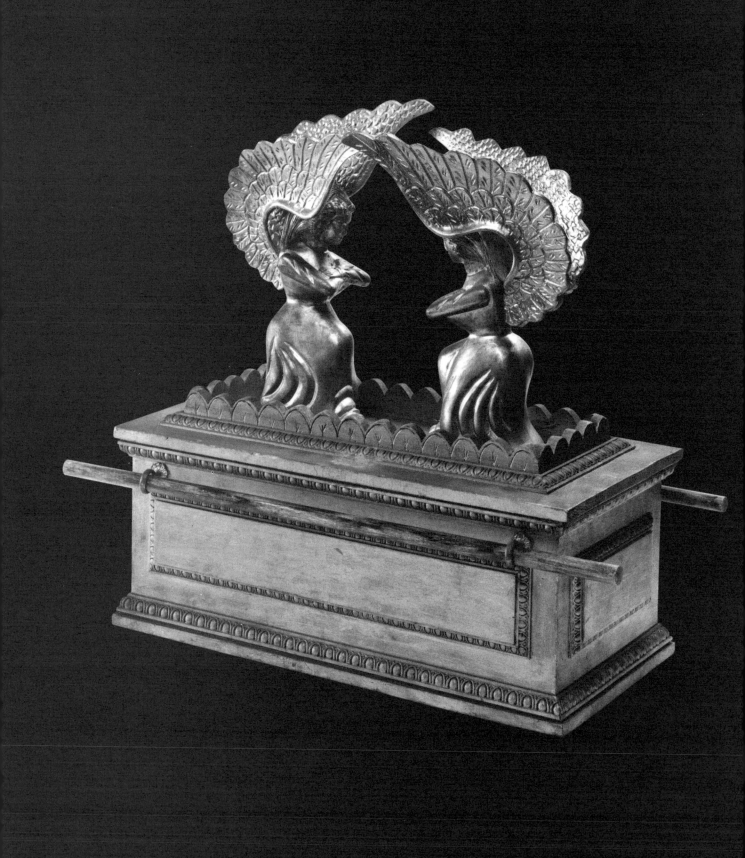

Paraphernalia

Paraphernalia — "noun: articles of equipment: furnishings, apparatus <ceremonial~>" (Webster's Third New International Dictionary)

ILLUSTRATION: 3.50, FACING SEE DESCRIPTION ON PAGE 85

In each of the degrees of Ancient Craft Masonry, certain stone mason's tools are used as symbols to teach lessons of morality. They are called the working tools of that degree. Just as such tools were once used to build actual temples, they or their non-functional versions are used as symbols by speculative Masons to build the spiritual temple that houses a moral being. Each one serves as a visual aid corresponding to a particular moral precept alluded to during the ritual lectures. In the American Masonic system the twenty-four-inch rule or "marking gauge", gavel, square, level, plumb, compasses, trowel, and mallet comprise the most commonly found working tools in Craft Masonry; and the pickax, crow[bar], and spade represent working tools associated with Royal Arch degrees. Other symbols that are not considered tools, but that sometimes appear in lodges as carved models, include the beehive, Noah's Ark, and the columns that represent the five orders of architecture.

The English system employs the less familiar pencil, skirret, and lewis (used in Pennsylvania lodges).[1] American lodges freely used these less common English working tools prior to severing their ties to the Grand Lodge of England in the latter part of the 18th century. After Jeremy Cross published his *Masonic Chart* in 1819 illustrating "approved" symbols, tools peculiar to the English rite are seldom encountered again in American Masonic usage.

Other items of paraphernalia included rods or staffs that were carried by various officers on ceremonial occasions. In a processional march that took place on January 29, 1729/30, the Stewards of the Grand Lodge of England carried white rods or staffs as ceremonial implements of office.[2] In 1741 the Grand Treasurer was presented with a "Staff, painted blue and tipped with Gold" for the use in the exercise of his office.[3] Black rods or staffs (staves), the height of a man, were carried by the Senior and Junior Deacon. Use of the black rod is cited in *Jachin & Boaz* (London, 1762) in conjunction with identifying the Deacons' station on a floor plan of the lodge.[4] Other references to the black rods further mention that they also were tipped with gold.

Costumes, scenery, special effects, theatrical props, and other paraphernalia were used to enhance the presentation of degree rituals. Those being initiated were subjected to

experiences well- calculated to insure that the moral lessons contained in the dramas were memorable.

All five senses were played upon in eliciting a maximum impact from the unfolding of ritual drama. A variety of paraphernalia helped create background scenery and such special effects as artificial fire, thunder, and lightning. The chief element among the various initiation techniques was hoodwinking, or the blindfolding of a candidate. Deprivation of sight placed the initiate in an unfamiliar and dependent state, mentally susceptible to false stimuli on his other senses, but better able to concentrate on oral descriptions.

Candidates being initiated were usually blindfolded or "hoodwinked" by a variety of methods during certain portions of the ritual. Albert G. Mackey offers the following definition of hoodwink in his *Encyclopaedia of Freemasonry*:

> A symbol of the secrecy, silence, and darkness in which the mysteries of our art should be preserved from the unhallowed gaze of the profane. It has been supposed to have a symbolic reference to the passage in St. John's Gospel (i.5), "And the light shineth in darkness; and the darkness comprenhended it not". But it is more certain that there is in the hoodwink a representation of the mystical darkness which always preceded the rites of the ancient initiations.

Early 18th-century initiation views show a piece of cloth tied over the candidates eyes. Masks made of silesia or velveteen with no eye openings were also in early use. Later developments in presenting rituals led Charles C. Fuller to invent a mechanical blindfold that could be used as a hoodwink by a broad variety of societies and lodges.

By 1900 many fraternal organizations had adopted unauthorized "side degrees" to provide revenue through special fees, frivolous entertainment for the brethren, and apprehension in the initiates. Side degree scenarios relied heavily on the use of trick props to insure success.

1. The skirret is an architectural or landscaping tool having a spool-like frame that turns on a center pin that can be driven into the ground or between blocks of stone. It is used to pay out or wind up chalk line. The lewis is a stone mason's lifting ring consisting of a three-piece dovetailed wedge, lifting ring, and connecting through-bolt. An iron lewis is used to hoist blocks of stone.

2. Entick 1756. Minutes of the Grand Lodge, January 29, 1729/30.

3. Ibid. minutes of January 12, 1741/42.

4. Refer to "Plan of the Drawing on the Floor at the Making of a Mason" in *Jachin and Boaz; or, an Authentic Key to the Door of Free-Masonry*. London, 1762.

Illustrations

3.42
Hoodwink
M.C. Lilley Company
Columbus, Ohio, c. 1890
Leather, tin
Gift of Eva M. Mahoney, 81.36
length: 19" h: 3" w: 3"

A mechanical blindfold with spring-operated eye covers mounted on a black leather face mask. The design was invented by Charles C. Fuller of Worcester, Massachusetts (U.S. Patent No. 327,438, issued Sept. 29, 1885). The shutters are manually raised to restore vision to the initiate. Fuller developed his design from an idea for spectacles with flip-up lenses that was patented in 1868 by Erastus S. Clapp of Montague, Massachusetts. Clapp's idea evolved from goggles patented in 1842 to cure strabismus, or squinting. Fuller's hoodwink was sufficiently popular to have been sold by nearly all the leading regalia manufacturing companies.

3.43
Hoodwink
M.C. Lilley Company
Columbus, Ohio, c. 1904
Cloth, steel
Collections Purchase Fund, 94.020
h: 3 ½" w: 9 ¼"

Cloth face pad with head-strap and metal frame enclosing rotary shutters that are opened and closed by means of a wing-nut. This design was patented by

Carl R. Lindenberg of Columbus, Ohio (U.S. Patent #773,291 issued October 25, 1904) and assigned to the M.C. Lilley Company. Lindenberg's hoodwink was advertised as the "Eclipse" model in an M.C. Lilley regalia catalogue of 1905. It also appeared in regalia catalogues for other fraternal orders.

ILLUSTRATIONS:
3.42, TOP
3.43, BOTTOM

3.44 SEE ILLUSTRATION ON PAGE 84
Steward's and Deacon's Rods
Massachusetts, c. 1819
Walnut
Gift of Amicable Lodge, A.F. & A.M.,
Cambridge, Massachusetts, 93.0022.1 & 2
length: 66 ½" and 64 ½"

Black and white painted staffs with turned finials. The finials are carved with a gilded spiraling branch of acacia and are surmounted by a gilded wood ball.
 In a *True Account of the Regalia of Amicable Lodge*, taken on December 7, 1819, there appeared on the *Invoice of The Furniture of Amicable Lodge* an entry for "6 Stewards & Deacons Rods." White rods would have been used by the Stewards, black ones by the Deacons. Amicable Lodge was chartered in 1805.

3.45 SEE ILLUSTRATION ON PAGE 84
Deacon's Rods
American Midwest, mid-19th century
Maple
Special Acquisition Fund, 87.15.2
h: 69"

Pair of ceremonial black rods, or staffs, tipped with gilt spheres. Rods were carried with pomp by various officers of the lodge during processions and on public occasions. In the case of matching rods used by a Senior and Junior Deacon, seniority of office was indicated by a minor difference in the size of the sphere or height of the staff.

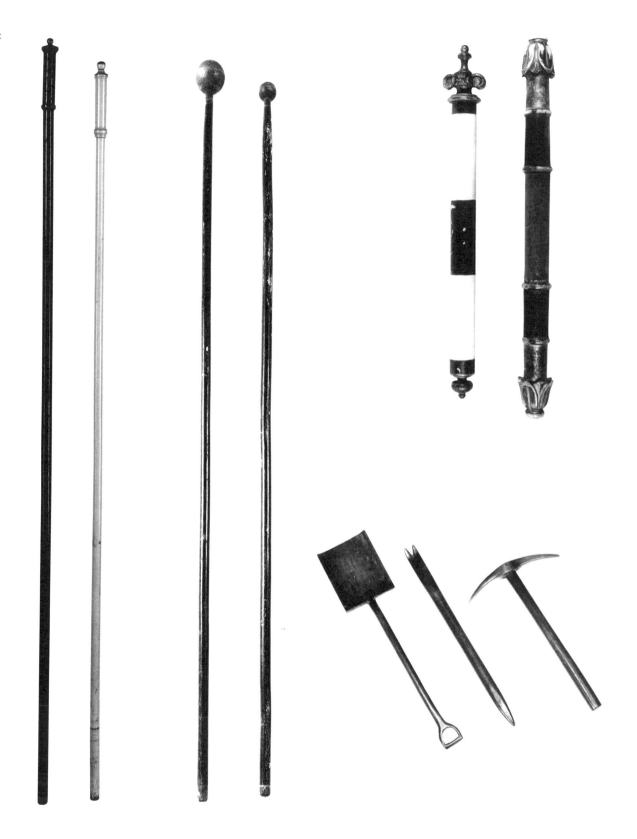

3.46

Truncheon and Scepter

Massachusetts, c. 1796
Wood
Gift of Union Lodge, A.F. & A.M.,
Dorchester, Massachusetts, 75.46.7 &.8
length: 22"

Carved ceremonial badges of office carried by the Marshal of a Masonic lodge. A Marshal's duties include the regulation of processions and transmission of the Master's directives to the Wardens. The Marshal may occasionally use his truncheon to ceremonially convey items that can be draped over it, such as documents or jewel collars. This truncheon and scepter were listed in the first inventory of Union Lodge furnishings in 1796.

3.47

Gavel

Massachusetts, c. 1796
Ebony, ivory
Gift of Union Lodge, A.F & A.M.,
Dorchester, Massachusetts, 75.46.23
length: 9"

The gavel is a badge of office of the Master of a lodge. It is also called a "Hiram" because, like that Biblical architect (Hiram Abif), it governs the Craft and keeps order in the lodge. The Master uses it in a parliamentary manner to call meetings to order, keep order, announce the result of a vote, and the recording of resolutions. In its true form as a stonemason's hammer, it also serves as one of the working tools associated with the Entered Apprentice Degree.

3.48

Royal Arch Working Tools

American, 19th century
Walnut
Supreme Council Archives
length: 9 ½"-13"

Set of miniature carved wooden tools consisting of a spade, crowbar, and pickax. These symbolic implements are the working tools of a Royal Arch Mason. They allude to the legend of the discovery of the Royal Arch and the removal of the arch or keystone by

which the sojourners gained entrance to the vaulted crypt beneath the Sanctum Sanctorum of Solomon's Temple.
Reference: Jones 1957,131.

3.49 SEE COLOR PLATE, PAGE 266

Cherubim

M.C. Lilley & Company
Columbus, Ohio, c. 1890
Pine
Gift of the Estate of Gerard Dallas Jencks, 90.5
h: 19" w: 36" (end to end) d: 10"

Carved and gilt cherubim, or winged celestial figures, that cover the mercy-seat of the Ark of the Covenant with their wings. Their form and position were decreed to Moses by God (Exodus 25:18). A replica of the ark is used in York Rite and Scottish Rite degree work.

3.50 SEE ILLUSTRATION ON PAGE 80

Ark of the Covenant

M.C. Lilley & Company
Columbus, Ohio, c. 1890
Pine
Gift of the Estate of Gerard Dallas Jencks, 90.5
h: 23" w: 24" d: 14"

Model ark covered with gold leaf and the top or mercy seat is surmounted by two Cherubim with outstreched wings. The ark that is used as a central prop during Royal Arch ceremonies is the substitute ark, a ritualistic imitation of the Ark of the Covenant.

3.51

Serpentine Staff

M.C. Lilley & Company
Columbus, Ohio, c. 1890
Pine
Gift of the Estate of Gerard Dallas Jencks, 90.5
length: 32"

Staff of wood in the form of a serpent alluding to Aaron's Biblical rod that became a serpent (Exodus 4). Serpentine staffs were used by costumed members of degree teams enacting ritual.

ILLUSTRATIONS:
3.47, LEFT
3.51, BOTTOM

ILLUSTRATION:
3.52

3.52
Bucking Goat
DeMoulin Brothers Company
Greenville, Illinois, c. 1915
Wool, pine
Special Acquisition Fund, 89.57.3
h: 13" length: 33" d: 10"

A vehicular saddle in the shape of a stuffed goat. "Riding the goat" was a form of initiation stunt that involved a blindfolded candidate remaining in the saddle while being subjected to a wild and bumpy ride. The goat was mounted on a vigorously propelled wheelbarrow-like vehicle with an eccentric axle. Various models, including a form shaped like a camel, were equipped with electrified stirrups and saddles that squirted water. A wide variety of initiation stunts were performed as ceremonies associated with frivolous side degrees, but they never comprised a part of solemn Masonic ritual degree work. The dignity of the Masonic Craft would not allow such demeaning treatment of candidates.

3.53
Trick Chair
DeMoulin Brothers Company
Greenville, Illinois, c. 1915
Oak
Special Acquisition Fund, 89.57.2
h: 40" w: 19" d: 19"

Common kitchen-style chair constructed with collapsible legs and a concealed .22 cal. blank cartridge detonator mounted under the seat. The seated initiate could suddenly find himself on the floor as a spring-driven release catch simultaneously fired the blank cartridge and caused the hinged legs to swiftly collapse outward.

It is most important to understand that the use of this chair and similar props was limited to unauthorized side degrees.

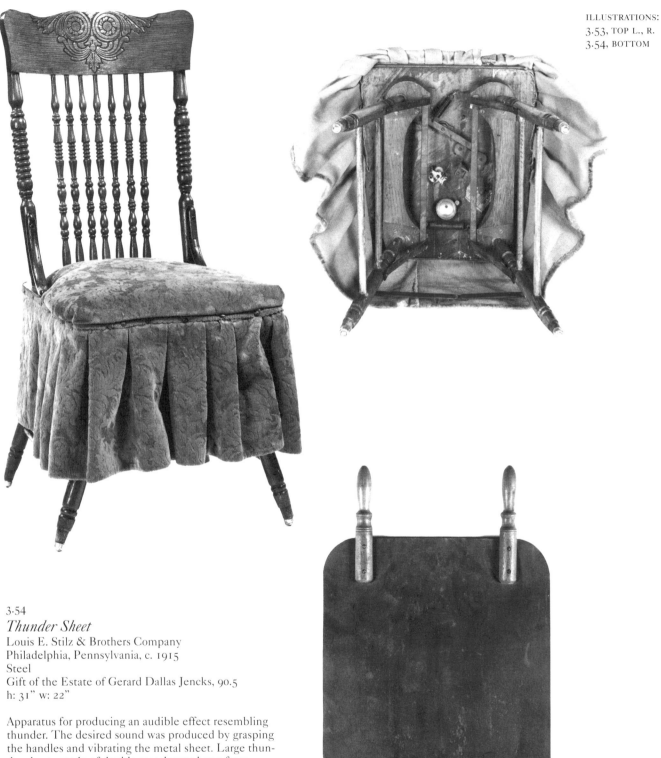

3.54
Thunder Sheet
Louis E. Stilz & Brothers Company
Philadelphia, Pennsylvania, c. 1915
Steel
Gift of the Estate of Gerard Dallas Jencks, 90.5
h: 31" w: 22"

Apparatus for producing an audible effect resembling
thunder. The desired sound was produced by grasping
the handles and vibrating the metal sheet. Large thun-
der sheets made of double metal were hung from
ceiling or wall offstage; smaller sizes were hand held
and used while initiates were hoodwinked.

Paraphernalia 87

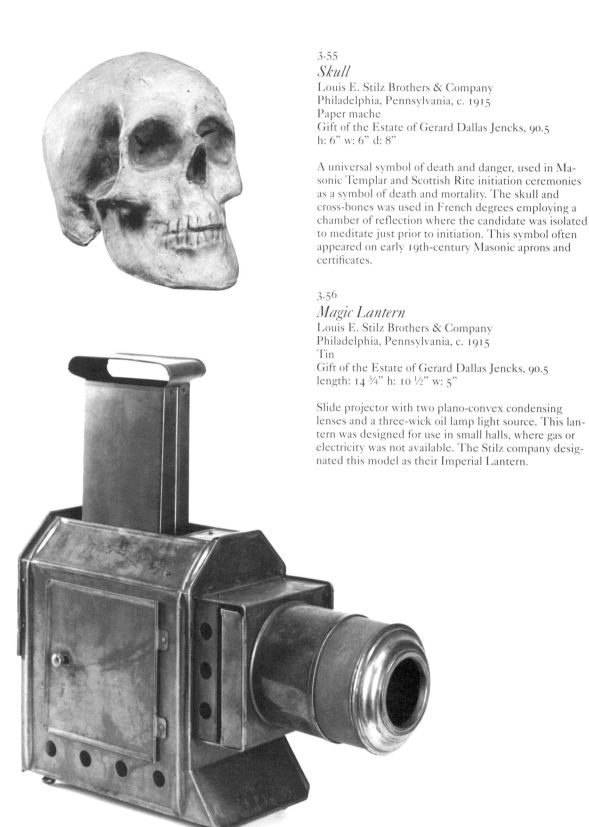

3.55
Skull
Louis E. Stilz Brothers & Company
Philadelphia, Pennsylvania, c. 1915
Paper mache
Gift of the Estate of Gerard Dallas Jencks, 90.5
h: 6" w: 6" d: 8"

A universal symbol of death and danger, used in Masonic Templar and Scottish Rite initiation ceremonies as a symbol of death and mortality. The skull and cross-bones was used in French degrees employing a chamber of reflection where the candidate was isolated to meditate just prior to initiation. This symbol often appeared on early 19th-century Masonic aprons and certificates.

3.56
Magic Lantern
Louis E. Stilz Brothers & Company
Philadelphia, Pennsylvania, c. 1915
Tin
Gift of the Estate of Gerard Dallas Jencks, 90.5
length: 14 ¾" h: 10 ½" w: 5"

Slide projector with two plano-convex condensing lenses and a three-wick oil lamp light source. This lantern was designed for use in small halls, where gas or electricity was not available. The Stilz company designated this model as their Imperial Lantern.

3.57
Low 12 Bell
American, c. 1870
Wood, brass
Gift of Union Lodge, A.F. & A.M.,
Dorchester, Massachusetts, 78.52.3
h: 7 ½" w: 6" d: 6"

Gong used to theatrically toll the hour of midnight during degree initiations. A clapper strikes the bell once during each revolution of the hand-operated crank. Mechanical gongs were replaced by organists who played somber chords to represent tolling the hours.

3.58
Slapstick
New York State, c. 1907
Ash
Gift of Mrs. Hugh B. Darden, 87.48.5
length: 23"

Spanking paddle with noisemaker vanes. This paddle bears a carved inscription testifying that it was presented to Dana B. Pratt as a humorous souvenir of his tenure as Grand High Priest of the Grand Royal Arch Chapter of New York. This is a prop that has no role in Royal Arch ceremonies.

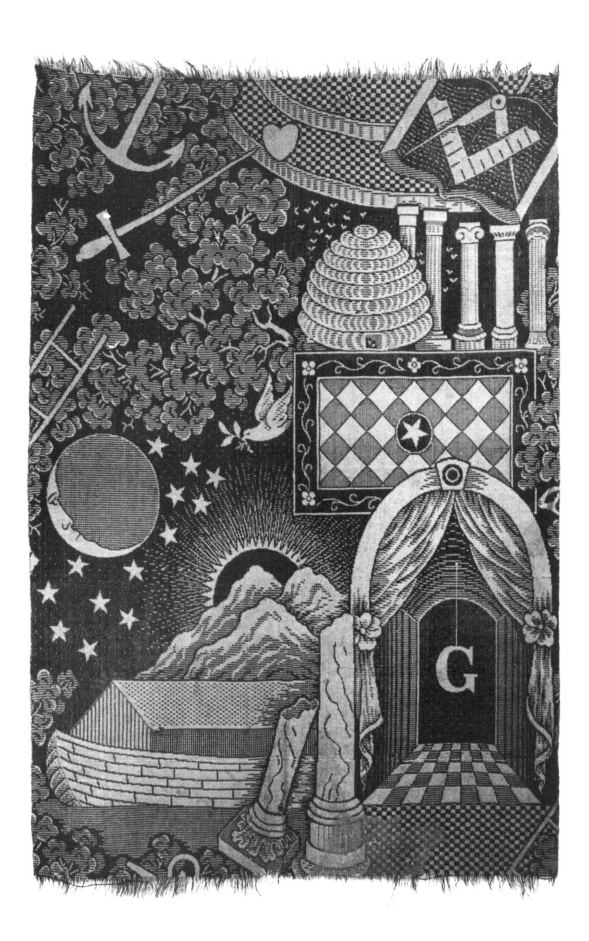

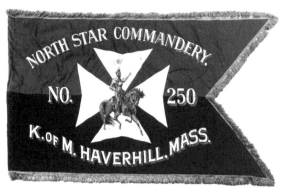

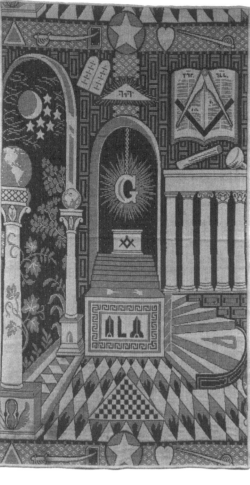

3.59
Banner
Knights of Malta
American, c. 1900
Sateen
Gift of the Estate of Gerard Dallas Jencks, 90.5
hoist: 42" fly: 74"

Swallow-tailed, hand-painted parade banner with yellow worsted fringe; the upper half of scarlet, the lower half of black. In the center is a white Maltese cross painted with the figure of a mounted knight in armor. The banner is inscribed "North Star Commandery No. 250, K. of M. Haverhill, Mass." Masonic Knights Templars use a black and white banner derived from the war banner, or Beauseant, of the ancient Templar knights.

3.60
Emblematic Carpet
American, c. 1880
Wool
Gift of Mr. and Mrs. Foster McCarl, Jr., 76.45.2
h: 51 ½" w: 36"

Red and black ingrain-woven carpeting. The symbols shown are generally associated with the Entered Apprentice, or First Degree.
 Repeat runs of patterned carpeting were sewn together to form large area rugs.

3.61
Emblematic Carpet
American, c. 1890
Wool
Gift of the Estate of Charles V. Hagler, 85.20.14
h: 62" w: 36"

Red and green ingrain-woven floor carpeting. The symbols shown are specifically associated with the Fellow-Craft, or Second Degree and include the pillars of Solomon's Temple, a winding staircase and the Five Orders of Architecture. This pattern was derived from a tracing board illustration, or chart of symbols, that appeared in Charles W. Moore's *New Masonic Trestle-Board* (Boston, 1850). Carpeting in this pattern was sold by most of the major regalia manufacturers from 1889 until about 1915.

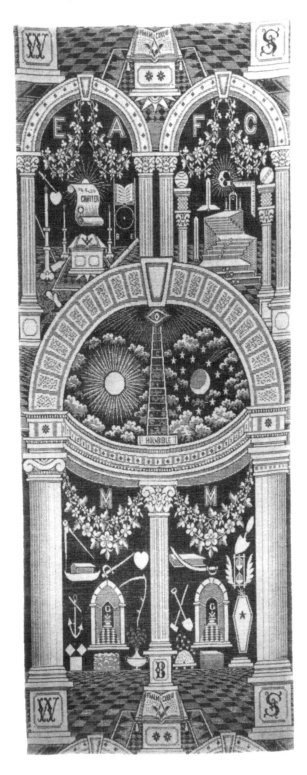

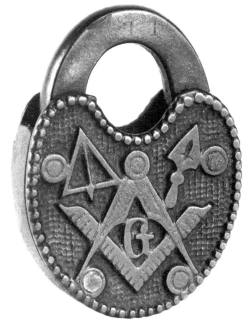

3.62
Emblematic Carpet
South Bend, Indiana, c. 1900
Wool
Gift of the Supreme Council, 33°, Ancient Accepted
Scottish Rite of Freemasonry, Northern Masonic Juris-
diction, 94.005
h: 94" w: 36"

Red and black ingrain-woven carpeting showing a full
repeat of a Masonic pattern consisting of a tiered series
of arches labled "EA" (Entered Apprentice), "FC"
(Fellow-Craft) and "MM" (Master Mason). This car-
peting was removed from Walkerton Lodge No. 619,
Walkerton, Indiana. It was woven on contract by the
Sisters of the Order of the Holy Cross at St. Mary's
College, South Bend, Indiana.

3.63
Padlock
American, c. 1875
Iron
Gift of Harriet G. Ward, 86.21
h: 2 ¾" w: 2 ¼"

Cast iron side panels decorated with gilded Masonic
square and compasses enclosing the letter "G," level,
and trowel in raised relief. A flat push-key must be in-
serted in a slot in the bottom edge. This style of
padlock was patented by Daniel K. Miller of Philadel-
phia, Pennsylvania on October 28, 1873 (U.S. Patent #
143,990).

Chapter 4

Regalia
Jewels
Swords

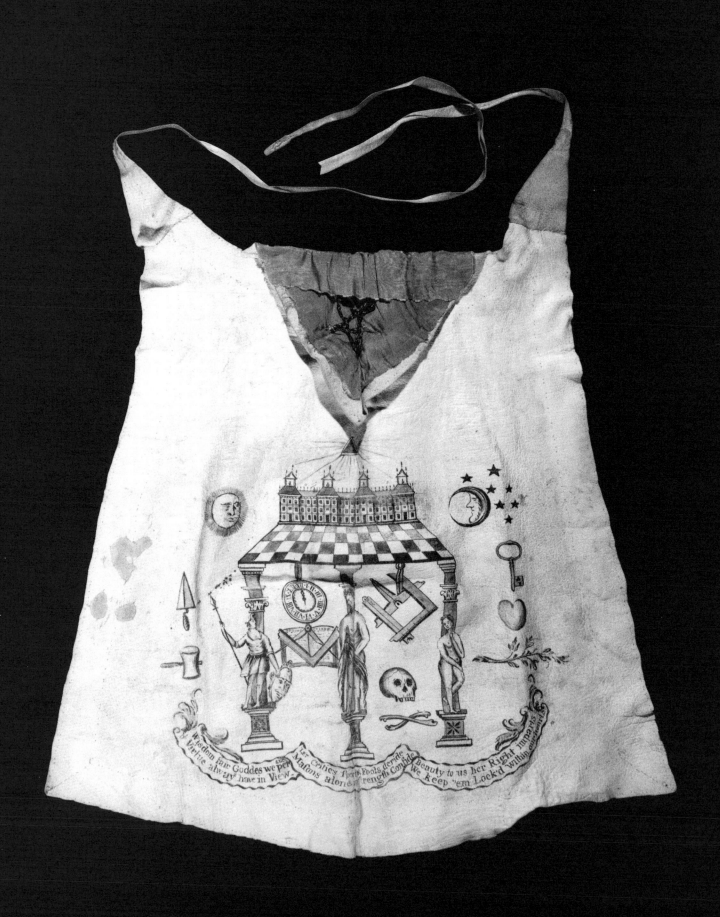

Wisdom fair Goddes we [...] / Virtue always have in View. [...] Critics [...] Fools deride / Masons alone [...] rength Confide [...] Beauty to us her Right imparts / We keep 'em Lock'd within our hearts [...]

Regalia

ILLUSTRATION: 4.01, FACING SEE DESCRIPTION ON PAGE 104

THE EARLIEST PUBLISHED REFERENCE TO REGALIA IN FREEMASONRY IS FOUND in Preston's *Illustrations of Masonry* (London, 1775) in which the author described the manner of decorating funeral processions with the "regalia and ornaments of the deceased."[1] Since Preston's time, the term "regalia" has come to signify almost any kind of Masonic badge, ornament, insignia, or article of clothing. Unlike England, where since 1813, all Masonry has been governed by a United Grand Lodge, the fragmented autonomy of the American Masonic system foiled attempts to impose uniformity in the matter of regalia. American Freemasons were not obliged to comply with any but their own jurisdictional practices. Codification of regalia seldom exceeded being able to distinguish between Subordinate and Grand Lodge usage, and the symbols and colors used in various Masonic degrees evolved more through tradition than by decree.

Throughout the greater part of the 18th century, the sewing and decorating of Masonic articles remained the domain of a Mason's female relatives. By 1800 growing numbers of professional artists and ornamental sign painters competed with professional engravers to provide Masons with decorated Masonic aprons.[2] The engravers and their printers developed networks to vend expanding lines of Masonic supplies that included books, aprons, jewels, and other forms of regalia. During the resurgence of Masonry in the late 1840s, milliners, drapers, and military uniform manufacturers were quick to recognize that expanding new markets existed among Freemasons for costumes that would enhance enjoyment of ritual (see 4.12).

In the 1850s, regalia manufacturers evolved a neutered form of regalia that was offered to Masonic and non-Masonic organizations alike. Some outfits were quite tawdry, and Masons were warned through periodicals such as the *Mirror & Keystone*, that "the gaudy regalia of modern beneficial societies has in more cases than one been palmed off as Masonic."[3]

The regalia and uniform industry boomed during the Civil War. Enlistments in the Union and Confederate armies exceeded 3.2 million men, and more than 270 firms have been identified as suppliers and outfitters of this armed horde. Leading firms such as W.H. Horstmann & Sons, Ames Manufacturing Company, and Schuyler, Hartley & Graham, had already been well established prior to the bombardment of Ft. Sumter. But, on April

12, 1865, the proceedings at Appomattox Courthouse put an end to lucrative government wartime supply contracts.

Many small firms went out of business, but many businessmen anticipated the reduction in military contracts and sought other markets for their products. What sociologists now identify as "male bonding" came to their rescue. Veterans' associations such as the Grand Army of the Republic were rapidly established and a mushrooming interest in fraternalism resulted in the establishment of a number of new organizations that included the Knights of Pythias. Older fraternal societies such as the Masonic order and the Independent Order of Odd Fellows became rejuvenated, creating a wide consumer field. The militant aspects of these organizations facilitated the industry's shift from military to civilian uniform production.

Advertisements for fraternal regalia began to appear almost as soon as the war ended. Regalia manufacturers issued attractive goods catalogs that catered to an expanding variety of organizations. The fraternal movement in America gathered momentum driven by the pomp attendant with national conclaves, massed public parades, and prestigious drill competitions. By 1897 over ten million Americans were members of fraternal organizations.

Aprons, Sashes, Gloves, & Hats

Of chief importance among the items of Masonic regalia is the apron. A plain white lambskin apron is considered the badge of all Speculative Masons, emblematic of a pure heart. Colored fringe or edging on the apron denotes use within a specific Masonic body or degree as much as the decoration and symbols placed thereon does.[4] At least seven colors have been assigned a symbolic significance in Freemasonry and used as decoration: blue, purple, red, white, black, green, and yellow.[5] Blue represents the Symbolic Lodge and the Third or Master Mason's Degree. In a Royal Arch Chapter prior to the early decades of the 19th century, yellow designated the Fourth or Mark Master Degree. It was subsequently replaced by the color scarlet, which now represents those degrees between the Third and Seventh. Purple is the color of the Royal and Select Master (8th and 9th) Cryptic degrees. Knights Templars are represented by the color black, but at the beginning of the 19th century their aprons were also white, trimmed in black.[6] Green is the color of Red Cross Knights.

In American ritual the wearing of a sash was reserved as a distinctive badge of office for the Master and officers of a Grand Lodge.[7] In the English York Rite the sash was worn as part of the regalia or costume associated with a particular degree. All Companions of the Royal Arch Degree wear a sash of scarlet with the words "Holiness to the Lord" inscribed upon it.[8] During the 19th century, Knights Templars wore a sash that alternated

from white trimmed with black to black trimmed with silver lace. Knights of Malta wore a dual purpose Templar sash, reversed, to show a green lining with a red cross.

White gloves are worn during Craft lodge meetings by the Master, all officers, and by all Masons participating in funeral services. The gloves are symbolic of clean hands, or a spotless and pure Masonic life. As a symbol of purity, gloved hands appear open or clasped together on many early emblematic pictures.[9] It was a practice in the 18th century to require newly initiated candidates to "clothe" the lodge by presenting to each member an apron and gloves. This was usually done in December at the Feast of St. John as part of the initiation fee.

Arising out of ancient social custom, it is a practice in the American rite for the Master to wear a hat while all around him are bareheaded. It is viewed as a token of the superiority of his office and a mark of respect. The Master is obliged to remove his hat when the lodge is visited by the Grand Master, who temporarily assumes control of the lodge and thus wears a hat. When control is returned to the Master, he resumes wearing his hat. The Master also doffs his hat at every mention of the Great Architect of the Universe (G.A.O.T.U.) and during prayer. Hat styles followed those of contemporary society with modern Masters usually wearing a black high-silk hat, although 18th-century style tricorne hats are worn in certain tradition-steeped lodges.

Jewels & Medals

"Mason's Medals" were an equally important form of regalia that included personal medals commemorating initiation into Masonry's several degrees.[10] In the 18th and early 19th centuries, jewels and medals were suspended from a silk ribbon worn about the neck, the color of the ribbon consistently indicating use within specific Masonic bodies or degrees.

By the late 1840s a practice had been established of wearing lodge jewels suspended from wide cloth collars of appropriate color. Numerous graphics of the period document the singular form of collar that Mackey described as being "triangular, terminating on the breast in a point and may be either of broad ribbon, embroidered or plain."[11] Quite often the collars were decorated with stars and rosettes. In the last quarter of the 19th century the cloth collars were gradually replaced by metal collar chains that were "derived from the practices of heraldry whereby collars are worn by municipal officers, officers of state, *and knights of various orders.*"[12] The use of silver or gold served to distinguish chains used by Subordinate or Grand bodies, respectively.

Degree Costume

Development of the dramatic presentation of Masonic degrees, particularly in Royal Arch and in other degrees within the York and Scottish Rites, fostered a use of theatrical costume and setting to heighten the impact upon candidates of the moral lesson contained within each degree. Teams of brethren, dressed in costumes recalling Biblical or historic figures, presented these morality plays for the benefit of initiates as well as the assembled membership. Costumed priests, Roman centurians, shepherds, kings, scholars, scribes, craftsmen, knights, and monks infused ritual scripts with memorable drama.[13]

The first printed reference of the Royal Arch being worked as a degree is to be found in Fifield Dassigny's *A Serious and Impartial Inquiry into the Cause of the present Decay of Free-Masonry in the Kingdom of Ireland* (Dublin, 1744). Other references to the Royal Arch Degree began to appear in England and Scotland during the 1740s, heralding a great progress in the spread of the Royal Arch during the 1750s and 1760s.[14] The first recorded initiation to the Royal Arch Degree occurred in the lodge at Fredricksburg, Virginia on December 22, 1753.[15] Not long afterward, other Royal Arch Lodges appeared in America's major cities, usually working under "Ancients" charters issued from Ireland or Scotland.

"Arching," an archaic term used to signify initiation to the Royal Arch Degree, was performed by the three principal officers of the chapter.[16] The High Priest (representative of Joshua, High Priest of the Jews) is the presiding officer, corresponding to the Master of a Symbolic Lodge; the King (representative of Zerubbabel, Governor of Judah) is the second principal; and the Scribe (representative of Haggai, prophet and expounder of the law) is the third principal.

In chapters working in the 18th century, the three principals wore traditional vestments consisting of robes and headdresses with a vaguely middle-eastern appearance. In the American rite the High Priest wears a mitre headdress, a sleeveless coat (ephod), and a breastplate that is mounted with twelve colored stones, each representing one of the twelve tribes of Israel. The King wears a crown and carries a sceptre; the Scribe wears a turban. Other attendants (Captain of the Host, and Sojourners) wear various hats or caps. An illustration of American Royal Arch vestments may be seen on the summons engraved in 1791 by Benjamin Hurd, Jr. (1750-1821) for St. Andrews Royal Arch Chapter.[17]

Uniforms

The original Order of the Temple, established in 1118 A.D. and known as the Knights Templar, had no historic association to Freemasonry, but the two were linked during the middle of the 18th century under the aegis of Masonic lodges.[18] There is a strong presumption that the order was of Jacobite origin, introduced to Scotland and Ireland from France by Prince Charles Edward in 1745. Whenever the Knights Templar Degree was

"worked" in the 18th century, it was in connection with the Royal Arch Degree as a pre-requisite; first in Ireland in 1743, then in England at York and London following in the path of the first traces of Royal Arch Masonry.[19]

The Knights Templar Degree was first conferred in America in 1769 in the meeting room of St. Andrew's Lodge of Boston.[20]

Many brethren of St. Andrew's Lodge had received the Royal Arch Degree in Ireland and either one of the members, or a visiting Irish Mason, probably introduced the Knights Templar Degree. The early American ritual was almost identical with the Irish. In 1785 an account was given of Knights Templars parading through the streets of New York in celebration of St. John the Evangelist's Day.[21] The Templars were described as "properly clothed," but no further description of their uniform is given.[22] Co-founder of the General Grand Encampment of the United States Thomas Smith Webb (1771-1819) described Templar dress in 1797 as "the same color as the Knights of Malta, viz..black."[23]

Twenty years later (1816), Thomas Smith Webb's "Observations on the Orders of Knighthood" provided a more detailed description of Templar regalia: "Aprons - White, with a black border. The flap black, and skull and cross bones embroidered in silver thereon." No official mention was made of a triangular-shaped apron until 1821.[24]

The Templar costume was described as: "A full suit of black, with a rapier and military hat; a broad black ribbon [baldric] on the right shoulder, across the body to the left side, ornamented with a silver star opposite to the left breast, having seven points; the Grand Master or Commander, a star of nine points; in the center of the star, a cross and serpent of gold, surrounded by a circle, on which is engraved or enamelled "In Hoc Signo Vinces."[25] Prior to 1841, no official uniform had been adopted. The procuring of one was held to be a matter of discretion with each Sir Knight, regulated only by his taste and purse.

The first attempt to standardize the Templar uniform was made by the Grand Encampment at New York City in September 1841 (8th Triennial Conclave).[26] In accordance with a committee recommendation published in the *Proceedings*, attendees were requested to wear all black dress including stock, gloves, scarf, chapeau with black satin cockade (no feathers), triangular apron, and straight sword. Trimmings of gold were to distinguish officers of the Grand Encampment; others were to wear silver.

In 1856 the Grand Encampment of New York asserted that there was no proper foundation for the prevalence of the distinguishing color black, which was not in keeping with the white garments worn by the "Knights of Christ." That year the matter was brought before the General Grand Encampment of the United States at the Triennial Conclave in Hartford.[27] There the Grand Master acknowledged that no statute regulating costume was in effect but that there was a necessity for permanent rules on the subject. The mat-

ter was referred to a special committee, which proceeded to draft a resolution revising the Constitution to include statutes establishing a *uniform* costume, but no action was taken until the next Triennial Conclave held at Chicago in 1859.

In 1859 the deferred uniform resolution was officially adopted. Templar uniform was to consist of a white sleeveless surcoat or tunic worn over a black coat, a red leather belt, and a white scarf or baldric, on the front center of which was to be a metal star of nine points (alluding to the nine founders of the order) enclosing the Passion Cross surrounded by the Latin motto, "In Hoc Signo Vinces." A cloak of white merino was to be worn on the left shoulder, a scarlet Templar Cross on the left breast. Headgear was limited to the military chapeau, trimmed with black or white plumes, and a black cloth "navy cap" worn with a black frock coat as "fatigue" dress. The triangular apron was not mentioned; officially it was eliminated from the uniform.

Rank-and-file Sir Knights were designated by white metal trimmings (silver) while officers wore gold. Various crosses also served to designate rank within Subordinate (local), Grand (state), or General Grand bodies (national) as follows: the Passion Cross for Sir Knights; Templar Cross for Grand and Past Grand Officers (states); Patriarchal Cross for Grand and Past Grand Officers of the United States, and the Salem Cross for Grand Masters (national). The various crosses were to be worn "on the side of the chapeau and on the sheath of the sword."

The "white" uniform adopted in 1859 was costly and difficult to keep fresh and clean. Such commanderies as then existed and which already had costumes, were exempted from compliance with the statute until such time as they procured new ones. As a result, two essentially different costumes were in use at the same time (white and black, not to mention numerous minor differences among each). Responding in 1862 to the problems encountered with the white costume, the 15th Triennial Conclave adopted a "black" uniform, modifying the regulations of 1859 by eliminating the white surcoat and cloak and introducing the use of shoulder straps to designate rank. The triangular apron continued to be eliminated from the costume. When the edict of 1862 was adopted, the resolution of 1859 was not expressly repealed, causing considerable latitude for interpretation. The ensuing controversy fostered an open uniform rebellion among several state Grand Commanderies.[28] For nearly a decade, dissenting commanderies simply refused to comply.[29]

In 1871, Grand Master John Quincy Adams Fellows (1825-1897) issued Order No. 3, which required a strict compliance with the edict of 1862. The ordinary "frock coat of society" was seen as the model "to prevent that tendency to extravagance of dress which is hardly consistent with the vows of a Templar." Deep resistance to Order No. 3 was again dealt with in 1874 when the Grand Master was forced to report, "The first and most

widespread objection to the Order was because it stripped from the uniform the lace trimmings, the peculiar buttons, and other additions which costume and regalia manufacturers had made." Grand Master Fellows also observed, "The greatest difficulty had no doubt arisen from the desire of regalia manufacturers to add tinsel to their articles of dress, and some there may be who still use gold and silver lace where none should be worn."

Rebellion against the edict of 1862 and Order No. 3 remained rife. In Maine officers of the Grand Commandery were suspended from office. The Grand Master of Washington Commandery No. 1, Washington, D.C. was also suspended because of circulars he sent to other commanderies containing the following statement:

> This Commandery, among the oldest in the Country, has
> worn the black uniform for nearly fifty years, and we
> regard the order to adopt a new dress as a violation
> of the compromise of 1859, without which the new dress
> never could have been carried in the Grand Encampment.
> It is our purpose to oppose the final enforcement of
> the Order by every proper means in our power, and in
> that purpose we are sustained and encouraged by many
> of the most distinguished members of the Order in all
> parts of the Country.

Actually, there was no "compromise of 1859" as interpreted in Maine. A Grand Encampment Committee on Jurisprudence upheld the Grand Master and ruled that the resolution of 1859 was silent on the matter of exemptions and that the edict of 1862, adopting an entirely new set of uniform regulations, "takes the place of the old one and repeals it." The committee also ruled that the statute of 1862 prescribes the dress of Templar Masonry without limitation or exception and that commanderies already provided with uniforms are not exempted from obedience to the law.

In 1877 amended statutes regarding the uniform of a Knight Templar also provided that "The Templar baldric reversed, exhibiting the green side, Templar cap covered; sword, and white gloves, constitute the uniform of a Red Cross Knight."

Continued difficulty was experienced in obtaining uniformity. The phrase with "appropriate trimmings" from the 1862 edict continued to create inconsistency. Prior to 1880, Kentucky had decided to use gilt buttons on their frock coats. The Grand Master voiced disapproval but did not take action until 1886 when he prescribed a double-breasted frock coat with stand-up collar and two rows of black buttons, eleven in each row, evenly spaced. Officers and Sir Knights below the rank of Commander were to wear a single-breasted

coat. In 1910 it was decreed that the uniform of a Knight of Malta would be the same as that of a Knight Templar, and that the two rows of buttons would henceforth consist of black velvet-covered ball buttons.

Efforts by the Grand Master notwithstanding, regalia manufacturers continued to offer lace and glitter to the Sir Knights. Although Templar aprons had not been authorized since 1859, they remained a standard article offered in all regalia catalogs. Photographs taken at the Triennial Conclaves show several different styles of aprons being worn by the Sir Knights as part of the uniform.

With America's involvement in World War I, an exemption was made in 1918 to the requirement that a candidate for orders procure a uniform. Sensibly, the uniform requirement was waived if he "had been called to the colors of his country in its hour of need." During the 1920s and 1930s, no great changes were made to the uniform, but more detailed descriptions emerged in order to give greater clarity to existing statutes.

1. William Preston (1742-1818), a distinguished teacher of Masonic ritual.

2. Franco 1980.

3. *Mirror & Keystone*, September 15, 1858, p. 443.

4. For a general discussion of Masonic aprons see Franco 1980. The author failed to illustrate any Knights Templar aprons.

5. Mackey 1920.

6. Webb 1816.

7. *Constitutions of the Grand Lodge of Massachusetts*. Boston, 1843. (Article VII, Sec. 1) - "Officers of a subordinate Lodge wear a blue sash, blue velvet collar, trimmed with silver lace, a silver jewel and white apron trimmed with blue ribbon."
"A Grand Officer will wear a purple velvet sash and collar, gold or gilt jewel and white apron trimmed with purple ribbon."

8. Jones 1957, 214. "The sashes of Grand Officers [Irish Royal Arch], including Kings, have their ends trimmed with gold fringe...all other Companions have a silk fringe."

9. See the emblematic frontispiece to *Jachin & Boaz*.

10. For use of term "Mason's medals," see the workbooks of Paul Revere.

11. Mackey 1873.

12. Ibid.

13. For an early illustation of the "Costume of High Priest" see: Oliver 1846.

14. Jones 1957.

15. George Washington was initiated in this lodge on November 4, 1753. Technically, *exaltation* is the term used for initiation to the Royal Arch degree.

16. In the American rite, the High Priest officiates; in the English rite the King presides. A convocation of Royal Arch Masons is called a Chapter, empowered to give the preparatory degrees of Mark, Past, and Most Excellent Master. See Mackey.

17. Figures of High Priest, King, and Scribe appear in appropriate vestment. A High Priest in vestment also appears on a certificate designed by Philip P. Eckel, and engraved by John Bannerman in 1806, for Maryland Encampment No. 1, Knights Templar.

18. The Order of Knights Hospitallers was instituted in 1048, was subsequently known as the Knights of St. John of Jerusalem, and later of Rhodes when expelled from Jerusalem by the Saracens. After the capture of Rhodes by the Turks in 1522, they were styled the Knights of Malta. In 1798, the French captured Malta and soon afterward the Order became extinct.

19. Lepper, John H. and Crossle, Philip. *History of the Grand Lodge of Free and Accepted Masons of Ireland*. Dublin, 1925. Lepper gives March 24, 1765 as the earliest recorded date known for conferring a Knights Templar Masonic degree.

20. Conferred in St. Andrews Chapter of Royal Arch Masons, Boston on August 28, 1769.

21. *The Independent Journal: or, the General Advertiser.* New York, December 28, 1785.

22. *Early History and Transactions of the Grand Lodge of Free and Accepted Masons of the State of New York, 1781-1815.* New York, 1876, Vol. I, p.42.

23. Webb 1797, 190.

24. Sachse 1919, 118. On June 8, 1821 the Grand Encampment of Pennsylvania adopted "a black apron with a white border, with suitable devices, and shaped as a Triangle...."

25. Webb 1816, 228. See also: Samuel Cole's *The Freemason's Library and General Ahiman Rezon;...* Baltimore, 1817, p.293. for provision to reverse the apron colors.

26. The Knight Templar administrative structure was comprised of local or subordinant bodies called Encampments governed by Grand Encampments at each state level, which were all subject to national authority of the General Grand Encampment.

27. In 1856 the term Encampment was replaced with the term Commandery at the subordinate and state levels. The national governing body continued to be called a General Grand Encampment.

28. Washington (DC), Virginia, Massachusetts and Rhode Island, Maine, New Hampshire, and Connecticut; twenty-four commanderies in all.

29. Scully 1952.

Illustrations

4.01 SEE ILLUSTRATION ON PAGE 94

Master Mason's Apron
Massachusetts, c. 1780
Ink and watercolor on leather
Gift of Dr. Phillip James Jones, 83.45
h: 24" w: 22"

Symbolic apron made in the shape of a craftsman's working apron. The hand-drawn design includes allegorical figures of Minerva (wisdom), Hercules (strength), and Venus (beauty) standing on pillars that support a mosaic pavement upon which rests King Solomon's Temple. The figures allude to the Master and Wardens of a lodge who are said to be its principal supports.

This apron was owned by Richard Harris of Marblehead, Massachusetts, who served as Master of Philanthropic Lodge, Marblehead, from 1778 to 1781. Harris served as an artilleryman under Paul Revere during the American Revolution. The design on Harris's apron is nearly identical to that on an apron presented to John Collins (1752-1824) by Essex Lodge, Salem, in 1781.
Reference: Hadley 1979.

4.02

Master Mason's Apron
New England, c. 1780
Lambskin
Gift of Union Lodge, A.F. & A.M.,
Dorchester, Massachusetts, 75.46.13
h: 13 ½" w: 17 ½"

Shaped leather apron bound in blue silk with three blue silk rosettes signifying the three degrees in Craft Masonry. This apron was owned by Capt. Levi Pease (1739-1824) who was listed as a member of Rising States Lodge, Boston in 1792.

Levi Pease was born in Enfield, Connecticut and trained as a blacksmith. He moved to Blandford, Massachusetts where he became a member of the local militia. In 1776, he received a comission as Adjutant of the 3rd Hampshire Co., Lieut. Col. Timothy Robinson's Regt., Massachusetts Militia. During the Revolutionary War Bro. Pease was detached on special foraging and courier duties for the Commisary General, Gen. Wadsworth. When Rochambeau landed in New-

port, Rhode island, Bro. Pease was made responsible for foraging for the French army on its march to Yorktown. After the war he operated the first stage line that ran between Boston and Hartford, procured the first charter for a turnpike road, and received the first U.S. Mail contract in New England. In 1794, he moved to Shrewsbury, Massachusetts where he purchased the farm and tavern that previously belonged to Maj. John Farrar (1741-1793). [see Chapter 7, 7.07]

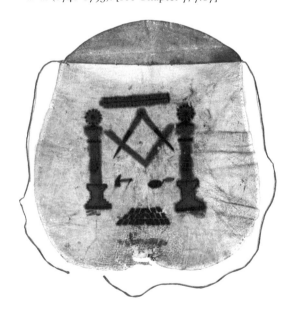

4.03
Master Mason's Apron
American, 18th century
Lambskin
Gift of Dr. Robert W. Raymond, 87.52.1
h: 16" w: 14 ½"

Stenciled Craft apron with ink detailing on lambskin, showing twin pillars marked "B" and "J", twenty-four-inch folding ruler, mallet, trowel, mosaic pavement in three tiers, square and compasses, and a coffin. The points of the yellowed [brass] compasses are colored black to represent blued steel. The colors yellow and blue were adopted by the Grand Lodge of Ireland and are symbolic of the compasses. A spurious ritual published at Dublin in 1730 described the Master as being clothed "In a yellow jacket and blue pair of breeches." The yellow jacket alluded to the compasses, and the blue breeches, the steel points.
Reference: A.Q.C. 1923, 36:284-286

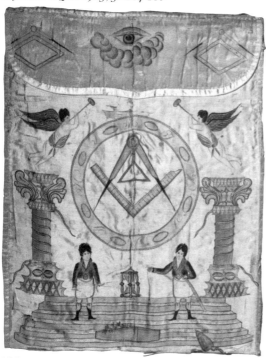

4.04
Mark Master Apron
Herkimer County, New York, c. 1800-1820
Painted silk
Special Acquisition Fund, 84.15
h: 18" w: 15"

Fraktur style apron with decoration attributed to a calligrapher working in the Palatine German settlements along the Mohawk River. The circular symbol of the

Mark Master Degree encloses the owner's personal mark of a delta suspended within the square and compasses. A similar apron (accession no. 76.22) was owned by Captain Conradt Edick (1763-1845) of Herkimer County, New York.

4.05
Master Mason's Apron
Wilkes-Barre, Pennsylvania, c. 1817
Painted silk
Special Acquisition Fund, 92.015
h: 16" w: 17"

Design adapted from a Grand Lodge of Pennsylvania membership certificate, which in turn was derived from an English certificate engraved by Thomas Harper in 1792. Above architectural columns surmounted by allegorical figures of Fortitude and Prudence, an angel bears a banner inscribed "Grand Lodge of Pennsylvania." The apron is edged in blue,

ILLUSTRATIONS:
4.04, LEFT
4.05, BOTTOM

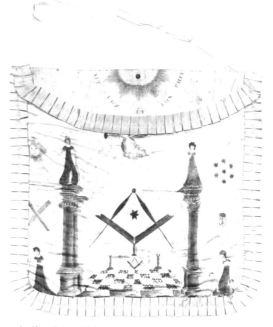

symbolic of the Third, or Master Mason's Degree. The apron belonged to William Franklin who was initiated into Lodge No. 61, Wilkes-Barre, in 1817. Five years later Samuel D. Bettle of Wilkes-Barre engraved a plate that printed aprons for Lodge No. 61. (accession no. 74.24).

4.06

Apron Pattern
J. Grice, artist
American, 19th century
Pencil on board
Special Acquisition Fund, 78.3
h: 12 ½" w: 15 ¼"

Composition for apron decoration composed of a
square and compasses entwined with a sprig of acacia,
resting on an altar between twin pillars. The pillars are
shown on a three-step dias flanked by a beehive and a
mound of mortar with a trowel. The mortar and trowel
allude to the cement of brotherly love that binds all
Freemasons together. This composition was illustrated
in Allyn's *A Ritual of Freemasonry* (Philadelphia, 1831).

4.07

Mark Master's Apron
American, c. 1820
Ink on silk
Special Acquisition Fund, 91.054
h: 16 ½" w: 16 ½"

Hand-drawn apron with blue silk edging and all-seeing
eye on the flap. The decoration is composed of two an-
gels whose extended wingtips support a keystone
inscribed with the mnemonic of the Mark Master De-
gree. Craft symbols are combined with symbols
representing the working tools of the Mark Master De-
gree (mallet and stonemason's indenting chisel) and of
the Royal Arch Degree (crow-bar, pick-axe and
shovel). The pedestal supporting the figure on the
right shows the jewel of a Treasurer of a Royal Arch
Chapter. The remaining pedestal shows the jewel of a
Senior Warden. This unidentified artist has naively

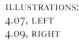

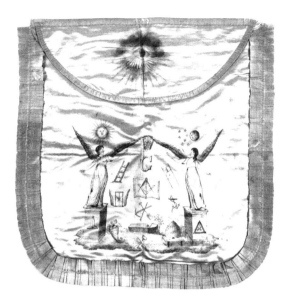

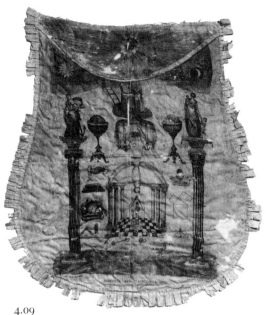

4.09

Master Mason's Apron
Jervis Cutler (1768-1846), engraver
Nashville, Tennessee, c. 1823
Engraving on silk
Special Acquisition Fund, 89.61
h: 16" w: 15"

copied design elements from apron and certificate designs engraved by Amos Doolittle.

4.08 SEE ILLUSTRATION ON PAGE 108
Master Mason's Apron
Possibly Maine, c. 1815-1820
Ink and watercolor on silk
Gift in memory of Starr H. Fiske, 85.6.1
h: 18" w: 14 ½"

Hand-drawn and painted apron with blue silk edging. A blazing star is shown in the center of a tresselated mosaic pavement flanked by twin pillars. A winding staircase, symbolic of the Fellow-craft Degree, leads from the pavement through one arched portico to another. The porticos represent the outer and inner chambers of Solomon's temple. Above the arch is an arc of roses.

The design is closely copied from an engraved "Master Mason's Apron or Flooring" that was copyrighted in 1814 by Edward Horsman of Boston. This apron is similar to another in the collection that has a red silk edging (Accession # 83.13.1). Several other aprons of this design and workmanship exist in Maine collections, They have been attributed to artist Charles Codman (1800-1842) who worked in Portland during the 1830s.

Engraved apron titled "Master's Apron Complete." The design depicts the figure of a Master who stands in a lodge and holds a trowel in one hand and a gavel in the other. Two flanking columns are surmounted by allegorical figures representing Hope and Charity. At the top of the design is the Biblical figure of Jacob and his vision of a ladder with the foot resting on the earth and the top reaching to heaven. The bottom imprint reads "engraved by Br. Jervis Cutler, Nashville, dedicated to the Lodges in Tennessee."

In 1825, Lafayette, the American Revolutionary War hero, visited Louisiana and from there travelled up the Mississippi River from New Orleans to Nashville. He was accompanied by Isaac Erwin, a Louisiana planter and owner of Melrose Plantation. On their arrival in Nashville a Masonic ceremony was held in which both participated. At the conclusion of the ceremonies, Erwin informed Lafayette that Mrs. Erwin was pregnant and if a boy was born they would surely name him Lafayette. The general divested himself of the apron, stating, "here, give him this in memory of me and perhaps it will serve to recall my visit."

Cutler is believed to have derived portions of this design from an apron design engraved by Thomas Kensett of Cheshire, Connecticut about 1812 (Acc.# 85.76.1).

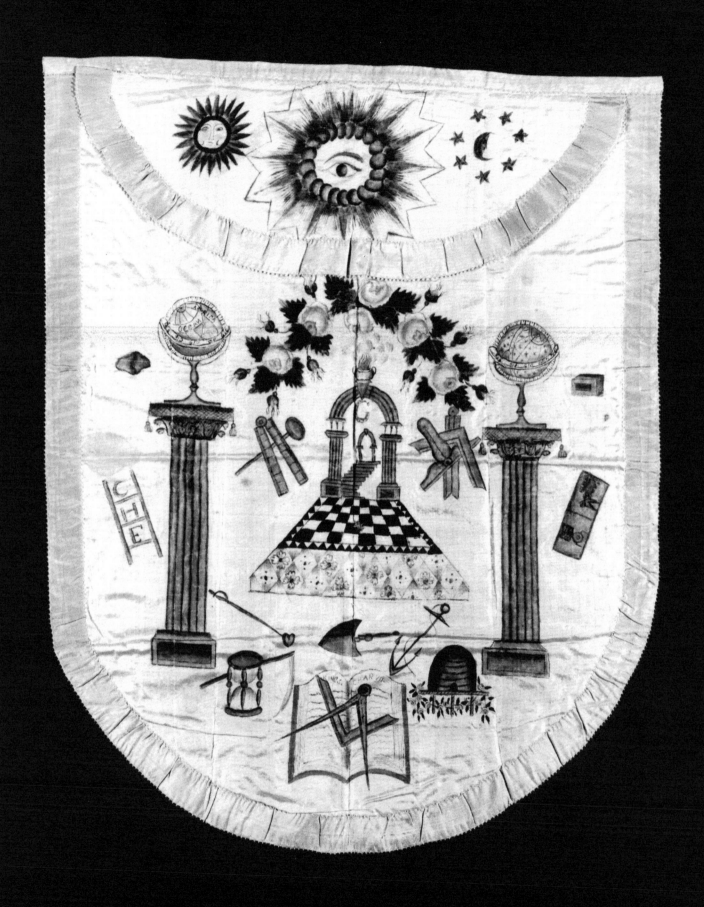

Master Mason's Apron

Nathaniel Lakeman (b.1756), artist
Salem, Massachusetts, c. 1825
Painted silk and gold leaf
Special Acquisition Fund, 94.002.1
h: 14 ¾" w: 14 ¼"

Craft apron with ruffled blue silk edging. The design is painted in sizing and then gold-leafed with the details added using an umber glaze. An Ionic and a Corinthian column flank a three-step mosaic pavement above which is shown an open Bible and the square and compasses enclosing the letter "G." A radiant all-seeing eye is painted on the flap. The reverse bears a printed paper label inscribed "Painted by Lakeman & (lined through), Corner of Essex and Washington streets, Salem, Mass." and an ink inscription "Charles Peabody."

Charles Peabody was Collector of Taxes for the town of Middleton, Massachusetts and owner of the apron. He was raised in Jordan Lodge, Peabody, Massachusetts in 1825. The artist Nathaniel Lakeman worked as a portrait painter in Salem, and had his paintings exhibited at the Boston Athenaeum in 1830.

Franklin Opening the Lodge

Kurz and Allison, lithographers
Chicago, 1896
Lithograph
Special Acquisition Fund, 81.56
h: 28" w: 22"

Benjamin Franklin (1706-1790) was raised in St. John's Lodge, Philadelphia in 1731 and elected Grand Master of the Grand Lodge of Pennsylvania in 1734. During his lifetime, he was accorded the highest Masonic honors at home and abroad.

4.12

Milliner's Model

American, c. 1830
Papier mache, kidskin, linen
Special Acquisition Fund, 86.14
h: 8" w: 3"

Miniature manikin dressed in black frock coat, Masonic apron and sash. The figure was probably intended as a milliner's commercial advertising model.

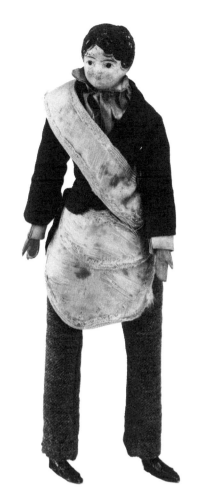

Mr. J. Hull - Mrs. M. Hull

New York or Connecticut, c. 1800
Watercolor on paper
Special Acquisition Fund, 78.47
h: 5 ⅜" w: 8 ¼"

Double portrait of a Freemason and his wife. The man is shown dressed in Masonic regalia wearing a silver Royal Arch medal, the sash of a Master, and an apron whose design was engraved by Abner Reed of East Windsor, Connecticut in 1800.

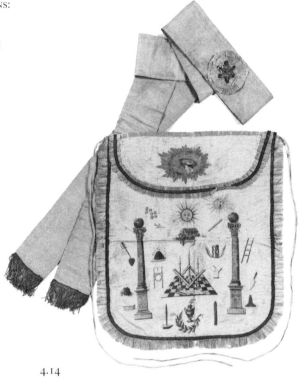

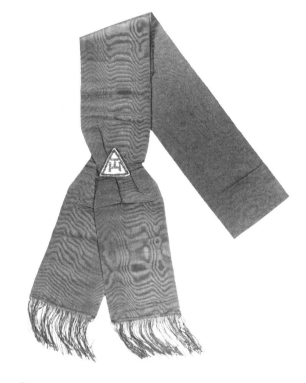

4.14

Master Mason's Apron and Sash
Massachusetts, c. 1800-1805
Engraving on silk, watercolor, and gold leaf
Gift of John F. Snow, 86.34.2
h: 17" w: 15"

Apron and sash owned by Jonathan Cook (1780-1862)
of Provincetown, Massachusetts. Bro. Cook was a
member of King Hiram Lodge, Provincetown, and
served as the second Master of that lodge from 1800 to
1805.

4.15

Royal Arch Sash
American, c. 1820
Silk taffeta
Supreme Council Archives
length: 36" w: 5"

In American Royal Arch ritual the sash is a solid crim-
son color worn over the right shoulder. The English
form of Royal Arch sash is crimson with a purple in-
dented border (dogtooth pattern) worn over the left
shoulder; the ends of the sash are joined by an insignia
consisting of a triple *Tau* within a triangle.

4.16

Royal Arch Apron
New York State, c. 1802-1810
Leather, silk, and gold leaf
Special Acquisition Fund, 87.12
h: 16" w: 15"

Crimson-edged apron decorated with a luminous equi-
lateral triangle, symbol of the Tetragrammaton or
four-letter Hebrew name for the Lord God Jehovah
[JHVH]. It was owned by Silvanus Smith of

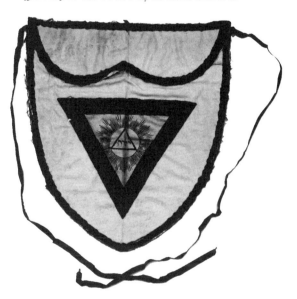

Hempstead, Queens County, Long Island. Smith was initiated in Morton Lodge No. 63, A.Y.M. (Ancient York Masons), Hempstead in 1802. (See Archives 87-37). The Tetragrammaton is used as a symbol in Royal Arch, Cryptic, Council, and Scottish Rite degrees. *Reference: Coil 1961.*

4.17 SEE COLOR PLATE, PAGE 268

Royal Arch Apron
A. L. Shaw, artist
Buffalo, New York, c. 1825
Painted leather and gold leaf
On loan courtesy the Masonic Temple Association,
Jackson, Michigan
h: 17" w: 18"

Crimson-edged apron with hand-painted floral border and circular symbol of the Mark Master Degree. Within the circle is shown the owner's personal mark, consisting of a representation of Noah's ark. The apron is inscribed "A.L. Shaw Pinxit, Buffalo" under the flap. A number of similar aprons are known; each has a common circular design of alternating stars and working tools. An Asa L. Shaw was a member of Union Lodge No. 261 in Livingston County, New York in 1830.

4.18 SEE COLOR PLATE, PAGE 270

"Benjamin Coffin"
Massachusetts, c. 1833
Watercolor on paper
Special Acquisition Fund, 77.12
h; 4 ⁷⁄₈" w: 3 ⁷⁄₈"

Portrait of a gentleman wearing the regalia sash, sword, and apron of a Masonic Knights Templar. The apron is trimmed in black and the sash is decorated with symbols of a Templar cross, skull and cross-bones, and a dirk. A small Templar cross is also pinned to the front of his shirt. The reverse is inscribed "Portrait of Mr. Benjamin Coffin, A Mason," and dated 1833. Benjamin Coffin was a member of St. Peter's Lodge, Newburyport, Massachusetts.

4.19 SEE COLOR PLATE, PAGE 269 TOP

Royal Arch Apron
American, dated 1837
Watercolor on silk
Gift of John J. Keefe, 87.14.13
h: 20" w: 18"

Apron design featuring a Royal Arch enclosing symbols specifically associated with Royal Arch Degrees including the keystone (Mark Master, or Fourth Degree), Ark of the Covenant and the Substitute Ark (Select Master, or Ninth Degree), and a hand holding a plum-

met (Past Master, or Fifth Degree). The edging is trimmed in crimson and the flap bears the symbol of the triple *Tau*. Beneath the flap is the owner's name "Adam W. Smith" and the date 1837.

The *Tau* Cross, or Cross of St. Anthony, forms an arrangement of three "T"s, (the Greek letter *Tau*) joined at their bases known as the triple *Tau*. When enclosed in the center of a triangle and circle it is the insignia of the Royal Arch Degree, and has been called the "grand emblem of Royal Arch Masonry." It was generally recognized as the badge of Royal Arch Masons prior to 1859, but was only then officially adopted by the General Grand Chapter of the United States.

4.20 SEE COLOR PLATE, PAGE 246, BOTTOM

Apron Casket
Japan, c. 1830
Lacquerware
Special Acquisition Fund 78.20.2
h: 4" w; 13" d: 7"

Red lacquered storage box for a Masonic apron. The design on the lid was copied from the frontispiece to *Jachin & Boaz* (London, 1776).

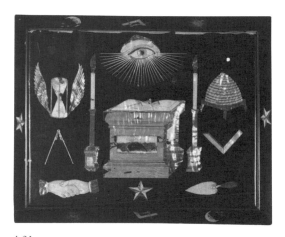

4.21
Apron Casket
Japan, c. 1830
Lacquerware, nacre
Special Acquisition Fund 74.1.1
h: 5" w: 17" d: 13"

Black lacquered apron storage box. The lid is inlaid with Masonic emblems in nacre or mother-of-pearl. The inventory of George Washington's personal estate, taken at the time of his death in 1799, included "1 Japan box containing a masons apron."

ILLUSTRATIONS:
4.22, LEFT
4.23, RIGHT
4.24, BOTTOM
4.11, FACING

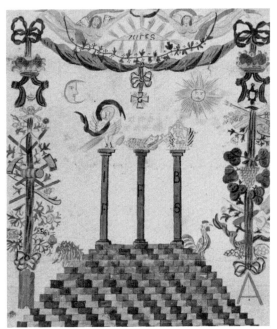

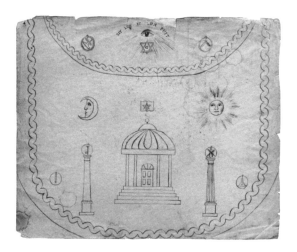

4.22

Apron Pattern
New York State, c. 1800
Watercolor on paper
Special Acquisition Fund, 80.13
h: 19" w: 14"

French-inspired pattern for a Scottish Rite apron. The image is derived from similar apron and certificate designs created by Thomas Bluget de Valdenuit, a French artist active in New York City from 1795 to 1797. The three central pillars are surmounted by symbols associated with degrees in the Scottish Rite: a pelican feeding its young, the Paschal Lamb, and a Rosy Cross [*Rose Croix*]. The flap decoration includes cherubim and a luminous delta inscribed with the Tetragrammaton.

4.23

Apron Pattern
Massachusetts, c. 1810
Ink on paper
Special Acquisition Fund, 89.32
h: 22" w: 28"

Apron design identified as "pattern of Free Masons Apron." Masonic working tools of a square, plumb, level, key, and crossed quill pens are shown suspended within circles in the manner of insignia worn by the officers of a lodge. An inscription on the reverse indicates that copies were made for Thomas Haynes, Thomas Darsching, and William Farmer.

4.24

William McKinley
Dominique C. Fabronius, artist
Joseph Deutsch, publisher
Chicago, 1901
Lithograph
Gift of Paul D. Fisher, 89.58
h: 39" w: 30"

William McKinley (1843-1901), twenty-fifth President of the United States, was initiated in Hiram Lodge No. 21, Winchester, Virginia. Bro. McKinley was active in Royal Arch and Knights Templar Masonry. President

FRANKLIN OPENING THE LODGE.

McKinley was assassinated in 1901 and received an immense Masonic funeral. Bro. McKinley is shown wearing a plain Masonic apron of the type often interred with deceased brethren.

4.25
Regalia Catalog
M.C. Lilley & Company
Columbus, Ohio, c. 1894
Library collection (MM011)
h: 9" w: 6"

Illustrated catalog and price list for Royal Arch Chapter and Council regalia and paraphernalia. The company was founded in 1865 by Mitchell C. Lilley (1819-1897).

4.26
Sir Knight
Snyder, Black and Stern, lithographers
New York, 1860
Lithograph
Library M17.9775 N567

Portrait of John W. Simons, Right Eminent Past Grand Master of the Grand Encampment of Knights Templar,

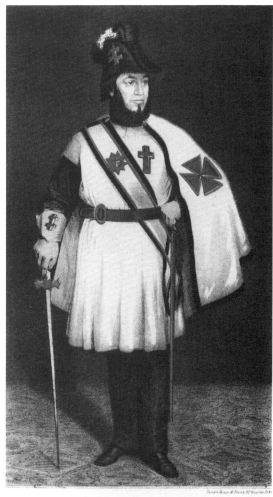

SIR KNIGHT.

state of New York. Grand Master Simons is shown wearing the regulation "white" Templar costume of 1856 that prescribed the wearing of a surcoat and cape.

4.27
The Centennial-Knights Templar Parade in Philadelphia
Theodore R. Davis (1840-1894), artist
Harper's Weekly, June 24, 1876
Wood engraving
Gift of F. Raymond Heuge, 75.22
h: 10 ¾" w: 15 ½"

Magazine illustration of Knights Templars parading on Chestnut St. in Philadelphia during the Centennial Exposition of 1876. The hour-long parade filed past the Masonic Temple. The presence of mounted Templar units was noted by the artist.

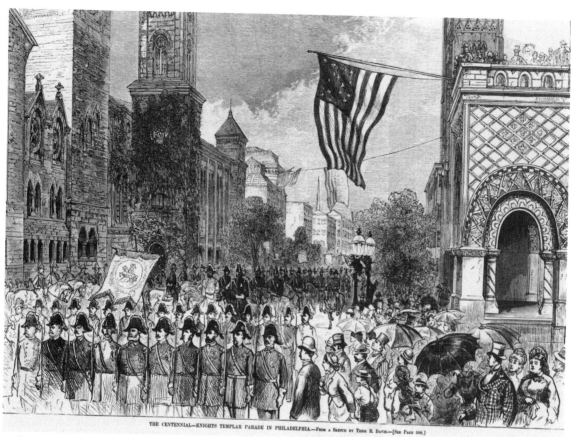

THE CENTENNIAL—KNIGHTS TEMPLAR PARADE IN PHILADELPHIA.—From a Sketch by Theo. R. Davis.—[See Page 506.]

4.28 SEE ILLUSTRATION ON PAGE 116

Grand Parade of the Knights Templar
H.S. Crocker & Company, lithographers
San Francisco, 1883
Lithograph
Special Acquisition Fund, 85.21.3
h: 17 ¾" w: 23 ½"

Scene of Knights Templars parading during their
twenty-second national triennial conclave held at San
Francisco in 1883. The size of the spectator crowd was
not exaggerated. Late 19th century Templar conclave
parades attracted huge crowds.

4.29 SEE COLOR PLATE, PAGE 271

Knight Templar
A. Edmonds, artist
New York, 1893
Oil on canvas
Gift of Walter C. Kimic, 80.58
h: 55" w: 35"

Portrait of an unidentified Knight Templar. Insignia
worn on his uniform indicate that this Sir Knight was
also a member of the Scottish Rite and the Ancient
Arabic Order Nobles of the Mystic Shrine.

4.30 SEE ILLUSTRATION ON PAGE 117

Degree Costume
Louis E. Stilz & Brothers Company
Philadelphia, Pennsylvania, c. 1915
Gift of the Estate of Gerard Dallas Jencks, 90.5

Cloth armor costume worn by a member of a Knights
of Malta degree team during initiation ceremonies. Sil-
vered lame fabric was used to simulate chain mail. The
character portrayed would have been a guardsman.

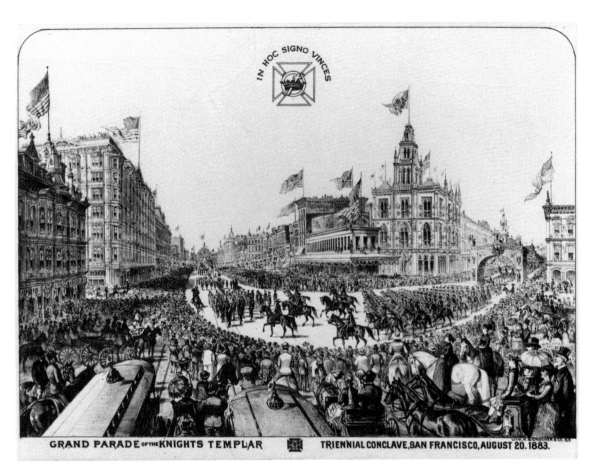

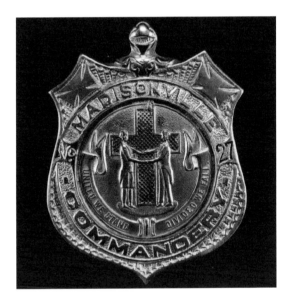

4.31
Belt Plate
c. 1890
Nickel-plated brass
Gift of Jacques N. Jacobsen, Jr., 89.46.17
h: 3" w: 2"

Customized Knights Templar sword belt plate made
for the members of Madisonville Commandery No. 27,
Madisonville, Kentucky. The plate design and motto
"United We Stand, Divided We Fall" is derived from
the Great Seal of the State of Kentucky.

4.32
Belt Plate
Pettibone Brothers Manufacturing Company
Cincinnati, Ohio, c. 1890
Enamelled brass
Gift of Jacques N. Jacobsen, Jr., 86.46.40
h: 3" w: 3"

Customized belt plate made for members of Empire
Commandery No. 66, Staten Island, New York.

4.33
Belt Plate
c. 1890
Nickel-plated brass
Gift of Jacques N. Jacobsen, Jr., 89.46.65
h: 3" w: 3"

Belt plate made for Red Jacket Commandery No. 81,
Canandaigua, New York. Plate design is derived from
the Robert W. Weir portrait of Seneca Indian leader
Red Jacket [Sagoyewatha] (1751-1830).

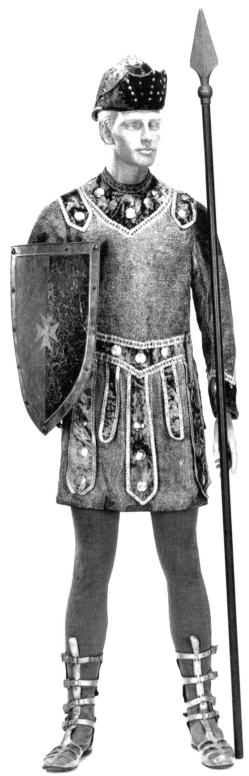

4.34
Jerkin
c. 1930
Leather
Gift of Floyd C. Popp, SC84.10

Sleeveless tan leather jacket decorated with pseudo ar-
morial device, gilt rondels, and glass jewels. This
costume jacket was worn during the exemplification of
various Scottish Rite degrees in Syracuse, New York.

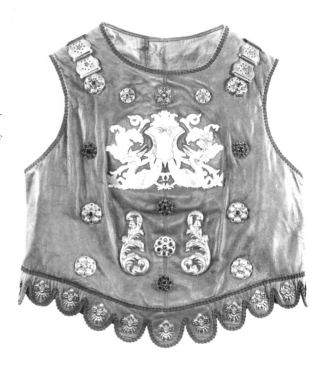

4.35
Costume Helmets
Louis E. Stilz & Brothers Company
Philadelphia, Pennsylvania, c. 1915
Pasteboard, tin, leather
Gift of the Estate of Gerard Dallas Jencks, 90.5

Regalia manufacturers produced a wide variety of
visored and unvisored helmets with spiked ornaments
and plumes, and bodies of cloth-covered gossamer,
nickel-plated spun brass, or leather.

4.36
Spears and Axes
Louis E. Stilz & Brothers Company
Philadelphia, Pennsylvania, c. 1915
Tin, brass, steel
Gift of the Estate of Gerard Dallas Jencks, 90.5

Degree teams were provided with a variety of theatri-
cal props in the form of swords, polearms, and battle
axes that added detail to historical costumes. Many
non-functional forms of axes and spears were con-
structed of lightweight sheet metal.

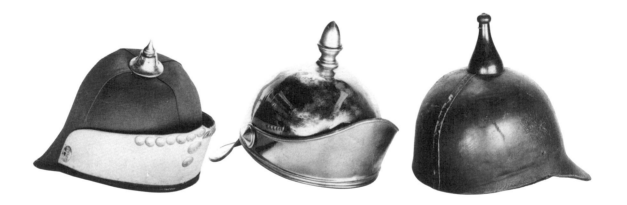

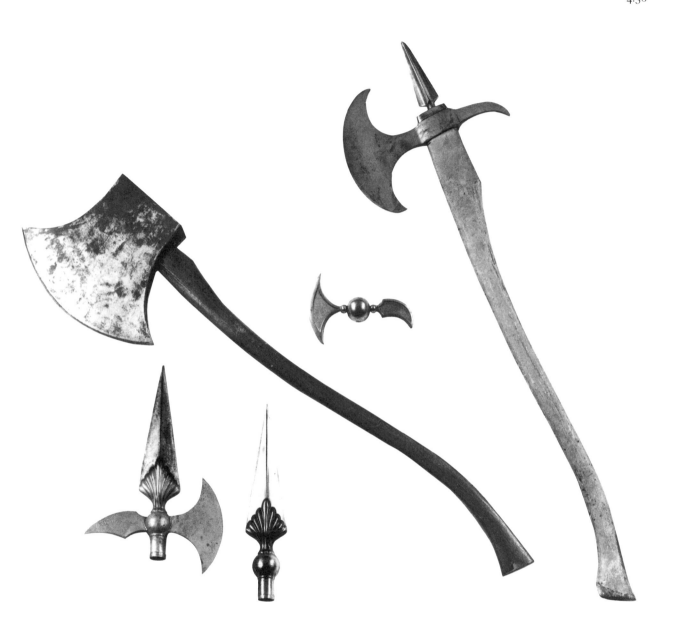

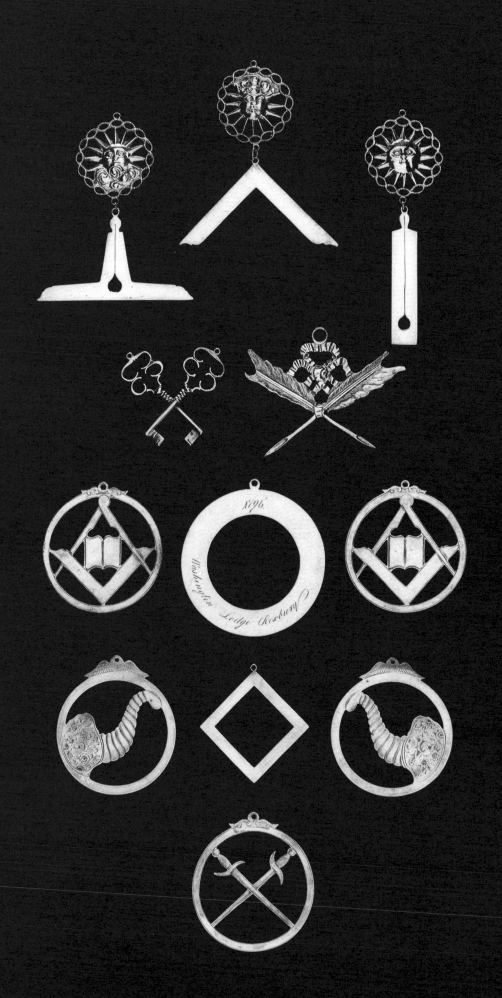

Jewels

 SPECIFIC BADGES OR "JEWELS" DESIGNATE THE PRIMARY EXECUTIVE OFFICERS of a Masonic lodge. They evolved from what has been termed the three "immovable jewels" of the lodge, which according to Masonic lore are the square, level, and plumb. These working tools of actual or operative stonemasons represent specific moral qualities assigned to the east, west, and south sides of the lodge room and to the personna of the three principal officers who preside from these locations; i.e., the Master in the east, the Senior Warden in the west, and the Junior Warden in the south.

ILLUSTRATION: 4.37, FACING SEE DESCRIPTION ON PAGE 134

With the establishment of modern philosophical or speculative Freemasonry in 1717, these working tools evolved into symbols of instruction used during rituals conducted in lodge meetings. The practice of wearing them as insignia of office was observed unofficially until 1727, when it was decreed in the minutes of the Grand Lodge of England that "the Master wear the Square, the Senr. Warden the Levell, and the Junr. Warden the Plumb rule."

By established convention, replicas of the tools were miniaturized and worn as insignia or jewels, suspended from the neck on a blue silk ribbon. Silver was used for these jewels because it was the coin (shekel) paid operative stonemasons for building King Solomon's Temple. In time other forms of jewels came to be adopted for administrative officials of the lodge. These insignia were chosen for their obvious functional association. Somewhat more esoteric insignia were adopted for other functionaries who nonetheless were indispensible to the smooth and efficient conduct of a well-regulated lodge.

Secretary. Crossed quill pens of a scribe denote the office of Secretary.

Treasurer. Crossed keys to a strongbox are assigned to the Treasurer.

Chaplain. The Chaplain's jewel passed from its 18th-century form as a "perfect circle" to become an opened Holy Bible.

Deacons. It is the task of the Senior and Junior Deacon to escort candidates and distinguished visitors into the lodge. The Senior Deacon uses as his insignia a radiant sun suspended within the square and compasses. The Junior Deacon is assigned a similar

device, but with a crescent moon substituted for the sun. Pennsylvania lodges became entirely "Ancient" in 1785 and followed the 18th-century English and Irish tradition of using the symbol of a dove carrying an olive branch to identify the Deacon. In the early decades of the 19th century the Deacon's symbol sometimes took the form of a plain equilateral triangle.

Marshal. Escorted by the Deacons, visiting dignataries are conducted in procession by the Marshal, whose baton of office is also his jewel. Like the Chaplain's jewel, the Marshal's has changed in form since the 18th century, when it was a square worn suspended diagonally enclosing a baton.

Tyler. The Tyler stands guard with a drawn sword outside the doors to the lodge meeting room to control entrance and prevent evesdroping. A single sword with naked blade has been used as the jewel of his lonely office. A similar device, but consisting of a pair of crossed swords, is used by the Master of Ceremonies.

Stewards. Stewards, usually two in number, are responsible for providing a collation for members of the lodge. Their insignia of overflowing cornucopia suggest tables laden with bountiful refreshment for the brethren.

Jewels of the Lodge were acquired when its charter was granted and the designated Master and the Wardens were installed in office. During the 18th and early 19th century, funds for purchasing silver jewels were often limited, and jewels for the other officers were often purchased later as funds became available. Thus, many early sets do not match, being comprised as they were from different sources at odd intervals. The records of Morning Star Lodge of Worcester, Massachusetts provide an example of this common occurance. In Morning Star's charter year of 1793 the brethren voted to purchase five jewels for the lodge at eighteen shillings each. At a subsequent meeting they finally voted to procure such other jewels "as might be necessary." The ledgers of silversmith Paul Revere reflect orders for sets of "five Masons jewels" (Machias Lodge [later Warren], 1784) as well as odd jewels for the Treasurer and two Stewards of Tryian Lodge, Gloucester, which were purchased in 1772.

In as much as a functional set of jewels was required to install officers of a newly chartered lodge, several expediencies might be resorted to in order to obtain a set. On such an occasion in the history of Lodge of Amity No. 5, Zanesville, Ohio, General Rufus Putnam wrote to Colonel Ichabod Nye at Marietta on August 29, 1806: "...as these Breth-

ren are not yet furnished with any jewels, They request you will bring those of Union Lodge to be used on the occasion." Amity No. 5's problem was solved temporarily, but the paucity of silversmiths in the Ohio country necessitated returning east to obtain a complete set of jewels. The minutes of the Grand Lodge of Pennsylvania in Philadephia reveal how Amity No.5 solved this problem:

> "... forward them a set of the Jewels belonging to
> the Grand Lodge which have been received from Lodges
> which have ceased, but that if there shall not be
> any Jewells on hand, belonging to the Grand Lodge,
> that then the Grand Secretary be authorized to
> purchase a set for the said Lodge and forward them."

The actual jewels of the Lodge of Amity No.5 are struck with the mark of Philadelphia silversmith William Gethen (a.w. 1797-1808).

As has already been pointed out, the jewels of a lodge were normally of silver, but in a temporary emergency situation, it was the symbolism that mattered most, not the material. George A. Baker, Grand Secretary of the Grand Lodge of Pennsylvania, wrote in 1806 that "I have known lodges to use Jewels cut out of Pastboard until they were provided with their Jewels." If a lodge was fortunate to have a silversmith among its candidates for initiation, it was not unheard of that his initiation fee was waived in lieu of a set of jewels. Junius Lodge No. 291 of Waterloo, New York received its set of jewels in 1819 from silversmith Caleb Fairchild under just such circumstances.

Jewels used by Grand Lodges and Royal Arch Grand Chapters are invariably distinguished from those of their subordinate bodies by being enclosed within a wreath or ring.

The Past Master — Actual and Virtual
Confusion arises over dual use in Freemasonry of the term Past Master. An actual Past Master is a brother Master Mason who having "passed the chairs" (served as Junior Warden and Senior Warden in succession), is elected and installed as the bona-fide Master of his lodge. In having served his scheduled term in that office, he steps down and makes way for his successor, becoming a ex-officer of the lodge.

A virtual Past Master is a conferred degree that follows the Mark Master Degree. It is one of the four Royal Arch degrees in the York Rite. The degree, known as the "Chair," or Installed Master's Degree, originated in England in 1768 as what was then considered a scandalous subtrafuge to "pass the chairs" in order to meet requsite qualifications for advancement to the Holy Royal Arch Degree.

There were many Masonic brethren who because of their professions (mariners in particular), could never regularly attend lodge often enough to attain the Master's chair by normal process. Therefore, to be eligible to attain the Holy Royal Arch Degree, a Master Mason who had never actually presided over a regular lodge was (and still is) temporarily made Master of a specially constituted "Emergent Lodge." The symbol of a hand holding a balance scale was used to represent an Emergent Lodge of Past Masters. The hand-held balance scale is often depicted on early Royal Arch medals. The artificial installation ceremony of "passing the chair" to a successor formed the essence of the degree. By 1812 the expediency of the procedure had become sanctioned in America by dispensation from Royal Arch Grand Chapters that arose in each Masonic jurisdiction.

The Past Master's Jewel — Origins
In 18th-century Scottish lodges the jewel of the Past Master was formed of compasses extended to sixty degrees, imposed on a square enclosing a sun in splendor, resting on a quadrant or scaled arc of ninety degrees. In Irish lodges at that time, its form was altered to that of a square and compasses with a letter "G" replacing the radiant sun, but without the quadrant. The English form of this jewel was a square with a pendant diagram of Euclid's 47th mathematical proposition. The unbalanced asymmetric form, with its oblong plate depicting the 47th Proposition suspended square within the angle of the square, was referred to with grim humor as a "gallows" style and was in vogue before and after the Grand Union of the "Ancient" and "Moderns" factions in 1813. The current English version, first illustrated in the *Constitutions* of 1841, suspends the pendant drawing from a square hung from its apex, making the entire jewel hang in symetrical balance.

The American Past Master's jewel was basically derived from the pre-1813 Scottish form, but without the tri-square. The American jewel, consisting of radiant sun within compasses and quadrant, was in general use by the end of the 18th century, although adherence to the Scottish style lingered in Virginia and the Carolinas until about 1800. The form of the jewel has been subject to interpretation from one American Masonic jurisdiction to another. In particulars of design, the spread of the compass points seldom coincided with the sixty degrees originally prescribed by the Grand Lodge of Scotland. A span of eighty degrees was inscribed on the Past Master's jewel that belonged to George Washington (now in the Kenmore Association collection, Fredericksburg, Virginia). Other variations in the span have ranged from ninety to forty-five degrees, depending upon each jewel's proportions and the amount of artistic license taken by the maker. Some of the earliest illustrated sources of an American Past Master's jewel are to be found in the margin borders of lodge meeting notices engraved by Paul Revere in the late 1760s.

In serving a two-fold purpose as regalia and personal memento, Past Master's jewels

were occasionally purchased in groups either for reasons of economy or similarity of design. One would be presented to the retiring Master, and another to his successor. The jewel was normally engraved with the recipient's name, the name of his lodge, and the date or dates he presided as Master. These dates, and most others given in symbolic Masonry, are set down in terms of Anno Lucis (A.L.) or "Year of Light," a concept expressed in Genesis 1:3 that God's "word" created the light of the world, which marked the beginning of creation (4,000 b.c.). (See Appendix 3.)

Variant Past Master's Jewels

Some confusion may arise when confronted with a jewel of The Order of Modern Sols, otherwise known by their official title as The Royal Grand Modern Order of Jerusalem Sols. The jewel of the Sols was composed of the square and compasses with a blazing sun pendent within the compass arms. It is more than coincidental, however, that the Sols' "sun in splendour" is derived from the heraldric arms of the Distiller's Company of London. The Sols were founded in England by John Drawwater as a secret convivial society, which was in no respect Masonic affiliated, although various bodies of the Sols were formed in imitation of the Freemasons. Their motto, "Do justice, love mercy, and walk humbly before your God," proclaimed noble sentiments but, in fact, represented a fashionable and entertaining drinking society that was active in the 1780s and 1790s.

During the 18th century there was constant demand among the natives of North America for silver trinkets and brooches, which were supplied by their white trading partners. Of the several forms of brooch favored by the Iroquois and other tribes, the Masonic "council fire" design remained very popular. Derived from the shape of the Past Master's jewel, this fretwork brooch was pyramidal in outline and had a curved base. To the Indians it resembled the stacked logs of a council fire. They had probably observed it being worn in its original form by British officers, important citizens, and traders. Although the jewel evolved into a more abstract design at the hands of silversmiths catering to the fur trade, actual Past Master's jewels have been unearthed from early Iroquois burials.

Sir William Johnson (1715-1774), British Superintendent of Indian Affairs, was also charter Master of St. Patrick's Lodge No. 8, when it opened in his residence at Johnson Hall, New York in 1766. While on a visit to London early in 1776, Johnson's protegé and chief sachem of the Mohawks, Joseph Brant (1742-1807), was raised in Hiram's Cliftonian Lodge No. 417. In 1798, Brant served as charter Master of Lodge No. 11, at Mowhawk Village (Brantford), Ontario. The respect that Johnson and Brant enjoyed among the tribes of the Iroquois confederation fueled a common desire to possess Masonic "council fire" brooches.[1]

Craft Medals

In the 18th century a profusion of medals illustrating the symbols of Freemasonry were made for the personal use of Masonic brethren. They were not worn as symbols of office but as badges that proclaimed their owner's Masonic affiliation. The medals might well be regarded as miniature tracing boards or carpets, upon which the principal symbols associated with Craft Masonry (the first three Degrees in Freemasonry: Entered Apprentice, Fellow-Craft, and Master Mason) were displayed. An early edition of the exposé *Jachin & Boaz, or An Authentic Key to the Door of Free Masonry* (London, 1776) contained an illustrated frontispiece that first depicted these symbols tidily arranged on a medallion, in imitation of those medals. (see 4.46) The illustration, originally drawn by James Baynes (1766-1837) and engraved by Isaac Taylor (1730-1807), continued to be offered in subsequent editions published as late as 1857. The accompanying "Description of the Regalia, &c." provided additional particulars of the medal:

> These medals are usually of silver, and some have
> them highly finished and ornamented, so as to be worth
> ten or twenty guineas. They are suspended round the neck
> with ribbons of various colours, and worn on their public
> days of meeting, at funeral processions, & c. in honour
> of the craft. On the reverse of these medals it is usual
> to put the owners coat of arms, or cypher, or any other
> device that the owner fancies, and some even add to the
> emblems other fancy things that bear some analogy to
> Masonry.

Craft medals were produced in three forms: plate, fret, and relief. Plate medals were usually oval in shape, engraved with the owner's name, the date of his initiation (being made a Master Mason), and a medley of Craft symbols. With care, the background between the symbols might be cut away, leaving a fretwork design that could be elaborately ornamented with engraved arabesques and scrollwork. More costly versions were rendered in relief, providing a base upon which to mount paste "brilliants" or gemstones. The simple plate medal had an appealing economy that was most appreciated in America, while the other two forms enjoyed greater popularity in Great Britain and Europe.

Numerous editions of *Jachin & Boaz* ensured that a design pattern remained accessible to American silversmiths and engravers who provided these medals to local Masons. A rearrangment of Bynes's original design was introduced in 1819 by engraver Amos Doolittle (1754-1832) as an illustrated frontispiece to ritualist Jeremy Cross's *Masonic Chart*

(New Haven, 1819). Doolittle's design, titled a "Masters Carpet," provided a significant pattern deviation that included the letter "G" placed prominently between the pillars Jachin and Boaz (1 Kings 7:15-22).

"Ancients" and "Moderns"

In 1738 a schism began to widen among English Freemasons over changes advocated and observed in Masonic ritual and ceremony, particularly the exclusion of the Royal Arch from Craft lodge ceremonies. In 1751 a group of Masons who had never affiliated with the Grand Lodge of 1717 were joined by a number of Irish and Scottish Masons in forming the Grand Lodge of Ancient Free and Accepted Masons. Arch-traditionalists, these "Ancients" dubbed the advocates of change as "Moderns," and charged them with departing from the "ancient landmarks" of Freemasonry, instituting changes in the installation ceremonies, and altering portions of certain rituals.

In a trend to veer away from ritual symbolism evolved from architectural elements, the Moderns did not regard the Royal Arch Rite as a recognized degree. The Ancients, on the other hand, adhered to the belief that the Royal Arch Rite held the basic tenets of Craft Masonry, confirmed by the ancient operative masons, and so decreed it the Fourth Degree of Craft Masonry. In this and many other areas of doctrine, the Ancients, sponsored by the Duke of Athol (and thus referred to as Athol Masons), found themselves more closely allied to the Irish and Scottish Grand Lodges in observing the Royal Arch Degree than with their fellow-English Moderns lodges. The earliest record of the Royal Arch having been conferred in America is found in the minutes of Fredericksburg Lodge, Fredericksburg, Virginia in 1753.

As early as 1732 the Premier Grand Lodge of England adopted the heraldric arms of the operative stonemasons which are emblazoned as "Sable on a Chevron between three Castles argent, a pair of compasses extended chevronwise."[2] The operative mason's armorial crest was a "naked arm dexter, embowed, couped above the elbow, holding a trowel" and the motto: *Amor Honor Et Justitia* (Love, Honor, and Justice). The speculative Freemasons retained the arms but changed the crest to a martin on a knight's helm. Arms, mottos, and crests all appear on Craft medals. About 1760 the Ancients appropriated their own heraldric arms with an armorial crest consisting of the Holy Ark of the Covenant guarded by cherubim supporters (wings extended), and the motto, *Kodes La Adonai* (Holiness to the Lord). Their arms are emblazoned as "quarterly per squares, countercharged vert; 1st Qr., azure, a Lion rampant, or; 2nd, or, an Ox passant, sable; 3rd, or, a Man with hands uplifted proper, robed in crimson and ermine; 4th, azure, an Eagle displayed, or."

By the 1770s tolerance between the two factions had deteriorated to such an extent that outright animosity emerged between them, on both sides of the Atlantic. Feelings

ran so high that a Master Mason "made" in an Ancients lodge had to be "remade" or "healed" prior to being admitted into a lodge of Moderns. Normally, a visiting Master Mason need only have established his bona fides in order to gain admission to any lodge of Master Masons, anywhere in the world. It was at this point during the height of the schism that Ancients Craft medals acquired a decidedly Royal Arch aspect, with one side reserved for that architectural symbolism specifically associated with these degrees. The two pillars normally supporting celestial and terrestrial globes of Craft Masonry now appear without the globes, but joined together by a masonry arch having a keystone placed prominently in the center.

In 1809 the disruptive effects of the schism were acknowledged and efforts were begun in England to effect a reconciliation. The healing process between the two factions was finalized and cemented by the Act of Grand Union, solemnized on November 25, 1813. The new arms of the United Grand Lodge were formed by impaling the arms of the Moderns on the dexter side, with those of the Ancients on the sinister. The crest and supporters used were those of the Ancients and the motto — *Audi, Vide, Tace* (Hear, See, Be Silent) — was adopted.

By 1780 certain geographic divisions between the two factions had become manifest in American Masonic lodges. Some states such as South Carolina had two Grand Lodges, one governing each faction. The Ancients reached a point of almost complete domination in Pennsylvania and Delaware. Rhode Island, on the other hand, gave itself over completely to the Moderns, who also predominated in Connecticut and North Carolina. Elsewhere, there was an even distribution of Ancient (A.Y.M.) and Modern (F.& A.M.) lodges. In the Federal period the original issues of the schism lost importance as they became submerged in a rapid growth in Masonic membership and general chartering of many new lodges.

The Mark Master Medal
The degree of Mark Master is one of the oldest of the "appended" Masonic degrees; its origins are perhaps the most confused. Historically, the degree was in existence in England by 1769, but, despite its long-standing practice in English lodges and its popularity among the "Ancients," the Mark Master Degree enjoyed no separate official status with the Premier Grand Lodge of England, only a sort of quasi-sanction. It was not until 1856 that a joint committee, set up by the Grand Chapter and the Grand Lodge, decreed that the Mark Degree "...is not essential to Craft Masonry," but that it "is not at variance with the Ancient Land Marks of the Order, and that the degree shall be an addition to, and form part of the Fellow Craft degree, and may consequently be conferred by all regular warranted lodges." Thus, official acceptance in England required nearly a century of agitation; the case, however, was different in America.

In the second half of the 18th century, American Masons received the Royal Arch Degree in Craft or symbolic lodges. The earliest record of Royal Arch proceedings is found in Fredericksburg Lodge of Virginia, dating from December 22, 1753, but without specific reference to the Mark Degree. The oldest American record of actually conferring a Mark Master Degree, and formation of a Mark Lodge, was found by Masonic historian Harold V.B. Vorhis in the Minute Book of St. John's Lodge No. 2, Middletown, Connecticut. The lodge Secretary's minutes state that on September 13, 1783, each of the founders of the Mark Lodge had been "...made a Mark Master Mason and duly initiated in this Sublime fourth Degree in a Regular Constituted Mark Lodge...four Brothers were duly initiated immediately thereafter."

This evidence from the records of St. John's Lodge No. 2 would indicate that (1) Mark Lodges had been formed in America prior to 1783 and reference to the Mark Degree as the "fourth degree of Masonry" was a result of actual practice within Craft lodges, or (2) the Mark Degree had been conferred while in England.

Formal acceptance and accommodation of the Mark Degree within the American Masonic system occurred in 1795, when a committee within the General Grand Chapter of Royal Arch Masons for the Northern States of America, comprised of noted Masonic ritualists, met and consolidated what were termed the "Chapter degrees." In so doing, they created the Mark Master Degree, fourth in order, and prerequisite to the Past Master (Fifth), Most Excellent Master (Sixth), and Royal Arch Degree (Seventh). The formalized degrees were published in 1797.[3] As the Mark Degree enjoyed increased popularity in the post-Revolutionary War years, Mark Lodges per se were gradually eliminated from the Masonic scene, disappearing nearly altogether by 1830.[4]

Prior to 1797 the Mark Degree was generally conferred in Craft Lodges empowered for that purpose. After 1800 and the formal structuring of Royal Arch degrees, Mark Lodges were absorbed by self-constituted Royal Arch Chapters, which were gradually brought under the control of Grand Chapters. The Mark Lodges were required to surrender their warrants whenever a Royal Arch Chapter was locally established. In New York State no Mark Lodges were constituted after 1819, but in North Carolina the Mark Lodges continued to be independently sanctioned by the Grand Lodge, remaining so until the mid-1820s.

The infant American Royal Arch chapter system operated in a chaotic state under sanction of the individual A.F. & A.M. Grand Lodges. In 1797 a representative committee of New England Chapters met at Boston to draft a circular calling for a convention to form a supreme Grand Chapter. As a result, representatives of the Grand Chapters for Massachusetts, New Hampshire, Connecticut, Rhode Island, Vermont, and New York met at Hartford (January 24, 1798) to establish a Grand Royal Arch Chapter for the northern states.

In 1806 the title was changed to General Grand Chapter of Royal Arch Masons for the United States of America, reflecting an extension of its territorial jurisdiction. From this body emanated nearly all of the state Grand Chapters, except those of recalcitrant Pennsylvania and Virginia.

Pennsylvania's chapters held their warrants from Grand Lodge which decreed that "Ancient Masonry consists of four degrees: Apprentice, Fellowcraft, Master, and Holy Royal Arch." Accordingly, every regular warranted lodge possessed the power of forming and holding lodges in each of those several degrees, the last of which was called a chapter. Therefore, each "Ancient" lodge in Pennsylvania's jurisdiction was in effect a Mark Lodge under jurisdiction of the Masonic Grand Lodge, and not the Grand Chapter. Definitive resolution of jurisdiction finally occured in 1825, when Pennsylvania voted to place Mark Lodges under the Grand Chapter.

Mark Medal

The Mark medal is a sacred token of the rites of friendship and brotherly love which are a solemn obligation of the Mark Master degree. The Mark medal may be pledged for a favor or act of friendship, but must be redeemed before it may be pledged again. Unlike lodge jewels, which were symbols of office, Mark medals were personal possessions retained by Masons and did not appear in American Masonic usage until about 1795.[5]

The Mark medal was worn suspended from the neck by a yellow ribbon, at one time the distinctive color of the Mark Degree. The medal was usually made of coin silver or silver plate, although rare examples of gilt copper and even gold are known. On one side was engraved a personal design, or "mark," that identified the owner. The individual's mark was placed within a circle of initials or mnemonic (H.T.W.S.S.T.K.S.) alluding to the ritual of the degree. English Mark medals of the early 19th century were commonly lozenge-shaped and made of steel or silver. The letters "HTWSSTKS" are located around their periphery. The reverse side bears the owner's name, the name of his Mark lodge, and the date of his exhaltation to the degree. This side might also bear general symbols associated with Royal Arch Masonry, or more specifically, the logo or seal of the lodge in which the owner was "marked." A Masonic alphabet cipher was occasionally used to include an initial or the owner's name, or a combination of initials having an esoteric signifance to him.[6]

Selection of a Mark

From time immemorial, craftsmen have selected a mark for themselves which they placed upon each piece of work they wrought. In Mark Master Lodges each Masonic craftsman is required to select for himself a mark, or personal symbol, which serves as an identifica-

tion for him and, symbolically, his character. This mark is what is engraved on one side of the Mark medal. American Grand Chapters imposed no restrictions on the selection of a mark design.

Traditionally, the mark was supposed to be one that could be produced with the working tools of a Mark Master, i.e., the chisel and the mallet. Masonic lore holds that with these implements the masons working on King Solomon's Temple carved an identifying mark upon their work, for which they received the traditional daily wage of one silver shekel. The traditional rule of "right angles, horizontals, and perpendiculars" was considered the most acceptable in making a regular "operative" mark.

Fanciful designs such as a "virgin weeping," or a "young lady seated in a chair in the attitude of reading," or the "five orders of architecture" would be difficult to carve on stone, yet such intricate designs were popular at the beginning of the 19th century.[7] While one may admire the artistic qualities of a miniature pen and ink rendering of "a Pilgrim in a boat, sailing down the river of time, with Hope at the helm, Charity as a Companion, and Christ as the goal to which his course is directed," such a mark was far from practical.[8] In as much as marks were not limited to Masonic devices, these allegorical scenes were as popular as the wide variety of tools that alluded to a member's profession. Nathan Cheever, a surgeon of New Hartford, New York, chose a hand holding a scalpel.

In Connecticut, for a brief period at the beginning of the 19th century, it was a general practice to record a "motto" along with a mark. Thus the "circle" as a mark might be accompanied by the word "Eternity" as a motto. "Two Hearts Entwined" was registered with the Latin tag "Una Cor, Una Vita" or others of similar scholarly origin.[9]

Registration of a Mark

Most American chapters have what is termed a "Mark Book" in which are recorded and preserved the mark designs chosen by its members (see 4.50). Once recorded, there is a mutual contract between the chapter and the member that his mark shall never be altered or changed or given to another within the chapter. The mark could, however, be transferred or sold with consent of the owner.[10] When a mark was no longer active, through the death of its owner, the design reverted to the public domain and could be reassigned.[11]

Early records might be used to reconstruct marks previously issued to deceased public figures. The Grand Chapter of Massachusetts has in its library an early Mark Book, commenced in 1793 by St. Andrews Chapter of Boston. In it are registered the marks of such distinguished Freemasons as General Joseph Warren, Paul Revere, and Benjamin Hurd, Junior. Warren, who died at the Battle of Bunker's Hill (June 17, 1775), would have had his mark registered posthumously. Hurd engraved the copperplate used to print the mark registration forms, which were then bound in book form. The first mark entered

belonged to John Jenkins (d. 1771); it shows a sheaf of wheat and is dated 1770. The second mark is annotated "previous to 1773."

Several regional design patterns have been distinguished among Mark medals made in New York. The earliest examples dating from 1795-1800 were engraved for members of Independent Royal Arch Lodge No. 2 in New York City. Their design utilizes a shield-shaped base that bears the name of the owner, lodge, date, and mark. Surmounting the shield is an openwork Masonic square and compasses. Examples produced in the Albany/Schenectady area from 1810 to 1825 have added an open Bible that fills the area behind the square and compasses.[12] (see 4.55)

Rarely did engravers sign their Mark medals, although one example engraved by Gideon Fairman (1774-1827) provides a key to the evolution of Mark medal design in upstate New York. It was made for Oliver Ruggles of Hiram Mark Lodge No. 1 of Newtown, Connecticut in 1796 and is marked "Bro. Fairman Sculpt."[13] Born in Newtown, young Fairman was encouraged to take up engraving by itinerant English engraver Richard Brunton. Fairman subsequently apprenticed to Isaac and George Hutton of Albany and then started his own engraving business there in 1796, moving to Philadelphia in 1810. Fairman's contribution to mark medal design introduced the use of the winged cherub's head motif that he probably borrowed from similar designs found carved on the heads of tombstones. A triple-lobed pendant at the base of these medals often bears the Anno Lucis date of the member's initiation. The Fairman design appeared in abstract form in Connecticut but disappeared from use in the Albany area when he relocated to Philadelphia.

The main distinction to be recognized concerning the demise of Mark medals is that the degree did not die out, only the independent status of the Mark Lodge. The need for adopting a symbol for the chapter that retained the heritage of the Mark Degree was served by appearance of the Chapter Penny. Important features of the Mark medal were retained: the keystone, working tools of the Mark Degree, name and personal mark, and the name and location of the chapter. A variety of metals were utilized for the pennies, but copper was favored because it was the most readily available through the reuse of early United States, English, and Canadian "large cents." The mint design on one side was usually retained, but the reverse would be defaced to receive Masonic information.

1. Gibb 1980.

2. The London Company of Masons (operative) was incorporated in 1412 and first assumed their arms about that time.

3. Webb 1797. Thomas Smith Webb was the leader of the Committee on Ritual.

4. Some Mark Lodges still exist.

5. We have yet to find empirical evidence that Mark medals made an appearance in America concurrently with the first recorded Mark Master proceedings in St. John's Lodge No. 2 (q.v.). Currently the earliest dated American mark medal (dated 1795) is the one that was owned by James Sullivan, Independent Royal Arch Lodge No. 2, New York City. Sullivan was exalted February 3, 1795.

6. Copestake 1951.

7. The symbolism of a virgin weeping at a broken column was created by engraver Amos Doolittle for Jeremy Cross' *Masonic Monitor* (New Haven, 1819).

8. This involved allegorical design was recorded as the mark of E.R. Jones in the Mark Book of Columbia Chapter No. 91, Philadelphia, Pennsylvania in 1844.

9. Case 1972.

10. Ibid. Johann Ludwig deKoven (c. 1750-1821) of Newtown, Connecticut sold his mark when he fled to Montreal to escape the wrath of an cuckolded neighbor.

11. Two medals from Independent Royal Arch Lodge No. 2, New York City are dated but three years apart; both bear the same mark, a three-masted sailing vessel flying American colors. The medals belonged to mariners Seth Buckley (dated 5798) and Elijah Tiffany (dated 5801). Buckley died at sea in 1799, allowing his mark to be assumed by Tiffany.

12. Perse 1966.

13. Ars Quatuor Coronatorum 1932, 43:194.

Illustrations

ILLUSTRATION:
4.38, FACING

4.37 SEE ILLUSTRATION ON PAGE 120

Lodge Jewels
Paul Revere, Jr. (1734-1818)
Boston, Massachusetts, 1796
Silver
Lent by Washington Lodge, A.F.& A.M., Lexington,
Massachusetts

A set of twelve silver jewels made by Paul Revere, for
Washington Lodge, A.F. & A.M. of Roxbury, Massachu-
setts at the time its charter was issued in 1796. The
square, level, and plumb jewels of the Master and the
Senior and Junior Wardens are suspended from radiant
solar faces mounted within entwined roped circlets.
The repoussé face on the Master's jewel appears to rise
in the East, set in the West for the Senior Warden, and
be suspended at meridian for the Junior Warden. These
solar aspects correspond to the location in the lodge tra-
ditionally occupied by each of the three officers, and
allude to Masonry's course within the lodge, as it flows
from East to West.

Crossed keys and crossed quill pens for the Treasurer
and Secretary are cast in full dimension. Other flat in-
signia of the set include two Deacon's jewels (open
book within square and compasses), two Stewards jew-
els (engraved cornucopia), the Chaplain's jewel (a
perfect circle) inscribed "Washington Lodge Roxbury
1796," crossed swords of the Tyler or Master of ceremo-
nies, and an open square suspended on the diagonal for
the Marshal. The Marshal's rod or baton that should be
displayed within the square is missing.

Paul Revere, Jr. (1734-1818) was made a Mason in St.
Andrew's Lodge on 17 January, 1761 and was elected
Grand Master of the Grand Lodge of Massachusetts in
1794, serving for three years (1794-1797). During his
tenure as Grand Master, Revere chartered twenty-three
new lodges and is known to have made sets of jewels
for South Hadley Lodge; St. Paul's Lodge, Groton;
Bristol Lodge, Norton; Kennebec Lodge, Howell [sic],
Maine; Adams Lodge, Wellfleet; Columbian Lodge,
Boston; Meridian Lodge, North Brookfield; and Wash-
ington Lodge, Roxbury. Bro. Revere refrained from
placing his mark on jewels that he made.

Washington Lodge possesses the original bill of sale
for the jewels. The invoice was issued from the firm of
Paul Revere & Son, and is dated April 20, 1796. It re-
veals that the set cost twelve Pounds and was ordered
by Simeon Pratt (1745-1805), the lodge's charter Senior
Warden. This set represents the second set of jewels

that Revere made for Washington Lodge. The first set
was purchased by Col. John Brooks (1752-1825) in
1781 at a cost of eight Pounds, ten Shillings, during the
period when Washington Lodge worked as a travelling
military lodge. The first Washington Lodge was dis-
solved at the conclusion of the Revolutionary War.
Reference: Zannieri 1987.

4.38

Past Master's Jewel
Attributed: Paul Revere, Jr.
Boston, Massachusetts, c. 1805
Silver
Gift of John F. Snow, 86.34.1

A radiant solar face cast in relief and mounted between
the legs of a pseudo-compass.

A Past Master's jewel owned by Jonathan Cook, Sr.
(1779-1862) of King Hiram Lodge, Provincetown,
Massachusetts. Brother Cook was a charter member of
King Hiram's Lodge and served as its Master from
1800 to 1805. The radiant sun design is similar to
work known by Paul Revere. The jewel appears to have
been separated from its quadrant arc, which nor-
mally connects the compass legs. (see Cook's sash
and apron 4.14)

4.39

Past Master's Jewel
Timothy Gerrish (1749-1815)
Portsmouth, New Hampshire, c. 1805
Silver
Special Acquisitions Fund, 86.10

Compasses of coin silver with bail-like suspension ring
and points connected by a quadrant arc of 60 degrees.
An engraved radiant solar face appears to rise from be-
hind the quadrant. The reverse is inscribed "St. John's
Lodge/No.1/Portsmouth, N.H./ to Dr. L. Spalding
Pastmaster 5806."

Dr. Lyman Spalding, MD (1775-1821) was raised in
Rising Sun Lodge No.3, Keene, New Hampshire in
1795. Bro. Spalding affiliated with St. John's Lodge
No. 1 on July 1, 1801, and served as Worshipful Master
in 1805. A noted physician and founder of Dartmouth
College Medical School, Dr. Spalding gained interna-

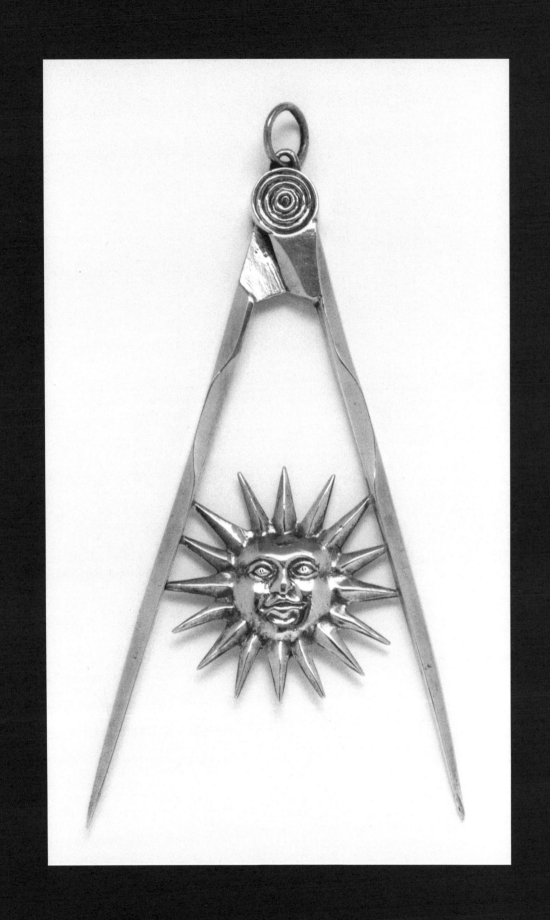

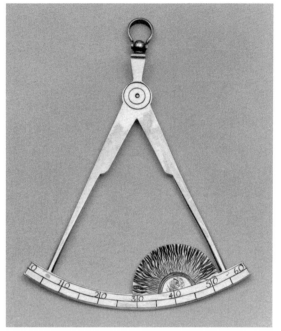

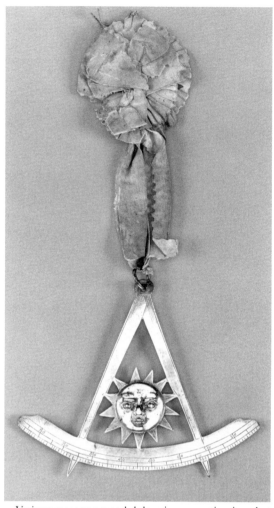

tional fame for his compilation of the *Pharmacopoeia of the United States*, which is still in use.

Silversmith Timothy Gerrish was raised in 1794 and served as Tyler and Steward of the lodge. The Minutes of St. John's Lodge record payment to Bro. Gerrish for making five Past Master's jewels, including jewels for Samuel Larkin, Joseph Willard, Rev. George Richards, B. Brierley, and the noted Masonic lecturer and ritualist Benjamin Gleason.

4.40
Past Master's Jewel
Boston, c. 1820
Silver
Gift of Union Lodge, A.F. & A.M.,
Dorchester, Massachusetts, 75.46.6

Compasses and quadrant arc of 90 degrees enclosing a radiant solar face in coin silver, with a blue silk cockade and ribbon attached. The reverse engraved "Presented to R.W. Daniel Withington As a Token of Esteem and Respect by Union Lodge 5820, Dorchester." The radiant sun is formed by engraving and low relief repoussé.

Daniel Withington (d. 1847) was admitted to Union Lodge in 1805 and served as Master of the lodge from 1809 to 1811. The initials "R.W." refer to the honorific form of address "Right Worshipful."

In 1820 a similar medal (Accession # 75.46.5) was also presented to Cyrus Balkam (d. 1842) who served as Master of Union Lodge from 1817 to 1820 and again from 1831 to 1841.

Various reasons caused delays in presenting jewels to Past Masters. Only upon relinquishing "Solomon's Chair" was a vote cast to recognize past service to the lodge as a presiding Master. Extended tenure might delay such an occasion for several years and depleted treasuries also served to delay the purchase of jewels.

4.41
Past Master's Jewel
Boston, Massachusetts, c. 1900-1920
Silver
Gift of Pricilla S. Robertson, 92.008.1

An engraved Past Master's insignia in the form of a circlular pendant, enclosing a pierced radiant sun within Masonic square and compasses. This jewel belonged to Albert L. Saunders (1878-1972) of Medway, Massachusetts. Bro. Saunders was initiated in Charles River Lodge, A.F.& A.M. in 1910 and served as Master

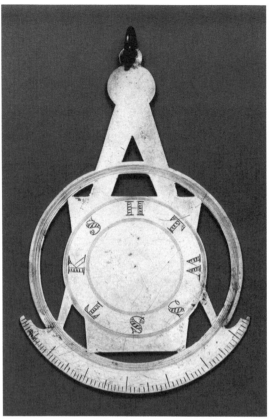

of the lodge. Designs that enclose a jewel within a circle usually indicate that the owner served in Grand Lodge.

4.42
Royal Arch Chapter Jewel
Connecticut, c. 1800-1820
Silver
Special Acquisition Fund, 88.4

Medal of coin silver pierced in the design of compasses joined by a quadrant arc enclosing a central device with concentric border inscribed with "H.T.W.S.S.T.K.S.". The mnemonic device is imposed on a keystone and both are enclosed within a circle.

This is an unusual York Rite jewel design that combines a Mark Master's medal (Fourth Degree), the Past Master's jewel (Fifth Degree), and the keystone symbol of the Most Excellent Master (Sixth Degree). A similar jewel (dated 1816) was made for Washington Chapter No.3 of Middletown, Connecticut. Washington Chapter received its charter in 1796.
Reference: Walker 1956, 23.

4.43 SEE ILLUSTRATION ON PAGE 138
Past Master's Jewel
Boston, c. 1858
Silver
Gift of Union Lodge, A.F. & A.M.,
Dorchester, Massachusetts, 75.46.4

Cast silver plaque with border of fern leaves and background of radiating stippled lines. A Masonic square and compasses are shown in the center in low relief, and the legs of the compasses are joined by a quadrant arc of 90 degrees. Imposed on the compasses is a rect-

angular plate engraved "Bro. I.W. Follansbee by the Brethren of Union Lodge, Dorchester June 22 A.L. 5858."

Isaac W. Follansbee served as Master of Union Lodge from 1857 to 1858. A similar medal in the collection of the Bostonian Society, was presented by St. Andrews Lodge to Henry Purkett in 1823. The time-lapse between both presentations illustrates that Past Master's medals might be stockpiled for future use.

4.44 SEE COLOR PLATE, PAGE 272
Past Master's Jewel
James Simmons
New York, dated 1811
Gold and silver
Gift of Mrs. Thatcher P. Luquer. 85.71

Gold compasses and quadrant arc enclosing a radiant sun beneath a Masonic Royal Arch. The pillars of the arch, drapery, keystone, and central three-step dias are of silver. The pillars rest on a horizontal bar that represents a mosaic pavement. The work is contained within a gold oval ribbon engraved "Presented by Independent Royal Arch Lodge No. 2 to W.P.M. Bro. Nicholas Roome New York December 27th A. 5811." The reverse is engraved "His Works Were Approved" and "Bro. J. Simmons Fecit."

Jewels 137

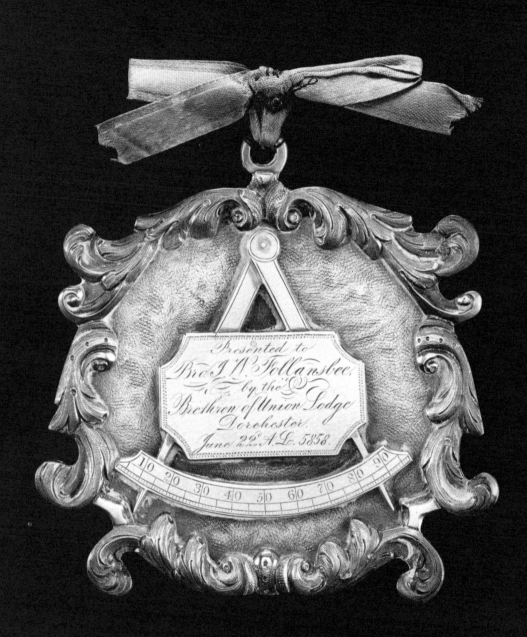

Nicholas Roome (d. 1824), was a successful merchant in New York city and served as Master of Independent Royal Arch Lodge No.2 from 1809 to 1811. Bro. Roome was also active in Royal Arch Ancient Chapter No. 1 and Knights Templar Columbian Encampment No.1. The minutes of I.R.A. No.2 record on March 17, 1812, that "A Past Master's jewel was presented to W. Bro. Nicholas Roome. Cost $75."

James and Abraham Simmons were in partnership as silversmiths in New York from 1803 until 1813. In 1815 their advertisements began to appear separately as James continued working as a silversmith, and Abraham was listed as an engraver.
Reference: Duncan 1904, 51.

4.45
Past Master's Jewel
Emmor T. Weaver (1786-c.1833)
Philadelphia, c. 1829
Silver and gilt bronze
Special Acquisition Fund. 83.8

Jewel and commemorative medal presented to a Past Master of a Mark Lodge. Cast silver compass legs and quadrant arc of 90 degrees enclose a radiant solar face of gilt bronze. The reverse of the quadrant is engraved " Concordia Mark Lodge No. 67 to Wm. Conrad. P.M." and struck "E.T. WEAVER" in a sunken rectangle.

William Conrad served as Master of Concordia Mark Lodge from 1828 to 1829. Like many other craftsmen of this period, Emmor Trego Weaver was a member of the Masonic fraternity. He was originally a member of Lodge No. 50 in East Whitehead, Chester County, Pennsylvania but affiliated with Lodge No. 2 when he

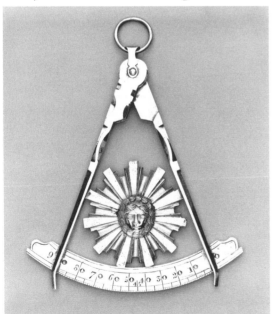

moved his business and family to Philadelphia in 1810. Although his name was recorded as a visitor to Lodge No.2 on numerous occasions, he did not officially become a member until 1819. In 1810 the minutes of Lodge No.2 record a payment to him of $14.00 "for making Jewel for the Master of Ceremony and repairing the Jewels of the officers." In 1811 he was paid $5.50 for making a sword for the Master of Ceremonies. Also active in Royal Arch Masonry, he eventually resigned from Lodge No.2 in 1830.
Reference: Barratt and Sachse 1909, 2:375-81, 3:57, 58, 214.

4.46 SEE ILLUSTRATION ON PAGE 140
Description of the Regalia and Emblematical Figures used in Masonry
Paraclete Potter (1785-1858), printer
Poughkeepsie, New York, 1815
Copperplate engraving
Library 19 .J12 1815

Frontispiece to an American edition of the popular Masonic expose *Jachin And Boaz: or an Authentic Key to the Door of Free-Masonry, Ancient and Modern*. The frontispiece illustrates a Freemason's medal and depicts the principal symbols of Craft Masonry that appear on it. An explanation, or key to the symbols, accompanies the illustration.

This illustration was not included in the first edition of *Jachin And Boaz* (London, 1760). It first appeared in the 1776 edition, shown with the medal placed in an octagonal frame and with a building representing the entrance, or porch to Solomon's Temple in the center. The design was altered in subsequent editions, in which the medal was placed in an oval frame and the temple was relocated to the side. The basic design was also adapted to decorate aprons and apron storage containers (see 4.20).

4.47 SEE ILLUSTRATION ON PAGE 142, TOP LEFT
Craft Medal
Massachusetts, c. 1780
Silver
Gift of Hugh S. and Caroline R. Grey, 75.67

Oval medallion of coin silver engraved with Masonic Craft symbols surrounding two pillars standing on a mosaic pavement. Below the pavement a diagram of Euclid's 47th mathematical proposition, a coffin, and the inscription "No.3." The reverse is engraved "Jethro Putnam 1780."

Jethro Putnam (1755-1815) was a tavern keeper by profession and a member of United States Lodge No.3, Danvers, Massachusetts. During the Revolution, Bro. Putnam served in Capt. Jeremiah Page's militia company and participated in the Lexington Alarm, on April 19, 1775. In 1782 he served as Junior Warden of United States Lodge.

The engraved design was derived from a drawing which first appeared as the frontispiece to the expose *Jachin and Boaz:or an Authentic Key to the Door of Free Masonry.* Numerous American editions of the book included this emblematical frontispiece.

4.48 SEE ILLUSTRATION ON PAGE 142, TOP RIGHT
Royal Arch Craft Medal
Philadelphia, Pennsylvania, early 19th century
Copper
Special Acquisition Fund, 83.41.1

Oval copper medallion engraved with a Masonic Royal Arch inscribed "Holiness to the Lord," a radiant Delta inscribed with the ineffable name, and an Ark of the Covenant surmounted with tablets of the Ten Commandments guarded by cherubim. Across the base is

engraved "S. Decatur N.3." The reverse is engraved with a version of the Baynes design of Masonic Craft symbols that also includes a triple arched bridge. The motto "Sit Lux Et Lux Fuit" (let there be light, and there was light) is engraved along the upper edge of the medal. At the base is the cabalistic number "15."

Naval Captain Stephen Decatur, Sr. (1751-1808) was initiated in Lodge No. 16, Baltimore, Maryland in 1777. Bro. Decatur moved to Philadelphia about 1801 and became of member of Tun Tavern Lodge No.3.
Reference: Schultz 1884, 1:60.

4.49 SEE ILLUSTRATIONS ON PAGE 142, MIDDLE
Royal Arch Craft Medal
Pennsylvania, c. 1804-1810
Silver
Special Acquisitions Fund, 80.10

Silver heart-shaped medallion of coin silver. The obverse engraved with angels' wings and an American eagle carrying a banderole in its beak inscribed "Benjamin Cannon." Above the eagle is inscribed "No. 91." The reverse is engraved with a Masonic Royal Arch inscribed "Holiness to the Lord," and various Masonic Craft symbols.

Columbia Lodge No. 91, A.Y.M. (Ancient York Masons) of Philadelphia was constituted in 1801. Benjamin Cannon is not listed as a member, but James Cannon was a charter member and served as Treasurer of the lodge from 1801 to 1804.

An eagle bearing a banderole with the legend "Columbia Lodge No. 91" was a feature of the emblematic design on the membership certificate that the lodge adopted in 1803, and engraved in 1804. The certificate plate was probably engraved by Bro. David Edwin (1776-1841) who was initiated in Columbia No.91 in 1806 (see 5.18).
References: Reilly 1901.

4.50 SEE COLOR PLATE, PAGE 273, TOP
Mark Book
M.S. Harding, artist
Greenwich Village, Massachusetts c. 1815-1836
Watercolor on paper
Special Acquisition Fund, MA 001.003

Book of marks, or design registration record of King Hiram Royal Arch Chapter, Greenwich Village, Massachusetts. Each of the 52 pages is allocated to a pro forma outline of a keystone, the symbol associated with the Mark Master Degree (4th Degree in York Rite Freemasonry). A circular center within each keystone is bordered by the mnemonic "H.T.W.S.S.T.K.S.," and filled with a unique design or mark chosen by members at the time of their initiation into the Mark Master Degree. The designs were drawn in ink and watercolor and described under the

owner's name. Four of the completed designs do not appear to have been assigned to any individual. Twenty-two of the drawings were signed "M.S. Harding."

The artist M.S. Harding, may be related to Chester or Spencer S. Harding, both of whom were Boston portraitists (active 1835-1845), or the less well-known New England portrait painter J.L. Harding (active c.1825).

Ezekiel L. Bascomb and other companions of the Royal Arch residing in Hampshire County, were granted a warrant by the Grand Chapter of Massachusetts on June 13, 1815, to hold a Royal Arch Chapter in the town of Greenwich. The chapter, designated King Hiram Royal Arch Chapter, was consecrated and its officers were installed with due ceremony on September 3, 1816. The first regular meeting was held the following day at the Greenwich house of Companion John Warner.

In 1836, King Hiram Royal Arch Chapter was found long delinquent in dues to the Grand Chapter, and was ordered to surrender its charter and records. A number of the members transferred to other chapters in the area. In the absence of any response to this order, the chapter's charter was declared forfeit, annulled and void on March 13, 1838. The Mark Book became the property of King Solomon's Royal Arch Chapter of Warren, Massachusetts and was safeguarded by Companion John T. Jordan (1799-1879) of Greenwich Village.

4.51 SEE ILLUSTRATION ON PAGE 143, TOP LEFT
Mark Master Medal
New York, c. 1814-1820
Silver
Collections Purchase Fund, 93.023
h: 3 ⅛" w: 1 ⅞"

Shaped medal with tri-lobate pendant edge. The obverse is engraved with an all-seeing eye above a circular border inscribed "Wm. Faulkner Geneva Royal Arch Chapt. No. 36." The central design shows a keystone inscribed with the mnemonic device HTWSSKS [sic] of the Mark degree flanked by a mallet and a trowel. The reverse depicts a level above the mnemonic HTWSSTKS, and a Mark in the form of a tall hat.

Geneva Royal Arch Chapter No. 36 was chartered to hold meetings in the village of Geneva, New York in 1814.

4.52 SEE ILLUSTRATIONS ON PAGE 142, BOTTOM
Mark Medal
New York, c. 1804
Special Acquisition Fund, 88.40
Silver

Medal of coin silver with a central circular shield and concentric border inscribed "Samuel Babcock Mr Mk Mn." The design in the center is of a hand holding two trophies of Masonic working tools in equipoise. One group represents a level, plumb, and mallet; the other, a

square and compasses, and plumb level. Cresting the medal is the figure of a winged angel's head. A tri-lobed pendant bears the symbol of the Pentalpha. The reverse is engraved with a mark device of an urn bearing the letter "O" within a concentric border inscribed with the mnemonic "H.T.W.S.S.T.K.S." On the crest appears the all-seeing eye, a radiant sun and crescent moon, a blazing comet with fiery tail, and a 24-inch marking gauge (ruler). The pendant bears the Anno Lucis date "5804."

The shape and engraved design is similar to other mark medals from the Albany/Schenectady region of New York. The Angel's head device appears to have been introduced on mark medals by engraver Gideon Fairman (1774-1827). A mark medal for Oliver Ruggles, of Hiram Mark Lodge, dated "5796" (1796) bears the rare imprint "Bror. Fairman Sculpt." (A.Q.C. vol. 43.).

Gideon Fairman was born in Newtown, Connecticut and sent to Isaac and George Hutton of Albany to learn silver-plate engraving. Fairman commenced his own engraving business at Albany in 1796, removing to Philadelphia in 1810.
Reference: A.Q.C. 1932, vol. 43.

4.53 SEE ILLUSTRATION ON PAGE 143, TOP RIGHT
Mark Medal
New York State, c. 1814
Silver
Special Acquisition Fund, 81.46.2

Engraved medal with central circular device of a Masonic Royal Arch resting on a mosaic pavement. Between the pillars of the arch is the all-seeing-eye and an open book. A concentric border is inscribed "Elijah Wheeler M.M.M. David's Chapter No. 34." The shaped crest is engraved with the symbols of a mallet and chisel representing the working tools of a Mark Master Mason. The shaped pendant is inscribed with the Anno Lucis date "5814." The reverse is engraved with a central mark design consisting of a plumb and level within a concentric border inscribed "H.T.W.S.S.T.K.S." A Masonic square and compasses appear within the crest.

David's Royal Arch Chapter No. 34 was located at Auburn, New York. At the time this medal is dated, silversmith John Osborn was working in Utica. Osborn was a member of Homer Lodge No. 137.

ILLUSTRATIONS:
FOLLOWING PAGE
4.47, TOP LEFT
4.48, TOP RIGHT
4.49, MIDDLE ROW
4.52, BOTTOM ROW

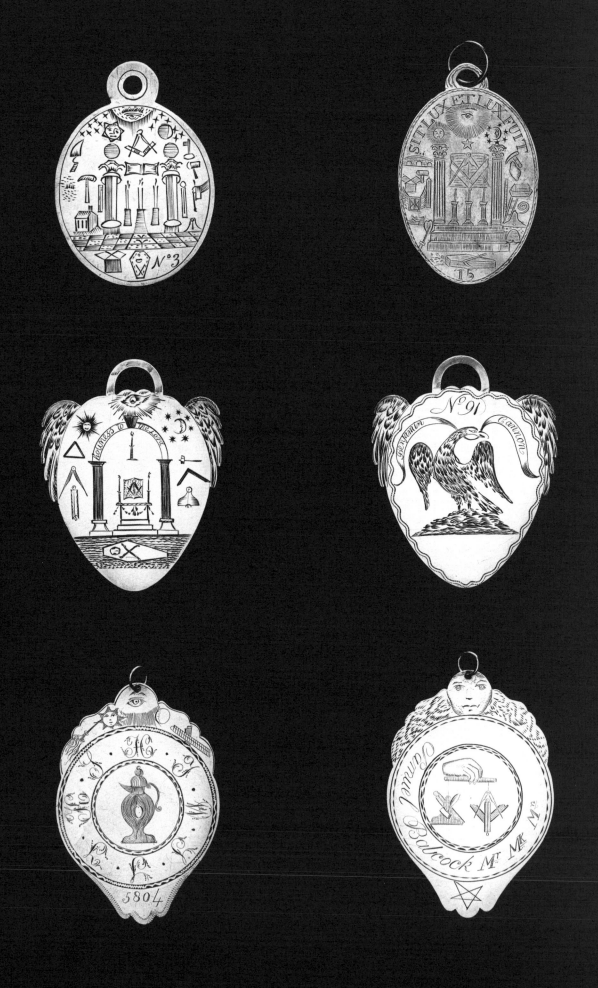

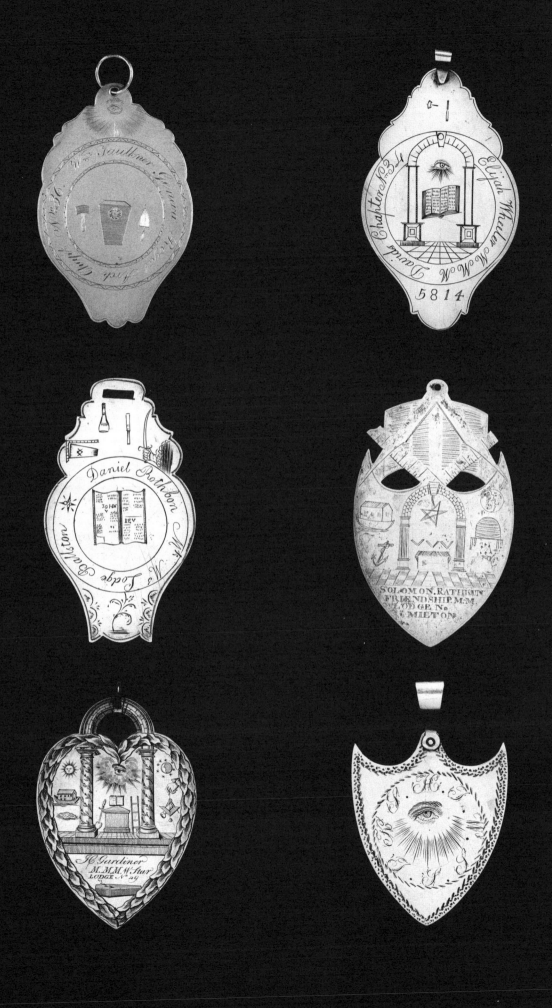

4.54 SEE ILLUSTRATION ON PAGE 143, MIDDLE LEFT

Mark Medal

New York State, c. 1803
Silver
Special Acquisition Fund, 78.45.1

Coin silver medal with engraved design of an open Bible within a concentric border inscribed "Daniel Rothbon Mk Ms Lodge Ballston." A shaped crest is engraved with a mallet, chisel, hand holding a sword, square, and keystone. The crest is provided with a rectangular shaped loop for suspension from a ribbon. Below the central portion extends a pendant engraved with a sprig of Acacia. The reverse is engraved with a Mark device of a bird on a branch, encircled by a serpent biting its tail, within a concentric border inscribed "H.T.W.S.S.T.K.S." The crest is engraved with a Masonic Royal Arch; the pendant, with a square and smooth block of ashlar.

Daniel Rathbone (b. 1731) was a member of Franklin Lodge No. 21, Ballston, New York. The lodge received its charter in 1803. Bro. Rathbone's certificate of membership in Franklin Lodge is dated 1796 (Library Archives 78-831). It was engraved by silversmith Isaac Hutton of Albany, New York. Daniel's son, Solomon Rathbone, was a member of Friendship Mark Lodge No. 39, Milton, New York.

4.55 SEE ILLUSTRATION ON PAGE 143, MIDDLE RIGHT

Mark Medal

New York State, c. 1808-1820
Gilt copper
Special Acquisitions Fund, 78.45.2

Shield shaped medal of gilt copper, surmounted by square and compasses imposed on an open Bible. The shield portion is engraved with a Masonic Royal Arch resting on a mosaic pavement. A pentalpha or Blazing Star is suspended from the keystone of the arch. Within the arch three squares appear above the Substitute ark. On each side of the pillars appear symbols of a crescent moon, beehive, Noah's ark, and the anchor of Hope. Below the pavement is the inscription, "Solomon Rathbun/Friendship M.M./Lodge No. 39/Milton." The reverse bears a mark design of a female figure with an anchor, representing Hope, within a concentric border inscribed "H.T.W.S.S.T.K.S."

Solomon Rathbone (b.1778), son of Daniel Rathbone, was listed as living in Milton (present day Rock City), Saratoga County, New York in 1813 before moving to Vincennes, Indiana in 1824. Friendship Lodge No. 39 was located in Milton and received its charter in 1808.

4.56 SEE ILLUSTRATION ON PAGE 143, BOTTOM LEFT

Mark Medal

New York State, c. 1797-1820
Silver
Special Acquisition Fund, 89.17

Heart-shaped medal with engraved foliage border. The engraved design is composed of two vine-entwined pillars supporting a Masonic Royal Arch that extends above the heart outline. The pillars are flanked on the right by symbols of a crescent moon surrounded by seven stars, a hand suspending a plumb bob or plummet, and a trophy comprised of the square and compasses and a mallet. On the left appears a radiant sun, Noah's ark, and an irregular rock representing rough ashlar. Between the pillars is the all-seeing eye, a book upon a triangular altar, sword pointing to a heart, and Jacob's ladder. The pillars rest on a mosaic pavement below which is a coffin with a sprig of acacia and the inscription "H. Gardiner/M.M.M. W Star/Lodge No. 49." The reverse bears a mark design of crossed keys within a concentric border inscribed "H.T.W.S.S.T.K.S."

Western Star Mark Lodge No. 59, Bridgewater, New York was chartered in 1797. In 1819 many mark lodges in New York were renumbered. Other New York lodges bearing the Western Star name were located at Unadilla, Scipio, and Sheldon.

4.57

Mark Medal

Harrisburg, Pennsylvania, c. 1826
Silver
Special Acquisition Fund, 78.70

Shield-shaped medal surmounted by square and compasses imposed on an open Bible. The obverse is engraved with symbols of a Masonic Royal Arch within which are a delta, trowel, and mallet. On either side of the arch appear a radiant sun and crescent moon encircled by seven stars, the Pentalpha bearing the letter "G" and a plumb and square entwined. Below the arch is the inscription, "Perseverance Mark Lodge No. 21 Harrisburg." The reverse is engraved with a central Mark device of a hand holding a key and the name "T.H. Cowen," within a concentric border inscribed "H.T.W.S.S.T.K.S."

Perseverance Lodge No. 21, Harrisburg, Pennsylvania received a warrant to work in 1799 and was consecrated as a Royal Arch Mark Lodge in 1810. Thomas H. Cowen was raised in Perseverance Lodge on December 13, 1826.

Reference: Egle and Lamberton 1901.

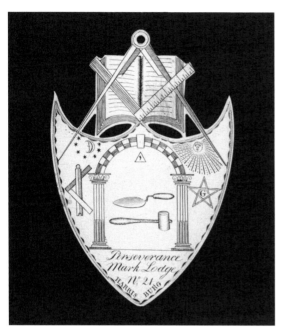

4.58 SEE ILLUSTRATION ON PAGE 143, BOTTOM RIGHT

Mark Medal

Maryland, c. 1818
Gold
Special Acquisition Fund, 86.29

Shield-shaped medal engraved "Morgan Nelson Union Mark Baltimore 2818." The reverse with a mark design of an all-seeing eye within a concentric border inscribed with the "H.T.W.S.S.T.K.S." mnemonic.

Dr. Morgan Nelson (c.1786-1853) was a member of Union Mark Lodge, New Market, Maryland. The lodge received its charter from the Grand Lodge of Maryland in 1817 and remained active until 1824, when the Grand Chapter of Maryland reorganized all Mark Lodges under the chapter system. The common date (1818) is obtained by subtracting 1,000 from the Anno Depositionis date "2818." (See Appendix 3).

4.59

Mark Medal

Bangor, Maine, c. 1849
Gift of Mr. & Mrs. Shattuck W. Osborne, 82.38
Gold

Keystone-shaped gold medal engraved with central concentric border inscribed "H.T.W.S.S.T.K.S." The reverse is inscribed "Presented by Mount Moriah Royal Arch Chapter to M.E. Comp[io]n John Williams elected High Priest Dec. 10 A.D. 1849."

John Williams was a member of Rising Virtue Lodge No. 10 and Mount Moriah Royal Arch Chapter which met in the town of Bangor, Maine. The owner's mark design was never engraved in the appropriate place.

4.60 SEE COLOR PLATE, PAGE 273, BOTTOM

Mark Medal

New England, c. 1800
Watercolor on ivory
Special Acquisition Fund, 93.026

Thin oval sheet of ivory painted with a design of an eagle in flight passing between the legs of a compass. Suspended from the eagle's beak is a delta bearing the letter "G." Around the border and encircling the design appears the usual mnemonic "HTWSSTKS" associated with the Mark Master Degree. This mark was probably originaly mounted in a locket, in a manner similar to the way miniature portraits were worn.

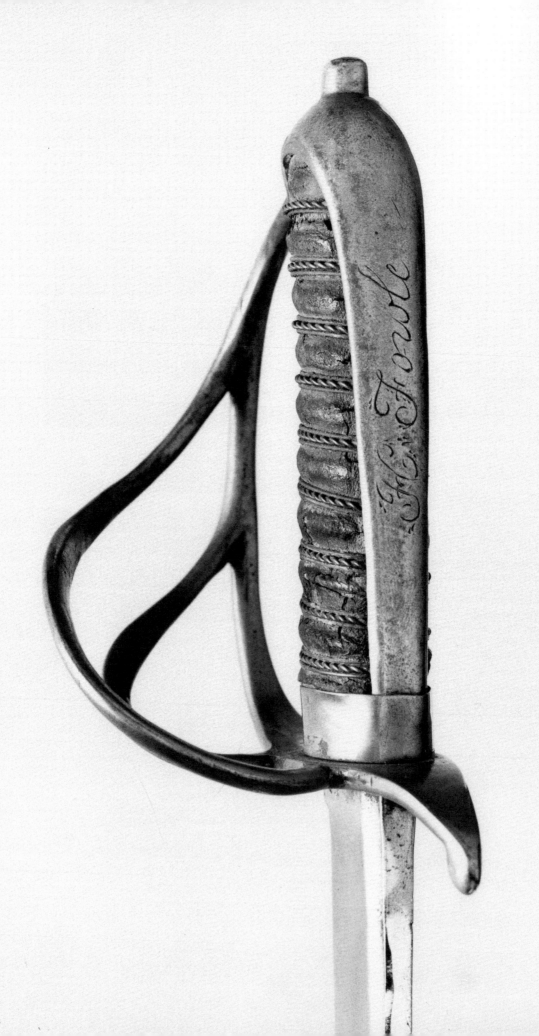

Swords

ILLUSTRATION:
4.62, FACING
SEE DESCRIPTION
ON PAGE 155

Symbolism

THE MEDIEVAL CEREMONY OF CREATING A KNIGHT ACQUIRED A RELIGIOUS CHARAC-
ter under the influence of the Christian Church, and chivalry assumed a moral
code based on honor and virtue. For knightly candidates, receiving the *colee* (accolade of
knighthood) and girding-on a sword marked the culmination of an arduous ritual in which
both the new knight and his sword were consecrated to the service of God and the laws
of the Church. The knightly sword was thus imbued with almost mystic symbolism and
attributes reflected in the physical characteristics of the sword itself: a cross-shaped hilt
alluding to the cross upon which Christ was crucified, and a bright shining blade symbol-
izing purity of thought and deed.

In Freemasonry the sword has been employed to guard the portals of the lodge, to
perform ritual degree work, and to enhance the costume of the militant orders. As a vi-
sual symbol alluding to moral principles, the representation of a sword is used in
conjunction with that of a heart to prick the conscience and remind brethren that justice
will prevail although one's actions may be hidden from others in the innermost recesses
of the human heart. The Masonic sword is also illustrated in a guardian role with the Book
of Constitutions, to pointedly remind brethren of the confidentiality of ritual.

A sword is incorporated as a symbol in many insignia of the higher degrees in the York
Rite and the Ancient Accepted Scottish Rite where it is used in ritual degree work and as
a general symbol of the chivalric virtues of justice, fortitude, and mercy. The sharp point
represents charity and mercy; the double-edged blade is capable of cutting in both direc-
tions and thus alludes to equality inherent in justice. A polished shining blade symbolizes
purity of intention.

Skull and Crossbones

The death's head appears in Craft Masonry in conjunction with the Hiramic legend, but
this morbid symbolism is encountered more often in the York and Scottish rites where
ritual and regalia sword hilt pommels are often formed in the shape of a skull, and
crossguards are created from crossed femurs. The skull and crossbones serve to remind
brethren of their frail mortality, the inevitability of death, and an ultimate accountability
for their earthly actions. The skull itself is also suggestive of suffering and alludes to bib-
lical Golgotha, "The Place of Skulls," where Jesus was crucified.

Delta

A triangle or delta shape alludes to God, who is referred to by Masons as "The Great Architect Of The Universe." The delta may be rendered devoid of additional symbolism, or may enclose Hebrew letters spelling the ineffable name of God, or Arabic numerals signifying various degrees.

Crosses

The Masonic sword hilt is normally regarded as being cruciform in shape, but is specifically described as such for the chivalric orders. Decorative designs on counterguard or quillon may reinforce the criciform theme. The use of additional Templar, Teutonic, Greek, or Maltese crosslets serves to signify affiliation with a particular Masonic order. Other cross forms, such as the Passion, Patriarchal, and Salem Cross, are used to distinguish hierarchy within those orders.

In addition to the Templar Cross, Knights Templar swords display a cross-in-a-crown, or the "Cross of Life," and the motto "In Hoc Signo Vinces" (by this sign conquer). The Cross of Life is derived from Revelation 2:10 — "Be thou faithful unto death, and I will give thee a crown of life" — and the motto refers to the Vision of Constantine. According to Church legend, before his battle with the Gaul Maxentius in 312 A.D., the emperor Constantine had a vision of a cross superimposed on the sun with the caption, "In Hoc Vinces" (by this sign conquer). Constantine adopted the sign as an imperial *Labarum* (banner), was victorious, and subsequently converted to Christianity.

Certain crosses may also denote specific degrees. The triple Tau Cross is considered an insignia of Royal Arch Masonry, and the form appears often on chapter swords. The triple Tau also occurs as a symbol in certain Templar and Scottish Rite Degrees, but generally not as a decorative motif on the swords of these orders.

The extension of Freemasonry beyond the Third Degree deals with biblical legend surrounding the completion, destruction and rebuilding of Solomon's Temple and the rediscovery of its subterranean vaults containing the Stone of Foundation and other important mysteries. A shovel, pickaxe, and crowbar were the principal tools used to gain access to these treasures, and as a result, are held to be the working tools of Royal Arch Masons. As symbolic reminders of the discovery, representations of the crow, pick, and spade are found on Royal Arch Chapter ritual swords.

Color is applied to sword scabbards and grip wrappings to designate use by specific Masonic bodies, much as colored edgings on Masonic aprons do. Although there are at least seven symbolic colors used in Masonry, only three are found on leather or fabric covered sword scabbards: blue represents the vault of heaven and the universality of Masonry in the symbolic degrees; scarlet represents the ardor and zeal that should actu-

ate all who attain the Royal Arch Degree; and black is the color of sorrow for the death of Christ that is experienced in the chivalric degrees of the York Rite. A "sword in mourning," a sword draped in black ribbon or crepe, was carried in Masonic funeral processions.

In Continental lodges, swords used by the Tyler traditionally had a flamberge, or wavy serpentine-shaped blade.[1] The unusual shape recalls the sword from the Book of Genesis that guarded the entrance to Paradise. In French lodges it is carried by "the Brother Terrible, who throughout the whole time of the Reception holds a naked sword in his hand, to test, they say, the steadfastness of the Candidate."[2] The flamberge blade is seldom encountered in American subordinate lodges, but its use has found favor on large hand-and-a-half or two-handed Swords of State used by various Grand Lodges. It is also carried in the talons of the double-headed eagle as a symbol of the Northern Masonic Jurisdiction of the Ancient Accepted Scottish Rite.

Evolution

In the 18th century, military hangers and gentlemen's smallswords (needle-like thrusting swords) were used by lodge sentinels and in ritual degree work. Wearing a smallsword was much in vogue in the middle of the century; no gentleman was considered well dressed without one.[3] However, as socially acceptable as it was to wear the smallsword in England and Europe, it was less so in America. In order to promote harmony in the lodge during meetings, the general wearing of a personal sword was prohibited. However, 18th-century engravings depicting lodge meetings illustrate a pervasive use of smallswords during the introduction and initiation of candidates.[4] The ritual use of smallswords by tradition-bound lodges continued to linger well into the 19th century. In 1812 an inventory of the furnishings of the Grand Lodge of Massachusetts still listed "three smallswords."

While carrying out their duties as sentinels, admitting visitors, and receiving candidates for initiation, Tylers were required to carry swords in lodge; but they were not necessarily adept in handling them. There is no prescribed sword drill in Craft Masonry to govern proper use or proficiency. In many cases the Tyler was given a wide berth during the course of performing his duties, during which his salutes and flourishes of the naked blade posed a threat to bystanders and to himself. There was also a time-honored custom in some English lodges for the Tyler to use the flat of his outstretched blade to receive a token shilling from a brother who had been newly conferred in a degree.[5]

The Tyler's sword was usually acquired by the lodge as a gift from a member, and the presentation would often be duly recorded in the Secretary's minutes. The variety of swords encountered in lodges range from military sabers and naval cutlasses to Saracen scimitars.[6] As various sword designs were adopted and superseded by the military, the discards became readily accessible to many lodges that welcomed "an impliment of war" for tyling.[7]

Freemasons who were silversmiths by profession often provided their lodges with Tyler swords as well as jewels. The list of silversmith brethren known to have made Masonic swords includes Emmor T. Weaver (1786-c.1833) of Philadelphia, and Peter Getz (1764-1809) of Lancaster.

In the era of the new Republic, a straight-bladed, single-edged, cut-and-thrust style sword was introduced that remained popular for nearly fifty years. Developed during the 1790s in an era of neoclassicism and growing national identity, its hilt contained design elements that combined Greco-Roman themes with American patriotic symbols such as the eagle, the Indian princess, or the allegorical figure of Columbia.[8]

Established military custom dictated that steel, silver or silver-plated hilts and scabbard mounts were to be used by the infantry; and brass or gilt hilts were reserved for the artillery. Subsequent military and Masonic regulations would further define prescribed guidelines for sword hilt color.[9] Under the U.S. Military Uniform Regulations of 1821, a cut-and-thrust, eagle-hilted sword was sanctioned for use by officers of the regular army and militia, with a curved-bladed version authorized for the artillery. Many eagle-hilted swords found their way into Masonic lodges where their ceremonial use was normally reserved for the Tyler. The popular eagle-hilt even appeared in a Masonic apron design engraved by Horatio G. Aspenwall, Jr. (Acc# 78.43).[10]

In the 1840s the regular military establishment adopted a series of swords based on French service patterns, while the militia continued to favor the hilt form that developed out of the neoclassic movement. The militia pattern sword of the 1840s combined a cruciform crossguard and a Roman style helmet-shaped pommel that was admirably suited to use by such chivalric orders of Masonry as the Knights Templars, Red Cross Knights, and Knights of Malta.

During the 18th century no specific regulations governed the form of Templar swords. In 1785, Templars participating in the procession of St. John's Day led the procession "with swords, etc." and formed a rear guard with "drawn swords."[11] In the early decades of the 19th century the founders of the Grand Encampment of the United States were concerned more with ritual and administrative matters and avoided coming to grips with the subject of Templar "costume" and sword patterns. Leaving such matters to personal choice, a simple straight-bladed, cruciform-hilted sword did gain general acceptance during the first half of the 19th century. An expose published in 1831 outlined ritual sword maneuvers for Knights of the Red Cross and illustrated a simple straight-bladed and cross-hilted sword.[12]

In 1841 it was determined by the Grand Encampment of New York that a Templar sword would be a "straight sword" with mountings of gold for Officers of the Grand Encampment and silver for all others. This early rank distinction in the color of mountings still generally holds true.

A uniform edict issued in 1859 confirmed adoption of a militia pattern sword by further defining the approved Templar sword as being "thirty-four to forty inches in length, inclusive of scabbard, helmet head, cross handle, and metal scabbard." In 1862 it was further decreed that the grips were to be black for all below the rank of Commander and white (ivory) for all above. As for mountings, rank-and-file Sir Knights were to wear white metal (silver) wherever metal appeared, and Commanders and Grand Commanders were to use gold. Scabbard mountings were to display a cross-in-crown or Cross of Life. Chain link guards for hilts were not authorized, unless prescribed by State Grand Commandries willing to exert a show of independence from the General Grand Encampment.

Swords worn by Grand Masters of Grand Commandries were to have a white grip bearing the owner's monogram and a Salem Cross. By 1900, "Parisian" or "Persian" imitation ivory grips were made of celluloid, which could also be processed to resemble tortoise-shell, horn, or ebony. Monograms and insignia of the order were engraved on the "ivoried" grips and filled with colored waxes. Mountings of "extra heavy" gold plate, deposited by electrolysis, were hand burnished to yield a high quality appearance similar to expensive gilding.

Other officers of the Grand Commandry were to substitute a Patriarchal Cross for the Salem Cross. Commanders were to use gilt mounts with a Passion Cross (with rays) on the white grip. Generalissimos were restricted to the use of silver mounts, black grip without owner's monogram, and Passion Cross (without rays). A metal device of the appropriate cross was applied to black grips of simulated ebony.

Until the period just prior to the Civil War, military and fraternal swords were traditionally worn suspended by various systems of rings, chains, straps, hooks, and fitted leather sockets called "frogs." All except the frogs caused an irritating dangling and rattling. Leather frogs were noiseless and firmly held sword scabbards in a fixed position, but they prevented the scabbard from being easily withdrawn from the socket. Should the wearer desire to remove the sword, he also had to take off the entire baldric or belt, an act that left him "out of uniform." Another problem with these systems was their cost.

In 1858, Jonathan Ball of Utica, New York patented a new and improved method of sword suspension, called a "Swivel Sword-Hanging."[13] Ball claimed that his arrangement — a key-shaped bitted pin, soldered or attached to the scabbard by means of a clasp, and a belt or sash plate with a key-shaped opening corresponding to the bit — would dispense with the need for traditional but more costly sword-hanging methods. Ball's method prevented the swivel pin from being dislodged while permitting the scabbard to pivot forward for the purpose of drawing or returning the sword. It also insured that the scabbard hung perpendicularly when the wearer was marching or standing in line.

Shortly after the introduction of Ball's swivel, Malonzo J. Drummond patented a variant suspension method he termed a "sword fasterner," which could be easily installed on any sword and was intended for use on baldrics.[14] The appearance of Drummond's invention coincided with significant changes in Templar costume prescribed by the Edict of 1860. In an article appearing in the *Masonic Messenger*, R.E. Sir John W. Simmons, Chairman of the Committee on Costume, clarified the intent that the white baldric, not the red belt, should support the sword; the red belt was to be used only to gird the white tunic.[15]

The advent of civil war in 1861 temporarily curtailed development of fraternal swords. During the war, many patriotic-spirited associations presented swords to members who were about to join the conflict. Similar presentations also occured among Masonic groups, but most Grand Masters of Grand Lodges were quick to condemn the practice and request that their lodges refrain from doing so during the war.[16] Numbers of military swords, engraved with Masonic symbols and bearing fraternal inscriptions, were placed in circulation before such restrictions were promulgated. Although they may bear Masonic symbols, such swords should not be regarded as other than military presentation swords.

After the Civil War, sword manufacturers turned their attention once again to fraternal markets. Virgil Price obtained a patent for an improvement on Ball's sword-hanging method, consisting of "securing the plate in which the scabbard is held to the belt by means of a chain so as to make a flexible attachment, which does away with all the straps used to hang officers swords, it being as simple as the frog attachment, which is generally used to attach fancy swords, for freemasons and other uses, to the belts."[17] Price's patent drawing illustrated a plate in the shape of a Templar cross.[18] The following year, David B. Howell patented an improvement on Price's system: a metal frog or plate with a tubular slide that moved freely on a short loop of chain suspended from the belt.[19] Both the Price and Howell methods were designed to operate from a sword belt rather than a baldric. In 1872, Howell patented another sword hanger, one that was specifically intended for "baldrics worn by the order of Knights Templar and others."[20] Specifications in the Letters Patent identified the plate as being "made in the form of a Maltese cross."

Price, meanwhile, obtained a patent to improve "methods of coating and finishing sword-scabbards." Scabbard surface treatment had been limited to either gold or silver-plating over brass, or bronzing. As Price explained:

> The gold or silver plated scabbards are not only too
> expensive for common use, but the plating on them being
> of soft metal, is liable to be indented or rubbed off.
> The scabbards for Templar's swords are mostly silver-plated.
> As they are considerably handled the silver is not only

rapidly worn off, but it also soils the gloves and hands.
The "bronzed" scabbards are not plated, but the outer surface
of the iron is artifically corroded, and the rust so treated
that it will adhere, and polish. The process is very tedious
and expensive, and tends to weaken the scabbards.[21]

Price's solution was to apply a nickel coating over a coating of tin or zinc on steel. The nickel adhered better and strengthen the steel. In addition, it "does not corrode, nor does it lose its bright appearance under atmospheric influences." Price followed this patent with an improvement in the method of casting scabbard mounts directly onto the scabbard to insure a perfect fit.[22] By the turn of the century a less expensive method of die-stamping scabbard mounts would be employed to further reduce the cost of regalia swords.

As attendance at Triennial Conclaves increased during the 1870s, 80s and 90s, a need was perceived to reduce the size of the typical Templar traveling wardrobe. James M. Mason patented a novel idea in 1871 that provided for a "sword and scabbard, each made in two or more parts, and capable of being readily disconnected, or so reduced in size as to admit of its being packed in a short box, valise, trunk, or other recepticle, and is particularly adapted for use by Knights Templar, Knights of Pythias, or others who use dress-swords."[23] Mason's scabbard was of a telescoping design, and his two-piece blade employed a lapped joint in the middle, the point being allowed to swivel and house itself in the guard of the hilt. "The handle may be of any design, such as a Maltese cross, helmet, or other device" and contained a small screwdriver which could be used to loosen or tighten the blade.

After the Civil War the scramble for shares in a burgeoning fraternal regalia market induced development of new sword mass-production techniques. Electro-plating, wax-adapted patterns for mold casting, template etching of blank blades, and grips of thermoplastic celluloid were measures that helped meet market demands. A few design patents protected proprietary rights to certain hilt designs. Virgil Price patented sword hilt designs for the Masonic Knights Templars, Knights of Pythias, and the Independent Order of Odd Fellows, for example. But generally sword hilt patterns remained in the public domain and available in thousands of varieties.

1. The Grand Orient of France has on display the flamberge-bladed sword of Lafayette.

2. Carr 1971, 334.

3. Aylward, John D. *The Small-Sword in England*. Batsford, London, 1960.

4. See Cepy's copperplate engraving "Assemblee de Francs-Macons pour la Reception des Apprentifs - Plate I" Paris, 1744 (see 2.18); and the English version of the same series by Thomas Palser, London, 1809-1818 (Acc# 77.10.1-6).

5. Wells, Roy A. - "The Tyler or Outer Guard", *Ars Quatuor Coronatorum*. Vol. 90, Abingdon, 1978. p.206.

6. Revolutionary War military hanger used by Russel Lodge, F.& A.M., Arlington, Massachusetts (Acc# 92.010).

7. See: *Minutes*, 1795, Columbia Lodge A.F.& A.M., Boston, Massachusetts.

8. Fleming, E. McClung. "From Indian Princess to Greek Goddess The American Image, 1783-1815." *Winterthur Portfolio*, vol. 3, 1967. Hamilton, John D. - "The Indian Princess and the Neoclassic Sword." *Man At Arms Magazine*, vol. 4, no.4, July/Aug 1984.

9. Peterson, Harold L. - *The American Sword 1775-1945*. New Hope, Pennsylvania, 1954.

10. The apron is dated January 20, 1823, and was owned by Andrew Bower Bohanon (b. 1795) of Salisbury Lodge, New Hampshire. Bro. Bohanon served in the Army during the War of 1812.

11. *Early History and Transactions of the Grand Lodge of Free and Accepted Masons of the State of New York, 1781-1815*. New York, 1876. Vol I, p.42. Order of march published in Grand Lodge on December 21, 1785.

12. Allyn 1831, 208. The maneuvers were not cutting strokes, but parries in mimicry, presenting the flat of the blade for contact.

13. U.S. Patent No. 21,933 issued on November 2, 1858.

14. Drummond's patent was issued on January 20, 1860.

15. *Masonic Messenger*. Vol. V, No.6, March 15, 1860. Simons had drafted the original 1856 resolution on costume that was adopted in 1859.

16. *History of Free Masonry in the State of New York*. Vol. IV, p.26. "A habit was growing rapidly upon the Lodges of the state of making presentations to individual members belonging to the Army, of swords, sashes and other impliments and insignia of war, clothing the language with expressions eminently calculated to weaken those Masonic bonds throughout the whole of these States."

17. U.S. Patent No. 67,800 issued August 13, 1867.

18. Also appeared in *Scientific American*, September 14, 1867. p.168.

19. U.S. Patent No. 79,761 issued July 7, 1868.

20. U.S. Patent No. 130,718 issued August 20, 1872.

21. U.S. Patent No. 112,131 issued February 23, 1871.

22. U.S. Patent No. 139,023 issued May 20, 1873.

23. U.S. Patent No. 112,729 issued March 14, 1871.

Illustrations

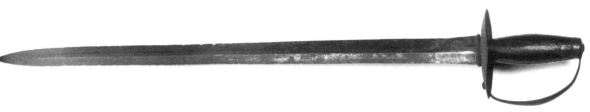

ILLUSTRATION:
4.61

4.61
Tyler's Sword
New England, c. 1775
Iron
Gift of Russell Lodge, F. & A.M.,
Arlington, Massachusetts, 92.010
Blade length: 25 ¾"

American infantry hanger with fragile iron knuckle bow, dished oval counterguard, leather-covered wood grip, and French blade. This crude blacksmith-made hilt is mounted with a cut-down 17th-century rapier blade inscribed "Moupetit, Fourbuseur Del Mais du Roy... St. Michel, A. Paris." This sword was given to Russell Lodge for use by their Tyler.

4.62 SEE ILLUSTRATION ON PAGE 146
Knight's Templar Sword
Dutch, c. 1770-1785
Brass
On loan courtesy of Harvey B. Leggee
Blade length: 26"

Dutch infantry hanger with brass hilt and two-branch counterguard. The grip backstrap is engraved "H. Fowle." Henry Fowle (1766-1837) received the Knight Templar degree in 1795 and became one of the organizers of Templarism in the United States. He was responsible for the formation of Templar ritual and became a noted authority on Templar ceremony. According to tradition, Bro. Fowle used this sword as a part of his Templar regalia.

4.63 SEE ILLUSTRATION ON PAGE 157, TOP LEFT
Tyler's Sword
Peter Knecht
Solingen, Germany, c. 1820-1835
Silver-plated brass
Special Acquisition Fund, 78.28
Blade length: 28"

Silver-plated cruciform hilt with a pommel in the form of a cross botonee (cluster of three buds). The pommel obverse shows a French style plumb level (*Niveau*); the reverse has a square and compasses within a triangle. The grip of reeded nacre plaques is secured by ferrules milled with a neoclassic vineleaf meander. Cruciform crossguard quillons also terminate in botonee crosses. A Masonic altar and the "three lights of Masonry" appear on the central portion of the guard, a beehive on the reverse. The quillons are decorated with the pillars of Solomon's Temple and a radiant sun and crescent moon. The partially blued and gilt-decorated diamond-section smallsword blade is marked "P. Knecht Solingen."

The distinctive curved legs of the compasses and the Niveau style plumb level indicate that this sword was hilted on the Continent for use in a symbolic degree lodge. The sword blade manufacturing firm of P.W. Knecht & Son was well established at Solingen by 1806. The firm's name was changed to P. Knecht about 1820.
Reference: Walter, John - The Sword and Bayonet Makers of Imperial Germany 1871-1918. *London, 1973.*

4.64 SEE COLOR PLATE, PAGE 275, TOP LEFT

Tyler's Sword

Pollard, Alford & Company
Boston, Massachusetts, c. 1877-1884
Gift of The Masonic Temple Association, Lawrence,
Massachusetts, 80.66.1
Blade length: 26 ⅜"

Silver-plated cruciform hilt with a pommel in the form
of a cross botonée. The hilt is nearly identical to that of
Acc# 78.28 except that it has a blue leather-wrapped
grip. The blue leather-covered metal scabbard has sil-
ver-plated mounts engraved with symbols of Craft
Masonry. The double-edged blade, of flat oval section,
is bright-etched with Masonic Craft symbols and in-
scribed "Phoenician Lodge." The ricasso is marked
"Pollard Alford & Co. Boston."

In 1830, Abner W. Pollard (d. 1886) opened a Boston
clothing store in partnership with Lendell F. Tarbett,
but by 1832 he was sole proprietor. In 1846, Pollard
was raised a Master Mason in Mt. Lebanon Lodge,
Boston and began to advertise himself as a draper and
tailor dealing in Masonic regalia. Bro. Pollard became a
retail agent of the Ames Sword Company, which al-
lowed him to market their regalia swords under his
own trade name. Late in his career, in 1877, he formed
a partnership with Frederick Alford (d. 1916) who had
been raised in Columbian Lodge in 1867. The firm
was chartered on October 1, 1877, and dissolved in
1884. Phoenician Lodge of Lawrence, Massachusetts
was chartered in 1871 and merged with Tuscan Lodge
in 1980.

4.65 SEE COLOR PLATE, PAGE 275, TOP RIGHT

Royal Arch Chapter Sword

Mrs. J.F. Marshall
Boston, Massachusetts, c. 1890
Gift of The Masonic Temple Association, Lawrence,
Massachusetts, 80.66.2
Blade length: 28"

Gilt cruciform hilt with a red leather-covered grip; the
pommel in the form of a knight's helmet; and the
crossguard langet decorated with a pickaxe, spade, and
crow (crowbar). The red leather-covered metal scab-
bard has gilt mounts, and a stud is mounted on the top
mount for suspending the sword from a baldric when
worn. The double-edged blade is of diamond cross-
section and decorated with bright-etched Royal Arch
symbols. An etched panel reserve is inscribed "Mt.
Sinai Chapter." The ricasso is marked "Mrs. J.F.
Marshall Boston Mass."

Certain working tools of operative stonemasons have
been chosen as symbols to teach lessons of morality for
various degrees in several Masonic Rites. The pickax,
spade, and crow are working tools adopted for perform-
ing ritual in a chapter of Royal Arch Masons. In

America a chapter, or lodge of Royal Arch Masons is
empowered to give the preparatory degrees of Mark,
Past, and Most Excellent Master. The color scarlet,
used on the leather-wrapped grip and scabbard, has
been adopted as the symbolic color of Royal Arch Ma-
sonry.

Mrs. Marshall, as well as a number of other such
widows, continued to operate the regalia business
founded by her husband.

4.66

Knight's Templar Sword

Ames Manufacturing Company
Chicopee, Massachusetts, c. 1859
Supreme Council Archives
Blade length: 24 ¾"

A standard militia non-commissioned officers sword,
with silver- plated cruciform hilt, plumed helmet-head
pommel, one piece reeded ivory grip, and shell-shaped
langets. The double-edged blade is bright-etched with
symbols of various Templar Degrees and with banners
engraved in dry point with the owner's name "J.D.
Kent," and "Richmond Encampment No. 2." The
ricasso bears the manufacturer's identification "Ames
Mfg. Co. Chicopee Mass." The black leather scabbard
has plain silver-plated mounts with the top scabbard
mount fitted with a stud for suspension in a frog or
leather socket.

In 1858 the Richmond, Virginia Commandry made a
trip to Boston to visit Revolutionary War historic sites.
To reciprocate the visit, the Boston and Providence
Encampments undertook a pilgrimage to Richmond,
Virginia in 1859. Involved were 79 members of De
Molay Encampment of Boston, and 67 members of St.
John's Encampment of Providence. The visitors were
hosted by Richmond Commandry No. 2. The sword's
owner, James D. Kent, was among the Boston contin-
gent.

The badge of a scallop shell was worn during the
Crusades by pilgrims to the Holy Land. As a memorial
of that pious journey, the scallop shell was worn on the
costume of a candidate in Templar degree ceremonies.
References: Memoir of the Pilgrimage to Virginia of the
Knights Templars of Massachusetts and Rhode Island,
May 1859. *Boston, 1859. Mackey 1915, 360.*

4.67 SEE COLOR PLATE, PAGE 275, BOTTOM LEFT

Knights Templar Sword

Ames Manufacturing Company
Chicopee, Massachusetts, c. 1858-1862
Gift of James H. Freeland, 79.24.3
Blade length: 27 ½"

Gilt hilt with plumed helmet-head pommel and black
wood grip plaques. A Passion Cross is inlaid on the ob-
verse plaque. An eagle (cock of resurrection) is carved

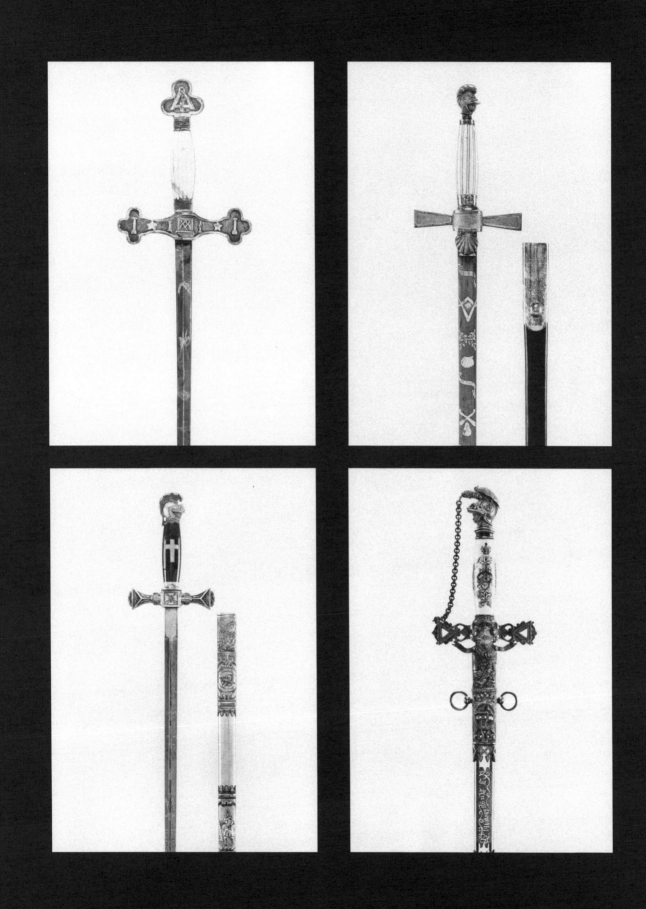

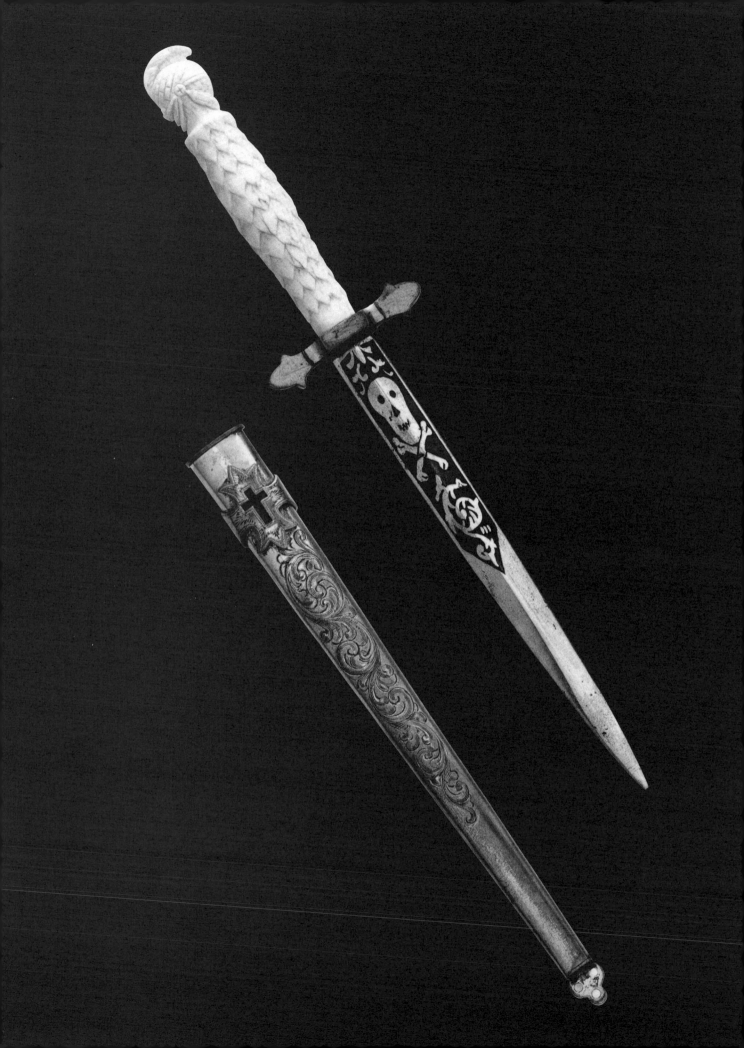

in low relief on the rectangular langet and quillons terminate in a Cross Patonce finial. The double-edged blade of flat oval section is bright-etched with strapwork, Templar symbols, and "Jas. H. Freeland DeMolay Encampment." The riccaso is marked "Ames Mfg. Co Chicopee, Mass."

The gilt brass scabbard is fitted for a two-ring suspension system. The top of the scabbard is engraved with the initials "J.H.F.," a brazen serpent on a cross, the Templar motto "In Hoc Signo Vinces," and a Masonic square and compasses. The reverse of the scabbard is stamped "Ames Mfg. Co. Mass."

A regular assembly of Knights Templars was originally called an "encampment," a term borrowed from the military. In 1863 the Grand Encampment of the United States changed the term "encampment" to that of "commandery." Thereafter, sword inscriptions followed prescribed terminology. This change aids in dating swords and other Templar articles.

4.68 SEE ILLUSTRATION ON PAGE 157, LOWER LEFT
Knights Templar Sword
David B. Howell
New York, New York, c. 1868-1875
Special Acquisitions Fund, 79.22.4
Blade length 27 ¾"

A silver-plated cruciform hilt with plumed helmet-head pommel, polished wood grip with inlaid Passion Cross, and square crossguard langet carved with a Templar Cross. The oval section blade is ground with a central fuller (groove) and bright-etched with a Cross of Salem, rayed Passion Cross, the Templar Beausant (war banner of the Medieval Templars), a Masonic square and compasses enclosing the letter "G," and the owner's name, "Thomas E. Miner." The ricasso is marked "D.B. Howell 434 Broadway New-York." The metal scabbard has silver-plated die-struck bronze mounts. The top mount depicts the Vision of Constantine, the Crown of Life, and the Templar motto "In Hoc Signo Vinces." A patented stud is affixed to the reverse for suspension. The mid-mount depicts the figure of a pilgrim warrior.

In 1868, David B. Howell succeeded William H. Price as proprietor of the American Masonic Agency located at 424 Broadway, New York. While supplying a wide variety of regalia to fraternal organizations, Howell retailed products made by sub-contractors such as Price's brother Virgil, whose sword manufacturing company was located at 144 Greene Street.

4.69 SEE ILLUSTRATION ON PAGE 157, LOWER RIGHT
Knights Templar Sword
E. A. Armstrong Company
Chicago, Illinois, c. 1895
Gift of Charles F. Ohl, 80.20
Blade length: 30"

A high-quality regalia sword with silver-plated cruciform hilt, chain link guard, and a helmet-head pommel surmounted by a mantling eagle. The ivoried grip is engraved with a "J.A.O." monogram and the engraving is filled with red and black wax. The crossguard langet is cast in the form of a knight's helmet with a banner inscribed "Knights Templar." Openwork red-enamelled triangles form the quillon finials. The double-edged blade of diamond section is bright-etched with a reserve panel inscribed: "J. Auguste Ohl." Near the hilt the blade is marked "The E.A. Armstrong Company Chicago," and stamped with the blade mark of Samuel Hoppe Sohn, Solingen. A nickled metal scabbard is etched with the owner's name, has silver-plated mounts, and a three-ring suspension system. The top mount depicts the Vision of Constantine and the Cross of Life. The mid-mount depicts the figure of a pilgrim warrior.

The owner of this sword, Jules Auguste Ohl (1848-1918), became a naturalized U.S. citizen on October 19, 1880, and lived in Utica, New York.

Edwin A. Armstrong (1848-1915) operated a family-run regalia business that his father had founded in Detroit in 1854 and which he relocated to Chicago in 1892 (*Detroit Free Press*, October 17, 1915).

4.70
Knight's Templar Dirk
Ames Sword Company
Chicopee, Massachusetts, c. 1890
Brass, ivory
Special Acquisition Fund, 80.64
Blade length: 5 ½"

Dagger with a one-piece ivory grip, carved with scales and a helmet head pommel. The blade is etched with designs of a square and compasses, skull and crossbones, and the Templar insignia of a cross-in-crown. The gilt brass sheath is engraved in rococo style floral strapwork and has a suspension mount in the form of a passion cross. Both real and false dirks were worn attached to a regalia baldric or sash as an insignia of the Templar order. Real dirks were prescribed for regalia worn by Knights Templars only in certain commanderies.

ILLUSTRATION: 4.70, FACING

ILLUSTRATIONS:
4.72, RIGHT

FACING PAGE:
4.73, TOP LEFT
4.74, TOP RIGHT
4.75, LOWER LEFT
4.77, LOWER RIGHT

4.71 SEE COLOR PLATE, PAGE 274
Knights Templar Sword
C.G. Braxmor Company
New York, New York, c. 1890
Gift of Mrs. Hugh B. Darden, 86.59.1
Blade length: 28"

Presentation grade regalia sword with gilt hilt and helmet-head pommel, one-piece ivory grip etched with "D.B.P." monogram. An enameled langet attached to the pierced crossguard is in the form of a Templar Cross and inscribed "York Commandery 55 New York." The double-edged diamond section blade is bright-etched with a gilt background. The obverse is inscribed "Dana B. Pratt" and the ricasso is marked "The C.G. Braxmor Co. 10 Maiden Lane New York." The gilt metal scabbard is decorated with a Passion Cross imposed on a silver plate of rays, the cross formed of twelve large garnets. The scabbard is engraved with a "DBP" monogram and other Templar symbols including the Gonfalon (banner), Templar crosses, and a Cross of Life.

4.72
Knight Templar
American, c.1860
Ambrotype
Half-plate
Special Acquisition Fund, 88.42.29

A young man in Knights Templar costume wearing an apron, baldric, gauntlets, shoulder tabard, Kossuth style chapeau, and a regalia sword with skull and crossbones pattern hilt.

The plumed headgear was associated with Bohemians in general and popularized by Hungarian political activist Lajos Kossuth (1802-1894). The Bohemian hat became a symbol during the 1840s and 50s of the bourgeoise struggle for political reform in Europe. As an honored political refugee in the United States, Kossuth was instrumental in popularizing the bohemian headgear at all levels of American society, but particularly among fraternal organizations and the military. In 1852 Kossuth was made a Mason "at sight" in Cincinnati Lodge #133, Cincinnati, Ohio; a prerogative of a Grand Master to confer the Craft degrees upon sight of the candidate. This was an honor accorded many important political figures.

The shoulder tabard and Kossuth style chapeau were adopted as a regulation costume for Sir Knights of San Francisco Commandery No. 1. The sword baldric is normally worn running from right shoulder to left hip, but appears reversed in the ambrotype image.

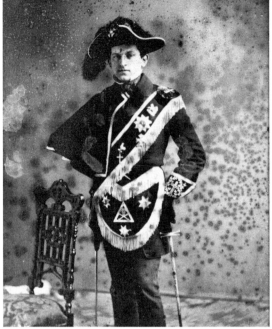

4.73
Red Cross of Constantine Sword
Ames Manufacturing Company
Chicopee, Massachusetts, c. 1872-1880
Special Acquisition Fund, 79.61
Blade length: 28 ¾"

Cruciform gilt hilt with a tri-lobed pommel (cross botonee) and grip wrapped with purple fabric. An oval langet on the crossguard bears a Greek Cross, the tips of which are inscribed with the letters "IHSV," representing the Templar motto "In Hoc Signo Vinces." The double-edged blade is etched with the legend, "St. Johns Conclave No. 85 Organized June 24th, 1872." The etched background has been bronze-filled. The ricasso is marked "Ames Mfg. Co. Chicopee, Mass." The metal scabbard has plain gilt mounts, purple velvet covering, and a two-ring suspension system.

The Masonic order of the Red Cross of Constantine was first organized in the United Kingdom in 1865, but was not introduced into the United States until the first conclave was established at Washington, Pennsylvania, on December 14, 1870. Membership is taken exclusively from the Masonic York Rite after reaching the Seventh Degree, and then only by invitation.

According to statute, members of the Grand Council wear a sword "Cross-hilted, and with crimson sheath" while all others wear a sword that is "Cross-hilted, purple sheath." This sword appears as pattern No. 117 in the Ames sword catalog of 1886.

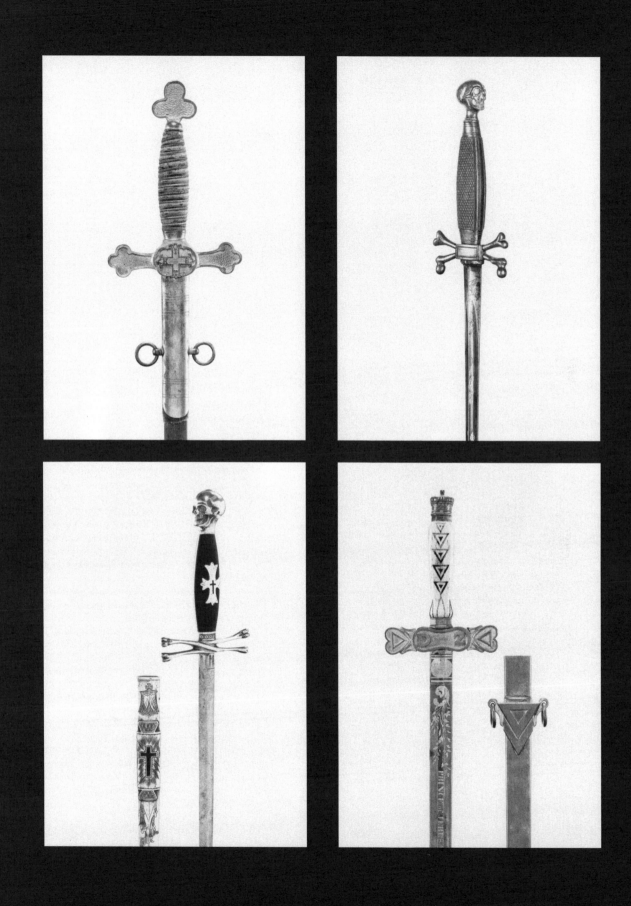

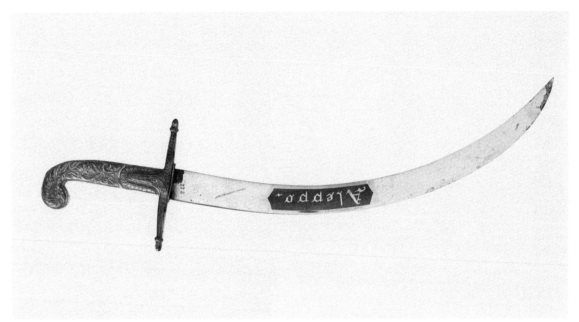

Reference: Proceedings of the Sovereign Grand Council
of the United States of America of Knights of the Red
Cross of Constantine, Holy Sepulchre and St. John,
1876, 77, 78 & 79. Philadelphia, 1879. Ames Sword
Company Catalogue. *Chicopee, c.1886.*

4.74 SEE ILLUSTRATION ON PAGE 161, TOP RIGHT

Consistory Sword

France
c. 1790-1820
Special Acquisition Fund, 79.8.1
Blade length: 30 ¾"

A smallsword style ritual sword with skull-shaped brass
pommel and checkered wood grip. Two crossed brass
femur bones form the quillons of the guard. The trian-
gular-section blade is blued with gilt-filled etched
decoration consisting of the interlaced triangles of
Solomon's Seal, trophies of a square and Jacob's Lad-
der, and compasses with sprigs of Acacia.

The use of such a morbid design is also appropriate
to Templar ritual that pertains to the Chamber of Re-
flection, in which the candidate contemplates symbols
alluding to his mortality.

4.75 SEE ILLUSTRATION ON PAGE 161, LOWER LEFT

Consistory Sword

Ames Manufacturing Company
Chicopee, Massachusetts, c. 1860-1880
Gift of Robert F. Rubendunst, 85.84
Blade length: 30"

A nickel-plated regalia sword with a skull-shaped pom-
mel and guard formed of two crossed femur bones. A
silvered Cross Patonce is applied to the middle of the
black wood grip. The double-edged blade of elliptical
section is etched with foliage, a Passion Cross, military
standards, an open Bible with key, and a knight's hel-
met. The ricasso is marked "Ames Mfg. Co Chicopee,
Mass." The nickel- plated metal scabbard is engraved
with a military tent (Taberna) and a rayed Passion
Cross. The reverse is stamped "Ames Mfg. Co.
Chicopee Mass." A patent sword hanger fitting is af-
fixed to the scabbard reverse.

The pattern of this sword was illustrated as No. 201
in the Ames sword catalog of 1886, where it was la-
beled a 32nd and 33rd Degree Consistory sword
(Scottish Rite). However, no markings on the sword in-
dicate that its use was restricted to a specific degree.
The pattern was equally applicable to chivalric degrees
in the York Rite.

This sword was acquired from the Taft family estate
in Cincinnati, Ohio. The manufacturer's markings in-
dicate that the sword probably belonged to Charles P.
Taft (1843-1929), brother of William H. Taft (27th
President of the U.S.). Charles Taft, editor/owner of
the *Cincinnati Times*, was exalted in Kilwinning Chap-
ter No. 97, on May 10, 1871.

4.76
Shrine Scimitar
M.C. Lilley & Company
Columbus, Ohio, c. 1916
Brass
On loan courtesy of Harvey B. Leggee
Blade length: 15 ½"

Solid cast hilt with Mameluke style grip and very curved, nickel-plated blade etched "Aleppo." The metal scabbard is covered with red morocco leather and has brass mounts. This costume sword was produced for the Arab Patrol of Aleppo Temple, Ancient Accepted Order Nobles of the Mystic Shrine, Boston, Massachusetts. The Arab Patrol is the personal staff of the Potentate of a Shrine temple and its purpose is to assist the officers in performing various ceremonies. Aleppo Temple's Arab Patrol was organized in 1885 to take charge of initiates and conduct them across the "burning sands" of the desert during initiation.

4.77 SEE ILLUSTRATION ON PAGE 161, LOWER RIGHT
Scottish Rite Sword
Nathan P. Ames
Springfield, Massachusetts, c. 1840-1847
Special Acquisition Fund, 89.75
Blade length: 22"

A regalia sword to be worn in the 16th Degree of the Ancient Accepted Scottish Rite. Gilt brass cruciform hilt, crown-shaped pommel, and bone grip carved with five tangent black triangles. The crossguard quillons terminate in heart-shaped finials that each contain an open triangle or delta. The crossguard langet is engraved with a balance scale in equipoise, flanked by the raised letters "D" and "Z." The double-edged blade has a central fuller and a bright-etched panel inscribed "Prince of Jerusalem." The ricasso is marked "N.P. Ames Cutler Springfield." The gilt brass scabbard is fitted with a top mount having an open triangle or delta, and two suspension rings. The chape or scabbard tip is in the form of a letter "D" enclosing a letter "Z."

Nathan P. Ames (1795-1847) founded America's largest sword manufacturing company at Cabotville, Massachusetts in 1831. His personal name was placed on all Ames sword blades until his death in 1847. Thereafter, markings reflect that the firm was incorporated as the Ames Manufacturing Company. This example represents one of the earliest commercially produced American regalia swords. The pattern was illustrated by Ames in the 1886 sword catalog as No. 152, a sword for Rose Croix. A similar pattern was also produced by rival sword manufacturer Christopher Roby of West Chelmsford, Massachusetts (Acc# 79.24.1).

The hilt and scabbard mounts allude to the jewel of the 16th Degree of the Scottish Rite, or Prince of Jerusalem. The ritual of the degree recalls the Biblical legend of Darius, King of Persia, who granted Zerubbabel permisssion to rebuild the temple in Jerusalem. Upon his return to Jerusalem Zerubbabel finds it is no longer the city of peace, and that no tribunal exists to judge equitably between men. Zerubbabel appoints five judges whose duties are to judge equitably and fairly.
References: Hamilton 1983. Sword Catalog, Ames Sword Company. *Chicopee, 1886.*

4.78 SEE COLOR PLATE, PAGE 275, BOTTOM RIGHT
Scottish Rite Sword
Christopher C. Roby
West Chelmsford, Massachusetts, c. 1863-1875
Gift of James H. Freeland, 79.24.1
Blade length: 24 ¼"

A regalia sword worn by 33rd Degree Masons of the Ancient Accepted Scottish Rite. A gilt brass hilt has a crown-shaped pommel, and an ivory grip is carved with five black open triangles. The langet is in the form of a triangle or delta engraved with a numeral "33." The crossguard quillons terminate in heart-shaped finials that enclose a delta. The double-edged blade has a central fuller and is bright-etched in floral patterns and panels inscribed "J.H. Freeland" and "S.G.I.G. 33 degree." The ricasso is marked "C. Roby and Co. W. Chelmsford, Mass." The gilt brass scabbard has a single mount decorated with a double-headed eagle clutching a wavy bladed sword in its talons.

Edged tool manufacturer Christopher Roby (1814-1897) produced nearly 35,000 military swords during the Civil War. In the post war period the Roby company augmented its limited production of military officers' swords with an expanded line of regalia swords. Bro. Roby was exalted in Mt. Horeb Royal Arch Chapter, Lowell, Massachusetts in 1862 and was forced to demit due to poor health in 1891.
References: Hamilton 1980.

4.79 SEE ILLUSTRATION ON PAGE 164
Scottish Rite Sword
M. C. Lilley & Company
Columbus, Ohio, c. 1930
Supreme Council Archives
Blade length: 27 ¾"

A 33rd Degree regalia sword worn by The Marshals of the Camp in the Supreme Council of the Scottish Rite for the Northern Masonic Jurisdiction. The gilt cruciform hilt has a pommel in the form of a sovereign's crown. Mother-of-pearl grip plaques are spiral-wrapped

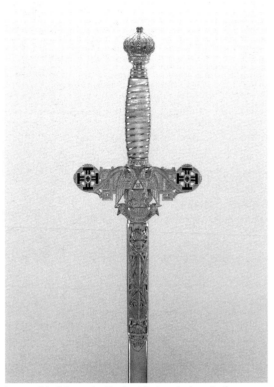

regalia. After Lilley's death in 1897, the company continued to operate and expand, and by 1924 it became the largest sword and regalia manufacturer in the United States.

Marshals of the Camp are officers of the Supreme Council who are appointed annually to act as a ceremonial escort for the Sovereign Grand Commander of the Ancient Accepted Scottish Rite.

References: Ohio State Journal, *June 23, 1897. Obituary of Mitchell C. Lilley.*

by a gold ribbon. A gilt double-headed eagle forms the counterguard. On its breast, a white-enamelled triangle bears the number "33," its talons clutch a wavy-bladed sword from which is draped a banderole inscribed with the motto "Deus Meumque Jus" (God and my Right). The quillons terminate in finials formed by the Jewel of the Kadosh, i.e., "a cross potent sable, charged with another cross double potent, or, and surcharged with an escutcheon argent, bearing a double-headed eagle, sable." The diamond section blade is etched with gold-filled foliate strapwork and a panel reserve inscribed "Supreme Council 33 A.A.S.R.N.M.J.U.S.A." Under the grip, the blade tang is stamped "Germany." The metal scabbard has gilt mounts with openwork floral patterns.

About 1840, Mitchell C. Lilley (1819-1897) formed a bookbinding partnership with Charles Siebert of Columbus, Ohio. The Siebert family printed Masonic lodge material. After having served in the Mexican War and the Civil War, Mitchell Lilley started a regalia business in 1865 that sold printed fraternal publications and swords. By 1887 the Lilley workshops employed 420 persons in the manufacture of Masonic

Chapter 5

Documents

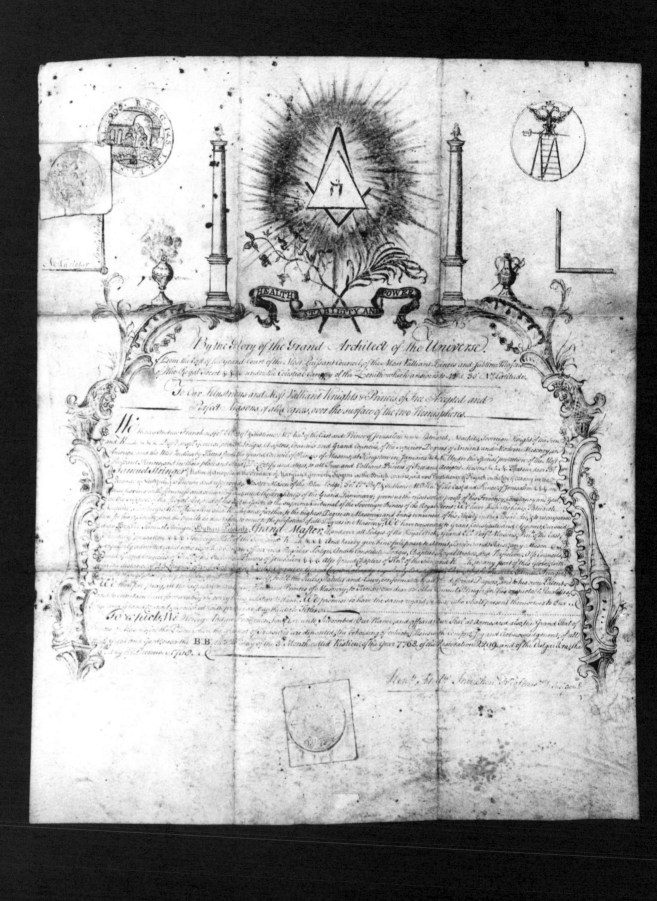

By the Glory of the Grand Architect of the Universe.

To Our Illustrious and Most Valliant Knights & Princes of Free Accepted and
Perfect Masons of all Degrees, over the surface of the two Hemispheres.

Documents

Charters and Warrants

CHARTERS — A LODGE "WORKS" OR OPERATES UNDER THE AUTHORITY OF A CHARter or Warrant of Constitution issued by a Grand Lodge. A group of Masons who wish to form a new lodge, must "work" temporarily under a dispensation issued by a Grand Master. This temporary dispensation is either revoked or confirmed at the next scheduled meeting of the Grand Lodge. Once a dispensation is granted, the founding members may then petition for a charter. Only chartered lodges are entitled to make bylaws, elect members, or have their officers installed. Every lodge must elect and install its officers on the constitutional night, which traditionally precedes the festival of St. John the Evangelist in December. Charters are preserved by the lodge and are presented for regular inspection by deputies from the Grand Lodge. They are calligraphic in nature and done on parchment with minimal illustration.

ILLUSTRATION: 5.33, FACING SEE DESCRIPTION ON PAGE 199

Military or traveling lodges operated under special warrants, which permitted them to travel from place to place with the regiments to which they were attached, and "work" with permission of the commanding officer. The Master was designated by the warranting authority. Military lodges have a long history in North America; the warrant for such a lodge was first granted in 1756 by the Grand Lodge of Massachusetts to Abraham Savage during the expedition against the French in Canada. A similar warrant was granted in 1756 to Col. Richard Gridley (1710-1796) for the expedition against Crown Point. Military lodges also existed during the Revolution and in all succeeding conflicts in which American military men have seen service.

Summonses

The custom of summoning the members of a lodge to every meeting is of very ancient origin, extending back to the 15th century when operative masters and fellows (fellowcrafts) were to be forewarned to come to congregations of the stonemasons guilds (Cooke MS.c. 1450). The Anderson *Charges* of 1723 stated: "In ancient times no Master or Fellow could be absent from the Lodge, especially when warned to appear at it, without incurring a severe censure." [1]

In the 18th century it became common usage to issue a *printed* summons as a warning to appear at each lodge meeting, but the earliest record of an *engraved* American sum-

mons is to be found in the minutes of First Lodge of Boston for June 28, 1741. The Secretary of First Lodge, engraver Peter Pelham (c. 1697-1751), was "directed to have a copper plate engraved for blank summonses." In as much as Bro. Pelham was one of Boston's leading engravers, it is reasonable to assume that he would have prepared the plate. Another early summons was specially engraved for Lodge No. 2 of Philadelphia ca. 1759, and bears the imprint of "Bro. Henry Dawkins" (fl. 1754-1780). The design was later copied by Bro. Paul Revere, Jr. (1735-1818) for a summons he produced for Boston's Lodge No. 169 during the late 1760s.

It remained the responsibility of each lodge to obtain its own summons; consequently, considerable latitude in artistic conception is evident in their design. A design might have far-reaching effect. Those produced by Revere were almost certainly used by New England ship captains to provide the painters of Chinese export porcelain with suitable Masonic inspiration. (See Chinese Export Ceramics).

Certificates

A certificate is a diploma issued by a Grand Masonic body, or by a regular subordinate body under its authority, testifying that the holder thereof has been "made" a true and trusty brother, has been initiated as a Master Mason or other specified degree, and is recommended to the hospitality of the fraternity around the globe. Inherent in such hospitality is a worthiness to receive aid from the brethren in the event of captivity, shipwreck, or some other circumstance of distress.[2]

As early as 1763, regulations required that Freemasons present a certificate that included the time and place of their "making" before being admitted to any lodge.[3] During the Grand Lodge of England's first forty years of existence (1717-1757), individual lodges issued "Clearance" certificates for members who traveled. Being hand-written on slips of paper, these vouchers were not durable and disintegrated easily.[4]

In 1755 the premier Grand Lodge of England (Moderns) awoke to the necessity of being able to identify its expanding membership and of the members being able to identify themselves to each other. A system of registration was instituted by issuing each brother a standard engraved certificate of membership.[5] The copperplate used to print the first certificate was designed and engraved by J. Cartwright (flourished 1754-1784). The image selected was composed of three female allegorical figures, Faith, Hope, and Charity. Faith and Hope were placed atop columns representing the three principal orders of architecture: Ionic, Corinthian, and Doric. Each order possessed structural attributes that corresponded to the theological virtues of wisdom, strength, and beauty. They also alluded to what were considered the three principal supports of each lodge: the Master and the Senior and Junior Wardens, respectively. Freemasonry was thus de-

picted as being in support of the highest moral goals. Such esoteric allusion to the Master and Wardens was further emphasized by the placement of their jewels of office against the base of each column.

Charity, surrounded by needy children, was seated on the ground between the column bases. A winged angel, representing the allegorical figure of Fame, flies above the image, her trumpet heralding the benefits of Freemasonry.[6] From the trumpet is suspended a banner that bears the inscription "Grand Lodge of England." When this design was adopted for private lodge use, the banner bore the name and number of the lodge.[7] Two of the columns often stand in perspective line at one side of the image, and the third column is positioned opposite to balance the design. An evenly balanced spatial division, with one column in the center, was also used to create a divided format that readily lent itself to the use of adjacent bilingual texts.[8]

American engravers readily and freely adapted English Masonic certificates.[9] Numerous lodge minutes recorded instances of committees being appointed to vet certificate designs and procure engraved plates. Such proceedings aid in establishing the date a certificate design was placed in use.[10] Plates commissioned for private use by a specific lodge had the lodge's name engraved in the text together with such allegorical Masonic vignettes and other devices as were deemed appropriate.[11] No official restrictions hindered artistic interpretation. As a result, American certificate designs either reflected an imitation of prior English examples, or a creative originality that often bordered on the whimsical.[12]

Spurred by the Neoclassical Revival, a number of standard variations on Cartwright's design evolved during the 1790s. The figures of Faith and Hope were often replaced by Minerva (wisdom and fortitude), Prudence (reflection), Temperance (restraint), Venus (beauty), or Justice (judgment), with the figure of Hercules providing an overt reference to strength. American engravers relinquished their penchant for the three pulchritudinous bare-breasted "Virtues" and began to provide their female figures with more modestly draped apparel. Thus, Cartwright's original inanimate allusion to the three principal officers of the lodge was either replaced or reinforced by the classical human form. As the number of allegorical figures expanded, so too did the number of architectural columns.

Another variation in the late 1790s depicted two pillars as opposed to three columns. The two pillars, known as Jachin and Boaz, represented the pillars that graced the portico of King Solomon's Temple. Early renderings show pillars with flat chapiter; later ones, after 1800, show pillars adorned with terrestrial and celestial globes. Alex Horne has observed:

> These Globes, as symbolical emblems representing the Earth and the
> Heavens, are believed to have rested on Lodge Floors in the early
> speculative days, and later came to be placed on Trestle Boards, along with

the other emblems of the Craft, as can be seen by reference to an illustration in the 1784 edition of the *Book of Constitutions*. But when this method of Masonic instruction was done away with, the Globes came to be superimposed upon the Pillars....many of our earliest illustrations of the Two Pillars show no spherical Globes whatever."[13]

A certificate engraved by Isaac Hutton and dated 1796 provides an illustration of flat-topped pillars while pillars depicted after 1800, by William Rollinson and others, appear surmounted by globes. The introduction of a certificate plate may occasionally be established from imprint information provided by the engraver, who often indicated that he was a brother Freemason, office holder, or member of a particular Masonic body (see Appendix). A plate engraved by William Rollinson for Phoenix Lodge No. 11 included the tidbit that he was "M. of P.L." (Master of Phoenix Lodge).[14] Although Francis Shallus engraved a certificate plate for Concordia Lodge No. 67, the imprint proclaimed that he was "S.W. Lodge No. 71, Philadela." (Senior Warden). Amos Doolittle's imprint on a Scottish Rite Patent included his title as "Sr. Kt." (Sir Knight).[15] From such clues, terms in office or admission to a specific Masonic body may be verified to provide an indication of when a plate was placed in use. Rarely, as in the case of Orramel Throop, did an engraver include the actual date of introduction in the imprint.[16]

The use of bilingual and trilingual texts insured that certificates could be understood wherever American Freemasons plied their trade. Mariners who frequented ports in the Mediterranian and West Indies found that a French version was desirable. In 1797 the Grand Lodge of Connecticut even specified that a certificate copperplate be procured that was "engraved in the English and French languages."[17] Latin was also used, but perhaps more for scholarly effect than illumination. Many Americans traded into South America where a Spanish text also proved helpful. Traveling certificates in particular made use of trilingual texts in English, French, and Spanish; an example of which is the certificate from Mariner's Lodge No. 385 of New York City. (see 5.22)

A certificate was not intended to act as a prima facie voucher for the bearer, but as *collateral* evidence of being a brother in good standing of whatever designated degree or body. The bearer was also required to undergo strict oral examination on points of ritual in order to gain access to lodge meetings. The phrase "Ne Varietur" (lest it should be changed) designated an area on certificates reserved for the owner's signature, which was affixed upon issue and could be used to confirm his identity. Many early certificates admonished brethren to "compare the bearer's hand writing with the name in the margin." All signatures thereon, including that of the lodge's Master and Secretary, were validated by having the seal of the lodge affixed to the document.

In the early decades of the 19th century many "impostors" attempted to gain access to lodges and lay claim to financial assistance. The oral examination process could become subverted by pseudo knowledge gained from numerous published exposes of the ritual, but documentation by sealed certificate did much to uncover such frauds. Discovery of Masonic impostors resulted in their names and descriptions being broadcast in Masonic publications and interlodge correspondence.

In England the issue of privately printed lodge certificates tended to perpetuate the Ancients vs. Moderns feud. The engraved plate designs invariably contained reference to armorial arms and crests of "Ancient York" or "Free and Accepted" lodges. After the Grand Union of 1813, steps were taken to dissolve these images into a noncontroversial design. In September 1818 the United Grand Lodge of England passed a resolution that, in effect, prohibited lodges from granting privately designed and printed certificates.[18]

At the beginning of the 19th century, American certificates too began to emanate from Grand Lodges, but, without a supreme control over the many autonomous American Masonic jurisdictions, their introduction occurred on an erratic basis. The text of these certificates, or "diplomas," was all-purpose in nature, leaving an open blank space for manuscript insertion of the name of a lodge. A subscript affidavit would attest that the lodge itself was in good standing with the Grand Lodge. Costs incurred by engraving the plates and printing the diplomas were defrayed by imposed registration fees that were usually used to build general charity funds. Occasionally, a plate intended to print certificates was altered to also print Masonic aprons.[19]

Patents

Patents are commissions granted to certain individuals authorizing them to confer degrees and form new bodies in the Ancient Accepted Scottish Rite. These "higher degrees" were brought to America in 1761 by Stephen Morin (n.d.), whose own patent was issued by the Grand Consistory in Paris. The patent empowered him "to multiply the Sublime Degrees of High Perfection and to create Inspectors in all places where the Sublime Degrees are not established."

After issuing patents to establish Sublime bodies in Santo Domingo and Jamaica, Morin also appointed many Deputy Inspectors who helped further this work in both the West Indies and North America. Prominent among Morin's followers were Henry A. Francken (1720-1795) of Albany and Frederick Dalcho (1770-1836) of South Carolina. Through these brethren, and the patents they in turn issued to others, early dissemination of the Sublime Degrees of the Scottish Rite occurred at Albany (1767), Philadelphia (1782), Charleston (1783), Holmes' Hole on Martha's Vineyard (1791), and Baltimore (1792).

In 1806, Scottish Rite bodies suddenly flourished in New York City under patents issued by Deputy Inspectors Antoine Bideaud, Abraham Jacobs (? -1834), and Joseph Cerneau (1763- ?). The three competed with each other in a race to sell patents for degrees for which they had no authority to confer. Cerneau's patent was typical of the others; it gave him authority to establish Sublime Degrees on the northern half of the island of Cuba, but none beyond the 25th Degree. However, in New York, Cerneau proceeded to create a Supreme Council of the 33rd Degree. The legally empowered Supreme Council of the Scottish Rite sitting at Charleston, South Carolina declared in 1813 that he and the others had exceeded the authority of their patents. The body Cerneau established in New York was declared spurious, and he was branded a "charlatan."

The Jacobs and Bideaud bodies acknowledged Charleston's authority, were regularized (made official), and received into the fold of the Ancient and Accepted Scottish Rite. In order to control further irregularities it was then decided to establish a second Supreme Council of the United States of America, to administer a "Northern District and Jurisdiction." Two jurisdictions had originally been authorized for America, but the second was not created until the situation in New York made it expedient to do so. The disruptive effect of Cerneau and his adherents, among whom were DeWitt Clinton (1769-1828) and Cadwallader D. Colden (1769-1834), lingered for many years afterward.[20] In contention with the Cerneauites were the principal officers of the recognized Jacobs-Bideaud bodies, which included State Governor Daniel D. Tompkins (1774-1825) and John James Joseph Gourgas (1777-1865).[21]

Another form of patent is a letter of credence, which is more akin to a certificate in that it attests that the bearer possesses certain "higher degrees" in Scottish Rite, but not necessarily all of them. A letter of credence issued by the Southern Jurisdiction may pertain only to the Lodge of Perfection (4th thru 14th Degrees), Chapter Rose Croix (15th thru 18th Degrees), Council of Kadosh (19th thru 30th Degrees), and Consistory (31st and 32nd Degrees), or all of them. In the Northern Jurisdiction the distribution of degrees among the several bodies of the Rite differ: Lodge of Perfection (4th thru 14th Degrees), Council of Princes of Jerusalem (15th and 16th Degrees), Chapter Rose Croix (17th and 18th Degrees), and Consistory (19th thru 32nd Degrees).

1. This universal aspect of reciprocal acceptance and assistance was emphasized by engravers Amos Doolittle, Samuel Hill, and Orramel Throop, whose plates incorporated terrestrial globes having meridians upon which pertinent text appeared.

2. *The Pocket Companion And History of Free-Masons.* London, 1764.

3. Only a few certificates survive from this period. Another contributing factor was that a preoccupation with secrecy caused the brethren to have their personal Masonic documents destroyed when they died.

4. Premier Grand Lodge of England; Meeting minutes, February 24, 1755.

5. A male angelic figure, intended to represent the genius of Masonry, appeared in Cipriani and Sandby's frontispiece to the 1784 edition of *Constitutions of the Antient Fraternity of Free and Accepted Masons* and inspired its further use on certificates. However, a male figure was seldom chosen to represent Fame.

6. See Doolittle's certificate for the Grand Lodge of Connecticut, and Maverick's certificate for Alexandria Lodge No. 22 (Library Collection 78-798). Similar Grand Lodge certificates were engraved by Billings and by Rollinson for New York, by Thackara for Maryland, and by Longacre for Virginia.

7. Engravers Paul Revere, Andrew Billings, and Amos Doolittle were among the chief American proponents of Cartwright's design.

8. See Haunch 1969, for a survey of English private and Grand Lodge certificates.

9. *History of Royal Arch Masonry*. 3:925. - Minutes of St. Andrews Royal Arch Chapter, October 21, 1790 - "Voted: that Bros. McKean, Moore, Groves & Hurd be a committee to procure a plate for the summonses to be stamped on." This plate, engraved by Benjamin Hurd, Jr., had chapter and commandery emblems on it.

10. See certificates by Rollinson for three examples based on the same design.

11. See the *Engravers Act of 1735*. England's copyright protection for engravers did not extend to the United States.

12. Horne 1958, 206-225.

13. William Rollinson (1762-1842) served as Master of Phoenix Lodge No. 11 from 1795 to 1797, and in 1800.

14. Amos Doolittle (1754-1832) became a charter member of New Haven Commandry No. 2, Knights Templar, in 1825.

15. *Proceedings of the M.W. Grand Lodge of AF&AM, of the State of Maine. vol.I (1820-47)*. For procurement of Throop's Past Master's diploma see Minutes for April 8, 1822 and July, 1824.

16. *Minutes of the Grand Lodge of Connecticut*, October 18, 1797 - "...to procure a copper-plate Grand Lodge certificate to be engraved, in the English and French languages, showing that the bearer is a member of a regular lodge under the jurisdiction of the Grand Lodge of Connecticut, which certificate shall bear the seal of the Grand Lodge, attested by the Grand Secretary, and any brother in good standing, whose name has been returned to the Grand Lodge, shall be entitled to a copy of such certificate, upon paying the sum of one dollar."

17. *Minutes of the United Grand Lodge of England, September, 1818*. "Resolved, That no Lodge shall grant a private Certificate, except for the purpose of obtaining a Grand Lodge Certificate, nor shall a Lodge, under any pretence, make a charge for such a private Certificate."

18. *Franco 1980, 89*.

19. Until the 1890s.

20. Baynard 1938, 1:153-213.

Illustrations

ILLUSTRATIONS:
5.01, LEFT
5.02, RIGHT

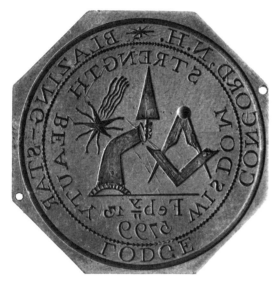

5.01

Lodge Seal
Blazing Star Lodge No.11
Concord, New Hampshire, c. 1799
Brass
Gift of William E. and Arthur D. Taylor
in memory of William B. Taylor, Sr., 91.044
dia.: 1 ¾"

Octagonal planchet with reversed intaglio design of
square and compasses, an upraised arm displaying a
trowel (heraldric crest of the Freemasons Arms), a star
with blazing trail, the motto "Wisdom, Strength,
Beauty," and "Feby 13, 5799" in exergue. The border
is inscribed "Blazing Star Lodge * Concord, N.H."
Seals were used to authenticate official lodge corre-
spondence and membership certificates.

5.02

Lodge Charter
North Star Lodge
Manchester, Vermont, c. 1785
Parchment
Archives Collection, MA007
h: 26" x w: 22"

North Star Lodge was one of five Vermont lodges that
were chartered by the Grand Lodge of Massachusetts.
Prior to the establishment of Vermont's own Grand
Lodge in 1794, lodges in that state received their char-
ters from either the Grand Lodge of New York or the
Grand Lodge of Massachusetts. North Star's charter
was drafted in manuscript and signed by Joseph Webb
(1734-1787), who presided as Grand Master, and by
Paul Revere, Jr. (1735-1818), who was then Deputy
Grand Master.

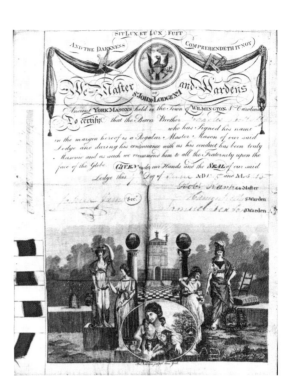

5.03
Lodge Summons
Henry Dawkins (C. 1735-c. 1790), engraver
Philadelphia, c. 1757
Imprint: "Brother Henry Dawkins Sculpt Philada"
Copperplate engraving
Special Acquisition Fund MA 001.015

A summons engraved for Lodge No. 2, A.Y.M., Phila-delphia. This summons was circulated on May 13, 1760, to inform the brethren that a meeting was to be held at the house of Bro. James Bell who had been ini-tiated in the lodge on January 6, 1760.

Henry Dawkins engraved the plate for this sum-mons in September 1757. On March 12, 1761, it was noted in the minutes of the lodge that "the original plate (summons) had been altered so as to read "No.2 Ancient York Masons." A membership certificate for the lodge was not engraved until after December 14, 1763, when Bro. Alexander Rutherford was directed to "get a plate cutt for a Certificate as ye Lodge shall Judge proper." A number of brethren demitted from Lodge No. 2 in December 1764 to form Lodge No. 3; Henry Dawkins was among them.

5.04
Private Lodge Certificate
St. John's Lodge No. 1, A.Y.M.
Wilmington, North Carolina
William Rollinson (1762-1842), engraver
Imprint: "Bror. Rollinson Sculpsit New York"
Line engraved
Library collection, 80-106

An "Ancients" Master Mason's certificate with sealed ribbon. Above nine lines of text are a central medallion of the Arms of the United States, swagged drapery, and displays of Masonic tools. Beneath the text is a vi-gnette of allegorical figures representing the four moral virtues: Justice, Prudence, Temperance, and Fortitude. An empty halter lies near Temperance; a lion reclines beside Fortitude. In the background, globed Ionic and Corinthian pillars give entrance to a mosaic paved forecourt leading to King Solomon's Temple. In the foreground is an oval reserve of the figure of Charity. Blanks in the printed text were completed in manu-script with appropriate information. The certificate was made out to Charles Bellamy and is dated June 7, 1815.

General Henry Knox (1750-1806) called upon Rollinson to engrave the great seal of the United States upon a set of gilt buttons for the coat worn by General George Washington on the day of his inauguration as president, at New York City Hall on April 30, 1789. The Bible that Washington took his oath of office on was provided by St. John's Lodge. Rollinson placed

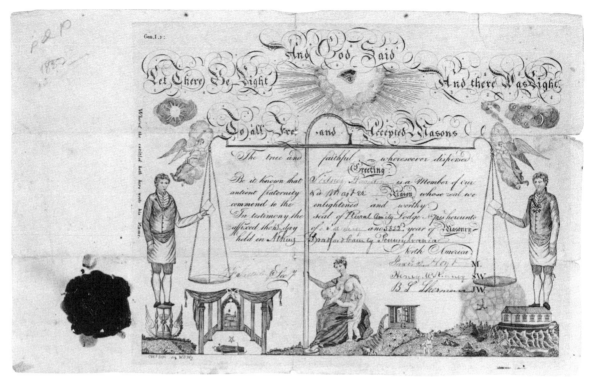

a similar great seal on St. John's certificates to recall the role the lodge played on that historic occasion.

5.05

Open Lodge Certificate

Charles Cushing Wright (1796-1846), engraver
Homer, New York, c. 1816-1818
Imprint: "CW.t Scpt. for W.B.W.y"
Line engraving
Library Collection 78-968

An unspecified degree certificate with wax seal. A design of the all-seeing eye lies above nine lines of text and balance scales held in equipoise by winged angels. At the left the figure of a lodge Secretary stands on a winged hourglass; at right, a Treasurer stands on the Ark moored by the anchor of Hope. Both figures wear aprons and their respective jewels of office, and present account books to be weighed. The figure of Charity supports the scale. Across the base are additional vignettes of the veiled Royal Arch sanctum sanctorum and a tyled lodge portal. The text was completed in manuscript for Sidney Hayden, Master [Mason] of Rural Amity Lodge No. 70, F.& A.M., Athens, Bradford Co., Pennsylvania, and is dated January 15, 1832.

Wright moved to Homer, New York in 1816 while in the employ of silversmith John Osborn. While residing in Homer, Wright engraved plates for William B. Whitney that included a Craft apron, a Royal Arch apron, and an open Master Mason's certificate. Whitney is believed to have been in the printing or mercantile business. He and Osborn were both members of Homer Lodge No. 137. About 1819, Wright departed Homer and briefly worked in New York City before settling in Savannah, Georgia.

William B. Whitney was twice sued for debts owed to Charles Cushing Wright; each claim amounted to about $20. This legal action might possibly have arisen over payment for engraving the plates. In 1820, Whitney's name disappears from Homer census records but reappears in the Town of Groton, Tompkins County.

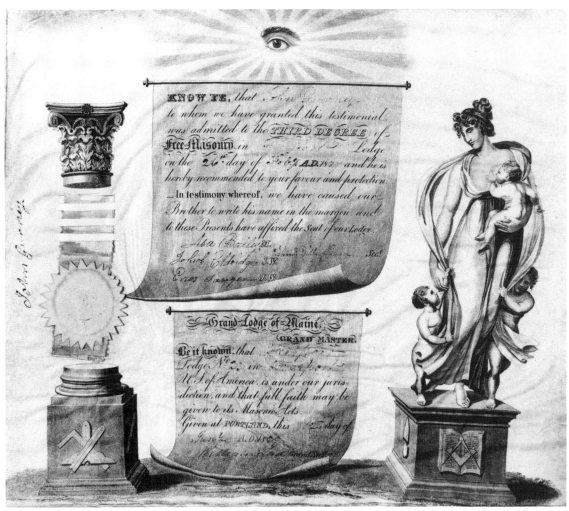

5.06

Master Mason's Certificate

Grand Lodge of Maine
William B. Annin (fl. 1813-1839) and
George Girdler Smith (1795-1878), engravers
Boston, Massachusetts, c. 1819-1823
Imprint: "Annin & Smith Sc."
Line engraved with roulette
Library Collection 78-966

A Third Degree Master Mason's certificate with sealed
ribbon. A design of an all-seeing eye lies above two
banners of text; the upper banner a testimonial from
lodge officials, the lower banner from the Grand Lodge
of Maine. At right is the figure of Charity on a pedes-
tal; at left, a Corinthian column, comprised of capital
and base with the column left blank for a ribbon and
Seal. The text was completed in manuscript for John
Gurney of Freeport Lodge No. 23, Freeport, Maine
and is dated February 26, 1827.

William B. Annin and George Girdler Smith were in
partnership as engravers and printers from 1819 to
1823 and from 1826 to 1833. Bro. Smith remained ac-
tive in Masonry until his death.

5.07

Open Masonic Certificate

Grand Lodge of Massachusetts
Hammatt Billings (1818-1874), artist
George G. Smith (1795-1878), engraver
Boston, Massachusetts, c. 1842
Imprint: "H. Billings, Del." and "G.G. Smith, Sc."
Line and stipple engraving
Archives Collection 76-293

An open certificate for a Master Mason, with printed
seal. The design is composed of a central Masonic altar
flanked by blocks of rough and smooth ashlar, and
Gothic architectural memorial spires. An all-seeing eye
appears above twelve lines of text between the spires.

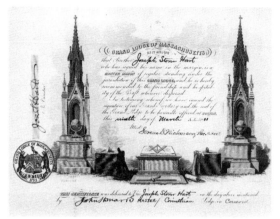

The text was completed in manuscript for Joseph Storer Hart of Corinthian Lodge, Concord, Massachusetts and is dated March 9, 1903.

On December 9, 1829, it was reported in Grand Lodge that "a travelling diploma was not considered necessary for the accommodation of the fraternity inasmuch as its members are generally already provided with Diplomas." Further action on the matter was deemed "inexpedient." The need for a new plate appears to have risen again, for, on December 14, 1842, a committee reported that they had "caused a suitable plate for a Gr. Lodge Certificate to be engraved...." The plate bears Billings' imprint and is another of his early efforts, but the A.L. date line was altered much later for use in the 20th century. (See Appendix IV.) Reference: *Proceedings of the Most Worshipful Grand Lodge of Ancient Free and Accepted Masons of the Commonwealth of Massachusetts for the years 1826 to 1844 Inclusive.* Cambridge, 1905. pp. 160, 162, 573.

5.08

Past Master's Certificate

Grand Lodge of Massachusetts
John Hawksworth (fl. 1819-1848), engraver
c. 1820-45
Imprint: "Engraved by Hawksworth"
Line engraved on steel
Library Collection 83-237

A open certificate commemorating past service as Master of a lodge. An all-seeing eye and a dove in flight appear above the figures of Minerva (wisdom), Hercules (strength), and Venus (beauty) on a three-step altar with a tablet bearing seventeen lines of text. The text was completed in manuscript for Albert L. Saunders of Charles River Lodge, West Medway and is dated September 19, 1923.

This neoclassical design was popular for more than a century. An identical design appeared on a needlework memorial picture, dated 1808 (Acc# 76.33.1), commemorating the term in office of Benjamin Russell

(1761-1845) who served as Master of Rising States Lodge, Boston. Engraver John Hawksworth was active in London, England from 1819 to 1848, but the printed pro forma Anno Lucius date of "A.L. 59__" would indicate that the plate was a 20th century restrike. (See Appendix IV.)

5.09

Master Mason's Certificate

Amos Doolittle (1754-1832), engraver
New Haven, Connecticut, c. 1815
Imprint: "Drawn and Engraved by Brother Amos Doolittle New Haven for H. Parmele, Copy right secured, The above may be had of Brothrs. Wm. McCorkle, Phila., Saml. Maverick, N. York, A. Doolittle, New Haven, and I.W. Clark Albany. DIPLOMA of the 3rd DEG."
Stipple and line engraved
Library Collection 76-322

An open Master Mason's certificate with sealed ribbon. A design of a central globe is mounted on a pedestal, with eleven lines of engraved text. The globe is supported by the female figures of Hope and Charity standing on pedestals bearing scenes of stonemasons working rough and smooth ashlar, and jewels of the Master and Wardens. Behind and above the globe stands the

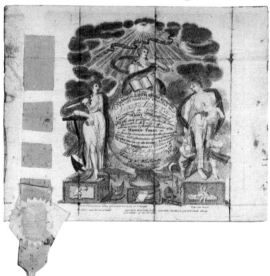

figure of Faith. In the background is a radiant cloud, the all-seeing eye, and a banner inscribed "Sit Lux Et Lux Fuit." Other Masonic symbols appear between the pedestals. The text was completed in manuscript for Edward M. Griffing of Amicable Lodge No. 36, Herkimer, New York, and is dated October 18, 1819.

This design was adopted by other engravers (see 5.10). Amicable Lodge No. 16 was chartered by the Grand Lodge of New York in 1794.

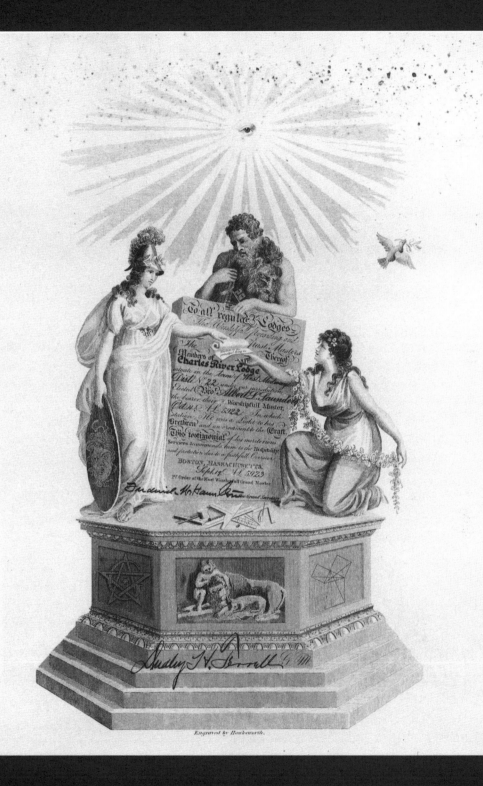

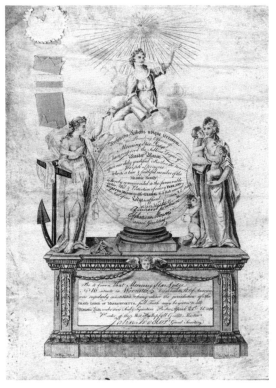

5.10

Master Mason's Certificate
Grand Lodge of Massachusetts
D. Raynerd (fl. 1803), artist
Samuel Hill (1750-1803), engraver
Boston, Massachusetts, c. 1802
Imprint: "D. Raynerd, Del." and "Saml. Hill Sculpt."
Line engraved
Library Collection 83-355

An open Master Mason's certificate with sealed ribbon.
A globe of text is mounted on an altar between the fig-
ures of Hope and Charity. Jewels of the Master and
Wardens appear beside the globe's base. A panel on
the altar is reserved for certification from the Grand
Lodge of Massachusetts. The figure of Hope is seated
on a cloud above the globe and basks in radiance from
the all-seeing eye. The text was completed in manu-
script for Joseph Sprague of Morning Star Lodge,
Worcester, Massachusetts and is dated April 21, 1812.

On January 17, 1798, it was voted in Grand Lodge
that a committee, consisting of Paul Revere, Isaiah
Thomas, and the Rev. Harris, be chosen for the
purpose of "determining the form of a plate for print-
ing certificates and to procure the same." On
December 15, 1801, the form of the design was ap-
proved with the stipulation that "At the foot of the
diploma shall appear a certificate, signed by the Grand
Secretary, by order of the Grand Master, expressing

the date of the charter of the Lodge unto whom it is in-
tended to be issued, and that the same was regularly
constituted and is under the Jurisdiction of this Grand
Lodge."

During the first decade of the 19th century, Masonic
membership in Massachusetts experienced a dramatic
increase. The number of certificates that were printed
began to effect the condition of the copperplate. By
March 1812, "...the diploma plate for initiates, was so
worn that fair and legible impressions could no longer
be taken from it...." In consequence, a committee was
appointed to look into having the old plate repaired or
procuring a new engraving.
Reference: Proceedings of the Most Worshipful Grand
Lodge of Ancient Free and Accepted Masons of
the Commonwealth of Massachusetts. *Cambridge, 1905.*

5.11

Past Master's Certificate
Grand Lodge of Maine
Orramel Hinckley Throop (1798- ?), artist and engraver
Portland, Maine, dated 1824
Imprint: "Designed and Engraved by O.H. Throop,
Portland, Me, 1824"
Line engraving
Library Collection 78-967

An open Past Master's certificate with seal. The design
is composed of a globe with text, resting on mosaic
pavement between two pillars surmounted by the fig-
ures of Faith and Hope. The square and compasses
rest on an open book placed at the base of the globe.
Figures of Charity and a "Weeping Virgin," accompa-

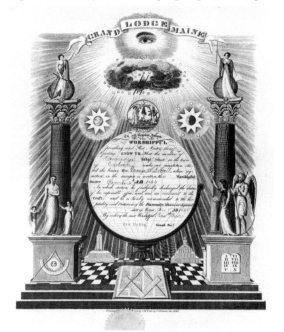

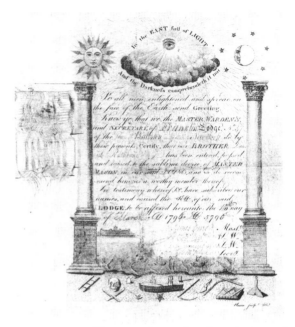

nied by Father Time, stand on pedestals at the base of each pillar. The pedestals bear the jewel of a Past Master and tablets of the Ten Commandments. A plumb rule is displayed on a two-tiered block while a level appears on a three-tiered block. Circular clouds above the globe contain a radiant sun and crescent moon with seven stars. At the globe's North Pole appears the Arms of the State of Maine. Above, a ladder leads through an opening in the clouds to the all-seeing eye. A ribbon above the eye is inscribed "Grand Lodge Maine." The engraved text was completed in manuscript for George W. Sewall of Harmony Lodge, Gorham, Maine and is dated January 8, 1868.

Throop arrived in Portland late in December 1823 and remained in business there until the following August. He next appeared in New York City in 1825, and later in New Orleans from 1831 to 1832. In the December 30, 1823, issue of the *Eastern Argus*, Throop advertised a willingness to do "all kinds of Seals, and Masonic Engraving."

In January 1824 the Grand Lodge empowered a committee to procure a plate for Past Master's diplomas, for under $150. In July "The Committee on Past Master's Diplomas, reported, that they had completed the business assigned them by procuring a plate and having a sufficient number of Diplomas printed for present use."

Reference: Shettleworth 1971. Proceedings of the M.W. Grand Lodge of AF&AM, of the State of Maine. *Portland, 1872. Vol. I (1820-1847).*

5.12
Open Lodge Certificate
Isaac Hutton (1767-1855), engraver
Albany, New York, c. 1796
Imprint: "Hutton, Sculp. Alby"
Line engraving
Library Collection 78-831

An open Master Mason's lodge certificate with sealed ribbon. The design composed of a radiant all-seeing eye, sun, crescent moon, and seven stars above twin unadorned pillars. Between the pillars are fourteen lines of text. In the background to the left is a small view of King Solomon's Temple. Various Masonic symbols appear in the foreground, including Jacob's Ladder, skull and crossbones, Euclid's 47th problem, Hiram's coffin with a sprig of acacia, and an hourglass, a scythe, trowel, 24-inch marking gauge, plumb rule, square and compasses on a Bible, and a plumb level. The text was completed in manuscript for Daniel Rathbone of Franklin Lodge No. 37, Ballston Spa, New York and is dated March 1, 1796.

The Grand Lodge of New York granted a warrant to Franklin Lodge No. 37 on May 6, 1794. Isaac Hutton (1767-1855) began working in Albany as a silversmith and engraver in 1796. This certificate would appear to have been one of his earliest commissions.

5.13 SEE ILLUSTRATION ON PAGE 182

Private Lodge Certificate
Independent Royal Arch Lodge No. 2
New York, New York
William Rollinson (1762-1842), engraver
New York, New York, c. 1795
Imprint: "Bror. Rollinson, Sculpt."
Line engraving
Library Collection 79-1204

A Master Mason's certificate with sealed ribbon. The design is composed of two pillars with pedestals bearing tablets decorated with three candlesticks (Lights of the Lodge) and the square and compasses on a Bible (Three Lights in Masonry), and their chapiter surmounted by the figures of Faith and Hope. Between the pillars are sixteen lines of English text; beneath the text on a mosaic pavement is the figure of Charity supporting the armorial Arms of the "Ancients." Within a radiant cloud above the text is a triangle inscribed in Hebrew with the ineffable name of God, an all-seeing eye, and the heads of three winged cherubim. The text was completed in manuscript for Robert Palmer and is dated February 10, 1795.

This certificate is an example of a rare American use of the Arms of the "Ancients." William Rollinson (1762-1842) was active as an engraver in New York City from 1789 until his death in 1842.

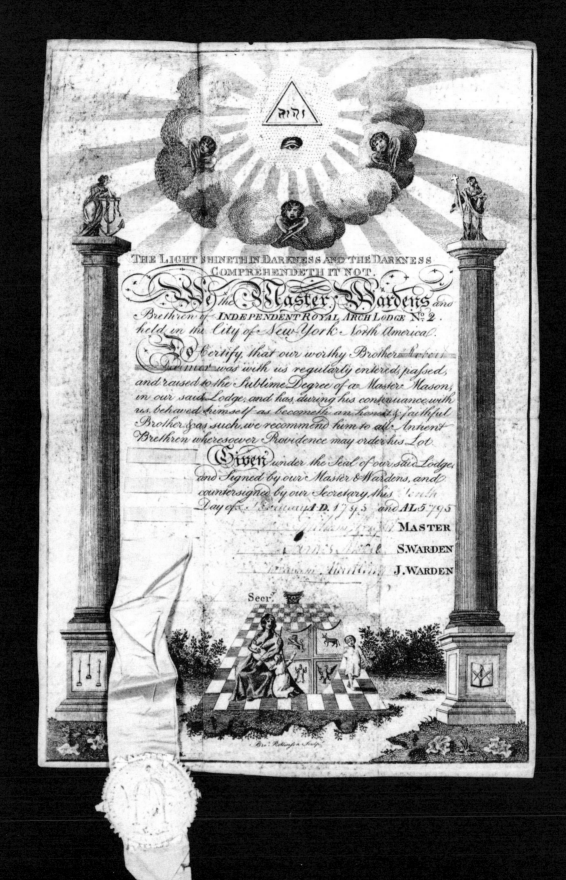

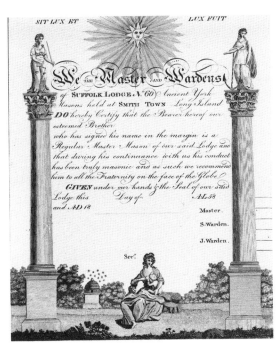

5.14

Private Lodge Certificate
Suffolk Lodge No. 60, A.Y.M.
Smith Town, Long Island, c. 1800
William Rollinson (1762-1842), engraver
Imprint: "Bror. Rollinson Scul."
Line engraved
Library Collection 84-01

Blank Master Mason's certificate. The design is composed of two pillars surmounted by figures of Justice and Hope. Between the pillars are thirteen lines of English text. Beneath the text the figure of Charity sits beside a beehive. Above the text are a radiant sun and the motto "Sit Lux Et Lux Fuit."

The Grand Lodge of New York warranted Suffolk Lodge No. 60 on March 7, 1797. Engraved date prefixes for the common year (A.D. 18__) and the Year of Light (A.L. 58__) indicate that Rollinson engraved this plate at the beginning of the 19th century. (See Appendix III.)

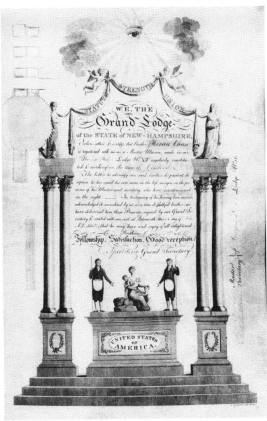

5.15

Master Mason's Certificate
Grand Lodge of New Hampshire
Alexander Anderson (1775-1870), artist and engraver
New York, New York, c. 1797-1815
Imprint: "A. Anderson del. & sc."
Line engraved
Library Collection 78-965

An open Master Mason's certificate with sealed ribbon issued by the Grand Lodge of New Hampshire. The design is composed of paired twin columns mounted on pedestals resting on a three-step dias. The columns are surmounted by figures of Hope and Faith who are assisted by two cupids in supporting swagged drapery inscribed "Statute Strength Union." Within a cloud above the drapery is a radiant all-seeing eye. Beneath the drapery are seventeen lines of English text and an altar upon which is seated the figure of Charity, flanked by Masons wearing aprons and carrying staffs. The altar panel is inscribed "United States of America." The text was completed in manuscript for Horace Chase of Blazing Star Lodge No. 11, Concord, New Hampshire and is dated November 14, 1815.

After graduating from Columbia Medical School in 1796, Alexander Anderson (1775-1870) decided that he

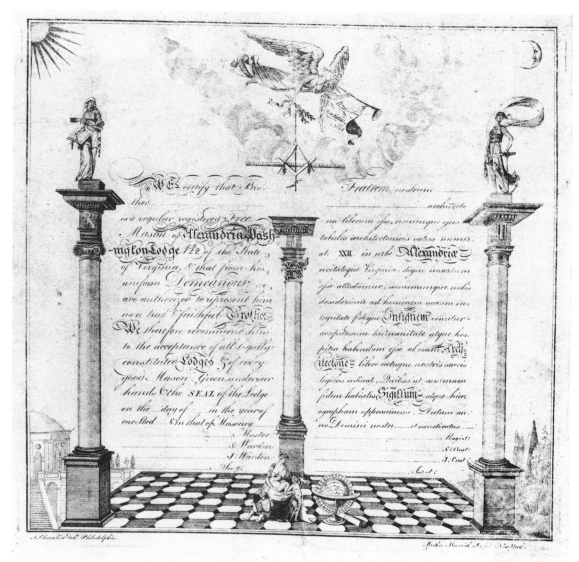

would rather work in New York City as a self-taught copperplate engraver. Although no reference is contained in Grand Lodge Proceedings of acquiring this certificate plate, it had to have been produced between 1796, when Anderson commenced work as an engraver, and the certificate's manuscript date of 1815. In 1816 an alteration was made to the plate to conform with the peripatetic sittings of the Grand Lodge of New Hampshire. On June 12, 1816, the Grand Lodge voted that "the plate for certificates be altered by the Grand Secretary, so as to leave a blank where the word Portsmouth is engraved."

Blazing Star Lodge No. 11 was chartered by the Grand Lodge of New Hampshire on February 13, 1799.

5.16
Private Lodge Certificate
Alexandria-Washington Lodge No. 22
Alexandria, Virginia
A. Chevalier (fl.1793), artist
attributed to Peter Rushton Maverick (1755-1811), engraver
New York, New York, c. 1789-1805
Imprint: "A. Chevalier, del., Philadelphia" and "Brother Maverick Sculpt., New York"
Line engraving
Library Collection 78-798

A blank private lodge certificate for a "regular registered Freemason" (Master Mason). The design is composed of three architectural columns (Ionic, Doric,

and Corinthian) resting on a mosaic pavement, dividing two sixteen-line texts in English and Latin. The figures of Faith and Hope surmount the left and right columns; the figure of Charity is seated beside a globe at the base of the center column. In the lower corners are vignettes of a pyramid in a garden and a Doric temple. Above, the winged figure of Fame sounds a trumpet bearing a banner inscribed "Alexandria Lodge No.22." A trophy of square and compasses, trowel, and 24-inch marking gauge are suspended from sprigs of laurel held by Fame.

In 1788, Lodge No. 39 of Alexandria, Virginia transferred allegiance from the Grand Lodge of Pennsylvania to the Grand Lodge of Virginia. Operating under a new charter as Lodge No. 22, the lodge elected George Washington as its first Master; he served in that capacity until his death in 1799. In 1805 the name of the lodge was changed to Alexandria-Washington No. 22 in his honor.

In the original design, the banner suspended from Fame's trumpet and the Latin text refer to the lodge's name as first chartered by the Grand Lodge of Virginia. The hyphenated insertion of Washington's name in the English text would appear to have been added about 1805. It is believed that Washington, while still Master of Alexandria No. 22, ordered the engraving of this plate during the early sessions of Congress in New York City. Peter Rushton Maverick (1755-1811) was admitted to Holland Lodge No. 8, F.& A.M. in 1789, the same year Washington assumed office as president of the United States.

5.17 SEE ILLUSTRATION ON PAGE 186

Open Certificate
Grand Lodge of New York
William Rollinson (1762-1842), engraver
New York, 1819
Copperplate engraving
Collections Purchase Fund, Archives Collection,
MA007

A bilingual Master Mason's certificate in English and French. The design is composed of two Corinthian columns surmounted by figures of Faith and Hope. Charity is seated at left; on the right, figures of Minerva (Wisdom) and Hercules (Strength) attend a Mason in apron wearing the jewel of a Master of a lodge. The Master holds a scroll showing the Arms of the "Ancients" Grand Lodge. In the center is a Masonic altar. Above the text an angel sounds a trumpet. This certificate was issued to Thomas Fischer of Mount Moriah Lodge No. 132, New York City, dated April 22, 1820.

The basic design of this certificate was first engraved by Andrew Billings (d. 1808) in 1784, but the plate was declared worn out and was replaced in October 1796. The 1796 plate was engraved by William Rollinson with an English text, and re-engraved in 1819 with a bilingual text to accomodate a number of French-speaking lodges that had been chartered in New York. *Reference:* Early History & Transactions of the Grand Lodge of New York 1781-1815. *New York, 1876. 1:108.*

5.18 SEE ILLUSTRATION ON PAGE 187

Private Lodge Certificate
Columbia Lodge No. 91, A.Y.M.
Philadelphia, Pennsylvania, c. 1804
attributed to David Edwin (1776-1841), engraver
Imprint: none
Line engraved
Library Collection 78-964

A privately printed Master Mason's certificate with sealed ribbon. The design is composed of three architectural columns (Ionic, Doric, and Corinthian) surmounted by the figures of Faith, Hope and Charity. The columns divide two groups of text in English and French. Above, three winged cherubs with torches and trowel support a curtain bearing square and compasses and other Masonic symbols. Above their heads, an eagle bearing a ribbon inscribed "Columbia Lodge No. 91" appears beneath the all-seeing eye. The certificate text was completed in manuscript for John Stevens and is dated May 27, 1816.

The minutes of Columbia Lodge reflect that in February 1803 it was resolved "to procure a draft or design for a certificate plate and seal for the use of the lodge." In May a design was adopted and authority was given to have the plate made. In March 1804 it was reported that the engraving had been completed.

David Edwin (1776-1841) was raised in Columbia Lodge on March 1, 1806. William Strickland (1787-1848) was raised in Columbia Lodge on November 27, 1809. Either of these artists could have produced the certificate plate prior to their afilliation but it has been attributed to Edwin because engraving was his primary occupation.

The vignette with the three cherubs was copied directly from a plate that appeared in *The Freemason's Magazine* (London, 1793). The scene was engraved by William Satchwell Leney (1769-1831) who dedicated it to Lord Rawdon, Grand Master of the Grand Lodge of England, showing "the Genii of the Masonic Order Lighting their Torches, Symbolizing Friendship." Edwin emigrated from England to Philadelphia in 1797 and would have been familiar with Leney's work. Leney also emigrated to America, in 1805, and settled in New York City where he often collaborated with engraver William Rollinson.

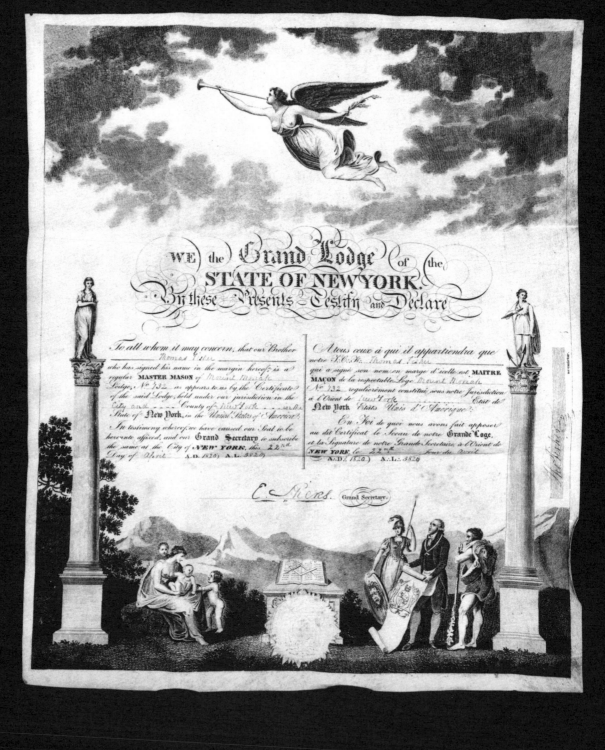

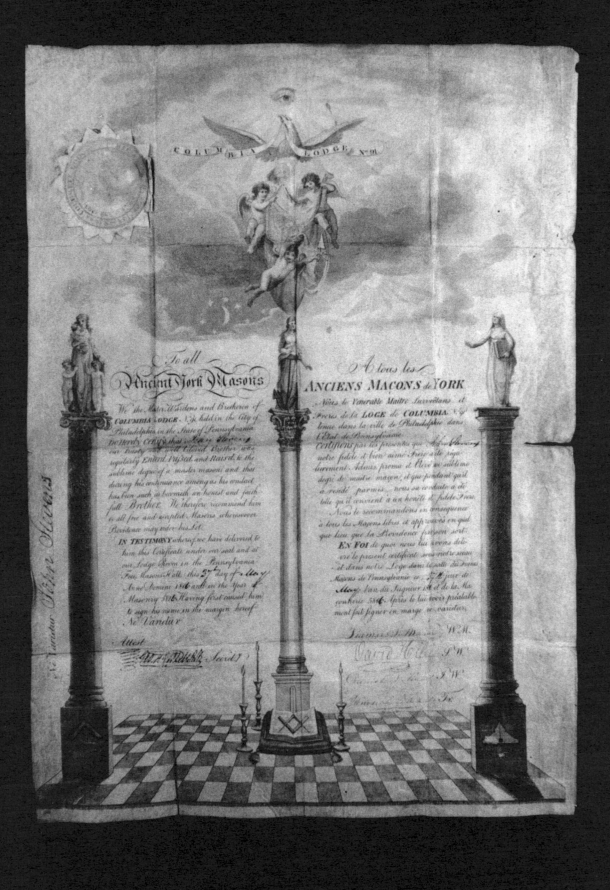

5.19
Master Mason's Certificate
Grand Lodge of Massachusetts
John R. Penniman (1783-1841), artist
William B. Annin (fl. 1813-1839) and
George Girdler Smith (1795-1878), engravers
Boston, Massachusetts, c. 1820
Imprint: "Drawn by Penniman & Mills" and "Engraved by Annin & Smith, Boston 12 Court St"
Line engraving
Library Collection 78-970

An open certificate for the Third Degree of Masonry with sealed ribbon. The design is composed of a triangular pedestal with text panel and mosaic top, supporting three architectural columns (Ionic, Doric, and Corinthian) surmounted by the figures of Faith Hope, and Charity. The columns are marked "S.W." (Senior Warden), "M." (Master), and "J.W." (Junior Warden), indicating where these officers are to place their signatures. The appropriate jewel of office also appears on the base of each column. Scrolls of English and Latin text hang from rods suspended between the columns. Faith and Hope support a long banner inscribed "To the Fraternity, Peace and Good Fellowship." Above, a radiant all-seeing eye illuminates the document. The text was completed in manuscript for Daniel E. Pratt of Revere Lodge, Boston and is dated December 2, 1856.

In March 1812 the Grand Secretary reported that "the diploma plate for initiates was so worn that fair and legible impressions could no longer be taken from it." A committee was appointed, but no further action was taken until December 1816, when a recommendation that the plate be repaired or replaced was reiterated. A year later (December 8, 1817) it was reported that "a new form of a Master's Diploma" had been prepared, for which authorization was given to "have it engraved and made ready for use." Many years later (March 11, 1857), Bro. Smith recalled, "to the best of my recollection, it was engraved about the year 1820." A replacement plate was engraved in 1842. All plates engraved by George G. Smith for the Grand Lodge of Massachusetts were kept in his custody. Bro. Smith furnished perfect impressions of diplomas at the same rate of fifty cents for nearly half a century. When the price of parchment doubled, he introduced the use of artificial parchment.
Reference: Proceedings of the Most Worshipful Grand Lodge of Ancient Free and Accepted Masons of the Commonwealth of Massachusetts. *Cambridge, 1905*

5.20
Master Mason's Certificate
Grand Lodge of Rhode Island
attributed to Thomas Pollock (fl. 1839-1849), engraver
Providence, Rhode Island, c. 1849
Imprint: none
Line engraved
Library Collection

An open Master Mason's certificate (blank). The design is composed of three columns (Ionic, Doric, Corinthian) on a mosaic pavement. Left and right columns are surmounted by the figures of Faith and Charity. Between the columns are lines of text in English and Latin. On the pavement are terrestrial and celestial globes, rough and smooth ashlar, an open Bible, and jewels of the Master and Wardens. Above, beneath an arch reading "To The Fraternity Peace And Good Fellowship," an angel and cupid support the Arms of Rhode Island.

On June 26, 1848, a Grand Lodge committee was empowered to procure an engraved plate from which to print diplomas. On May 28, 1849, the committee made their report: "After procuring all the forms they were able to obtain, they blended together the American and the Grand Lodge of England, giving the preponderance to the latter as being best adapted to a Grand Lodge diploma...the plate was engraved for the very low sum of $75, ... and so far as mechanical skill and workmanship are concerned it is pronounced ex-

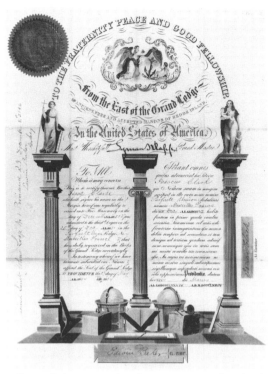

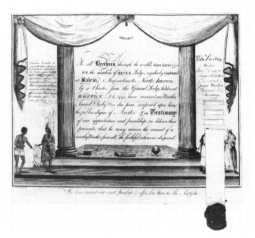

cellent...." Accompanying the report was an itemized expense account indicating that Thomas Pollack engraved the plate.

The design was in fact copied, with only minor alteration, from the United Grand Lodge of England's "1st Pillars" certificate that had been engraved by R.W. Silvester in June 1819.

Reference: Reprint of the Early Proceedings of the Most Worshipful Grand Lodge of Free and Accepted Masons of the State of Rhode Island. *vol.2 (1820-1849). Providence, 1909. Haunch 1969, 230.*

5.21
Private Lodge Certificate
Essex Lodge
Joseph Hiller, Jr. (1777-1795), artist
Samuel Hill (1750-1803), engraver
Salem Massachusetts, c. 1790-1795
Imprint: "J. Hiller, Junr. del." and "S. Hill, Sculp."
Line engraved
Library Collection 84-74

Master Mason's certificate with cachet. Twin pillars on a three- tiered dias frame ten lines of English text. Above, drapery obscures the pillar chapiters. On a tiled pavement between the pillar bases lies a globe, a Bible with square and compasses, and a strongbox. At left, two natives examine a chart; one wears a feathered headdress and fur cape, the other only a loincloth. At right, two Biblical figures confer. Above the natives are

twelve lines of Latin text. The certificate was issued in 1796 to master mariner Samuel G. Derby (1767-1843) of Salem. The reverse bears an affidavit, dated 1802, that the certificate was used by Derby to gain admittance to La Vertieuse Lodge in Batavia, Surinam.

The affidavit from Le Vertieise Lodge indicates the document was used as a "traveling certificate" for the express purpose of gaining admittance to foreign lodges. Bro. Derby's profession as a ship's master led him to all parts of the globe. Joseph Hiller, Jr. (1777-1795) of Salem was lost overboard from a ship off the Cape of Good Hope in 1795. The artist's father, Joseph Hiller (1745-1814) was initiated in Essex Lodge on January 25, 1780. In 1780 he cut the seal of the Lodge "gratuitously for the honor of the Craft," and served as Master of the lodge from 1780 to 1786.

Reference: Centennial Anniversary of the Introduction of Masonry in Salem by the Institution of Essex Lodge. *Salem, 1880.*

5.22 SEE ILLUSTRATION ON PAGE 190
Open Lodge Certificate
John Reubens Smith (1775-1849), artist
Peter Maverick (1780-1845), engraver
Samuel Maverick (1789-1845), publisher
New York, August 23, 1823
Imprint: "Drawn by Jno. R. Smith, N.Y., Engraved by Peter Maverick" and Publicade por el Hermanos Samuel Maverick New York, Published by Brother Samuel Maverick New York, Public par le Fere Samuel Maverick New York" and "Enter'd According to Act of Congress the 23rd day of August, 1823 by Samuel Maverick, of the State of New York"
Line and stipple engraving
Library Collection 85-18

A trilingual Master Mason's certificate in English, Spanish, and French. The design is composed of a terrace with mosaic pavement and a Masonic altar surrounded by three candelabra and flanked by globed

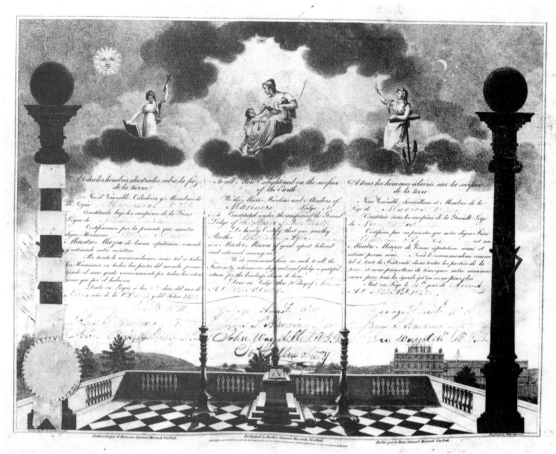

pillars. Solomon's Temple is shown under construction in the distant background. Above, allegorical figures of Faith, Hope, and Charity float on heavenly clouds. The certificate was issued to William Hylar of Mariner's Lodge No. 385, New York City and is dated November 11, 1828.

The trilingual text versions, as well as Maverick's enlarged trilingual imprint line, would indicate that this document was intended for principal use as a traveling certificate. Maverick probably hoped to gain some commercial benefit from the free advertising.

5.23

Royal Arch Certificate
Attributed to Charles Cushing Wright (1796-1846), engraver
Homer, New York, c.1818
Imprint: none
Line engraving
Library Collection, 81-366

An open Royal Arch certificate with seal. The design shows an architectural arch supported by paired Corinthian columns. The arch's keystone has been dis-

placed to permit rays from above to illuminate King Solomon's seal and two winged cherubim who gaze down upon the Ark of the Covenant. The ark rests atop an architectural monument bearing text. Masonic cipher appears on the columns and within a panel on the ark. The columns and monument rest on a mosaic pavement with three blocks of finished ashlar. The certificate was completed in manuscript for Elijah Wheeler of David's Royal Arch Chapter No. 34, Auburn, New York and is dated May 11, 1818.

The design is closely derived from the certificate issued in 1792 by the Grand Royal Arch Chapter of England. The engraving is attributed to Charles Cushing Wright (1796-1854) by virtue of (1) the similarity of line engraving technique and caligraphy to the Master Mason's certificate bearing imprint of "C.Ws. Scpt. for W.B. Wy" (see 5.05) and (2) Wright's proximity to Auburn during the period he was active in nearby Homer, New York.

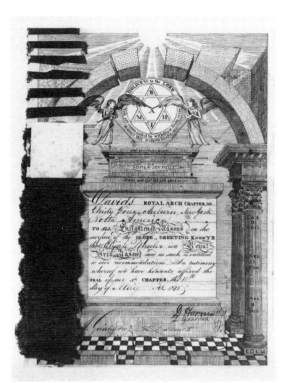

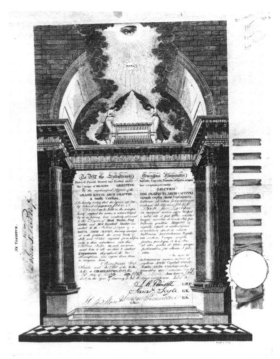

5.24

Royal Arch Certificate

Grand Royal Arch Chapter of South Carolina
Charles Cushing Wright (1796-1846) and
Daniel H. Smith (fl. 1816-1823), engravers
Charleston, c. 1820-1823
Imprint: "Wright & Smith"
Line engraving
Library Collection 85-53

Certificate issued for use within jurisdiction of the
Grand Royal Arch Chapter of South Carolina, sitting at
Charleston. The design is composed of an architectural
arch recessed within a heroic stone wall. Above, within
a column of clouds, is an all-seeing eye that illuminates
Solomon's seal and two winged cherubim who gaze
down upon the Ark of the Covenant. The arch is sup-
ported by a pair of twinned columns, between which
are panels of bilingual text in English and Latin. The
certificate was completed in manuscript for John F.
Kern, Jr., and is dated May 19, 1823. The certificate
was also signed by Joel R. Poinsett as Grand High
Priest.

The design was derived from the certificate issued
in 1792 by the Grand Royal Arch Chapter of England
(Acc# 78-792). Unlike Wright's earlier attempt at this
design (see 5.23), his collaboration with Smith yielded
a more sophisticated work. Wright departed Homer,
New York in 1818 and relocated to New York City for a

brief period prior to arriving in Charleston where he
and Daniel Smith were partners from 1820 to 1823.

Joel Roberts Poinsett (1799-1851) served as Grand
High Priest of the Grand Chapter of South Carolina
from 1821 to 1841. He introduced Royal Arch Masonry
to Mexico while serving as U.S. Minister to that coun-
try from 1825 until 1829. He also served as U.S.
Secretary of War from 1837 to 1841.
Reference: Denslow 1959.

5.25 SEE ILLUSTRATION ON PAGE 192

Open Royal Arch Certificate

Ralph Rawdon (fl.1813-1820), engraver
Albany, c.1816-1817
Imprint: "R. Rawdon, Sc. Alby." and "Publish'd by
Comp. H. Parmele, Copy Rt. Secured"
Line engraving
Library Collection 81-104

An open Royal Arch certificate. The design is com-
posed of an architectural arch supported by a pair of
twinned Corinthian pillars. Beneath the arch an in-
flamed delta illuminates two winged cherubim who
gaze down upon the Ark of the Covenant. Figures rep-
resenting Minerva, Hercules, and Venus appear on an
octagonal platform that also supports blocks of rough
and smooth ashlar, a terrestrial globe on a pedestal, and
groups of tools representing the Royal Arch Chapter
(crowbar, pick, and shovel), Craft Masonry (square and
compasses and trowel), and the jewels of a Master and
Wardens (square, plumb, and level). Panels on the

Documents 191

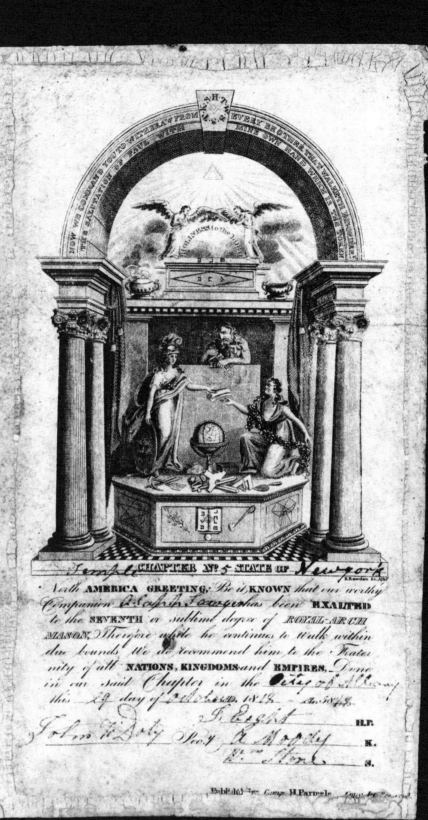

Temple CHAPTER Nº 5 STATE OF New York

North AMERICA GREETING. Be it KNOWN that our worthy
Companion _____ has been EXALTED
to the SEVENTH or sublime degree of ROYAL-ARCH
MASON, Therefore while he continues to walk within
due bounds We do recommend him to the Frater-
nity of all NATIONS, KINGDOMS and EMPIRES, Done
in our said Chapter in the City of Albany
this 29 day of October AD 1818 — An 5848

F. Knight H.P.
John H. Doty Secy. K. Mosley K.
 S.

Publish'd by Comp. H.Parmele

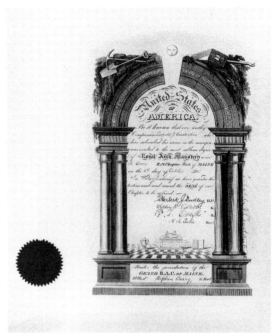

mosaic pavement beneath the text and between the pillars, two winged cherubim guard the Ark of the Covenant. An urn, an open book, and a sprig of acacia are placed around the ark. The certificate was completed in manuscript for Leopold J. Constantini of St. Croix Royal Arch Chapter and is dated October 6, 1915.

The plate has been altered to reflect an Anno Lucis date in the 20th century. During a period extending from 1810 to 1826, Penniman collaborated with Annin and Smith in producing a number of certificates for various organizations. Annin and Smith formed a partnership in 1819 which lasted three years. They reunited again in 1826, but by then Penniman was undergoing serious mental and physical health problems and had ceased to produce work.
Reference: Andrews 1981.

5.27 SEE ILLUSTRATION ON PAGE 194

Royal Arch Certificate
Grand Royal Arch Chapter of Massachusetts
John Ritto Penniman (1783-1841), artist
William B. Annin (fl. 1813-1839) and
George Girdler Smith (1795-1878), engravers
Boston, c. 1821
Imprint: "Drawn by J.R. Penniman" and "Engraved by Annin & Smith, Boston"
Line engraving
Library Collection 78-969

A Royal Arch certificate with seal. The design is composed of a landscape with temple ruins in which, seated under a baldachino, are the figures of a High Priest, King, and Scribe representing the principal officers of a chapter. Beneath them an opening in a subterranean archway illuminates two winged cherubim guarding the Ark of the Covenant. Between the arch and pillars on each side are scrolls of bilingual text in English and Latin. Beneath a mosaic pavement supporting the arch, a panel contains the Grand Chapter affidavit. The certificate was completed for Addison Putnum of Mt. Horeb Royal Arch Chapter, Lowell and is dated April 30, 1855.

Minutes of the proceedings of the Grand Chapter of Massachusetts record that on December 11, 1821, a sketch for a new certificate design was approved, and authorization was granted to have a plate engraved. Grand Secretary Edward Horsman had been involved in developing a new certificate, but his death in 1819 required that another artist be found to provide the design.
Reference: Proceedings of the Grand Royal Arch Chapter of Massachusetts. *Worcester, 1876. 1:232. Andrews 1981.*

pedestal bear symbols of the Pentalpha (five-pointed star), diagram of Euclid's 47th proposition, a sprig of acacia, sword pointing to a naked heart, and an open book inscribed in Masonic cipher resting on the point-in-a-circle within parallel lines. Cipher characters also appear on panels of the ark. The certificate was completed in manuscript for Aspeth Sawyer of Temple Royal Arch Chapter No. 5, Albany, New York and is dated October 29, 1818.

In developing this design, Rawdon combined a neoclassical format derived from the Massachusetts Past Masters diploma with Laurence Dermott's original sketch of the Biblical Royal Arch. Ralph Rawdon worked in Albany from 1813 to 1817.

5.26

Royal Arch Certificate
Grand Royal Arch Chapter of Maine
John Ritto Penniman (1783-1841), artist
William B. Annin (fl. 1813-1839) and
George Girdler Smith (1795-1878), engravers
Boston, c.1820-1825
Imprint: "Drawn by J.R. Penniman" and "Engraved by Annin & Smith, Boston"
Line engraving
Library Collection 89-221

A Royal Arch certificate with seal, issued by the Grand Chapter of Maine at Portland. The design is composed of a subterranean arch supported by a pair of twinned pillars. In the earth above the arch lie a pickaxe, shovel, and crowbar. The arch keystone is dislodged to allow a radiant sun to illuminate the English text. On a

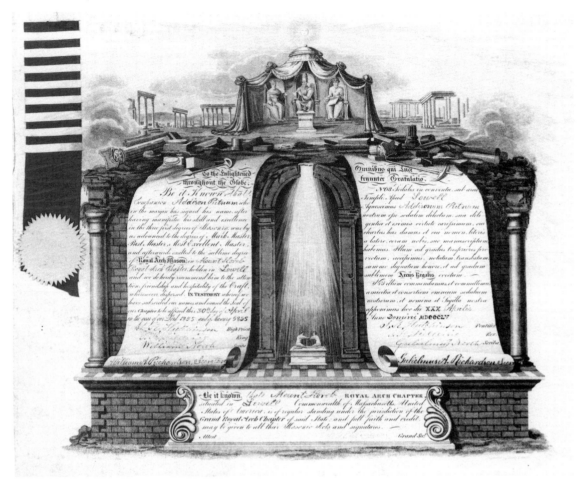

5.28

Royal Arch Certificate
Grand Royal Arch Chapter of Massachusetts
D.T. Kendrick, engraver
Boston, c. 1850
Imprint: "D.T. Kendrick, Engraver Boston"
Line and stipple engraving
Library Collection 78-803

A Royal Arch certificate with seal. The design is centered on the three principal officers of a chapter (High Priest, King, and Scribe), seated together under ornamental canopies. Above and behind them fly five banners bearing the heraldric arms and badges of the "Ancients." In the background are scenes of the destruction and rebuilding of Solomon's Temple. Lines of text appear between Egyptian-style monuments surmounted with square and compasses representing Craft Masonry, and a delta representing Royal Arch. Below, a Grand Chapter affidavit appears on an Egyptian sarcophagus. The certificate was completed in manuscript for Edward G. Graves of St. John's Royal Arch Chapter, South Boston and is dated June 28, 1886.

5.29 SEE ILLUSTRATION ON PAGE 196

Open Knights Templar Certificate
Jeremy L. Cross (1783-1861), designer
William M. Thompson (fl. 1833-1860), engraver
New York, 1848
Imprint: "Designed by Jeremy L. Cross Engraved by W.M. Thompson" and "Entered According to Act of Congress in the year 1848 by Jeremy L. Cross, in the Clerk's Office of the District Court for the Southrn Dist. of NY."
Line engraving
Library Collection 81-140

An open Knights Templar certificate with seal. A rayed-cross within a triangle appears above seventeen lines of English text. Corinthian pillars flanking the text are surmounted by the figures of a pilgrim with staff and a crusader with upraised sword. Lozenges at the base of each pillar bear the symbol of a Paschal Lamb and the Cock of Resurrection. A river flows between the bases and is spanned by a bridge having

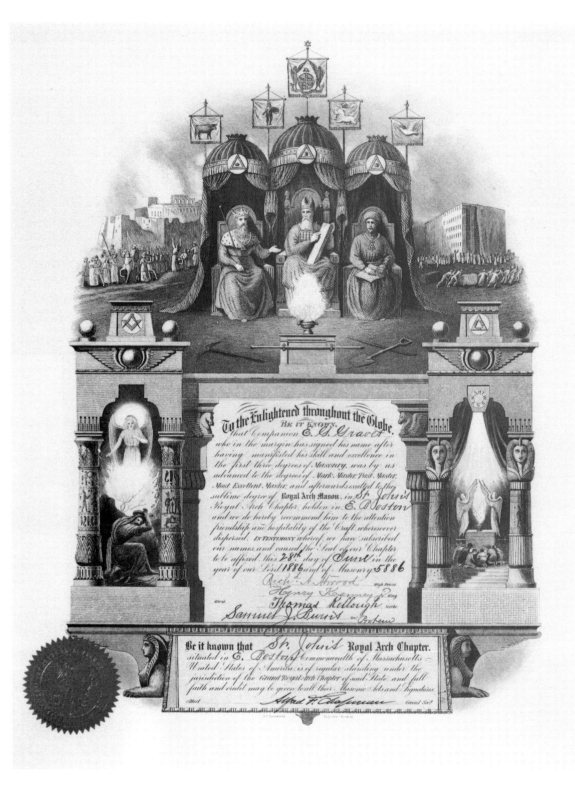

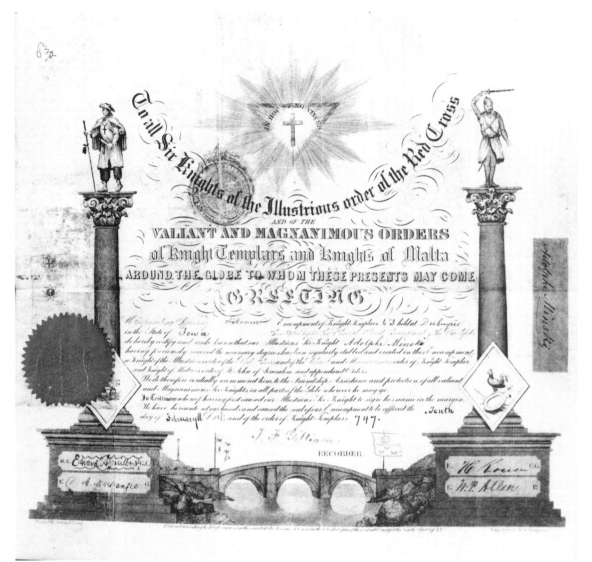

three arches. Military standards fly above the abutments at each end of the bridge. One standard bears the arms of the "Ancients" and the other the crescent of Islam. The certificate was completed in manuscript for Adolphe Minski, of Siloam Encampment No. 3, Dubuque, Iowa and is dated February 10, 1865.

5.30

Open Grand Encampment Certificate

Hammatt Billings (1818-1874), artist
George G. Smith (1795-1878), engraver
Boston, 1841
Imprint: "Drawn by Hammatt Billings Engraved by Geo. G. Smith" and "Entered according to Act of Congress in the Year 1841 by Chas. W. Moore, John B. Hammatt & John J. Loring (Committee) in the Clerk's

Office of the District of Massachusetts. Published under the sanction of the Grand Encampments of Mass. & R. Island"
Line and stipple engraving
Archives Collection MA 006

An open Grand Encampment certificate for a Knight Templar, with seal. Two Gothic-style architectural memorials flank fourteen lines of text. The foundations contain arched vignettes of a bridge and knights tilting at each other. An effigy of a mailed knight reclines on a Gothic tomb that bears a Grand Encampment affidavit. The certificate was completed in manuscript for Richard Spofford of Newburyport Encampment, Newburyport, Massachusetts and is dated 1856.

In a session of the Grand Encampment of Massachusetts and Rhode Island on December 24, 1839, Charles

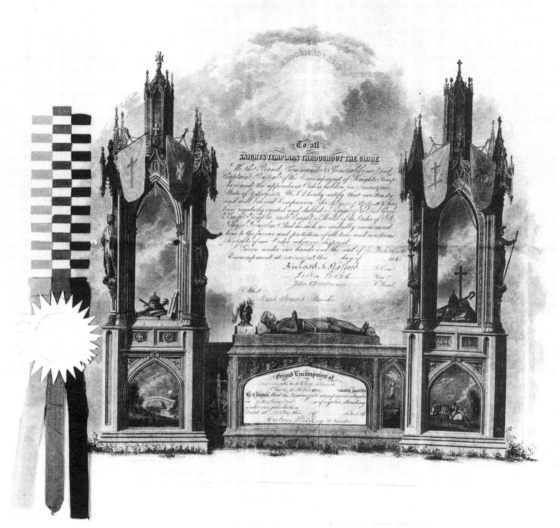

W. Moore, John J. Loring, John B. Hammatt, and
Luther Hamilton were appointed a committee to pro-
cure a diploma plate. They submitted a design that
was adopted on October 12, 1840:

"Whereas, the Boston Encampment have, at great
expense, procured a diploma of peculiar appropriate-
ness and beauty, therefore, Resolved, That this Grand
Encampment allow them the priviledge of the copy-
right of said diploma, and hereby sanction and
recommend its adoption by all Encampments and Sir
Knights under its jurisdiction."

The copyright for the design was renewed in 1874;
at which time F.T. Stuart reengraved the Billings de-
sign of 1841.

Hammatt Billings emerged as an accomplished illus-
trator and architect from the early training he received
under Abel Bowen, Asher Benjamin, and Francis
Graeter. By the 1840s, Billings' artistic skill was well
developed in a variety of graphic genre.

Reference: Proceedings of the Grand Encampment of
Knights Templars and the Appendant Orders of Mas-
sachusetts and Rhode Island, From its organization in
1805 to 1863, inclusive. *Central Falls, Rhode Island,
1875. O'Gorman 1983.*

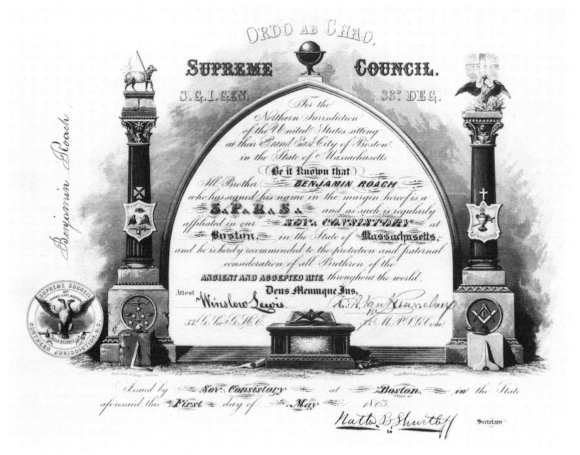

5.31

Scottish Rite Certificate
Supreme Council of the Scottish Rite,
Northern Jurisdiction
Hammatt Billings (1818-1874), designer
Smith, Knight & Tappan, engravers
Boston, c.1860
Imprint: "Hammatt Billings, Designer" and "Smith,
Knight & Tappan, Engs. Boston"
Line and stipple engraving
Archives Collection SC 040

An open certificate issued by the Supreme Council,
with seal. Two architectural pillars flank an arched
panel containing fifteen lines of text in English and a
Masonic altar. The pillars are surmounted by a Paschal
Lamb and a Phoenix and are hung with Templar and
Red Cross shields. The pillar bases bear insignia of the
jewel of a Prince of Jerusalem (16th Degree) and the
square and compasses. Blocks of rough and smooth
ashlar are placed in front of the bases. The certificate
was completed in manuscript for Benjamin Roach,
S.P.R.S., of Boston and is dated May 1, 1863.

This Scottish Rite certificate attests that Benjamin
Roach attained the 32nd Degree, also known as Sover-
eign Prince of the Royal Secret.

5.32

Letter of Credence
Engraver unidentified
American, 18th century
Imprint: none
Line engraving
Library Collection 85-295

An engraved masthead on a letter sheet with wax seal,
certifying and giving credence to the fact that the
bearer has been initiated a Prince of Jerusalem (16th
Degree) and a Sovereign Knight of the Sun (28th De-
gree) in the Scottish Rite. The head design consists of
a square and compasses enclosing a radiant triangle or
delta inscribed with the Hebrew letter *"He."* Beneath
the delta are crossed branches of acacia and palm, and
a ribbon inscribed "Health, Stability, and Power."
Flanking the ribbon are an urn of incense and an ewer
with a smallsword thrust through a handle. The text

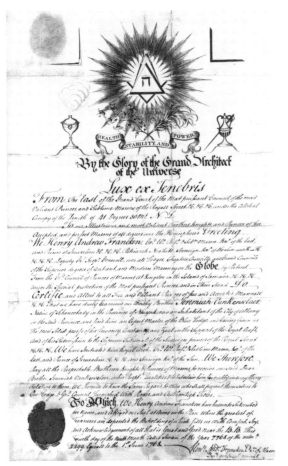

Scottish Rite Patent

Engraver unidentified
American, 18th century
Imprint: none
Line engraving
Library Collection 78-778

An engraved masthead with impressed paper seals. The central design of a square and compasses enclosing a radiant delta is inscribed with the Hebrew letter "*He*." At upper left a circular scene of two men lowering a third into a subterranean vault (symbol of the 13th Degree, or Royal Arch of Solomon). At upper right is a circular design consisting of a two-headed eagle with sword in talons, perched on a double ladder having seven rungs (30th Degree, or Knight Kadosh). Each rung of the ladder represents one of the seven liberal arts and sciences of the ancients. Beneath stalks of acacia and palm is a ribbon inscribed "Health, Stability, And Power." Flanking the center are twin pillars with an urn of incense and compasses opened to a right angle, and a vase with smallsword and a square rule. The area reserved for the text is enclosed by a rococo border. The certificate was completed in manuscript for Samuel Stringer of Albany, New York and is dated December 6, 1768. The certificate was issued by Henry Andrew Francken (1720-1795).

This design elaborated on an earlier one (Acc.# 85-295), by addition of symbols relating to the Lodge of Perfection (4th-14th Degrees) and the Council of Kadosh (19th-30th Degrees). Dr. Samuel Stringer (1735-1817), a native of Annapolis, Maryland, settled in Albany to practice medicine. He served as a surgeon in the British army during the French and Indian War and in the Continental Army in the Revolution. Dr. Stringer was invested with the powers of a Deputy Inspector General although this patent did not name him as such.
Reference: Baynard 1938, 1:60.

was completed in manuscript for Jeremiah Van Rensselaer of Albany, New York and is dated June 1, 1768. The patent was issued by Henry Andrew Francken.

This is the first form of Scottish Rite certificate or credence letter used in North America. The Hebrew letter "He" refers to the Tetragrammaton, or the Hebrew four-lettered, ineffable name of God (Jehovah). In the high degrees the symbol of a cinerary urn was derived from lore surrounding the burial of Hiram Abif, builder of Solomon's Temple. The master architect's heart was enclosed in a golden urn, on the side of which a triangular stone was affixed and inscribed with the initials "J.M.B." within a wreath of acacia.

Henry Andrew Francken (1720-1795) was the first Deputy Grand Inspector General appointed for North America.

5.34 SEE COLOR PLATE, PAGE 276

Certificate of Credence

Ancient Accepted Scottish Rite, Southern Jurisdiction
Amos Doolittle (1754-1832), engraver
New Haven, c.1825
Imprint: "Written and Engraved by Sr. Kt. A. Doolittle"
Line engraving
Supreme Council Archives 78.779

A patent certifying the conferring of a 32nd Degree in the Scottish Rite. The design is composed of an arched ribbon inscribed with the formal opening epigraph, "Universi Terrarum Orbus Architectonis per Gloriam Ingentis" (By the Glory of the Great Architect of the Universe). In the upper right corner, a pelican feeds her young with her blood (symbol of the 18th Degree

or Knight of the Rose Croix). In the upper left corner, a radiant delta and a crown above a lamb lying on a book of seven seals (17th Degree) are surrounded by symbols representing the Council of Kadosh (19th through 30th Degrees) including an eagle, lion, bull, and a cherubim. Immediately below the ribbon, square and compasses enclose a radiant triangle with the Hebrew letter "He" which is flanked by an urn of incense and a ceborium with sword. Beneath that are crossed branches of acacia and ribbon inscribed with the motto "Deus Meumque Jus." To the left is the flaming and winged heart of man (26th thru 28th Degrees). On the right is an upraised arm holding a naked sword (21st Degree, Noachite, or Prussian Knight). The design contains crossed branches of acacia and corn, crossed scales in equipoise on the point of a sword surrounded by five stars (jewel of the 16th Degree), and two keys, one bearing a Greek delta on its wards and another with the letter "Z" (jewel of the 4th Degree, Secret Master). A vaulted crypt with a radiant delta appears above an altar. A bridge, labeled "YH," with three arches initialed "L," "D," and "P," leads to a fortification guarded by a pikeman. Beneath the motto "Ordo Ab Chao" (Order out of Chaos) are 29 lines of text in English. The certificate was completed in manuscript for Peter Pease of Clinton, Georgia and is dated May, 1825. The document was countersigned by Frederick Dalcho (1770-1836).

The bridge with three arches alludes to a ritual in the 15th Degree of the Scottish Rite known as the Liberty of Passage. The letters "YH" represent "passage of the river" [in Hebrew, *Yaveron Hamaim*], which refers to the return of the Jews from their Babylonian captivity. The initials "L,D, and P" stand for "liberty of passage" [in Hebrew, *Lakak Deror Pessah* - or in French, *Libre de Passage*].
Reference: Hutchens 1988.

5.35

Rose Croix Chapter Charter
Sovereign Grand Consistory of the United States of America, its Territories and Dependencies
Joseph Cerneau (c. 1763- ?), engraver
New York, c.1824
Imprint: "Cerneau alenile" (in cipher)
Line engraving
Supreme Council Archives

A charter appointing officers to establish a Rose Croix Chapter in New York City. The document is certified by three silver skippets containing wax seals. The skippets are engraved with an "LFC" monogram (LaFayette Chapter). The design is composed of a masthead with a radiant delta in the center inscribed with the Tetragrammaton. At left and right are swagged cinerary urns hung with a skull and crossbones medallion. At far left and right are a square and a pair of compasses. In the center, beneath the

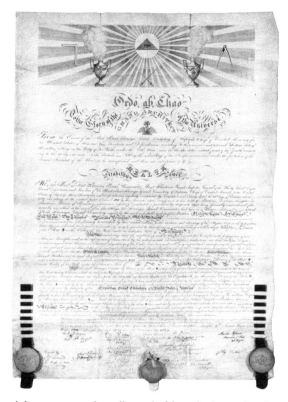

delta, are crossed smallswords. Near the base of each urn is a group of characters in Masonic cipher. The charter was issued in 1824 by Joseph Cerneau establishing LaFayette Rose Croix Chapter in New York City.

The four Hebrew letters within the delta represent the Tetragrammaton, or ineffable name for God (Jehovah). Cerneau encoded his imprint in a variety of Masonic cipher that had originated in France among Knights of the Rose Croix and was exposed by him in 1806. Cerneau issued this charter, establishing a Chapter of Rose Croix in honor of General Lafayette, at the time of the general's much acclaimed visit to the United States in 1824. This and other organizations chartered by Cerneau were declared illegal by the Supreme Council sitting at Charleston, South Carolina.
Reference: Chereau, Anlaine-Guillaume. Explication de la Croix Philosophique, des Chev. Souv. Princ. R.+. *Paris, 1806.*

Chapter 6

Feasts & Festivals
Ceramics
Glassware

A true and Exact Account of the Celebration of the Festival of Saint John the Babtist, by the ancient and Honourable Society *of free and accepted Masons*, at *Boston* in *New-England*, on *June* the 26 1739. Taken from the *Boston* Gazette and rendered into Metre, that Children may more easily commit it to, and retain it in their Memory.

They might diftinguifh Diffrent Noife
Of Hornes and Pans and Dogs and Boys
Aud Kettle Drums whofe fullen Dub,
Sounds like the Hooping of a Tub.
Hud,

IN *Roman* Calendars we find,
Saint *John* the *Baptift* Feaft affign'd,
To *June* the Twenty fourth ; and He,
(For fo all Mafons do agree.)
A famous Lodge in days of old
In *Jordans* Wildernefs did hold,
For this, as Legends, us acquaint,
They made a Patron of the Saint.

Right worfhipful BOB THOMLINSON
Having this duly thought upon,
The Lodge on Tuefday laft did call
To Celebrate the Feftival,
For *June* the Twenty fourth was Sunday,
And Brother B———r fafts on Monday,
So for the Sake of eating Dinner
He Trick'd the Saint to pleafe the Sinner.
The Brethren foon as this was known,
All met to walk about the Town,
Firft Brother *Waghorn* was their Choice
Waghorn of founding Fame and Voice.
At Three they to his Houfe repair
And having ftaid a little there
Proceeded onward through the Street,
Unto his Excellency's Seat,
For as this *Waghorn* was a Brother
His Excellency was another ;
Unlucky Name it grieves full fore
Wag—*born* and B———r but no more.

Here having Drank and giv'n the Sign
By which He was Oblig'd to Joyn ;
From hence in Leather APRON Dreft
With Tinfel Ribbons on their Breafts,
In Pompous order march'd the Train
Firft Two, then Three, then Two, again,
As through the Street they paft along,
All kinds of Mufic Led the throng

Trumpets and Kettle Drums were there
And Horns too in the Front appear

Thus they went on thro' various noifes,
To hear e'm Fiddle at *Deblois's*
And thence came thro' another Street
To Brother *Luk's* to Drink and Eat,
For *Luke* was Order'd to prepare
Plenty of every Dainry Fare,
Tongues, Hamms, and Lamb, green Peafe and
So that in fhort 'twas pretty picking(Chicking)

Girls left their Needle, Boys their Book,
And Crouded in the Street to Look,
And if from Laughing we guefs right
They were much pleafed with the fight
All this by Land, now follows a'ter,
The gallant fhew upon the Water.

The Ship that *Hallowell* is Nam'd
From *Hallowell* for building Fam'd ;
Of which their Brother *Alexander*
French ; was part Owner and Commander,
Soon as appeared the Eaftern Beam
This Ship haul'd off in o the Stream,
Red Bays was tack'd on the round Top,
And all her Colours hoifted up
And on the Mizzen peak was fpread
A Leathern Apron Lin'd with Red,
The Men on board all day were glad
They Drink'd and Smoak'd like any mad,
And from her Sides three times did ring
Great Guns as Loud as any thing
But at the fetting of the Sun
Precifely, ceaf'd the Noife of Gun
All Ornaments were taken down
Jack, Enfign, Pendant and APRON.
FINIS

Gave me August 1739

Feasts & Festivals

ILLUSTRATION:
6.01, FACING
SEE DESCRIPTION
ON PAGE 206

CONVOCATION OF THE CRAFT AT CERTAIN FEASTS FOR THE PURPOSE OF PROMOT-
ing social interaction and cementing the bonds of brotherly love is a time-
honored custom. Feast days traditionally celebrated by the Masonic fraternity
are those of St. John the Baptist (June 24th) and St. John the Evangelist (December 27th).

The Saints John have been regarded as patrons of Masonry since the 16th century,
and the virtue of their lives is held by Masons as the "Two Grand Parallels," symbolized
by the parallel lines on both sides of the point-in-a-circle. The observance of St. John's
Day by speculative Freemasons became an annual occasion for a public procession, church
service, general meetings for the transaction of business and installation of officers, re-
ception of newly admitted apprentices, the dispensing of charity, and feasting.[1] It was
also an occasion to insure that the lodge was "properly clothed" for the coming year in
new white aprons which were paid for by the newly initiated.

"A True and Exact Account of the Celebration of the Festival of Saint John the Babtist
[sic]...," published in the *Boston Gazette*, June 26, 1739, chronicled the noisy progress of
reveling Freemasons as they wended their way through the crooked streets of Boston.
Whether that first account was exaggerated or not, the festivals tended to range in the
extent of merriment enjoyed by the brethren. A less detailed notice appeared the previ-
ous year in Ben Franklin's *Pennsylvania Gazette*.[2] Public processions became *de rigueur*,
complete with banners and musicians. The feasts also became occasions for delivering a
sermon, which was usually published afterwards.[3]

The December feast day of John the Evangelist was observed most often, but it was
the practice in some lodges to alternate between the Saints days so as not to slight one in
favor of the other. On June 24, 1797, the Feast of St. John coincided with the installation
of officers of Union Lodge, Dorchester. It was recorded in the minutes of the lodge that
"through the whole performance the greatest decorum was observed, & the Day was
concluded with Festivity, Harmony & Social Glee."

Table Lodge

In the 18th century the lecture that accompanied each degree had its particular toast. At
the lecture's conclusion the lodge was called from labor to refreshment by certain cer-
emonies and the toast, called a "charge," was drunk with honors. The toasts were

frequently accompanied with an appropriate song such as those contained in the *Book of Constitutions*. After toasting, the lodge was recalled to labor and another lecture was delivered with similar ceremony.

Throughout the 18th century many lodges routinely worked with their members seated at tables that could be removed during initiations if more room was needed. Boards set on trestles in the middle of the lodge served as the tables. Coverings of green baize cloth were common. Engravings published about mid-century also reflect that some lodges arranged their tables in a U-shaped configuration. It was the duty of the Junior Warden, assisted by the Stewards, to prepare the food and drink.

The proceedings, conducted at the appropriate degree level, were presided over by the Master in an unchanging ritual. None but Masons could be present at Table Lodge. During the course of the repast, a set of obligatory toasts were given to Masonic officials and other notable brethren. A special vocabulary evolved by which normal table implements were given peculiar names.[4] Drinking glasses were called "cannons," and to drink a "charge" was to "fire a cannon." The sound made by the heavy bottomed glasses as they were returned to the table, was fancifully said to resemble the thunderous roar of ordnance. The glasses, with their extra thick bottoms, were known in the glass-making trade as "mason-ware."[5] In France it was customary to strike the table with the hand rather than damage delicate glassware.

The taverns in which many early lodges met had much to do with the ease and convenience with which spirituous drink could be readily obtained at meetings. The author of *The Praise of Drunkenness* made note of brethren drinking habits as early as 1723, citing "Freemasons and other learned men that used to get drunk" as being "very great friends to the vintners."[6] Artist William Hogarth gave a more graphic view of the effects of lodge drinking in his engraving titled "Night," in which a wary Tyler escorts his tipsy Master safely home through London's perilous alleys.[7]

An unsavory reputation became attached to lodge activities that fostered drinking bouts at meetings. Early in the 19th century, alcohol abuse had become so prevalent throughout American society that many Grand Lodges recognized a moral need to prohibit the use of distilled spirits, but without curtailing fraternal activities. Typically, in 1816 the Grand Lodge of New York saw drinking as an "evil example... productive of pernicious effects," and took steps to expressly forbid the use of ardent spirits in the lodge under any pretense whatever.[8]

1. St. John the Baptist's Day, 1717, was the day chosen on which to hold an assembly feast and elect Anthony Sayer as the first Grand Master of the Premier Grand Lodge of England.

2. *Pennsylvania Gazette*, February 15-21, 1738.

3. The first sermon published in America was "*Brotherly Love Recommended In a SERMON Preached before the Ancient and Honourable Society of Free and Accepted MASONS in CHRIST-Church, BOSTON, on Wednesday the 27th of December, 1749. By Charles Brockwell, A.M. His Majesty's Chaplain in Boston. Published at the Request of the Society.... Boston: in New England: Printed by John Draper, in Newbury-Street. M,DCCL.*"

4. Tschoudy, Louis Theodore Baron de (1720-1769). *L'Etoile Flamboyante, ou la Societe des Francs-Macons consideree sous tous les Aspects* [The Blazing Star, or the Society of Freemasons considered under Every Point of View]. Paris, 1766. The special terminology seems to have originated in France.

5. *Transaction of the Lodge of Research*, No. 24229, Leicester, 1898/99. p. 42.

6. Boniface Oinophilus, de Monte Fiascone. *Ebrietatis Encomium or the Praise of Drunkenness wherein Is authentically, and most evidently proved The Necessity of frequently getting Drunk; and, That the Practice of getting Drunk is most Antient, Primitive and Catholic. Confirmed by the Example of Heathens,... Saints, Popes, Bishops, Doctors, Philosophers, Poets, Free Masons and other Men of Learning in all Ages.* London, 1723. Chap. XV.

7. "Night," copperplate engraving by William Hogarth (1697-1764), published in London, March 25, 1738. The drunken Master is Sir Thomas de Veil, escorted by Bro. Montgomery, "Guarder of ye Grand Lodge" in 1738. See Keytell - "William Hogarth & Masonry", *Lodge of Research*, Leicester, 1908/09.

8. *Early History and Transactions of the Grand Lodge of Free and Accepted Masons of the State of New York, 1816-1827.* New York, 1876. The resolution imposing temperance was passed June 12, 1816.

Illustrations

6.01 SEE ILLUSTRATION ON PAGE 202

A true and Exact Account
of the Celebration of the Festival of
Saint John the Babtist [sic]...
by Joseph Green
Boston, June 26, 1739
Printed Broadside
Library Collection 80.167sc

A satirical poem describing the first public procession and observances of the Feast of Saint John the Baptist by Freemasons in America. After Robert Thomlinson was elected Grand Master, the brethren, led by Grand Sword Bearer John Waghorn, proceeded to the residence of Royal Governor Jonathan Belcher (1681-1757). Belcher was the first American-born Freemason. Upon extending hospitality to the brethren, the governor joined the procession which continued enroute to the Royal Exchange Tavern where they enjoyed a festive repast provided by Luke Vardy.

Joseph Green (1706-1780), a successful Boston distiller, maintained a reputation of being the foremost wit of his day. He often contributed to the columns of the *Boston Gazette*, in which this poem first appeared. It was again reproduced in the *St. James' Evening Post*, London, on August 20, 1739, indicating trans-Atlantic interest in significant American Masonic events. A loyalist in 1775, Green fled to England where he remained until his death. His poem appeared posthumously in the *American Apollo*, a Boston magazine.

6.02

Nouveau Catechisme des Francs-Macons
by Louis G. Travenol
Paris, 1749 (3rd ed.)
Library Archives 81-274

This exposure of Masonic ritual contains an engraved scene titled "Ceremonie des Festins" depicting Freemasons conducting a Table Lodge. The tables are set in a U-shaped configuration and the proceedings are accompanied by music.

*A Selection of Masonic Songs
Arranged with Chorusses in Parts and
Respectfully Dedicated to the Brethren
of the Most Ancient & Honourable
Fraternity of Free and Accepted Masons.*
David Vinton, publisher
Dedham, Massachusetts, 1816
Library Collection, M65 .V791

A song book compiled by the author as "The Masonick
Minstrel, a selection of Masonick, Sentimental, and
Humorous Songs, Duets, Glees, Rounds, and
Canzonets." Vinton believed that his song book would
"exhilirate [sic] the lodge, the parlour, or the social
circle." Many of the songs were to be sung at table
lodge and Masonic festivals. The frontispiece was
copied from S. Holden's *Selection of Masonic Songs &c.
Arranged and Composed in Parts....* (Dublin, 1802), from
which Vinton borrowed heavily. Holden, in turn,
obtained his frontispiece design from a trade card that
had been engraved for James Brush (1774-1812) of
Dublin, a jeweler who specialized in making Masonic
insignia.

David Vinton (1774-c.1833) was a goldsmith and
jeweler in Providence, Rhode Island. He was initiated
in Mount Vernon Lodge No. 4, Providence in 1811
and appointed by the lodge to procure Masonic song
books. Brother Vinton found existing songsters
unsuited for the brethren and decided to compile his
own. He is also known for having written the words for
Pleyel's Hymn which is used as a Masonic funeral
dirge. The dirge was first published in this volume,
which sold more than 12,000 copies.
*References: Flynt and Fales 1968, 347. Denslow 1961,
4:280. Leicester Lodge of Research 1947/48.*

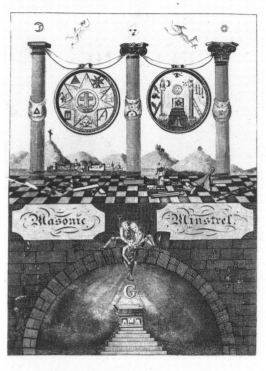

And the darkness comprehendeth it not.

Sit lux et lux fuit lux Sapientiæ.

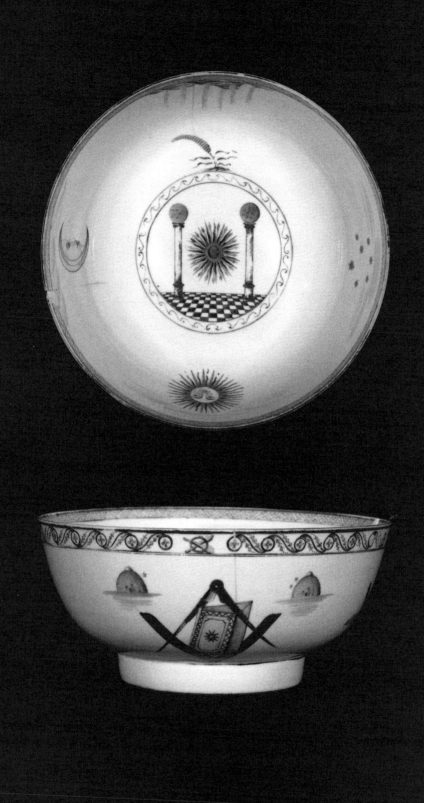

Ceramics

ILLUSTRATION:
6.04
SEE DESCRIPTION
ON PAGE 215

IN THE LAST HALF OF THE 18TH CENTURY AND DURING THE EARLY DECADES OF the 19th century, large quantities of ceramics decorated with Masonic motifs were produced for Masonic brethren in England and America. English transfer-printed creamwares comprised the bulk of these ceramics. However, before the end of the 18th century the English potters who were producing Masonic ceramics for the American market experienced serious competition from hand-painted porcelains made in China.

Chinese Export Ceramics

Americans first entered direct trade with China in 1785, but another decade passed before ship captains routinely returned from their voyages to Canton laden with fine porcelains. The bulk of these ceramic cargoes was common blue and white "Willow" pattern porcelain, which was carried as ballast. By special order, dinner services of finer porcelain could be custom-decorated with armorial arms, images from popular prints, patriotic insignia, or the symbols of fraternal orders.

In catering to the Masonic market, Chinese artists were permitted little latitude for individual artistic license. Western engravings provided patterns for the decorative designs they executed by rote. Images extracted from these sources were seldom used intact. Compositional units were borrowed piecemeal, to build a narrow range of standard symbolic ensembles. Confined to a specific *entrepot*, during a narrow time frame (1795-1810), the same artists used the same designs to satisfy the middlemen who dealt with ship captains.

Masonic lore surrounding the building of King Solomon's Temple touched construction concepts readily understood by the Chinese. Summonses to attend lodge meetings, similar to those engraved by Paul Revere, Jr. (1735-1818) and published in the *Freemasons' Magazine* (January 1812), provided oriental artists with a lexicon of approved symbols and images. Punch bowls were decorated with stonemason's tools to the virtual exclusion of other symbols.

Once Chinese potters and artists had established an acceptable vernacular of Masonic motifs, they seldom deviated. On the other hand, the continuing development of transfer-printing techniques in England allowed potters in that country to be more responsive to changing currents in decorative style and motifs.

English Transfer-Printed Creamware

In 1751, Birmingham engraver John Brooks applied for patent rights to a then revolutionary method by which an image could be transferred from an engraved wood or copper plate to the surface of "enamel and china." Key to the eventual success of his process, as applied to porcelain and pottery, was the intermediate step of printing engraved images on tissue paper with special vitreous pigments. The image could then be transferred and fused to the surface of glazed ceramics. This overglaze process became the special domain of the transfer printer. Although Brooks' process was inaugurated at the Battersea enamel works, it was soon introduced in the porcelain works at Bow, Worcester, Chelsea, and Derby. Orders addressed to Bow were soon forthcoming from American lodges.[1]

By the late 1750s, Liverpool had developed as a center for earthenware pottery and free-lance transfer-printing. Rarely was a transfer printer also an engraver. The leading Liverpool ceramic printing firm of Sadler and Green employed a stable of artists who engraved transfer-print plates. These firms employed engravers who were seldom allowed to sign their work. The imprint at the foot of an image could belong to a free-lance engraver/printer such as Richard Abbey (1754-1819) or Thomas Baddeley (fl. 1797-1822) as well as a printer like John Sadler (1720-1789) or Joseph Johnson (fl. 1789-1810). The imprint of a potter, such as John Aynsley of Lane End (fl. 1780-1809), did not appear as often as that of the printers or engravers.

Underglaze transfer-printing was introduced at Worcester by 1760, but it did not reach a successful and economic level of development until about 1810. In the initial stages, it was limited to the color blue, derived from cobalt oxide that could withstand high fluxing temperatures of the glazing oven. Then black and red were added to the potter's palette. Applied to a porous "biscuit" body, the design softened as the glaze melted over it, causing a somewhat blurred effect. Henry Fourdrinier's (1766-1854) invention, in 1803, of a machine that made specially thin and strong transfer tissue paper greatly improved the beauty and quality of the fired patterns. This preceded development in 1805 and 1813 of stronger, more durable, and less expensive stoneware china.

In the second half of the 18th century a small amount of English Masonic porcelain was produced at Worcester in imitation of imported Chinese porcelain. However, the majority of English Masonic ceramics was comprised of transfer-printed earthenware pottery, known as creamware from its color. English potters appear to have focused their Masonic production on jugs or pitchers and tankards or mugs. Such a high proportion of drinking-related vessels points to intended use in the lodge. In contrast, the large number of Chinese Masonic tea services indicated a consumer market beyond the confines of the lodge. Delicate and personalized, the Chinese porcelains were better suited to a genteel household setting.

Creamware production was primarily confined to three major pottery centers located in Liverpool, Sunderland, Staffordshire, and, to a much lesser extent, at Leeds. Liverpool Masonic jugs and tankards are generally of a fine ivory or cream-colored earthenware with a smooth fluid glaze, and overglaze printed transfers in monochrome ranging from a silver grey to jet black. In form, the jugs are nearly all barrel-shaped and tall proportioned, like the tankards. Masonic transfers introduced at Liverpool were copied from well-known engravings that appeared as frontispieces to various books and on certificates, summonses, and aprons.

Liverpool's leading transfer-printing firm of Sadler & Green specialized in utilizing these images and embellishing variations on the armorial arms of the Premier Grand Lodge of England. Only in rare instances were the arms of any other Masonic faction (Ancients) or body (Knight Templars) used. In order to enhance appeal to the American market, much Liverpool ware was decorated with a dual theme. In addition to a Masonic subject, jugs might also bear a view of a sailing vessel flying American colors, which would appeal to mercantile interests, or a memorial to George Washington, which could evoke patriotic sentiment.

Staffordshire Masonic jugs were often gaily decorated with hand-enamelled polychromatic floral designs applied over the glaze. The jugs are often bulbous in shape or at least of more stout proportions than those of Liverpool. Colorful glazes such as canary yellow were introduced to enhance transfers printed in red as well as black. Through experimentation, the potter's colorful palate of vitreous transfer-printing inks was expanded to include even a visually arresting magenta. Unmarked flatware, enamelled with bucolic rural scenes and borders of molded Masonic symbols, are attributed to later Staffordshire production. During the early decades of the 19th century, Staffordshire became synonymous with the production of dark blue under-glaze printed historic views. Many such patterns were specifically made for the American market, but very few were Masonic in nature.

Potteries in the Sunderland district manufactured large quantities of heavy, white creamware. Jugs are ovoid in shape with high-collared rims glazed in solid or "splash" resist pink lustre. Black transfer-printed images of King Solomon's Temple with allegorical figures of the "Cardinal Virtues," or of Iron Bridge, the famous cast-iron trestle bridge over the Wear River, were favorite subjects. Pink lustre characteristically surrounded printed images that were also highlighted with polychrome enamelling. Sailors, whose ships docked at the mouth of the Ware, speculated in ceramics to resell at other ports of call. Numerous Sunderland potters who were Freemasons accommodated orders on short notice for ceramics customized with the names of brethren, lodges, and commemorative dates. This trade helped to promote the spread of Sunderlandware and inspired the use of maritime-related images in combination with standard Masonic symbols.

A high proportion of Sunderland Masonic mugs are of the "frog" variety, having a brown or green enamelled ceramic frog attached to the interior bottom. Although "frog" drinking vessels were originally intended as a physician's emetic to induce vomiting when the frog was revealed by drinking the contents, the frog mugs of Sunderland seldom astonished anyone and served only to induce comic relief.

The specialist engravers who produced transfer-print plates were seldom original or innovative. The images they required were invariably borrowed from the published works of other engravers. In this they were not unlike their Chinese competitors. There was an understandable reluctance on the part of potters to venture into the complex area of Masonic symbolism without the benefit of commercially safe guidelines. This copyist approach often allows us to trace the origin of the English designs despite Parliamentary legislation protecting the rights of the artist (Engravers Act of 1735, and May 16, 1763).

Masonic transfer-printed images can be traced directly to plates engraved for texts, exposes, membership certificates, meeting summonses, and aprons. The bibliotheca of Freemasonry provided "approved" illustrations dense with Masonic heraldric devices, allegorical figures, and symbolic imagery. The symbolism employed progressed from an early use of male figures, representing a Master and Wardens wearing the jewels of their office, to more allegorical scenes derived from apron and certificate designs. These latter images can be traced directly from original engravings inspired by classical mythology and architecture of the Neoclassical Revival.

Various heraldric devices adopted by the Freemasons, but which were never granted by the College of Heralds, were often used to decorate English "Masonic" transfer-printed ceramics. In 1472 the Free Company of Operative Stonemasons was granted arms emblazoned with "Azure, on a chevron between three castles argent, a pair of compasses somewhat extended of the first." A castle was also adopted for their armorial crest. After the establishment of the Premier Grand Lodge in 1717, the "Free and Accepted Masons" adopted arms similar to those granted the operative stonemasons, but with the addition of beaver supporters, and the substitution of a dove on a sphere for a crest. The motto they adopted was "Relief And Truth" but its use was limited and more often replaced by "Amor, Honor et Justitia" (Love, Honor and Justice). These arms remained in use from 1765 until 1813. An unauthorized crest device of a "bowed arm dexter, holding a trowel" gained very limited use after having been illustrated in the 1764 edition of Dermott's *Ahiman Rezon*. The arms of the Provincial Grand Lodge of Massachusetts were similar to that of the Grand Lodge of England, but with a change in motto to "Follow Reason," a translation of the motto "Suivez Raison" on the Duke of Montague's arms.[2]

The factionalism within English Freemasonry, which had begun between the traditionalists and progressives in 1738 and had fully ripened by 1751, impelled the Ancients,

or traditionalists, to adopt arms of their own.[3] Known as the Tetrarchial, the Ancients arms were comprised of a shield quartered with a lion, rampant; a robed man, with hands up-lifted; an eagle, displayed; and an ox, passant. They adopted the Holy Ark of the Covenant, supported by two cherubim with wing tips extended over the ark, as their armorial crest. The motto they adopted was "Kodes La Adonai" (Holiness to the Lord). These unlaw-fully assumed quasi-armorial bearings remained in effect until 1813.

The schism was healed in 1813 when the Duke of Sussex (1773-1843), aided by his royal brothers, was elected Grand Master of both factions and was able to reconcile and unify the rival bodies under one title as The United Grand Lodge of England. The schism had also blighted the smooth course of American Masonry, but with the example of a United Grand Lodge in England, similar "healings" between Ancients and Moderns were welcomed in each separate state jurisdiction. Armorial arms adopted in 1815 by the United Grand Lodge were substantially those of the Ancients impaling those of the Moderns. The motto, however, reverted to that first adopted by the Premier Grand Lodge in 1717, i.e., "Audi, Vide, Tace" (Hear, See, and be Silent).

Other popular Masonic designs were created from allegorical representation of the seven principal virtues, of which three were theological and four were moral. The cardi-nal virtues were represented by Minerva, with helmet and shield as Fortitude; Prudence, holding a mirror that reflects one's actions; Justice, with balance scales and sword allud-ing to judgment and penalty; and Temperance, holding a bridle symbolic of restraint. The three theological virtues are represented by Faith, holding a book (Bible) or some-times a cross in one hand and a chalice in the other; Hope (salvation), holding an anchor; and open-handed Charity or Benevolence, comforting small children or relieving the poor and lame.

Traditionally, the three principal supports or pillars of the lodge are wisdom, strength, and beauty. Wisdom is symbolized by an Ionic architectural column that combines the strength of the Doric with the beauty of the Corinthian. It is also symbolic of the Master who presides from the east side of the lodge and represents the wisdom of King Solomon. In the neoclassical lexicon of 18th-century engravers, Wisdom appeared in the guise of helmeted Minerva.

Strength was represented as a Doric column, strongest of the architectural orders, sym-bolic of the Senior Warden and of King Hiram of Tyre who provided materials and workmen to build the temple. The attribute of strength was allegorically illustrated by the figure of Hercules, readily identified as clad in the skin of the Numean lion and wield-ing his famous club.

Beauty was represented by a Corinthian column, symbolic of the Junior Warden who personifies Grand Master Hiram Abif and the skill that resulted in the temple's great

beauty. The goddess Venus (with or without Cupid in attendance) was used to represent Beauty.

The Grand Union of 1813 defused the need for dual Masonic imagery. Resolution of the schism led to reintroduction of a universal set of symbols evolved from those found in the earlier Master's Carpet. It was not long before revered Masonic ritualists such as Jeremy Cross would formalize a package of symbols that represented basic tenets of the Craft (*Masonic Chart*, New Haven, 1819).

1. Adam and Redstone; Royal White Hart Lodge No. 2 at Halifax, NC ordered four punch bowls from Bow, each to hold one gallon, and enameled with the words "Halifax Lodge No. Carolina". See also Rauschenberg 1975.

2. In 1721, John, Duke of Montague was the first nobleman to be elected Grand Master of the Grand Lodge of England.

3. The arms appeared on the frontispiece to Dermott's *Ahiman Rezon* (2nd ed., London, 1764).

Illustrations

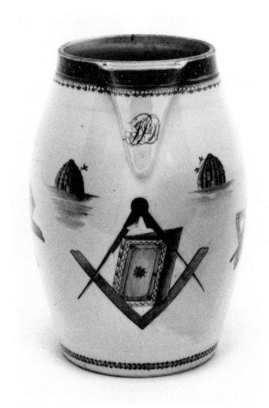

6.04 SEE ILLUSTRATION ON PAGE 208
Large Punch Bowl
Chinese Export, late 18th century
Porcelain
Special Acquisitions Fund 84.7
h: 6 ½" dia. 15 ½"

Underglaze painted designs in magenta highlighted
with gold. The bowl has a Nanking type rim border
and shows repeated image of two cherubs, enclosed
within a rococo frame and working blocks of stone; one
uses a frame saw while the second sculpts a portrait
bust. Extremities of the rococo frame enclose small vi-
gnettes of the floor plan of Solomon's Temple and a
beehive. Tool groups consist of plumb and square,
and level and compasses. The interior of the bowl
shows a domed architectural building (Doric Temple)
surmounted by a statue of Fame.

The images of cherubs working stone, rococo frame-
work, and tool clusters are nearly identical to those
found on a meeting summons engraved by Paul
Revere in 1772 for St. Paul's Lodge of Newburyport,
Massachusetts.
Reference: Bingham 1954 pl. 59.

6.05 SEE COLOR PLATE, PAGE 277
Small Punch Bowl
Chinese Export, late 18th century
Porcelain
Gift of Frederick B. Doolittle 77.32
h: 4" dia. 9 ⅛"

Underglaze painted designs in sepia. A book enclosed
by square and compasses forms the primary image
group. Other images that allude to stonemason's work
consist of a trestle table with ink pot, feather brush,
and dividers; rough ashlar with frame saw and lube
pots; smooth ashlar with a lewis or lifting ring. En-
twined displays of drafting tools include a protractor,
hinged marking gauge, and parallel ruler. The interior
shows a medallion with two globed pillars on a mosaic
pavement, flanking a radiant sun with the letter "G."
Around the interior rim are a sun, moon, seven stars,
and raining clouds. A head of wheat acacia rises from
a mound of earth at the top of the medallion. The
outer rim is bordered with a Vitruvian scroll that is seg-
mented by small medallions composed of crossed
clubs encircled by a serpent biting its tail.

An identically decorated bowl was once owned by
Robert R. Livingston (1746-1813) of New York
(Howard Fig. c41). Bro. Livingston served as Grand
Master of the Grand Lodge of New York from 1784 to
1801. The drafting tools allude as much to nautical
navigation as architecture. The head of wheat may also
represent cereals in general or corn, symbolizing the
elements of consecration — corn, wine, and oil. As
supporters of life and a means of refreshment, they are
used to consecrate lodges and are carried in Masonic
processions. The symbol of the serpent devouring it-
self represents the eternal cycle of life. The bowl
descended in the Doolittle family from General
George Doolittle, a Connecticut officer in the Revolu-
tionary War. The bowl is said to have been given to
him as a testimonial by his brother officers.
Reference: Howard 1984.

6.06
Cider Jug
Chinese Export, late 18th century
Porcelain
Special Acquisition Fund 77.16
h: 8 ¼" dia.: 4 ⅜"

Barrel-shaped jug with double intertwined handle,
decorated with underglaze painted Masonic symbols.
The rim is bordered in blue overglazed enamel with

gold stars and a Nanking style edge. The initials "JPD" are in gold beneath the spout. Masonic designs include the square and compasses laid upon the Bible flanked by beehives in sepia; a group of entwined drafting tools comprised of a protractor, hinged compass-joint marking gauge, and parallel ruler. A second tool group includes a plumb and level.

6.07 SEE COLOR PLATE, PAGE 287, LEFT

Tankard
Chinese Export, late 18th century
Porcelain
On loan courtesy of
the Lodge of St. Andrew, A.F.& A.M.,
Boston, Massachusetts
h: 5 ½" dia. 4 ¼"

Straight-sided can with double intertwined handle decorated with overglazed polychrome enamel and gold. The rim is bordered with a band of blue overglazed enamel with a trailing grape vine in gold. A stalk of wheat or corn rises above a central medallion containing a radiant sun with the letter "G" suspended between the two pillars of Solomon's Temple on a mosaic pavement. On either side of the medallion are blocks of ashlar in the rough stage with a stone-cutting frame saw and pots of blade lubricant, and blocks of ashlar smoothly dressed with a lewis inserted for hoisting into position. An array of drafting tools includes protractor, hinged compass-joint marking gauge, and parallel rulers. A group of stonemason's working tools includes plumb and level. The square and compasses are laid upon a book representing the Bible. Other symbols include a trestle table laid with various brushes and paints, and a beehive skep. This tankard was once the property of John Suter (1781-1852), a former member of the Lodge of St. Andrew.
Reference: Franco 1976.

6.08

Tankard
Chinese Export, late 18th century
Porcelain
Special Acquisition Fund 77.53.1
h: 5 ¼" dia.: 4 ¼"

Straight-sided can with double intertwined handle with foliate ends. The rim is overglaze enameled cobalt blue with repeat of gold stars. Under/overglaze decorations include square and compasses and a book representing the Bible, a radiant sun, and crescent moon.

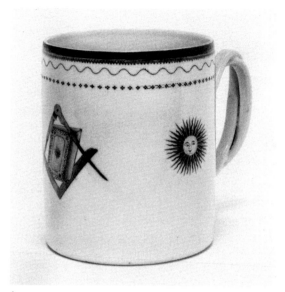

6.09

Tankard
Attributed to Dawson & Co. Pottery
South Hylton, England, c. 1795-1800
Creamware
Special Acquisition Fund 92.002
h: 5 ½" dia. 3 ¾"

Cream-colored softpaste ceramic tankard with rimmed base and loop handle. The line-engraved black transfer-printed design is comprised of a Masonic Royal Arch, Master and two Wardens, the Triple TAU and other symbols of Craft and Capitular Masonry, all within an indented oblong border with quadrant corners. The arms and crest of the Premier Grand Lodge appear in panels on the column pedestals. The lower right corner bears the imprint initials "W.C." A brown ceramic frog is applied to the bottom of the interior. Across the base in two lines is the verse:

> The world is in pain, our secrets to gain,
> But still let them wonder & gaze on,
> For they ne'er can devine, the word nor the sign,
> of Free & an accepted Mason.

Singer and actor Matthew Birkhead (d. 1722) was the author of the "Entered Apprentice's Song," which was first published in Anderson's *Book of Constitutions* (London, 1723). Bro. Birkhead was a member of Lodge of Friendship No. 6 in London. Popular use of this refrain reflects a contemporary obsession with disclosures of "secret" Masonic rituals. The triple TAU, a symbol adopted among English lodges as the jewel of the Royal Arch Mason, was not officially adopted in American Royal Arch Chapters until 1854.

The identity of the engraver is unknown, but his initials are found on transfer-printed wares produced from

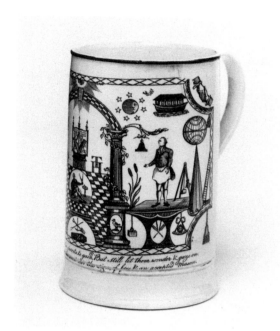

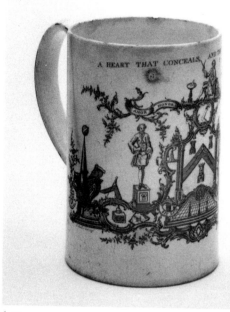

1790 to 1805 by John Dawson (1760-1848) at his Low Ford Pottery, South Hylton from 1790-1805, and by Robert Dixon (1779-1844) at his Garrison Pottery, North Hylton. Williams-Wood assumed that "W.C." was a local Hylton free-lance engraver.
Reference: Williams-Wood 1981, 206.

6.10 SEE ILLUSTRATION ON PAGE 218

Tankard
John Phillips & Company
Wear, England, c. 1807-1813
Creamware
Special Acquisition Fund 87.28
h: 5 ⅞" dia.: 4 ⅝"

Ivory-colored softpaste ceramic tankard with rimmed base. A brown ceramic frog is attached to the interior. The design is comprised of a black-printed transfer engraving of King Solomon's Temple, flanked by two globe-topped pillars and female figures representing the virtues Justice and Prudence. In panels at the base are a stanza of the "Entered Apprentice's Song" and the imprint "J. Phillips & Co. Sunderland Pottery."

In 1807, John Phillips leased the Garrison Pottery, situated at the mouth of the Wear River, in a district of Sunderland known as Bishopswearmouth. Phillips' enterprise, known as the Sunderland Pottery, remained under his control until 1813.
Reference: Williams-Wood 1981, 208.

6.11

Tankard
Wedgwood & Co.
Knottingly, England, c. 1796-1801
Creamware
Special Acquisition Fund 85.36.1
h: 6" dia.: 4 ⅛"

Ivory-colored creamware can with base bearing the impress mark "Wedgwood & Co." Black overglaze transfer-printed engraving shows an "I. Sadler, Liverpool" imprint; armorial arms and crest of the Moderns; a Master and his two Wardens; and the motto "Amor, Honor et Justitia." Above the design and around the rim is the legend, "A Heart that Conceals, and the Tongue that Never Reveals."

In 1796, Ralph Wedgwood became a partner in a pottery located at Knottingly in West Yorkshire, remaining there until 1801, at which time the company changed its name. Wares produced during Ralph Wedgwood's term were frequently marked "Wedgwood & Co." in order to profit by the reputation of his more famous cousin, Josiah Wedgwood. John Sadler (1720-89) of Liverpool worked as a free-lance transfer printer whose business depended upon engravers employed by various potteries. Sadler entered into a printing partnership with Guy Green that lasted from 1756 until 1799, but many transfer prints sold by the firm of Sadler & Green bear an "I. Sadler" imprint.

The armorial crest of the Freemasons Arms with "naked arm dexter, embowed, couped above the elbow, holding a trowel" and the motto "Armor Honor et Justitia (Love, Honor, and Justice), was adopted by the Moderns faction of Freemasons in 1764.
Reference: Williams-Wood 1981, 101-105, 200.

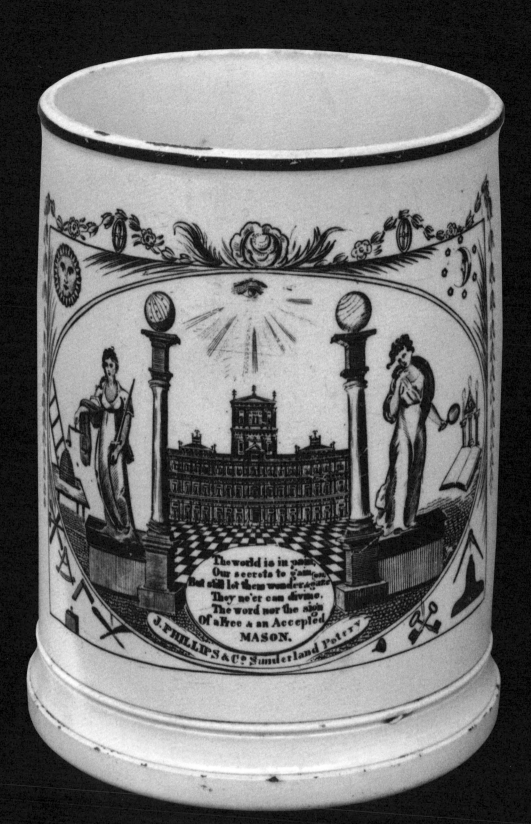

The world is in pain
Our secrets to gain
But still let them wonder & gaze on
They ne'er can divine
The word nor the sign
Of a Free & an Accepted
MASON.

J. PHILLIPS & Co. Sunderland Pottery

6.12 SEE COLOR PLATE, PAGE 278, RIGHT

Tankard
Liverpool, England, c. 1780-1800
Creamware
Special Acquisition Fund 76.51
h: 4 ⅝" dia.: 3 ¼"

Ivory creamware can with rimmed base. The heavy black underglaze transfer-printed engraving shows "The Freemasons Arms." The letter "G" in a triangle has been substituted for the usual armorial crest. Other elements include ribbons with the mottos "Sit Lux Et Lux Fuit," and "Virtute Et Silentio," and "Armor Honor Et Justitia" (Moderns), and the figures of a Master and Wardens. The engraving is overenamelled with red, green, yellow, and blue.

6.13

Tankard
Liverpool, England, c. 1800
Creamware
Special Acquisition Fund 80.51
h: 5 ¾" dia.: 4 ¼"

Straight-sided tankard with rimmed base; black overglaze transfer-printed engraving in Venetian red on ivory creamware. Female figures representing Faith and Charity stand atop Corinthian columns that flank

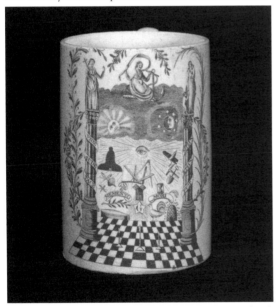

the seated figure of Hope. The columns are entwined by ribands inscribed "Vide, Aude, Tace" and "Sit Lux Et Lux Fuit." Other Masonic Craft symbols and the motto "Memento Mori" ("Remember Death") are illustrated above a mosaic pavement that forms the base.

The image design is derived from the format of Masonic membership certificates of the 1795 period. The "Vide, Aude, Tace" motto was later adopted with slight alteration by the United Grand Lodge in 1815.

ILLUSTRATIONS:
6.10, FACING
6.13, LEFT
6.14, RIGHT

6.14

Creamer
England
late 18th century
Creamware
Special Acquisition Fund 79.11.3
h: 4 ½" dia.: 2 ¾"

Small barrel-shaped pitcher with dark black underglazed stipple and line-engraved transfer-printed design on ivory creamware. The principle design shows a circular medallion containing a caricature of a man assembled from masonic symbols with bordering

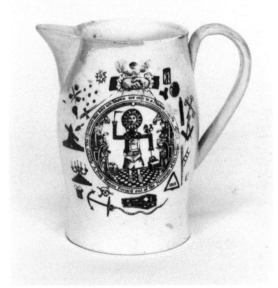

legends titled: "A Free Mason form'd out of the Materials of his Lodge" and "The Mysteries that here are shown are only to a Mason known." The medallion is surrounded by various Masonic Craft symbols. On the opposite side is an oval haying scene of a husbandman sharpening a scythe.

The caricature of "A Free Mason form'd..." is derived from a copperplate drawn by Alexander Slade and published by W. Tringham, Castle Alley, Royal Exchange, London, on August 15, 1754. Slade's parody of Masonic ceremonies titled "The Free Mason Examined" (London, 1754) inspired this caricature.
Reference: Thorp 1907, 95-111.

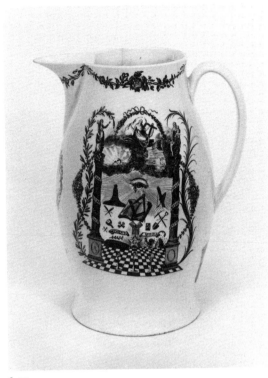

6.15
Pitcher
Liverpool, England, c. 1800
Creamware
Gift of Norris G. Abbott 74.1.35
h: 10 ½" dia.: 5 ¾"

Tall, barrel-shaped jug with heavy black underglaze transfer-printed design on ivory creamware. The principal allegorical design is of the figures Faith and Charity standing atop two Corinthian columns on a mosaic pavement. The columns flank various Craft symbols and are entwined with ribbons inscribed with the mottos "Vide, Aude, Tace" and "Sit Lux, Et Lux, Fuit." A figure representing Hope is placed between Faith and Charity. The secondary design shows a verse from the "Entered Apprentice's Song." Beneath the spout are the initials "WNT" in script. Below the handle is a Royal Arch Triple *Tau* symbol within a triangle on a radiated background in the shape of a five-pointed star. The image was adapted from a combination of designs found on English Masonic membership certificates. This piece descended from Judge Walter B. Vincent of Rhode Island.
Reference: Johnson and Bramwell 1951, Pl. 5.

6.16 SEE COLOR PLATE, PAGE 279, BOTTOM LEFT
Pitcher
Liverpool, England, c. 1800
Creamware
Gift of Robert W. Raymond 87.52.4
h: 7 ¾" dia.: 5 ½"

Squat baluster-shaped jug with overglazed Venetian red line-engraved transfer-printed design on ivory creamware. The principal design shows a circular medallion containing various Masonic Craft symbols within an indented border interspersed with various other Masonic symbols. Under the spout is inscribed "Lodge of Relief No. 37." The center of the secondary design shows a medallion with two hands clasping beneath a heart, surrounded by the rhyme "Happy the Man whom no vain fears Torment/Who lives at Peace within himself Content/For happiness he surely need not roam/Tis easiest found with little, and at home." Both medallion and rhyme are framed by a grapevine border that includes a small medallion of a sailing vessel. The imprint foot is marked "T. Clarke, sculp." Beneath the spout is the commemorative inscription "Lodge of Relief No. 37."
 The design of the principal medallion is derived from the frontispiece to the 18th-century English exposé of Freemasonry, *Jachin & Boaz*, in which is illustrated a "medallion, in imitation of those medals, or plates, that are common among the brotherhood. These medals are usually of silver...."
Reference: Jachin & Boaz 1776.

6.17
Pitcher
Liverpool, England, c. 1811
Creamware
Gift of Union Lodge, A.F. & A.M.,
Dorchester, Massachusetts 75.46.11
h: 11"

One of an identical pair of barrel-shaped jugs with dark brown banding and acanthus decoration under the spout. The design is comprised of three Masonic designs in black overglaze transfer-print on ivory creamware: (1) circular medallion of Freemasons about to enter an arched building doorway, and a medallion portrait labeled "Veritas prevalebit" in the sky above; (2) beneath the spout, armorial arms of the Ancients with motto "Holiness to the Lord" displayed within a Masonic Royal Arch inscribed "Cemented with Love," and the name "Union Lodge" applied in brown overenamel below the arch; (3) certificate-style Master's Carpet depicting twin Corinthian pillars on a mosaic pavement surmounted by standing figures of Faith and Charity with the figure of Hope seated in the sky above.

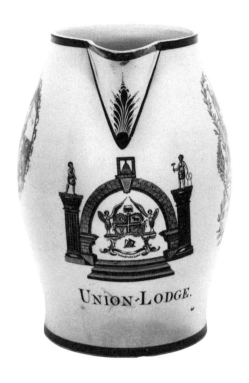

UNION·LODGE.

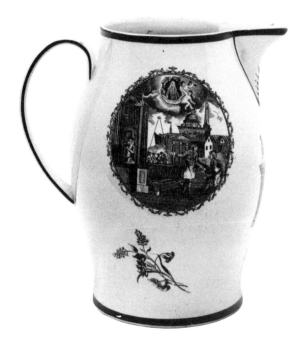

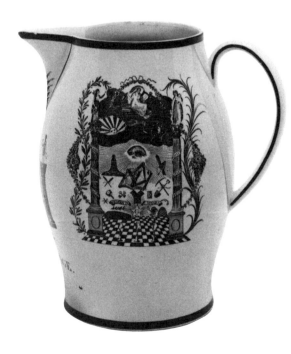

(1) Design copied from the frontispiece of *A Serious and Impartial Enquiry into the Cause of the Present decay of Freemasonry in Ireland*, by Dr. Fifield Dassigny (1707-1743). Dassigny's work, published in Dublin in 1744, contained the first typographical reference to the Royal Arch Degree as represented by the arched doorway to the lodge. The image was designed by Dassigny, drawn by Joseph Tudor (d.1759), and engraved by P. Hodge. (2) The quartered armorial arms and crest of the Ancients was designed by medalist John Kirk (1724?-1778?) and adopted in 1775. The Kirk design was used by the Ancients until the Grand Union occurred in 1813, at which time it was incorporated in the arms of the United Grand Lodge of England.

The pair of matching jugs was given to Union Lodge in 1811 by ship captain Nehemiah Skillings, who was admitted in St. Andrew's Lodge, Boston in 1764.

Reference: Dassigny 1744. Franco 1976, fig. 87.

6.18 SEE COLOR PLATE, PAGE 279, BOTTOM RIGHT

Pitcher

Staffordshire, England, c. 1800
Creamware
Special Acquisition Fund 78.12
h: 8 ½"

Barrel-shaped jug with underglazed black striping and transfer-printed designs on canary yellow glazed creamware. The armorial arms of the Moderns with figures of the Master and Wardens appear above the rhyme "The World is in pain the secret to gain of a Free and Accepted Mason." There is also a view of a trestle bridge with sailing vessels in the river beneath. In the center is an oval medallion titled "A South East View of the Iron Bridge Over Wear near Sunderland first stone was laid by R. Burdon Esq. M.P. Sept 24 1793 & opend' the 9th of Aug' 96" and "Cast Iron 214 tons Wrought 46 do. Span 236 feet Height 100 do." At the base of the imprint, within a swagged border, are the initials "EA" in script.

When completed in 1796, Iron Bridge was the longest single-span, cast-iron bridge in the world. Construction of the bridge was promoted by Rowland Burdon, a prominent and ardent Mason. Twenty-two different transfers of this bridge are known and outnumber all other designs used on Sunderland ware.

6.19 SEE COLOR PLATE, PAGE 279, TOP RIGHT

Pitcher

Staffordshire, England, c. 1805
Creamware
Special Acquisition Fund 79.11.2
h: 10" dia.: 5 ½"

Bulbous jug with high collar, double C-scroll handle, and blue banding; magenta overglazed transfer-printed white creamware. The decoration consists of three imprints, two Masonic and one patriotic in nature. On one side figures representing Faith and Charity stand atop architectural pillars with Hope and various Masonic symbols in the center. A mosaic pavement forms the base, beneath which is the statement "United for the benefit of mankind." On the opposite side the figure of Charity and her children beneath the all-seeing eye and a Masonic Royal Arch. Beneath the design, the credo "To judge with candor and to speak no wrong, The feeble to support against the strong, To soothe the wretched and the poor to feed, will cover many an idle foolish deed." Under the spout the initials "EG," the Great Seal of the United States, and the quotation "Peace Commerce and honest Friendship with all Nations Entangling Alliances with none. Jefferson/Anno Domini 1805" (First Inaugural Address, March 4, 1801).

6.20

Pitcher

Staffordshire, England, c. 1820-1830
Creamware
Gift of Union Lodge A.F. & A.M.,
Dorchester, Massachusetts 75.46.10
h: 8"

Bulbous jug with C-scroll handle and blue rim; magenta overglazed transfer-printed creamware. The principal design is composed of three architectural columns, topped by seven stars, a radiant sun, and a crescent moon. The columns are joined by a rope from which two circular medals are suspended, one showing an indented mosaic pavement with the letter "G" in the center, and the other a Masonic Craft medal with the motto "Virtuti Et Silento." A clock dial is fixed to the center column and tablets bearing geometric shapes and angles are on the other columns. A tent and a temple are erected between the columns. The imprint of the "Free Mason's Arms" is on the opposite side. Beneath the spout is a seated woman with children titled "Charity."

The unusual three-column imprint was adapted from the frontispiece of *The Builder's Jewel* (London, 1746), a primer authored by Bro. Batty Langley (1696-1751), outlining the rules of architecture for workmen and apprentices. The original image, engraved in 1741 by Batty's brother Thomas Langley, appeared in nu-

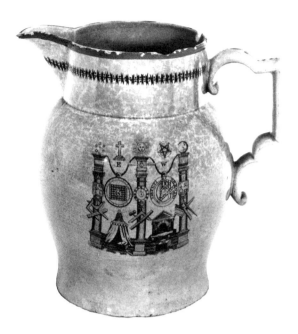

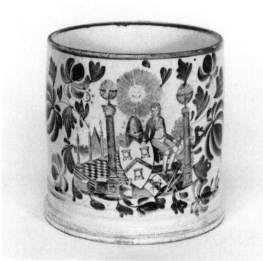

merous editions and was adapted by Freemasons to illustrate Masonic lore derived from the building of Solomon's Temple.
Reference: Lovegrove 1898, 134.

6.21 SEE COLOR PLATE, PAGE 279, TOP LEFT
Creamer
England, c. 1830
Creamware
Special Acquisition Fund 77.3
h: 5"

Small bulbous creamer with brick red underglazed transfer-printed designs and black striping on yellow creamware body. The principle design shows a Master of a lodge seated amid the working tools of a Mason. He supports a shield charged with the Freemason's arms, and is flanked by temple pillars of unequal height. On the opposite side is the motto "Masonry, Friendship and Love" within a floral border headed with square and compasses laid upon an open Bible, the three "lights" of Masonry, and the sun and moon.

6.22
Mug
Staffordshire, England, c. 1810-20
Creamware
Special Acquisition Fund 77.11.1
h: 4 ⅝" dia.: 4 ¾"

Mug with molded base and loop handle with foliate terminals; light purple striping on rim, base, and handle; French grey overglazed transfer-printed de-

sign; overenamelled flowers in red, green and blue on bone creamware. The design is an engraving of a Master of a lodge seated beneath a radiant sun and among the working tools of a Mason. He is flanked by the pillars of King Solomon's Temple, and supports a shield bearing the armorial arms of the Moderns.

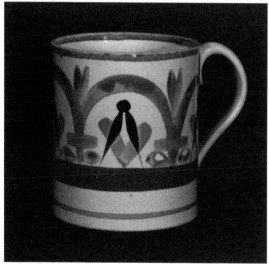

6.23
Mug
Sunderland, England, c. 1810-20
Creamware
Special Acquisition Fund 76.50.2
h: 4" dia.: 3 ½"

Mug with rimmed base, and gaudy broad-brush over-enamelling in purple, black, orange, and green. The free-hand repeat design consists of a series of arches, each enclosing a Masonic square and compasses.

Ceramics 223

ILLUSTRATIONS:
6.24, RIGHT

FACING PAGE:
6.25, TOP LEFT
6.26, TOP RIGHT
6.27, BELOW LEFT
6.28, BELOW RIGHT

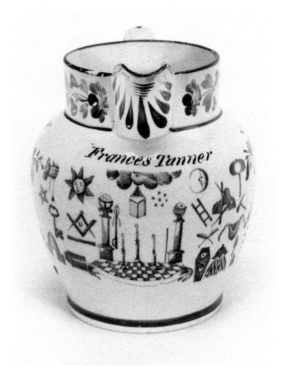

6.24
Pitcher

Staffordshire, England, c. 1820-30
Creamware
Special Acquisiton Fund 78.1.2
h: 7 ¼" dia.: 4 ½"

Ovoid pitcher with collared rim; spout, base and
handle striped in dark brown; medium blue under-
glazed transfer-printed engraving with overenamelled
polychrome flowers in purple, green, orange, and yel-
low. The ivory glaze has fine over-all crazing. The
name "Frances Tanner" is enamelled in black beneath
the spout. The engraving design is comprised of three
adjacent transfers. The central imprint section is cen-
tered under the spout and illustrates Masonic pillars,
mosaic pavement, and the three "lights" of Masonry.
Various other Masonic Craft symbols are arranged
on either side of the central section. A band of enam-
elled flowers runs around the collar of the rim,
terminating at the spout. Each side is enamelled with a
polychrome bouquet of flowers.

6.25
Pitcher

Staffordshire, England, 1821
Creamware
Special Acquisition Fund 77.72
h: 7" dia.: 5 ¼"

Ovoid jug with footed base, tall collared rim, and C-
scroll handle with foliate end; the collar and upper half
of the handle glazed in copper lustre with overenamel-
led flowers in blue, green, red, and yellow; the jet
black transfer-printed design with overenamelling in
red, yellow, and green on bone creamware. The name
"L. Smith" and the date "1821" are enamelled be-
neath the spout. The design is a Masonic engraving of
a medallion on a five-pointed star, showing a Tyler
standing at the top of a flight of stairs, guarding the
portals of a lodge. He is flanked by pillars of King
Solomon's Temple. The medallion is bordered with
the rhyme "A Mason"s chief and only care, Is how to
live within the square," and the motto "Wisdom,
Strength and Beauty." Above the design is a banner
with the motto "Amor Honor Et Justitia." A variety
of Masonic Craft and Capitular symbols encircle the
medallion.

The design within the medallion was copied from
an 18th-century English Masonic tracing board and en-
joyed an active life. It appeared on Masonic Craft
medals and was described in detail by the noted En-
glish Masonic lecturer, the Rev. George Oliver. As
an engraved plate, it performed double duty for ce-
ramic transfers as well as for bookplates.
Reference: Oliver 1846, 1:440 fn. 2.

6.26
Pitcher

Sunderland, England, c. 1820
Creamware
Gift of Mr. & Mrs. James DeMond in memory of
Gertrude and John D. Lombard 80.49.2
h: 6" dia.: 3 ⅞"

Ovoid jug with tall collar glazed in splash resist pink
lustre; black transfer-printed engraving with poly-
chrome overenamel on bone creamware. The principal
image is composed of allegorical figures representing
Faith and Hope, flanking Charity seated above a
trophy of Masonic symbols. A six-pointed star (double
triangle) forms the center upon which rests an open
book with square and compasses. Rising behind the
book is a radiant sun. On the opposite side a verse
reads "Women make Men Love/Love Makes them
Sad/Sadness makes them Drink/And Drinking Sets
them Mad." Beneath the spout the secondary image is
a view of a bridge titled "Sunderland Bridge."

An apron with this transfer, in the museum of the
Grand Lodge of England, was illustrated in *A.Q.C.*, vol-

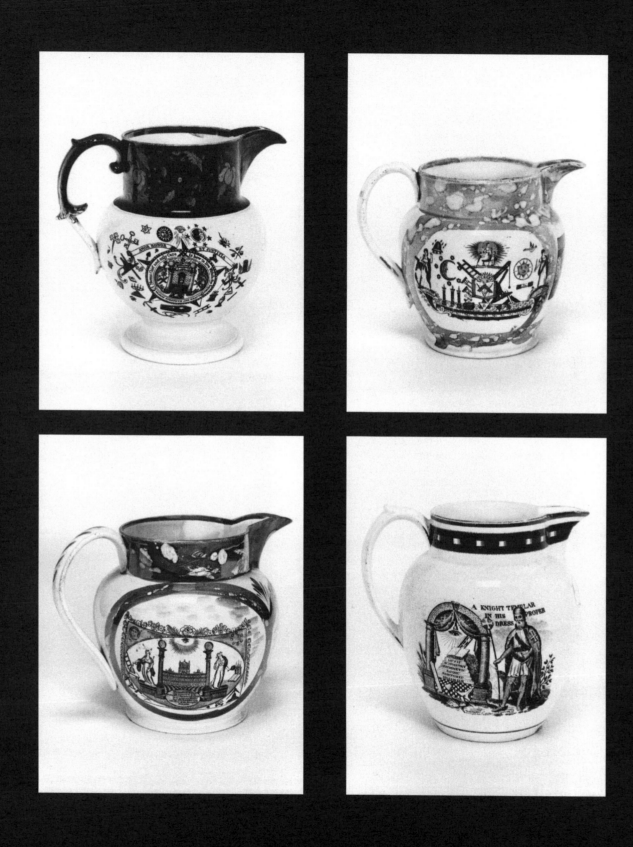

ume 19. The imprint was cited as "Drawn & Engraved by Brother Hixon, No. 13 Bridges Street, Covent Garden & sold by Griffin & Lay, No. 117, Oxford Street, London, Published Augt. 1, 1794."

The Hixon design was subsequently copied and used to print aprons and broadsides in the Leeds district. The Leeds imprint reads "Engraved by Brother Butterfield of Leeds. Nov. 7, 1806." William Butterfield joined Fidelity Lodge on May 22, 1815. Butterfield appears to have extended the application of his plate to illustrating ceramics.

References: Scarth, Alfred and Braim, Charles A. History of the Lodge of Fiedlity No. 289, from 1792-1893. *Leeds, 1894. Mason, Charles L.* The History of Philanthropic Lodge No. 304, Leeds, 1794-1894. *Leeds, 1894.* A.Q.C. *1906, 19:239, 240. Johnson & Bramwell - (Pl. IX -XI).*

6.27
Pitcher
Sunderland, England, c. 1810-20
Creamware
Estate of Charles V. Hagler 85.20.6
h: 8 ½"

Ovoid, pink lustre jug with black transfer-printed design on creamware. Within a rectangular panel, an oval view of King Solomon's Temple is flanked by Masonic columns and female figures representing cardinal virtues of Justice and Prudence. At the foot an oval panel with a verse from the "Entered Apprentice's Song."

Beneath the spout, the rhyme "Swiftly See Each Moment Flies, See and Learn Be Timely Wise, Every Pulse Beats life Away, Thus Thy Every Heaving Breath, Waft Thee on to Cerytain [sic] Death, Seize the Moments As They Fly, Know to Live and Learn to Die." On the opposite side is the imprint "A West View of the Wear under the Patronage of R. Burdon, Esq. M.P." and "Span 256 fte. Ht. 100/Cast 214."

Rowland Burdon was a prominent and ardent Mason, and promoter and designer of the scheme to build a bridge across the Wear River. Built of cast iron, it was inaugurated with Masonic ceremonies.

6.28
Pitcher
Staffordshire, England, c. 1814-25
Creamware
Special Acquisition Fund 77.57
h: 6 ½"

Bulbous jug with high collar decorated with red band of plaid. The imprint is a medieval Templar knight standing next to a Masonic Royal Arch and titled "A Knight Templar in His Proper Dress." On the opposite side an oval heraldric shield, bearing the blacksmith's arms with motto "By Hammer & Hand All Arts Do

Stand," is supported by the female figures of Justice and Beauty. Above and beneath the shield is the legend "Both United AM 5814 Under The Duke of Sussex." Under the spout are the initials "DS" in gold.

The figure of the Knight Templar is meant to represent Jacques de Molay (1244-1314), Grand Master of the Order of the Temple.
The Grand Union was effected through the efforts of Augustus Frederick, The Duke of Sussex (1773-1843), sixth son of George III.

6.29
Emetic Mug
Sunderland, England, c. 1830-40
Creamware
Gift of William D. Mathieson 75.30
h: 4 ¼" dia.: 4"

Mug with medium blue underglazed transfer-printed design on ivory creamware; inner rim with blue "Willow" pattern transfer border. The design is of a Masonic Master's Carpet with mosaic pavement, pillars, and various Craft symbols repeated on each side.

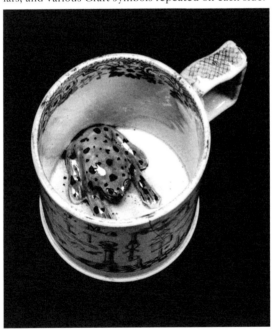

On the end opposite the handle are the initials "A:J:M." The initials stand for A.J. Mathieson, ancestor of the donor. A spotted green ceramic frog is attached to the bottom.

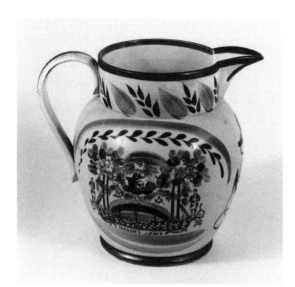

6.30
Pitcher
Sunderland, England, c. 1825
Creamware
Special Acquisition Fund 77.33.1
h: 7 ⅛"

Bulbous jug with a pink lustre glazed high collar; black transfer-printed design with green and blue over-enamelling. The principle imprint is titled "Mason's Arms," a variant of the standard "Free Mason's Arms" pattern. The secondary pattern on the opposite side consists of a rhyme found more often on tombstones, "When this you see, remember me, And keep me in your mind, Let all the World say what they will, Speak of me as you find." An enamelled dark brown fouled anchor appears beneath the spout.

6.31
Pitcher
Sunderland, England, 1823
Creamware
Special Acquisition Fund 78.69
h: 5"

Ovoid shaped jug with C-scroll handle. Overglaze-printed line and stipple engraved black transfer on white creamware with over-enamelling in red, green, and yellow. Design of the "Free Mason's Arms" with the verse:

> The graces and virtues united,
> Regard with fond admiration,
> Beholding their work so completed,
> In forming the heart of a Mason."

Beneath the spout "Thomas Chapman No.3 1823" is enamelled in brown. On the opposite side is a scene of a dog and hunter.

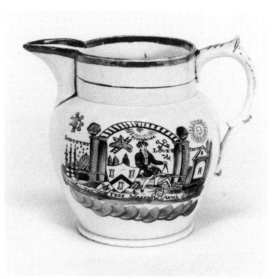

The hunting scene was copied from a popular series of four aquatints on shooting, published by F.P. Cook in 1791. The same scene was used to decorate the painted dials of tall clocks.

6.32
Pitcher
Sunderland, England, c. 1830
Creamware
Gift of the Estate of Charles V. Hagler 85.20.7
h: 6"

Ovoid shape jug with purple lustre striping; overglazed red transfer-print with polychrome enamelling in red, blue, green and yellow on creamware. The principal design is of the "Free Mason's Arms" with the motto

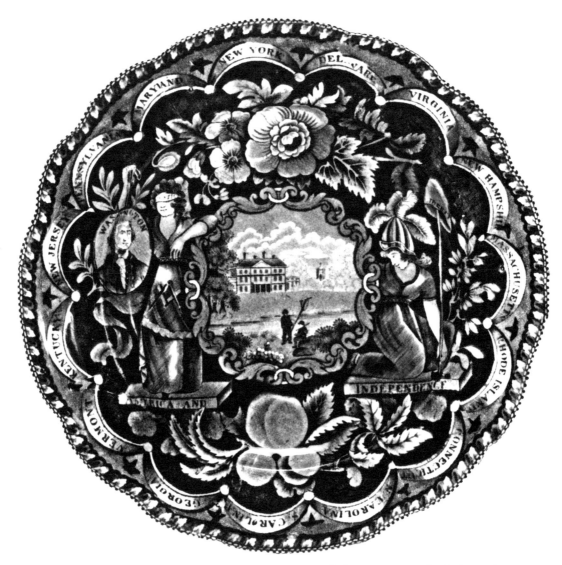

"Industry Loves Truth." An all-seeing eye beneath a Royal Arch is labeled "Providence." The secondary design is composed of a verse from the "Entered Apprentice's Song."

6.33

Plate
James & Ralph Clews
Cobridge, England, c. 1818-1834
Earthenware
Museum Collection 75.26
Special Acquisiton Fund
Diam: 10 ½"

Dark blue underglazed transfer-print. The female figure of Justice wears a Masonic apron and holds aloft an oval medallion portrait of George Washington. The fig-

ure of Minerva, representing Independence, supports a staff topped with a "Liberty" cap. The border pattern consists of swags containing names of the first fifteen states to join the Union. In the center is a vignette of a three-story building with a river and farmers in the foreground. The reverse is impressed "Clews Warranted Staffordshire."

The design of "Justice" wearing a Masonic apron first appeared in an allegorical frontispiece titled "Justice, Fortitude and Prudence Supporting a Medallion Portrait of H.R.H. the Prince of Wales, Grand Master of Masons in England." It was engraved by J. Corner and published in the *Freemasons' Magazine* in 1793. In 1795 it appeared again, but in altered form, as a "Vignette Portrait of His Excellency George Washington, Esq. &c., &c." in the June issue of the *Sentimental and Masonic Magazine*. Laidacker recorded fifteen variations

of the design utilizing changes to the central landscape vignette.

References: Laidacker 1954. Evans 1982. Sentimental and Masonic Magazine, Vol. VI (January- June), Dublin, 1795. Crawley 1904, 17:152. Franco 1976, fig. 108.

6.34
Platter
Staffordshire, England, c. 1835
Earthenware
Museum Collection 77.27.1
h: 13 ¾" w: 17"

Medium blue underglazed transfer-print on earthenware. The inner border is of lyres; the outer border pattern has rosettes alternating with Masonic symbols: trowel and marking gauge, square and compasses, plumb and level, five-pointed star (pentalpha) with letter "G" in center, and the jewel of a Past Master. The center is a rectangular street scene with a view of Freemason's Tavern, London. The transfer-printed back mark is "John Burn, Newport Market, London, J.J. Cuff."

An identical platter is in the collection of the Grand Lodge of England. The Grand Lodge collection also contains 9- and 12-inch plates of this pattern in blue and brown glaze. The transfer-print was copied from an engraved 1789 view of Freemason's Tavern titled "Freemason's Tavern, Great Queen Street, Lincolns Inn Fields," published in London in 1811.

Newport Market was situated on the north side of Leicester Square and was named after the nearby townhouse of the Earl of Newport. Newport Market was composed mainly of small shops which included Messrs. Cuff & Son who were tenants of Freemason's Tavern from 1831 to 1839.

References: Tudor-Craig 1938, 1:28. Haunch 1982, 65; fig. 40.

ILLUSTRATION:
6.34

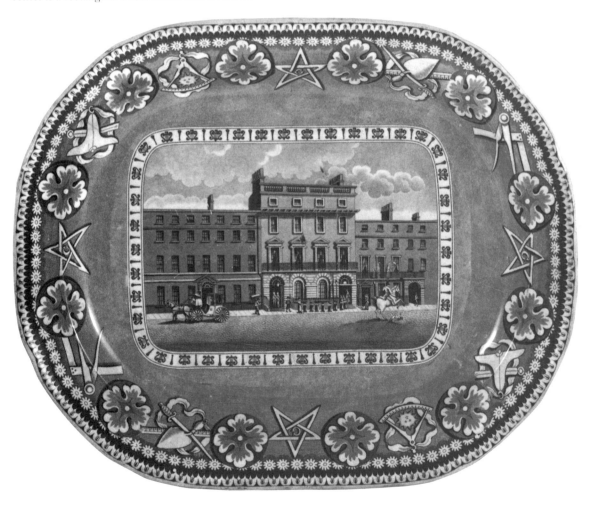

6.35

Pitcher

England, c. 1860
Earthenware
Gift of Mrs. Allan H. Brown 84.68
h: 7 ¾"

Bell-shaped jug with roped handle and black striping; gray-black underglazed line-engraved transfer-print on earthenware. The central design is comprised of Masonic chart emblems surrounding the twin pillars of King Solomon's Temple. The pillars support a central medallion containing a radial arrangement of Masonic symbols. Beneath the spout are an all-seeing eye, square and compasses, and a five-pointed star with clasped hands. The transfer-printed backmark is composed of a circular strap and buckle device inscribed "John Hay Glass & China Merchant, Greenock."

This pitcher has descended in the family of ship captain Moses Brown of Newburyport, Massachusetts. Bro. Brown was a member of St. Mark's Lodge, Newburyport. The design of Masonic emblems was en-

graved as a lithograph by Keith & Gibb and published in April 1867 by William Garey of Aberdeen, Scotland. Garey dedicated publication to the Grand Master of Scotland, J. Whyte Melville Esq., of Bannochy.
Literature: Old Masonic Art. *Masonic Service Association, Washington DC, 1952. (p. 50).*

6.36

Plate

American, c. 1903
Earthenware
Gift of Mrs. Robert B. Laird 78.15
Dia.: 10"

Dark blue underglazed transfer-print commemorating the fiftieth anniversary of Northern Lodge No. 25, F. & A.M., Newark, New Jersey. The border pattern represents an indented border of a tracing board and the central design is a variant of the Batty Langley print. The reverse has a list of the lodge officers serving in 1903.

6.37 SEE COLOR PLATE, PAGE 280

Water Cooler

M. Tyler & Co.
Albany, New York, c. 1825-26
Salt-glazed stoneware, cobalt slip-decorated
Special Acquisition Fund 83.16
h: 18"

Pear-shaped jug with double handles, an opening at the base for insertion of a spigot. The impress stamp "M. Tyler & Co./Albany" and incised cobalt-filled inscription "Ed. Raynsford" appear above raised cobalt blue Masonic square and compasses, candlestick, crescent moon and star, and beehive.

Moses Tyler (1794-1846) operated his own pottery in Albany, New York from 1822 to 1825. He took over the shop of Calvin Boynton in 1826 and operated it in partnership with Charles Dillon until 1834. Pots made during the partnership were marked "Tyler & Dillon Albany."

Edmund Raynsford (1784-1855) was a merchant-
farmer in the town of New Scotland, Albany County,
New York. Raynsford's career included having been a
hotel owner, New Scotland's Postmaster (1839-49), and
member of the New York legislature in 1838.
References: U.S. Census for 1850 (Albany Co.).
Ketchum 1970, 91. Howell & Tenney. *History of Albany
County.* Albany. (p.892). Munsell 1859, 10: 372.

6.38

Harvest Jug
New York State, dated 1805
Stoneware, incised and cobalt-decorated
Special Acquisition Fund 91.045
h: 7" dia.: 8"

Squat jug with handle, mouth and spout, the side deco-
rated with an incised Masonic apron and inscription
"J. Romer/1805." Floral vines, a fish, and fishhooks are
outlined in blue cobalt slip.
 During the American Revolution, John Romer (1764-
1855) was one of seven Dutchess County militamen

Ceramics 231

involved in the capture of British spy Major John
Andre. In 1800, Romer was admitted to Hiram Lodge
No. 72 at Mt. Pleasant, New York. He was buried
in Elmsford Reformed Church yard, with Masonic cer-
emonies, under a headstone decorated with Masonic
symbols.
Reference: Romer 1917. Lossing, Benjamin. Pictorial
Fieldbook of the Revolution. *2:755.*

6.39
Jug
Attributed to Clement Minor (1765-1810)
Northfield, Massachusetts, c. 1790-1810
Earthenware
Special Acquisition Fund 91.051
h: 15"

Pear-shaped two-gallon jug with band of tooled rings
below rim of neck, and an applied and molded strap
handle. Incised design includes a portrait bust, crossed
sabers, crossed flintlock pistols, a military flag, a heart,
and Masonic square and compasses.
 Clement Minor (1765-1810), a potter from Stoning-
ton, Connecticut, purchased quantities of unglazed
earthenware pottery from John Parker of Charlestown,
Massachusetts. Minor might have acted as an agent for

the Charlestown earthenware pottery rather than as a
potter on his own. In June 1782, Minor performed mili-
tary service in the Springfield area. He moved from
West Springfield to Northfield in 1787, married there,
and set up a pottery at Pauchaug Meadow.
 It is believed that the incised decoration on the jug
might have been done in commemoration of General
George Washington. On the premise that the portrait
was intended to represent Washington, the banner
might represent Washington's headquarters standard,
which was composed of thirteen stars on a blue field.
Washington instituted the heart-shaped Order of Merit
and was a noted Freemason. There is no record in the
Grand Lodge of Massachusetts, nor in the Grand Lodge
of Connecticut, of Clem Minor having been a Freema-
son. The jug has descended in a Northfield family.
*Reference: Watkins 1950, 33. Parsons 1937, 234. Minor
1981, 68.*

6.40
Jar
American, c. 1850
Stoneware
Special Acquisition Fund 76.27.2
h: 13"

Large open-mouthed jar with tooled rim and two ring-
handles. The salt-glazed body is decorated in blue
cobalt slip with a pair of joined "Xs" encircled by seven
crosses.

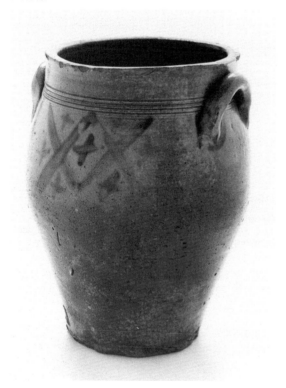

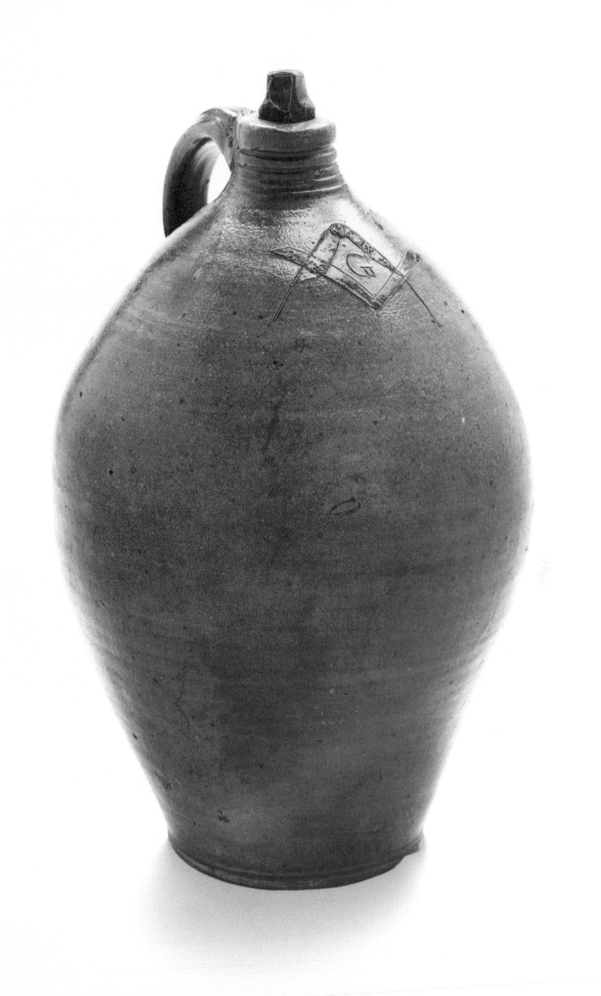

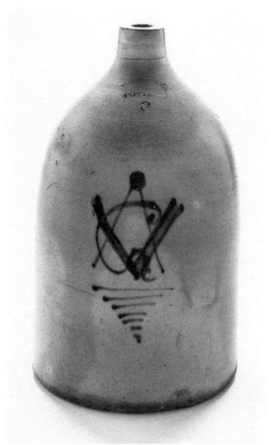

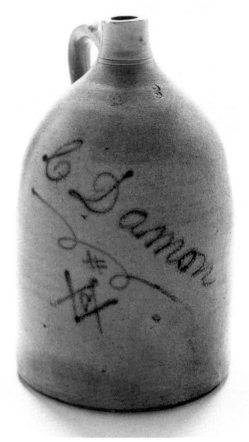

The blue cobalt slip decoration forms an abstract design of the Masonic square and compasses. The seven crosses represent the number of officers in a Masonic lodge.

6.41 SEE ILLUSTRATION ON PAGE 233

Jug
Attributed to Goodwin & Webster
Hartford, Connecticut, c. 1830–1840
Stoneware
Special Acquisition Fund 85.56
h: 14 ½"

A two-gallon pear-shaped jug with cobalt blue slip-decorated and incised Masonic square and compasses enclosing the letter "G." Horace Goodwin and Mack Webster operated a pottery in Hartford from 1830 to 1840.
Reference: Watkins 1950, 195.

6.42

Jug
West Troy Pottery
West Troy, New York, c. 1870
Stoneware
Estate of Charles V. Hagler 85.20.13
h: 16 ½"

A three-gallon salt-glazed jug impress stamped "West Troy Pottery" and the numeral "3." The cobalt blue slip-decorated design is of an entwined Masonic square and compasses and the letter "G."
Reference: Franco 1976, fig. 62.

6.43
Jug
American, c. 1850
Stoneware
Special Acquisition Fund 75.39
h: 17 ½"

A three-gallon salt-glazed jug with cobalt blue free-hand decoration of "3" and the name "C. Damon" above Masonic square and compasses enclosing the letter "G."

6.44
Pitcher
Probably England, c. 1850
Stoneware
Estate of Charles V. Hagler 85.20.4
h: 9 ½"

Helmet-shaped pitcher with mottled brown on custard Rockinghamware style glaze. A raised slip-cast design of the Masonic square and compasses encloses the letter "G" on both sides.

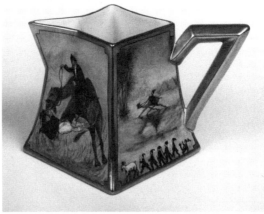

6.45
Pitcher
French, 20th century
Porcelain
Gift of Mrs. Thomas J. Vaughan 84.29

Four-sided art deco pitcher with gilt and enamelled desert scenes of initiation high jinks, and a jewel of the Ancient Arabic Order Nobles of the Mystic Shrine. The hand-painted scenes are signed by the artist, "Ruby Lacy." The bottom is marked "B & Company, France."

Established in 1872, the Ancient Arabic Order Nobles of the Mystic Shrine required its members, "Nobles," to be 32nd Degree Scottish Rite Masons or Knights Templar in the York Rite. The jewel of the order is a crescent, made of claws of the Bengal tiger, united at the base in a gold setting, a sphinx on one side and a pyramid, urn, and star on the other. The crescent is shown suspended from a scimitar and with a star pendent between its curved ends.

6.46 SEE ILLUSTRATION ON PAGE 236
Pitcher
Thomas Maddock's Son's Company
Trenton, New Jersey, c. 1902-1929
Graniteware
Special Acquisition Fund 84.84.2
h: 12"

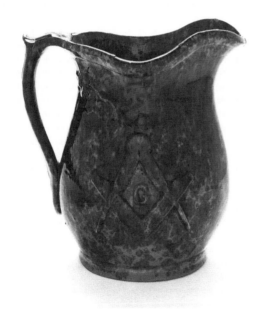

This is an unrecorded pattern that was probably produced in England, although the glaze is similar to brown manganese-glazed wares produced by the Norton Pottery at Bennington, Vermont. A similar but taller pitcher in the Bennington Museum bears a figure in relief of George Washington wearing a Masonic apron; the scene is titled "Washington As A [Mason]."

Tall pitcher with silver lustre rim, handle, and base. It is decorated with an enamelled transfer-print entitled "Taking his First Degree" and depicts a Masonic candidate riding a billy-goat. The opposite side shows a Masonic altar.

The Maddock pottery company progressed from the manufacture of vitreous sanitary china to a speciality of producing ceramics for hotel use, souvenir purposes, and fraternal organizations. Maddock had the "in-house" ability to produce their own decals and transfer engravings in order to customize a standard line of sou-

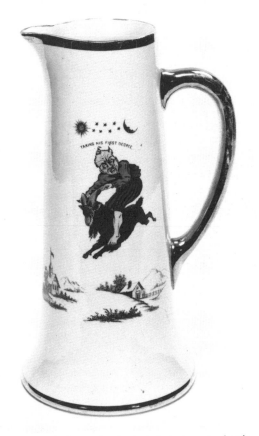

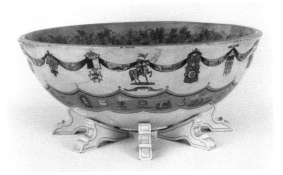

venir ceramic forms that included pitchers, tankards, and plates. The overglaze enamelling process permitted Maddock to copy fine line detail designs from steel engravings.
Reference: Lehner 1988.

6.47
Punch Bowl
Hugo A. Possner (1859-1937), artist
Waterbury, Connecticut, dated 1906
Wood
Gift of Clark Commandery No. 7, Knights Templar, Waterbury, Connecticut 92.034
h: 11" (with stand) dia.: 27 ¼"

Large, turned wooden punch bowl on a cross-tree stand. The exterior is painted with Knight Templar badges suspended from a swagged ribbon below the rim. Beneath the ribbon, a scalloped frieze is decorated with illustrations of Masonic buildings and symbols and Biblical scenes. The interior rim is decorated with painted maple leaves and signed "Hugo Possner, Artist 1906." The wooden support stand is decorated with

various Craft symbols. Clark Commandery ceased its operations in 1992. Possner, a native of Eisennach, Germany, specialized in painting portraits and still lifes.

6.48
Punch Bowl and Pitcher
Josiah Wedgwood & Sons
Staffordshire, England, 1887
Creamware
Gift of Peter Van Buren Sundquist 83.23.1 & .2
Pitcher, h: 9 ¾"
Bowl, h: 6 ½" dia. 11 ½"

Bulbous pitcher and footed bowl with bottoms impressed "QRP Wedgwood." Beneath the gold rims runs a frieze of sepia transfer-printed jewels of various Masonic orders. The pitcher is decorated with jewels of the Past Master, Mark Master, Red Cross of Constantine, Royal Arch Grand High Priest, Rose Croix, and a medallion portrait. The Mark Master jewel is inscribed "John Haigh, Somerville, Mass." The bowl's inside rim and foot are decorated with a band of floral vines; the outside shows the jewels of a Past Master and Grand High Priest; a Knights Templar jewel inscribed "Bethany Commandery, Lawrence 1864;" and jewels of the 32nd and 33rd degrees of the Scottish Rite.

The bottom of the jug is transfer-printed with the statement that "This punch jug and bowl are unique being the first made by Josiah Wedgwood and Sons potters on the understanding that no similar Jug and Bowl will ever be made by them. Etruria, Staffordshire, August 1887."

John Haigh (1832-1896) was raised in Grecian Lodge, Lawrence, Massachusetts in 1859 and was active in chapter, council, and commandery activities. He received the 33rd Degree in Scottish Rite under authority of the Supreme Council for the Northern Masonic Jurisdiction, but later withdrew to join the Supreme Council for the United States of America, an irregular Cerneau body in which he become Sovereign Grand Commander.
Reference: Supreme Council (Cerneau) Proceedings, 1895-1897. New York, 1897.

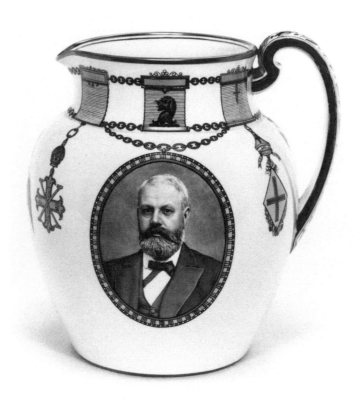

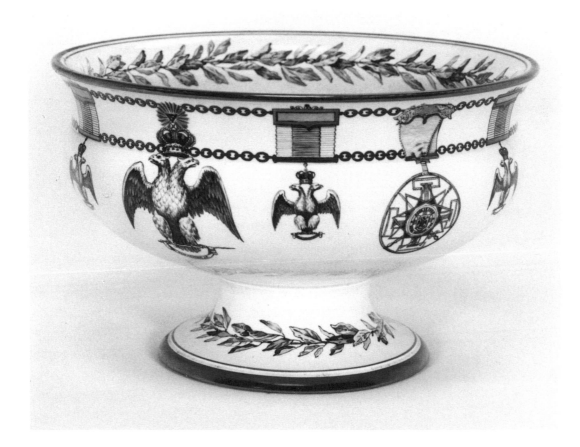

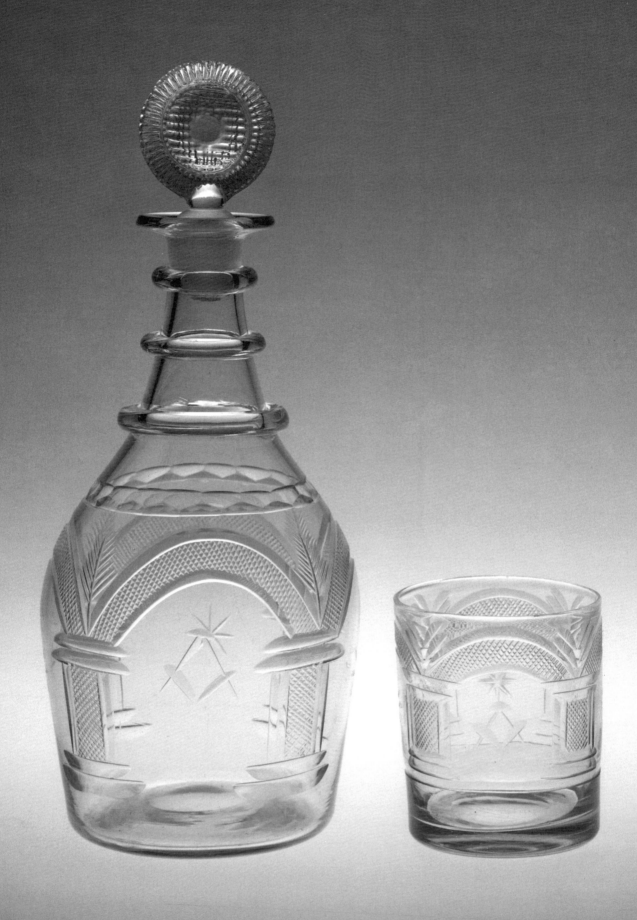

Glassware

AMERICAN MASONIC LODGES USED A VARIETY OF GLASSWARE. EARLY LODGE INVEN- ILLUSTRATION: 6.51, FACING SEE DESCRIPTION ON PAGE 241 tories list great numbers of tumblers, wine glasses, and rummers (large-bowled, footed drinking glasses). The large quantities insured that the lodge could ac- commodate visitors as well as members at its feasts and could offset the high incidence of breakage. In placing their order for punch bowls from England in 1767, for example, the brethren of White Hart Lodge, Halifax, North Carolina also ordered twelve dozen glasses and nine decanters.

In 1789 Holland Lodge No.7, New York City, received a gift of "Baltimore" glass, consisting of 8 quart and 6 pint decanters, 5 pair of large tumblers, and 12 dozen wine glasses. The name of the lodge was inscribed on one side of each piece, and a Masonic emblem was placed on the other.[1] There is also a large set of glass in the possession of Alexandria-Washington Lodge No. 22, the lodge of which George Washington was the first Master. That set currently consists of 165 pieces of glassware (originally there were 2,500 pieces). The square and compasses and the initials and number of the lodge ap- pear on each piece.[2]

Decanters were often necessary items during the course of a Table Lodge. The lodges that met in or near taverns had their refreshment needs easily satisfied but lodges not so conveniently located might order wine and other beverages by the cask or barrel, which were then stored on the premises. The contents of the casks had to be transferred into bottles, decanters, and jugs that were more suitable and convenient for table use.

Most of the glassware in the museum collection was made outside the United States. This is especially true of early engraved or cut glass pieces. Relatively little glassware was produced in North America during the colonial period. With the exception of en- graved wares produced in Pennsylvania by Henry Stiegel (1729-1785) or in Maryland by John Frederick Amelung, almost all engraved or cut glass used in America prior to Inde- pendence was imported via England. In the early 1800s a number of glasshouses were established that soon provided stiff competition in the production of cut glass. Imported glass, however, still retained a degree of popularity.

1. Schultz 1884. 1:74. Brother John Frederick Amelung had moved his glass factory to Baltimore by 1789.

2. Ibid. This set of glass is also attributed to Amelung.

Illustrations

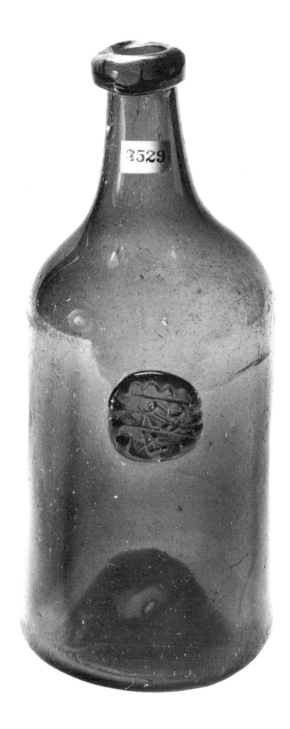

6.49

Sealed Bottle
England
c. 1790-1820
Blown glass
Special Acquisition Fund 75.62.8
h: 7" dia. 3"

A cylindrical olive-green binning bottle, with a glass wafer seal applied at the shoulder. The short neck has a folded down mouth. The seal is impressed with the initials "R.B." above the Masonic square and compasses.

Wine bottles were sealed to indicate private, organizational, or commercial ownership. Research by Sheelah Ruggles-Brise disclosed that proprietary seals with three initials invariably indicated tavern ownership. Seals bearing only two initials might belong to a wine merchant or a private individual who could afford this luxury. The lack of a lodge number on the seal would indicate that the bottle was made for an individual who was a Freemason, rather than for a specific lodge.

Dark-colored glass bottles made at Bristol, England provided inexpensive material for binning, or storage, and the aging of wine, and was thought to protect its contents from the deleterious effects of exposure to sunlight. The practice of sealing became widespread throughout the 18th century, and many sealed bottles were sent to America. Four different bottle seals have been excavated at Jamestown and Williamsburg bearing a merchants' mark entwined with initials and what resembles a Masonic square and compasses.
References: Ruggles-Brise 1949. Davis 1972.

6.50
Decanters (pr.)
Germany, c. 1790
Blown glass
Special Acquisition Fund 78.16.1 & .2
h: 10" dia. 5"

Blown crystal with faceted and polished sides, triple-ring necks, and mushroom-shaped stoppers. The copper wheel-cut designs include Masonic Craft symbols and the pentalpha, or five-pointed "blazing star." In the 18th century, wines such as Port, Claret, Madeira, and Vidonia were sold by the barrel. For table use the contents were decanted into decorative glass bottles without disturbing the undesirable sediment.

6.51 SEE ILLUSTRATION ON PAGE 238
Decanter and Tumbler
Ireland
early 19th century
Blown glass
Special Acquisition Fund 76.24 and 77.2.1
Decanter, h: 9" dia. 6"
Tumbler, h: 4" dia. 3"

Free-blown and cut lead glass with triple-ring collars and cut decoration of pillars and arches; within one arch a square and compasses; stars in the others.
 Expensive cut glass became much more popular after 1780 when favorable trade policies permitted Irish glass to be profitably shipped to North America. From 1801 to 1812, Irish glass houses such as those at Waterford (County Kilkenny) shipped large quantities of drinking glasses to America. After repeal of the Non-intercourse Act in 1812, Irish exports increased dramatically. Decanters and tumblers cut in Waterford's characteristic arched-panel pattern appear decorated with the Masonic square & compasses in lieu of the usual star motif.

6.52
Toddy Rummer
Germany or Bohemia, c. 1800
Glass
Special Acquisition Fund 77.11.22
h: 10" dia. 7"

Large flint glass bowl with applied base. The sides are copper wheel engraved with Masonic symbols that are highlighted by gilding. The motif consists of three medallions of Masonic symbols amid floral patterns: (1) an array of Masonic working tools, (2) a certificate-inspired design of pillars, carpet, altar and symbols, and (3) pillars and altar with three "lights of Masonry."

ILLUSTRATIONS:
6.50, LEFT
6.52, BELOW

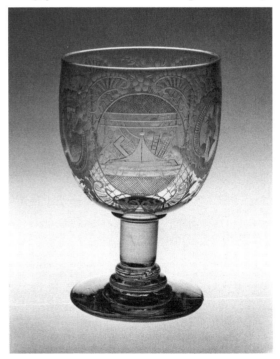

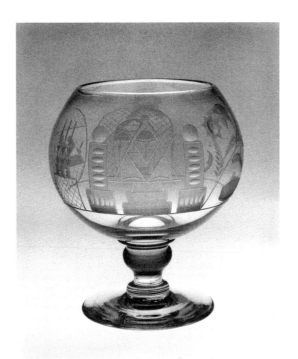

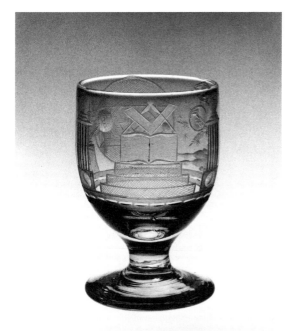

6.53
Toddy Rummer
England
early 19th century
Glass
Special Acquisition Fund 80.27.4
h: 9" dia. 5 1/2"

Free-blown bowl cut with four medallions enclosing Masonic Craft symbols, the Scottish Rite symbol of Solomon's seal of interlaced triangles, and the Royal Arch Triple *Tau* (three letter "T"s, conjoined).

Hogarth's engraving "Night" depicts a street scene outside the Rummer and Grapes Tavern. The tavern's sign, which is above the heads of the drunken Master and the lodge Tyler, displays a rummer. From 1717 to 1723 the tavern was the meeting place of Lodge No.4.

6.54
Goblet
Germany, 19th century
Blown glass
Special Acquisition Fund 77.11.19
h: 4 1/2" dia. 4"

Short stemmed bowl, copper wheel cut with Masonic symbols and a medallion. A Bible, square, and compasses (the three "Great Lights of Masonry") are shown resting on a three-step dias. The dias is flanked by twin pillars, a radiant sun, crescent moon and 7 stars. A square, plumb, and level appear on the circular

medallion which is flanked by the three "Lights of the Lodge" and a mosaic pavement, and the figure of a recumbent man (Hiram Abif) with an acacia planted near his head.

6.55
Tumbler
Germany or Bohemia, c. 1790-1810
Blown glass
Special Acquisition Fund 80.35.1
h: 5" dia. 4"

Free-blown clear glass with copper wheel-cut medallion panels surrounded by floral vines and surmounted by decorative bows. The medallions bear symbols of a square and compasses, radiant sun, crescent moon, plumb line, level, and a delta. Two c. 1800 German glass catalogs in the collection of the Winterthur Museum Library illustrate similar Masonic design patterns on decanters, tumblers, wine glasses, and cruets. The cut-wheel work that created the floral vines bears even greater similarity to engraving on a tumbler attributed to the Amelung glass factory at New Bremen, Maryland, which is in the collection of the Connecticut Historical Society. This general design pattern appears to be typical of German glass engravers.

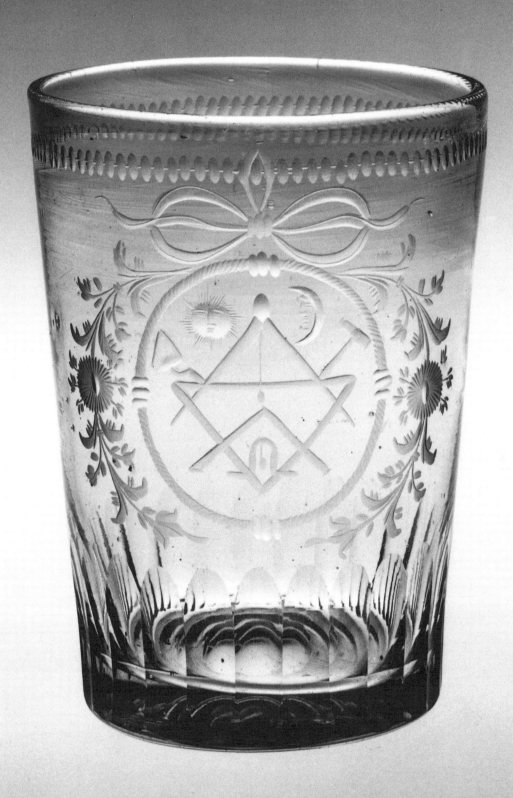

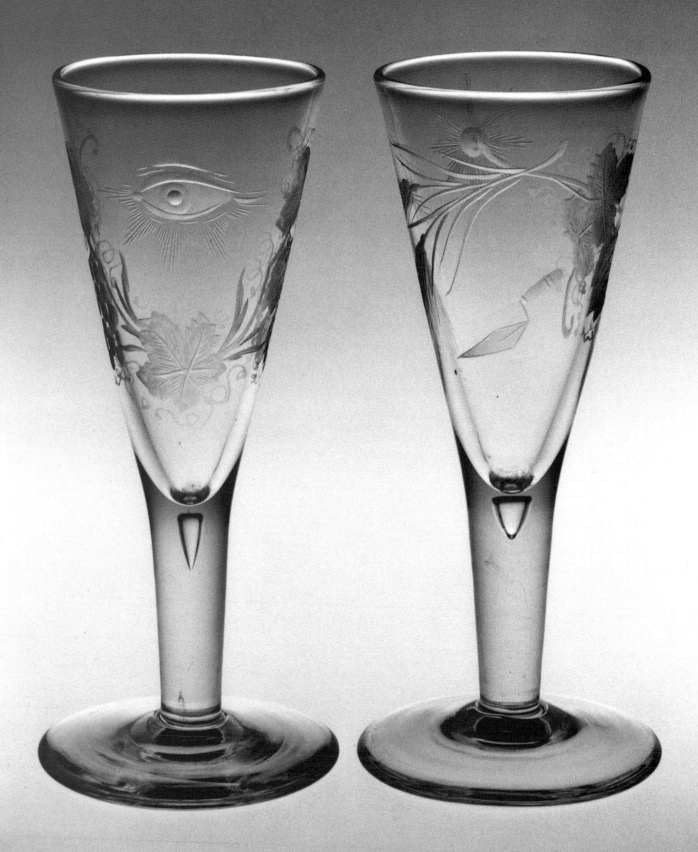

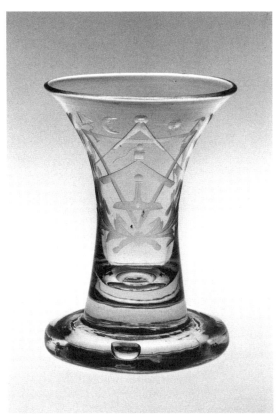

6.56
Wine Glasses (pr.)
England, early 19th century
Blown glass
Special Acquisition Fund 78.25.4
h: 6" dia. 3"

A pair of clear wine glasses with a teardrop-shaped air bubble captured in the stems. The sides are copper wheel-engraved with grape vine motifs and Masonic symbols of an all-seeing eye, radiant sun, and Masonic trowel.

English glass houses in the Georgian period commonly used a grape vine engraved motif and a special treatment of the stems that produced an internal air-twist spiral. During the American Revolution, while British troops still occupied New York, glass merchants such as Daniel Ebbets continued to import glassware from Liverpool, England. Ebbets' advertisement in the *New York Gazette* (July 5, 1779) described having received a recent shipment that included "flower'd wineglasses, Mason and common ditto...."
Reference: Gottesman 1954.

6.57
Firing Glasses (pr.)
England, 18th century
Blown glass
Special Acquisition Fund 77.11.13 and
Gift of Russell W. Knight 79.28
h: 4" dia. 3"

Free blown, copper wheel-engraved glasses with trumpet-shaped rim. The glasses were obtained from different sources, but their similarity supports the assumption that their design was common. Sturdy wine glasses or "cannons" with thick applied bases were used during Table Lodge to "fire" or tap out a cadenced salute in response to certain Masonic toasts.

During the French and Indian War in 1755, Sir William Johnson (1715-1774) purchased one dozen "Freemason glasses" from the New York firm of Colden & Kelly. In his position as Superintendent for Indian Affairs, Johnson was constantly required to entertain civil and military officials and Indian leaders who appeared at his residence, Johnson Hall. It is likely that the "Freemason glasses" listed on the invoice were durable firing glasses of this style rather than fragile wine glasses. Sir William did not become a Freemason until 1766.
Reference: Sullivan 1921, 1:697.

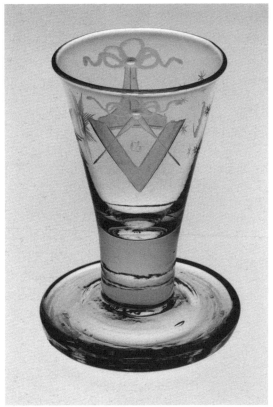

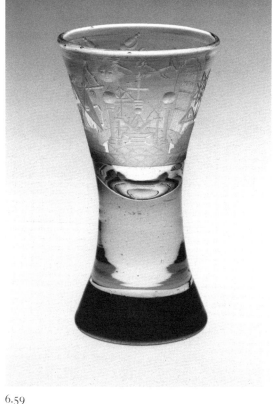

6.58

Firing Glass
England, mid 19th century
Blown glass
Special Acquisition Fund 77.10.5
h: 4 ¾" dia. 2 ⅛"

Hand-blown trumpet-shaped glass with heavy base.
The sides are engraved with copper wheel-cut Ma-
sonic symbols of square and compasses enclosing a
letter "G," radiant sun, crescent moon and seven stars,
and a level. The letter "G" was used to denote God,
G.A.O.T.U. (Great Architect Of The Universe), or Ge-
ometry from the middle of the 18th century. Its use
enclosed within an interlaced square and compasses
did not appear until about 1850 when "it is supposed
to have originated as a jeweler's design." Under no cir-
cumstances does the letter "G" appear in the lodge in
connection with the square and compasses. In the
lodge, the letter "G" is found displayed suspended in
the East.
Reference: Coil 1961.

6.59

Firing Glass
England, 19th century
Blown glass
Gift of Robert W. Raynard 87.52.3
h: 5 ¼" dia. 3"

An hourglass-shaped glass with extra-thick solid base.
The sides bear numerous copper wheel cut Masonic
Craft and Royal Arch symbols. The design of firing
glasses changed in the 19th century to provide a glass
whose base was less subject to damage from hard use.

Chapter 7

The Masonic Funeral & Burial

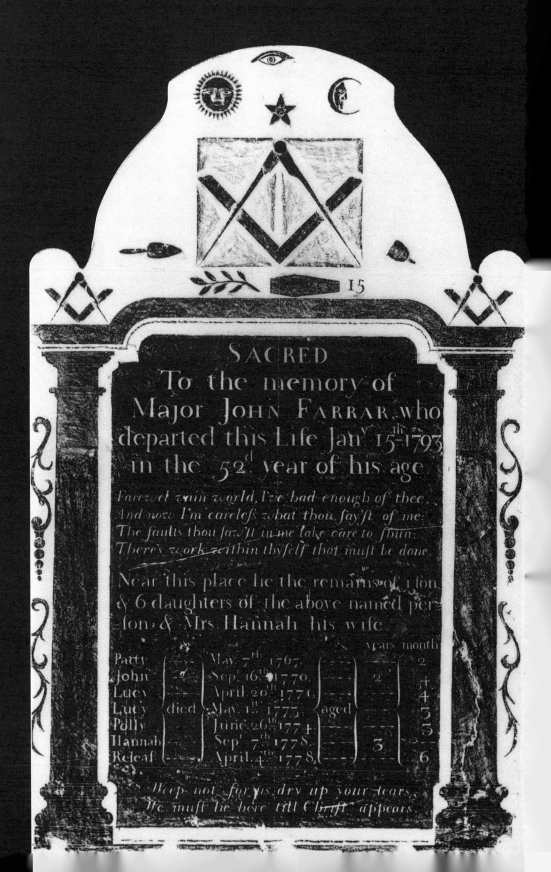

SACRED
To the memory of
Major JOHN FARRAR, who
departed this Life Jan^y 15th 1793,
in the 52^d year of his age

Farewel vain world, I've had enough of thee,
And now I'm careless what thou say'st of me:
The faults thou saw'st in me take care to shun,
There's work within thyself that must be done.

Near this place lie the remains of 1 son
& 6 daughters of the above named per-
=son & Mrs. Hannah his wife.

						years	month
Patty		May 7th 1767,					2
John		Sep^t 16th 1770,			2		4
Lucy		April 20th 1771,					4
Lucy	died	May 1st 1773,	aged			3	
Polly		June 26th 1774,					3
Hannah		Sep^t 7th 1778,			3		
Releaf		April 4th 1778,					6

Weep not for us dry up your tears
We must lie here till Christ appears.

15

The Masonic Funeral & Burial

ILLUSTRATION: 7.07, FACING SEE DESCRIPTION ON PAGE 255

IN 1632 THE COMPANY OF MASONS OF LONDON LEVIED A FINE ON BRETHREN who failed to attend a Masonic funeral. This first reference to a Masonic funeral was followed in 1723 by notice of the burial of Matthew Birkhead, author of the "Entered Apprentice's Song." It was recorded that Birkhead's pallbearers and the attending brethren wore white aprons. Other than this, it was not until the middle of the 18th century that either the *Book of Constitutions* or Grand Lodge regulations made reference to the burial of Masons, and then only in the context of a prohibitive measure.

In November 1754 the Grand Lodge of England prohibited any Mason from attending a public procession wearing any of the jewels or clothing of the Craft, except by dispensation of the Grand Master or his Deputy. (*Constitutions*, 1756, p. 303). This 1754 regulation was enacted in response to abuses resulting from public processions assembled "...upon so trifling an occasion as a private benefit at a playhouse, public garden, or other place of general resort; where neither the interest of the fraternity, nor the public good, is concerned; and which, ... can never redound to the good of Masonry, or the honour of its patrons."[1] The prohibition was not considered in force in America, where Masons have generally been permitted to bury their dead without the necessity of a dispensation.

In 1775, Masonic ritualist William Preston outlined a ceremony to be observed at funerals which was adopted as general practice.[2] "No Mason can be interred with the formalities of the Order unless by his own special request communicated to the Master of the lodge, of which he died a member; nor unless he had been advanced to the Third Degree of Masonry. All brethren walking in the procession should observe an attitude of decent mourning, and a uniformity in their dress while clothed in white stockings, gloves, and aprons... No person ought to be distinguished with a jewel, unless he be an officer of one of the lodges invited to attend."

A quarter century later Thomas Smith Webb's remarks on American Masonic funerals further explained that these ceremonies commenced with the brethren assembling at the lodge or other convenient place, where the Master opens the lodge at the Third Degree.[3] After a brief service is held, a procession forms to move the casket to the place of interment. Brethren actually in office are distinguished by the wearing of white sashes and hatbands. Brethren of the lodge of which the deceased was a member walk nearest the corpse. The procession is led by the Tyler with drawn sword in mourning (black hilted

or draped in black crepe), followed by the Stewards with white rods, musicians (drums muffled and trumpets covered), Deacons, the Secretary and Treasurer, Past Masters, and the Holy Bible carried on a cushion covered with a black cloth. The Master and clergy precede the casket, which is draped with the deceased's regalia and two crossed swords. Pallbearers attend the casket.

At the church yard the lodge forms a circle around the grave, and the service is resumed with the officers at the head of the grave and the mourners at the foot. Members of the lodge carry flowers and herbs in their hands. Sometimes the gloves and apron of the deceased are cast into the grave, and usually all present drop sprigs of acacia or evergreens into the grave.

Following a benediction given by the Master, the service ends, and the procession returns to the place where it was formed. If the deceased was an officer of the lodge, insignia and ornaments he was entitled to wear are borrowed from the lodge to decorate the casket. They are returned to the Master, after which the lodge is closed in the Third Degree.

One of the earliest accounts of an American Masonic funeral was that of Thomas Oxnard (1703-1754), Grand Master of North America. Bro. Oxnard's Grand Master's jewel was carried on a tasseled black velvet cushion while the officers wore their jewels pendent from black ribbon.[4]

A notable funeral procession was that accorded Major General Dr. Joseph Warren (1741-1775), who was killed at the battle of Bunker Hill. At the time of his death, Warren had also been Grand Master of the Provincial Grand Lodge of Massachusetts. Immediately after the evacuation of Boston by the British on April 6, 1776, his Masonic brethren searched for the body of their Grand Master among the fortifications and conveyed it to the State House in Boston where an oration was delivered over his remains. After the funeral ceremonies, the remains were deposited in Boston's famous Granary Burying Ground. An engraving by Compagnon titled "The translation of Bro. Warren's Mortal remains to Boston" illustrated the event.[5]

Massive Masonic funeral observances were held in numerous cities upon the death of George Washington. Grand Lodges throughout the nation conducted public processions and funeral services. In Boston more than 1,600 brethren formed the grand Masonic funeral procession that was held on February 11, 1800. In the procession were fourteen-foot high arches, memorial pedestals and urns, and decorative emblematical banners.[6] A silver medal was struck to be worn by the participating brethren.[7] It should be emphasized that a Masonic funeral is a secular non-denominational memorial not a religious service.

Lodge of Sorrow

A custom among Freemasons to hold special lodges once a year, for the purpose of commemorating the virtues and deploring the loss of departed members and other distinguished worthies of the fraternity, was termed a Lodge of Sorrow. In America the custom was common in Scottish Rite bodies, whose impressive Sorrow Lodge ritual has been generally adopted by the American Rite. On such occasions the lodge is clothed in the habiliments of mourning (black drapery) and decorated with the emblems of death. A catafalque, or temporary structure of wood, appropriately decorated with funeral symbols and representing a tomb or cenotaph, forms a part of the decorations of a Lodge of Sorrow. Solemn music is played, funeral dirges are chanted, and eulogies on the life, character, and Masonic virtues of the deceased are delivered. Notable among such rituals was the Lodge of Sorrow conducted for U.S. President James A. Garfield in 1881.

1. Preston, William - *Illustrations of Masonry*. London, 1775 (2nd ed.).

2. Ibid.

3. Webb. *The Freemason's Monitor....* Salem, Massachusetts, 1812.

4. *Proceedings, St. John's Grand Lodge 1733-92*.

5. Clavel, F.T.B. *Histoire Pittoresque De La Franç-Maconnerie Et Des Societies Secrets Anciennes Et Moderns*. Paris, 1843. (Plate 11).

6. Heard, John T. 1856, 258-263.

7. Marvin 1880, 109. The medal (no. 265) was struck by die-sinker Jacob Perkins (1766-1849) of Newburyport, Massachusetts. Its obverse bears a portrait bust of Washington; its reverse, a skull and crossbones symbol of mortality. A similar medal, but with its reverse bearing an urn, was worn at the civic funeral procession that occurred eleven days later, on February 22, 1800.

Illustrations

ILLUSTRATIONS:
7.01, LEFT
7.03, RIGHT
7.02, FACING

7.01

Masonic Casket Clip
American, 19th century
Iron
Gift of Mr. & Mrs. John R. Kay 77.55

Spring-mounted clip in the form of a Masonic square
and compasses, and a trowel with the letter "G." Clip
attachments were used in draping coffins, caskets, and
catafalques with black mourning cloth.

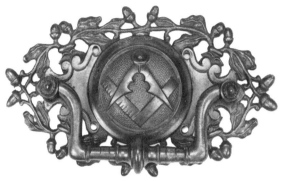

7.02

Shrine Casket Clip
American, 19th century
Brass
Gift of Jacques N. Jacobsen, Jr. 89.74

Spring-mounted clip in the form of the Sphinx's head
and the jewel of the Ancient Arabic Order Nobles of
the Mystic Shrine.

7.03

Casket Handle
American, 19th century
Bronze
Gift of Armen Amerigian 90.19.7
h: 5 ½" w: 9"

Pierced back plate with oak leaves and acorns and cen-
tral medallion with square and compasses; a rectangu-
lar bail handle.

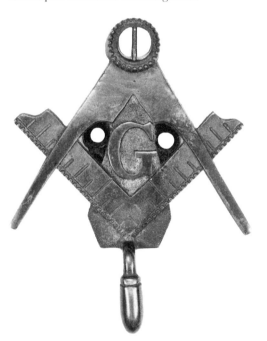

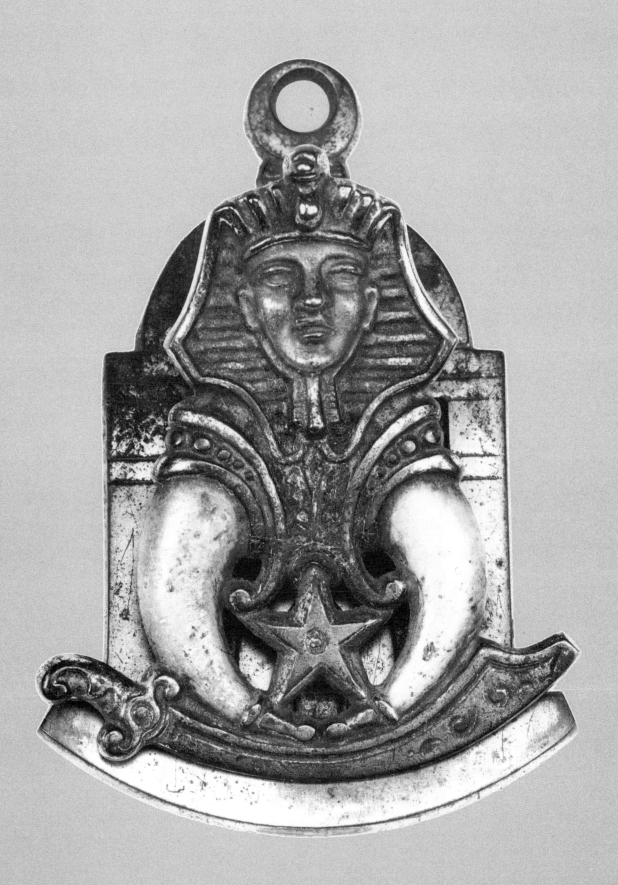

ILLUSTRATIONS:
7.06, BELOW LEFT
7.04, RIGHT

7.04
Grave Marker
New England, c. 1912
Iron
Gift of the Estate of Gerard Dallas Jencks, 90.5
h: 32" w: 10 ½"

Cast iron grave marker in the shape of a Maltese cross with crossed swords, Cross-in-crown symbol in the center and a raised-letter border. The marker was made to be placed at the grave of Albert Judson Oliver, a Past Grand Commander of Isle of Rhodes Commandery No. 208, Ancient and Illustrious Order, Knights of Malta, Providence, Rhode Island. Brother Oliver died October 16, 1912.

 Symbolic grave markers were used to identify the site of interred members of fraternal organizations. Small loops on the back of the marker plate provide a means for the attachment of small flags or flower stems during special memorial observances.

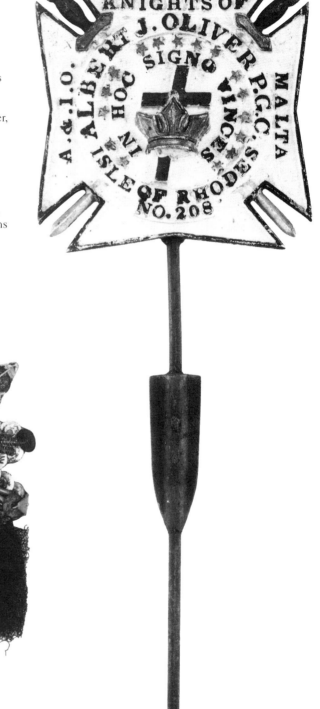

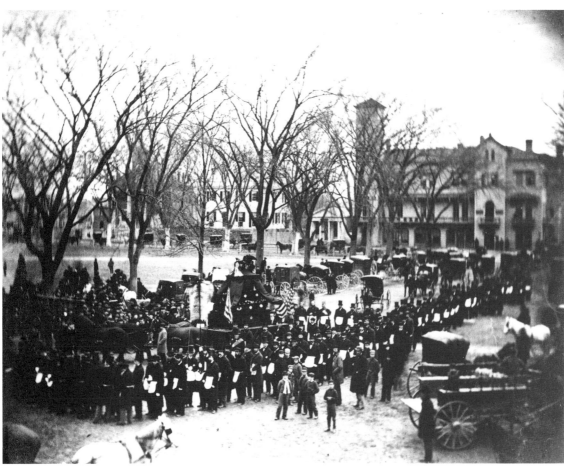

7.05
Masonic Funeral
Taunton, Massachusetts
Photograph
c. 1883
Special Acquisition Fund 83.18

Funeral procession of A.H. Blake, showing the Masonic catafalque and horses draped with Masonic mourning blankets. Brethren wear white aprons; officers wear white sashes.

7.06
Mourning Badge
Providence, Rhode Island
1886
Silver and net
Supreme Council Archive 74.1.76

Used at the Masonic funeral of Thomas Arthur Doyle (1827-1886), former Mayor of Providence, prominent Mason, and active member of the Scottish Rite.

7.07 SEE ILLUSTRATION ON PAGE 248
Gravestone Rubbing
Shrewsbury, Massachusetts
1793
Gift of Mr. & Mrs. Fred R. Youngren 85.46.1

Rubbing taken from the gravestone of Major John Farrar (1741-1793).
 Bro. Farrar was made a Master Mason in Trinity Lodge, Lancaster, Massachusetts in 1781.

7.08
Gravestone Rubbing
Groton, Massachusetts
1821
Gift of Mr. & Mrs. Fred R. Youngren 85.46.2

Rubbing taken from the gravestone of Mr. Alpheus
Richardson (1774-1821).

7.09
Sheet Music Cover
Masonic Ode
Oliver Ditson, publisher
Boston, 1845
Lithograph
Library 79-1063

Image copied from an engraving by Abel Bowen
(1790-1850) of the original monument to Dr. Joseph
Warren (1741-1775), Grand Master of Massachusetts.
Bro. Warren fell at the battle of Bunker's Hill. His
body was reinterred after the British troops evacuated
Boston and given a solemn Masonic funeral. The
monument was destroyed by youthful vandals in 1825
and later rebuilt.

Color Plates

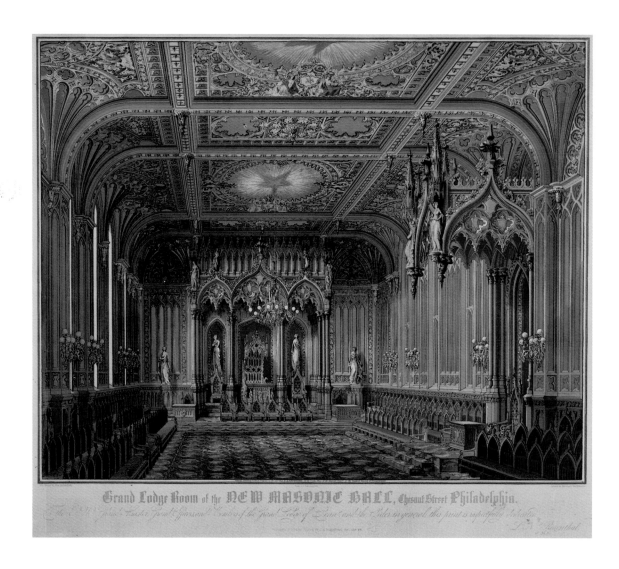

Grand Lodge Room of the NEW MASONIC HALL, Chesnut Street Philadelphia.

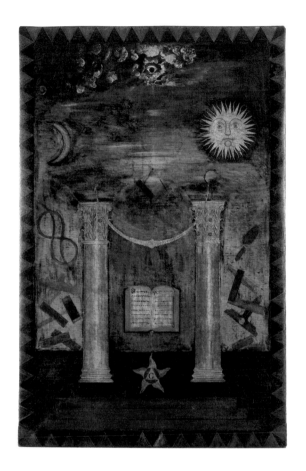

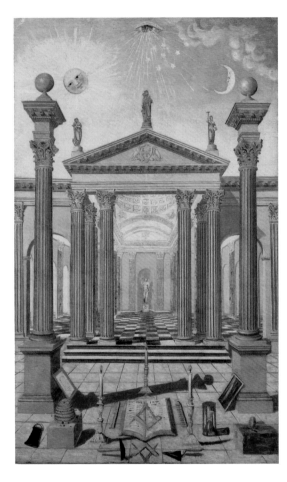

ILLUSTRATIONS:
2.23, LEFT
2.25, RIGHT

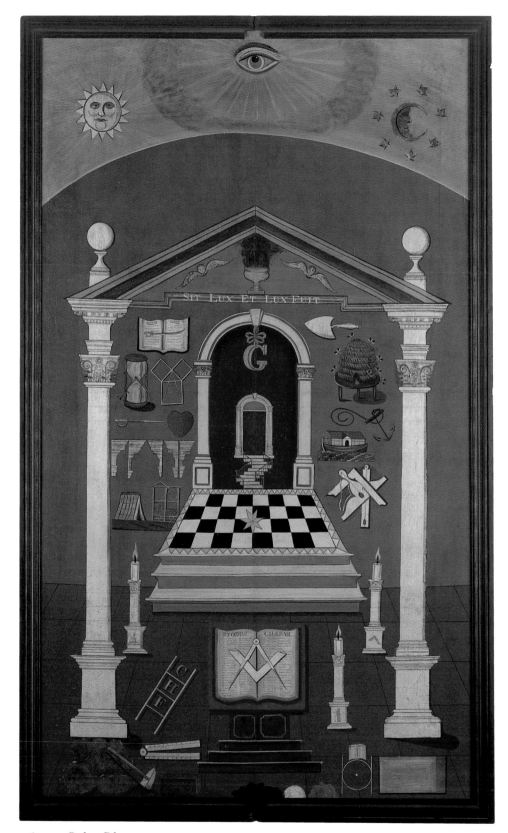

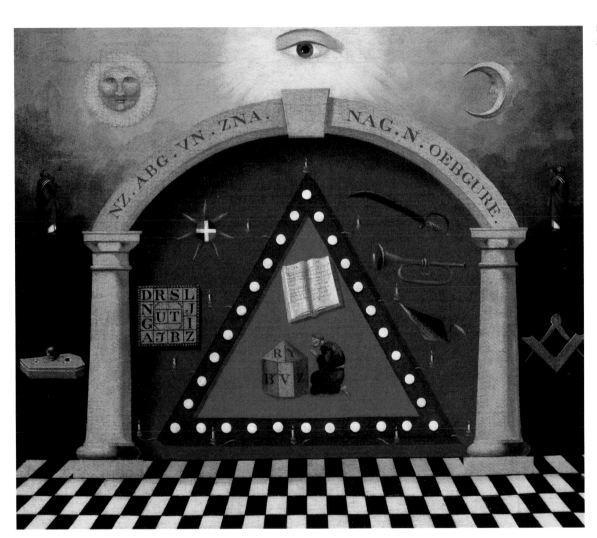

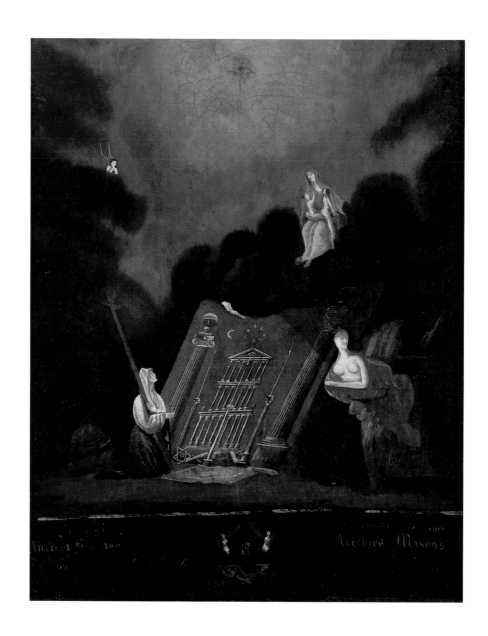

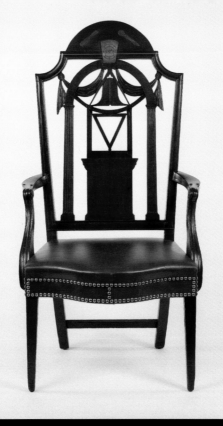

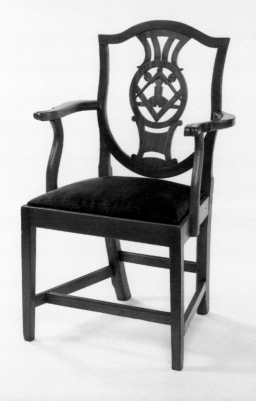

ILLUSTRATIONS:
3.15, TOP
4.20, BOTTOM

FACING:
3.19, AND DETAIL

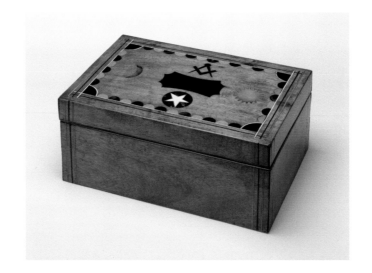

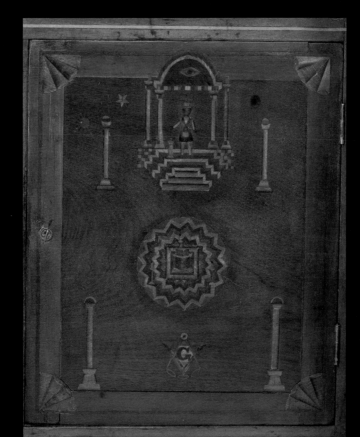

ILLUSTRATIONS:
3.49, FACING
4.13

Color Plates 267

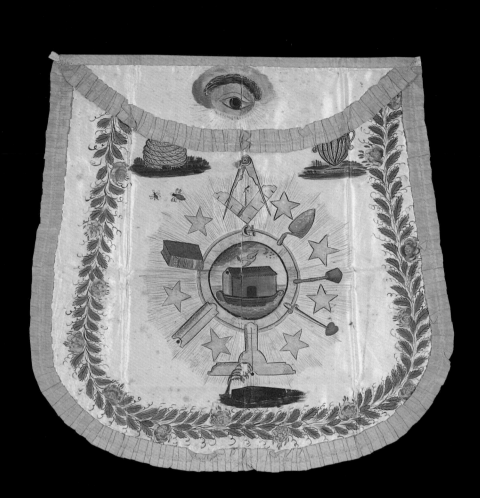

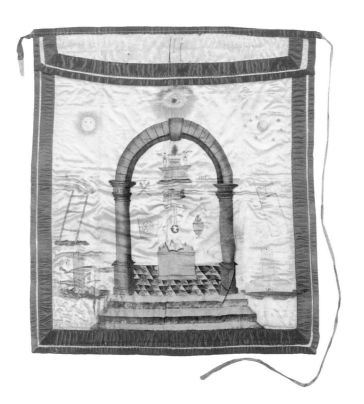

ILLUSTRATIONS:
4.17, FACING
4.19, TOP
4.10, BOTTOM

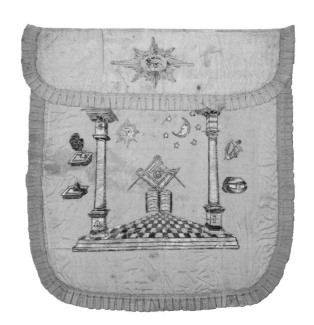

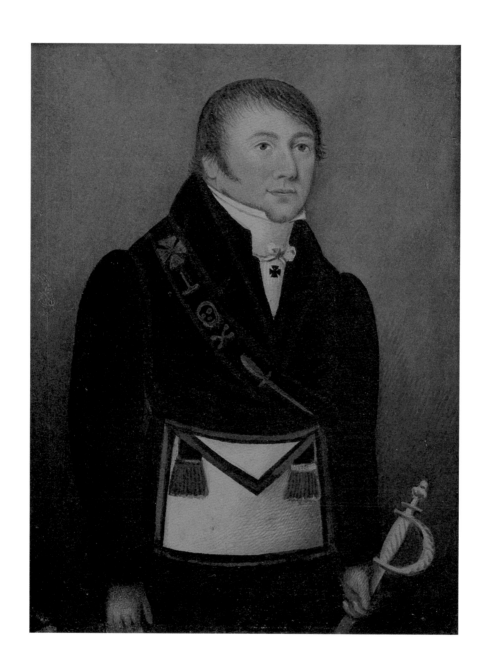

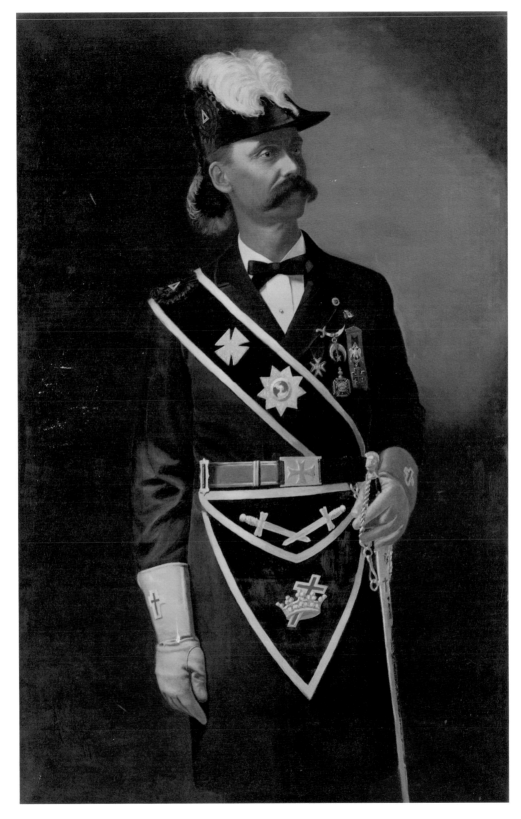

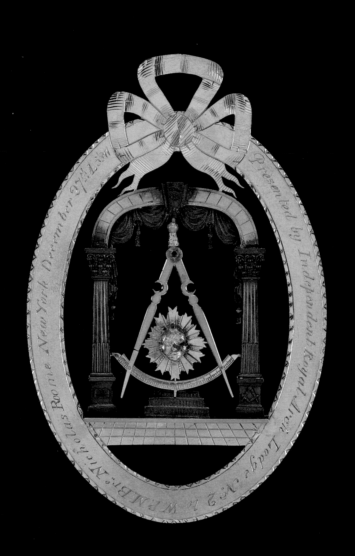

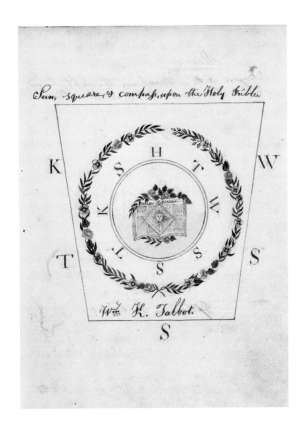

ILLUSTRATIONS:
4.44, FACING
4.50, TOP
4.60, BOTTOM

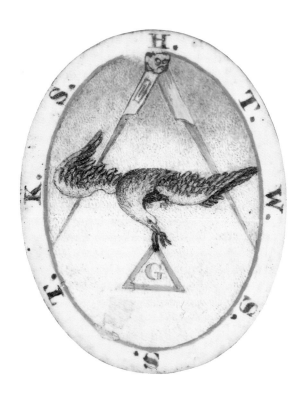

ILLUSTRATIONS:
4.73

FACING PAGE:
4.69, TOP LEFT
4.66, TOP RIGHT
4.67, BOTTOM LEFT
4.80, BOTTOM RIGHT

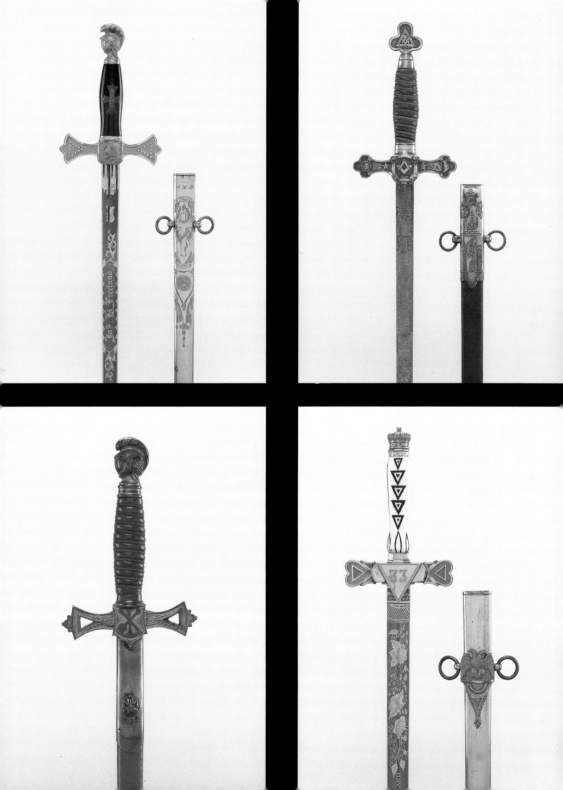

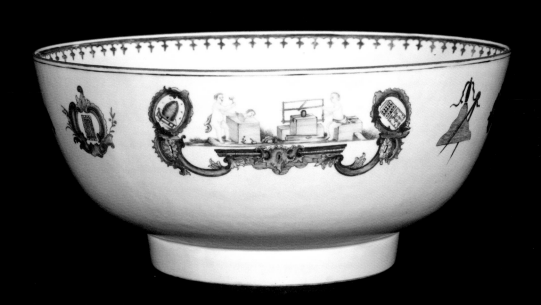

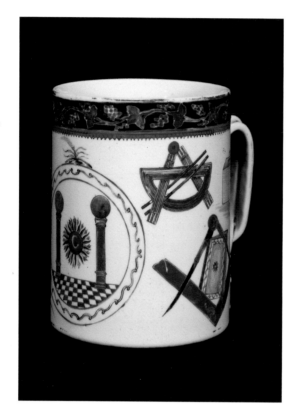

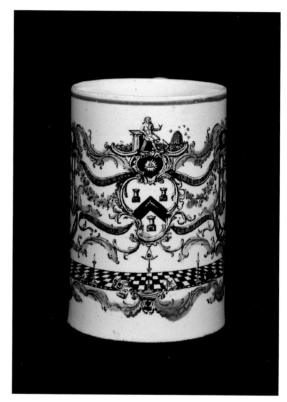

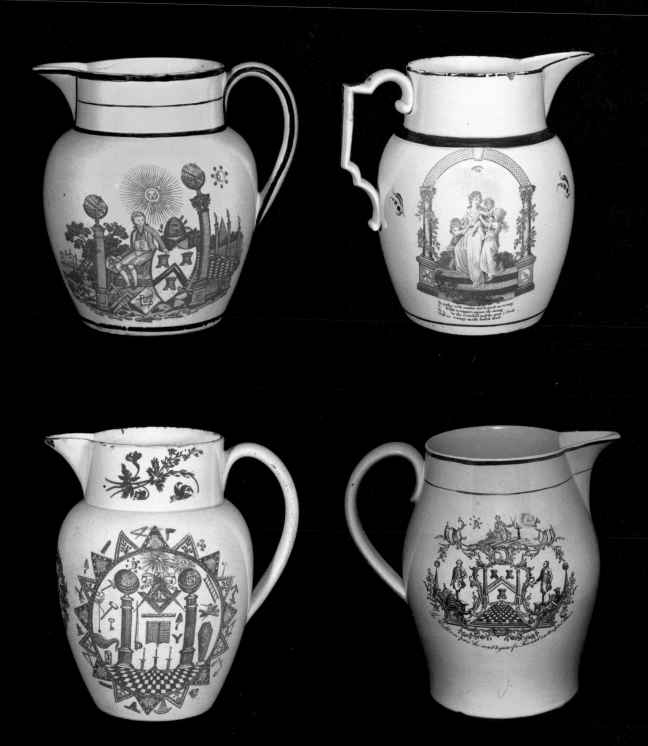

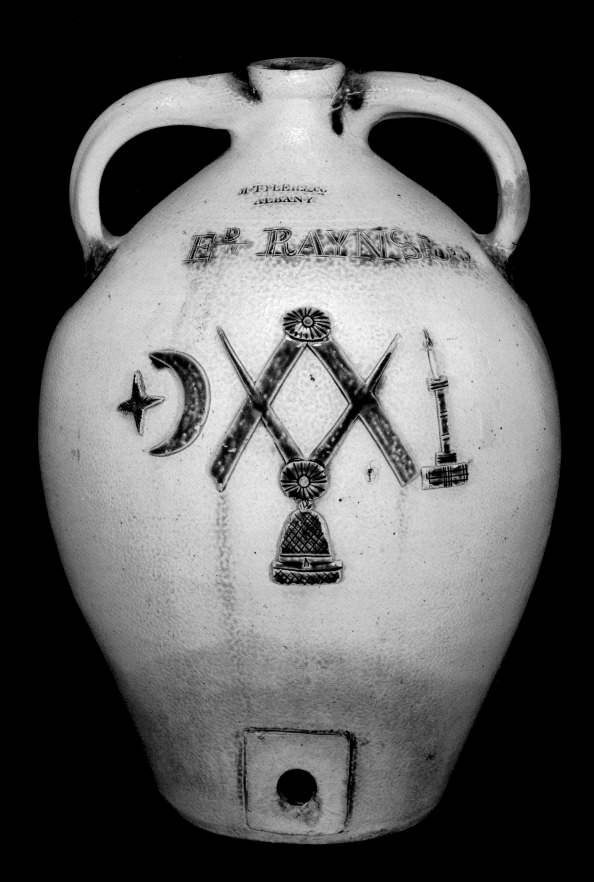

Appendices

Appendix I
Dealers of Fraternal Regalia & Paraphenalia

Addis, William
Cincinnati, Ohio
c. 1853 located at 6th St.
Manufacturer of Masonic regalia.

Allien, Henry Vincent & Co.
New York, New York
c. 1910.
A regalia house for the NYC militia. Member of the Light Guard (1835-40) and supplier to the 7th regt., NYNG.
n.b. swords in New York Historical Society

Ames, Nathan Peabody
Springfield, Massachusetts
1829-1847
Sword cutler, manufacturer of U.S. regulation, militia, Masonic and society swords. Incorporated as Ames Mfg. Co. in 1834.
Nathan Peabody Ames, Jr. (1803-1847)
Brother, James Tyler Ames (1807-1886) continued business.
Acc# 89.75 (AASR)

Ames Manufacturing Co.
Cabotville, Massachusetts
1834-1847
Chicopee, Massachusetts
1847-1898
Manufacturer of U.S. regulation swords, bronze castings, cannon, firearms, machinery, and regalia for all societies. Sword and regalia production assumed in 1880 as the Ames Sword Co.
Acc# 79.24.3 (KT)
Acc# 80.30 (KT)
Acc# 85.84 (KT)

Ames Sword Co.
Chicopee, Massachusetts
c. 1881-1932
Chicago, Illinois
1891 located at 148 to 154 Monroe St. with "Eastern factory in Chicopee, Mass." John D. Bryant, Pres.; Gamiliel Bradford, Treas.; Charles A. Buckley, Superintendent.
Sword and regalia manufacturers, "Perfection" padlocks, and firearms. Business bought out in 1925 by M.C. Lilley & Co. of Columbus, Ohio.
Acc# 74.1.60 (KT)
Acc# 78.29 (KT)
Acc# 79.14 (SBL, Guarde Lafayette)

Acc# 79.24.2 (KT)
Acc# 79.25 (KT)
Acc# 79.53.1 (regalia ?)
Acc# 79.61 (RCofC)
Acc# 79.65 (KT)
Acc# 79.69.1 (KT)
Acc# 80.64 (KT, DIRK)
Acc# 81.54.1 (KT)
Acc# 81.55.1 (KT)
Acc# 84.25.3 (KT, w/dirk blade)
Acc# 84.66 (KT)
Acc# 88.22.10 (Soc. St. JB)

Armstrong, Jones & Co.
Detroit, Michigan
c. 1854 located at No.202 Jefferson Ave., Masonic Regalia Depot. Dealer in Masonic regalia and "Fashionable Hat & Cap Store."
Thomas H. Armstrong, Eminent Commander, K.T. 1865-66.

Armstrong, Thomas H.
Detroit, Michigan
prior to 1870 located at 176 Jefferson Ave., Detroit Masonic Regalia Depot (estab. 1848). Succeeded by E.A. Armstrong c. 1870.

Armstrong, Edwin A. & Co.
Detroit, Michigan
c. 1874 located at 176 Jefferson Ave. "P.E. and T.H. Armstrong superintending the regalia department." Advertised as "Successors to T.H. Armstrong." 1877 established at 196 Jefferson Ave. In 1894 Detroit factory bought out by Frank Henderson. In 1892 moved to Chicago and located at 142-148 W. Washington St. In 1910 located at 315-321 Wabash Ave. and in 1918 located at 434-440 S. Wabash. J.P. Doyle, Manager.
Edwin A. Armstrong (1848-1915) A.A.S.R. (Valley of Chicago) 1895. Relinquished presidency of E.A. Armstrong in 1912.
Acc# 80.20 (KT)

Bailey, John C.W.
Chicago, Illinois
c. 1866 located at 164 Clark St. Sold regalia, Masonic books, and swords. Offered Royal Arch and chapter and K.T. swords and Price's patent sword hanger. Moved to 129 Dearborn St. by 1871. Publisher of *Voice of Masonry*, 1868.

Beall, Horatio
Washington City, District of Columbia
c. 1864 located at 499 7th St. Manufactured leather goods, military equipment, and Masonic goods. Advertised in *The National Freemason* (March 1865).

Bent & Bush
Boston, Massachusetts
Reputed to have been established in 1823. 1851-59 located at 30 Central St. and then 1862-1914 located at corner of Court and Washington Sts. Manufacturers of and dealers in Masonic regalia. Advertised in the *Freemason's Magazine* (1862 only). Affiliated with Boston Badge Co. (estab. 1895) located at 15 S. Washington St., Whitman, MA. Prize Trophy catalog c. 1932.
Acc# 79.29 (KT)
Acc# 79.69.2 (KT)
Acc# 86.19 (KT)

Bingham, W.P.
Indianapolis, Indiana
c. 1868. Dealer in regalia. Advertised in *Voice of Masonry* (Feb. 1868).

Blackington, Virgil H. & Co.
Attleboro Falls, Massachusetts
In 1852 commenced manufacture of Japanning. 1869 began manufacture of insignia, tags, awards, medals, trophies, society swords, and regalia. Virgil H. Blackington, Pres. 1852-1888.

Boston Regalia Co.
Boston, Massachusetts
c. 1895 located at 7 Temple Place. Regalia dealer. Samuel P. Leighton, Pres.; William C. Remy, Treas.

Bowen, E.R.
Chicago, Illinois
c. 1868 located at 20 Clark St. Advertised Rives' Patent Sword Hangings in *Voice of Masonry* (1868).

Braxmor, C.G. Co.
New York, New York
c. 1890
Acc# 86.59.1 (KT)

Bremand & Florence
Philadelphia, Pennsylvania
c. 1849 located at Chestnut & 6th Sts. Dealers in military goods.

Browning, King & Co.
Boston, Massachusetts
c. 1910 located at 407, 409 and 411 Washington St. Dealers in K.T. uniforms.

Bruce, L.C.
Boston, Massachusetts
1915-1919 located at 202-03 Masonic Temple, replacing E.C. Phillips as New England representative and headquarters for Henderson-Ames of Kalamazoo, Michigan. February 1917 moved to 501 Washington St. and then in July to 16 Wyola Dr, Worcester, Massachusetts, ceasing business in 1919.

Buhl, Walter & Co.
Detroit, Michigan
c. 1880s-90s. Regalia dealers. (see also: Morgan, Puhl & Morris).

Bush, John A.
Peoria, Illinois
c. 1862 located at 7 North Adams St. Dealer and manufacturer of military uniforms and fraternal regalia. Employed Sir Kt. Charles H. Deane.

Carberey, Harvey R.
Chicago, Illinois
1862 located at 91 Lake St. then moved to 60 State St.in 1866; 98 E. Madison St. in 1873, and finally to 80 E. Madison by 1876. Dealer and manufacturer in military and Masonic goods, swords,

regalias (full line). C.C. Carber, Agent in 1870.
Harvey Raymond Caberey, knighted Apollo Commandry No. 1, 1867; AASR (Valley of Chicago) 1869 (suspended by 1907).

Caldwell, John D.
Cincinnati, Ohio
c. 1867-1902. Regalia dealer, imported swords from W. Clauberg, Germany. Blades stamped "J.D. Caldwell, Cinti".
John Day Caldwell (1816-1902): raised in Amity Lodge No. 5, Zanesville, Ohio in 1844, also in chapter (1844), council (1849), commandry (1850), AASR (1865) and SGIG 33 (1885).

Caldwell & Co.
Philadelphia, Pennsylvania
c. 1890s.

Chandler & Barrow
Atlanta, Georgia
c. 1868. Regalia dealers, southern branch of the Masonic Publishing & Mfg. Co. Advertised goods at New York prices.

Chaplin & Ihling
Kalamazoo. Michigan
c. 1869 located at 71 Main St. Masonic book manufacturers. Succeeded by Ihling & Everard Regalia Co.

Cincinnati Regalia Co.
Cincinnati, Ohio
c. 1900 located at 400-406 W. 4th St. Col. George W. Morris (K.T.), company representative in 1902.

Clement & Hawks & Co.
Northampton, Massachusetts
1866-1878. Cutlers, offering sabers and bayonets.

Combs, Elias & Co.
New York, New York
Established 1844, 1851 located at 244 Grand St. (east of Bowery), then by 1858 located at 465 Broadway. "Swords and dirks kept on hand, regalia...." Advertised in the *Masonic Register* (Jan. 1855).

Conning & Faser
Mobile, Alabama
c. 1861. Manufacturers of Masonic regalia and swords. (see: Faser, Jacob).

Curtis, William
Philadelphia, Pennsylvania
Established 1846. In 1870 located at 146 N. 6th St., Philadelphia Masonic Depot. Dealer in "regalia, emblems, jewels books, ballot-boxes and all other proper-

ties." Curtis died c. 1871 and business carried on by his widow, assisted by John Curtis. Advertised in *The Evergreen* (1872), *The Landmark* (1871), *Masonic Library* (1870).

Deane, Charles H.
Peoria, Illinois
c. 1857 located at 18 Water St., corner of Fulton. Manufacturer and dealer in regalia and swords. Joined the firm of John A. Bush in 1862.
Advertised in *Masonic Review* (June 1857).

DeMoulin Brothers & Co.
Greenville, Illinois
c. 1915-1932 located at 1105 S. 4th St. Manufacturers and dealers in swords, regalia, and degree paraphernalia. Specialized in "side degree" materials.

Detroit Regalia Co.
Detroit, Michigan
c. 1894 located at 227 Jefferson Ave. Regalia manufacturers of Masonic and all society goods. Operated by George D. Adams and F.A. Updike. Logo: Knight on horse, carrying shield with motto "We Challange All Competitors."
Advertised in *The American Tyler* (June 1894).

Dinsmore, William J.
Boston, Massachusetts
Established in 1887, located at 521 Washington St. Dealer in society regalia, including Red Men.

Donaldson, Garvey
New York, New York
c. 1887-89 located at 309 W. 22nd St., then by 1889 at 591 Broadway. Dealer in regalia "representing the manufacturer who has secured the largest contract ever awarded for Knight Templar uniforms."

Drew, William H.
Buffalo, New York
c. 1853 located at Washington and Exchange Sts. Regalia manufacturer. Drew served as Grand Lecturer of the Grand Lodge of New York.

Dewitt, A.N.
Buffalo, New York
c. 1855 located at 1,2 and 6 Kremlin Hall. "Regalia manufacturer for blue lodge, chapter and encampment degrees...."

Drummond, Malonzo J.
New York, New York
c. 1853 located at 331 Grand St. Regalia manufacturer, specializing in Royal Arch and Templar paraphernalia. Patentee of the "Templar's Sword Fastener" (Jan. 20, 1860). Publisher of *The Masonic Messenger*. Advertised in *The Masonic Register* (Jan. 1855) and *The Masonic Review* (June 1857).
Malonzo J. Drummond was created Knight Templar in 1849 in Palestine Commandry No. 18, and demitted to Morton Commandery in 1853.

Emerson & Silver
Trenton, New Jersey
c. 1865. Manufacturer of military swords during Civil War. Advertised as manufacturers of Masonic swords for lodges, chapters, and councils...exclusive right to manufacture "Price's Patent Sword Hanger"...also lodge jewels, regalia.
Advertised in Rob Morris' *Freemason's Almanac* (1865).

Faser, Jacob
Macon, Mississippi
c. 1854. Apprenticed to F.W. Widmann, then Wm. H. Horstmann of Philadelphia. Moved to Macon in 1854, occupation as silversmith and gunsmith. c. 1861 worked for James Conning in Mobile, Alabama (Conning & Faser).
Jacob Faser (1823-1891) died in Macon and was buried in the Odd Fellows Cemetery (*Antiques*, Aug. 1958).

Fecheimer Brothers & Co.
Cincinnati, Ohio
c. 1865-1876. Firm noted on back-die in Scoville button collection.

Ferd-Hahn, J.H.
Baltimore, Maryland
c. 1890-1900
Acc# 86.64.2 (KT)

Floding, W.E.
Atlanta, Georgia
c. 1909 successor to George A. Flooding at 155 Whitehall St.

Flooding, George A.
Atlanta, Georgia
Established in 1875 and located at 155 Whitehall St. Advertised as "Largest Regalia House in the South." Succeeded in 1909 by W.E. Floding at same address (note change of spelling).

Fuller Regalia & Costume Co.
Worcester, Massachusetts
c. 1898 located at 5 Pleasant St., corner of Main. Manufacturers of regalia, costumes, uniforms, banners, flags, and society goods. Sole manufacturers of "Fuller's Patent Hoodwink" (Patented Sept. 29, 1885 and Oct. 25, 1904).

Gaylord Manufacturing Co.
Chicopee, Massachusetts
c. 1863-1881. Manufactured society, Masonic, and regulation military leather goods and accoutrements. Firm bought out by Ames Sword Co. in 1881 and operated under management of James T. Ames' son-in-law, A.C. Woodworth.
Emerson Gaylord (1817-1899). Started as superintendent of N.P. Ames leather department. Began own company c. 1855. Made leather scabbards and angular bayonets for Model 1855-70 rifled musket, using W. Hoffman patent of May 8, 1860. Became stockholder and member of the board of directors of Ames Manufacturing Co. after the Civil War (1870-75). Sold swords using surplus Ames blades. Die sinkers and engravers, cast belt plates for Wells Fargo and Tiffany Co.

Gibson, George
Boston, Masssachusetts
n.d.
Regalia dealer, sold swords with his name on them, actual manufacturer unknown. Example in Detroit Historical Society coll.

Goff, Azro
New York, New York
c. 1888 located at 150 Nassau St. Dealer in regalia.

Graves, Alonzo
Morristown, New Jersey
c. 1903. Maker (noted on box label) of Masonic regalia.

Greenwood, Atkinson, Armstrong Co.
Detroit, Michigan
c. 1918 located at 421 Woodward Ave. Manufacturers of uniforms and regalia.

Harding Uniform & Regalia Co.
Boston, Massachusetts
c. 1917 located at 22 School St. Made items for Independent Order of Red Men (IORM).

Harrington, Smith B.
Boston, Massachusetts
c. 1917 located at 370 Washington St. Dealer, sold "Jointed and other presentation swords."

Haskell, W.E.P. & Chapman, A.P.
Boston, Massachusetts
c. 1846 located at No.1 1/2
Tremont Row. Merchant tailors
dealing in Masonic and other regalia.
Freemason's Monthly Magazine
(May 1, 1847)

Hausmann, Henry
Erie, Pennsylvania
c. 1900. Sold nickel-plated fraternal swords.

Hayward, B.T. & W.A.
New York, New York
c. 1867-1873 located at 208/210
Broadway. Started as a Masonic
jeweler. Manufacturer of Masonic
and military swords, jewelry,
badges.

Henderson & Giddings
Kalamazoo, Michigan
c. 1870-73 located at 110 Main St.
Manufacturers of Knights
Templar equipment. Partnership
dissolved in 1873, succeeded by
Frank Henderson Co. Advertised
in *Michigan Freemason*, Aug. 1873.
Theron F. Giddings (1843-n.d.), a
member of Penninsular
Commandry with Henderson and
Grand Commander K.T. in 1884.

Henderson, Frank
Kalamazoo, Michigan
c. 1873-1893 located at 104 Main
St. Manufacturer of regalia for all
Masonic orders, IOOF, KofP,
IORM, PSofA, IOGT, KOTM,
SofV. Began regalia business in
partnership with Theron F.
Giddings in 1870. Succeeded in
1893 as Henderson-Ames Co.
Advertised in *Freemasons Monthly*
(April 1879).

Henderson-Ames Co.
Kalamazoo, Michigan
1893-1924 located at E. Main and
Edward Sts. Manufactured regalia, lodge furnishings for all
fraternal and military organizations, and specialized in Knights
Templar uniforms. "Successors to
Frank Henderson, Kalamazoo,
Mich. and Ames Sword Co., Chicago." Firm dissolved in 1923 but
rechartered by the Lilley Company who relinquished the
Henderson name in 1933. Continued until 1949 as the
Kalamazoo Regalia Co.
Acc# 79.59 (KT)
Acc# 91.047.19 (KT)

Horstman, William & Sons
Philadelphia, Pennsylvania
c. 1840-1859
Acc# 79.8.2 (POSA)
Acc# 82.7 (KT)
Acc# 82.39 (KT)
Acc# 83.43 (RAC)

Horstmann Brothers & Co.
Philadelphia, Pennsylvania
c. 1859-1954 located at 5th and
Cherry Sts. Manufacturers
and importers of Masonic lodge,
chapter, commandery, Scottish
Rite, society and military regalia.
Began the manufacture of regalia
immediately after Civil War. Succeeded their father, Wm. H.
Horstmann, who acquired the
sword-making business of
Frederick W. Widmann in 1848.
W.J. and S.H. Horstmann in partnership with John G. Franklin
establishing a New York branch,
Horstmann Sons & Drucker. Advertised in *Masonic Review* (Sept.
1865) "... this house fast rising in
importance to the first rank of
Masonic fitting."
Acc# 91.047.20 (KofM)

Horstmann & Drucker
New York, New York
c. 1845-1859

Howell, David B.
New York, New York
c. 1862-1895. First located at 434
Broadway, corner Howard St.
"Sword and regalia
manufacturer...swords made to
order...hung with Price's Patent
Sword Hangings." Advertised as
the American Masonic Agency.
David.B. Howell. Emminent
Companion, Adelphi Chapter
No. 158. Served as High Priest in
1873.
Advertised in *Voice of Masonry*
(Jan. 1868).
Acc# 79.22.4 (KT)
Acc# 80.62

Ihling Brothers, Everard Co.
Kalamazoo, Michigan
c. 1869 to present located at 2022
Fulford, in business until 1924 at
233-239 E. Main St. Uniforms,
costumes, and regalia. Successors
to Chaplin & Ihling.

Joel, J.A. & Co.
New York, New York
c. 1898 located at 88 Nassau St.
"Dealer in flags, banners, swords,
belts, caps, ... and all kinds of
military equipment."
Advertised in *Confederate Veteran*
(Feb. 1898).

Johnson, T. Rodgers
San Francisco, California
c. 1869 located at 325 Montgomery St. Dealer in Masonic and
other regalia and military goods.
Advertised in *The Masonic Mirror*
(Dec. 1869/70).

Kalamazoo Regalia Co.
Kalamazoo, Michigan
1927-1933. Changed name to
Henderson-Ames in 1933 when
Lilley consolidated and relinquished name. Continued as
Henderson-Ames until August
31, 1949. W.A. Scougale was last
agent for the company.

Kelly, James
Philadelphia, Pennsylvania
c. 1855 located at Odd Fellows
Hall on N. 6th St. Dealer in Masonic and Odd Fellows regalia.
Advertised as successor to Wm.
Curtis who was at N. 6th St. c.
1867.
Advertised in *The Universal Masonic Record* (1857).

Kendrick, William
Louisville, Kentucky
c. 1868. Dealer in regalia.
Advertised in *Voice of Masonry*
(Feb. 1868).

Kinsey, M.V.
Atlanta, Georgia
c. 1923-25. Southern representative for Henderson-Ames.

Lampson
Boston, Massachusetts
n.d. Regalia dealer, sold swords
with "Lampson" name.

Lampson & Hubbard
Boston, Massachusetts
c. 1910 located at 90-94 Bedford
St. Dealer in KT regalia.

Langhoey
c. 1864. Obtained patent for
sword slide attachment.

Leighton, Samuel P.
Boston, Massachusetts
1894 President of the Boston Regalia Co., the New England
office for Horstmann & Co. of
Philadelphia.
Samuel Perkins Leighton (1836-1916) Raised: Joseph Warren
Lodge, Dec. 1860. Moved to Columbus, Ohio in January 1909.

Lehmberg, William & Sons, Inc.
Philadelphia, Pennsylvania
c. 1908-1919 located at 928 Arch
St. then in 1920 moved to 138 N.
10th St. and in business there until 1929. Dealer in Masonic
clothing, regalia, paraphernalia

and costumes. (Order of Eastern
Star catalog # 100).
Firm consisted of William, William B., Stanley, and Henry.

Leonard, Jonathan W.
New York, New York
1855 located at 384 Broadway.
Regalia dealer, succeeded by
Wm. H. Milnor in 1857.

Leweck, G.
New York, New York
c. 1871 located at 283 Grand St.
Regalia manufacturer for Masonic, IOOF and other secret
societies.

Leweck & Cahn
New York, New York
c. 1855 located at 283 Grand St.
Dealer in regalia.

Lilley, M.C. & Co.
Columbus, Ohio
c. 1865-1897 located at 27-45 W.
Gay St. Moved to 261 Long St. in
1903. Sword and regalia manufacturers, absorbed the Ames Sword
Co. in 1923, absorbed by the C.E.
Ward Co. in 1951. Lilley started
in bookbinding business in partnership with Charles Siebert
(Columbus, Ohio) and his
brother Christian (gunmaker
from Circleville, Ohio). The
Siebert family were printers, engravers, gunsmiths, and
publishers of Masonic books and
rituals.
Captain Mitchell C. Lilley (1819-1897). Served in the Mexican
War (1847-48) with Co. E 4th
Ohio and in the Civil War with
Co.H, 46th Ohio Inf. (wounded
at Shiloh).
Acc# 79.22.3 (UR, KofP)
Acc# 79.36 (WOW)
Acc# 79.52 (KT)
Acc# 80.17.1 (PM, IOOF)
Acc# 80.37 (KT)
Acc# 81.22 (KT)
Acc# 81.28 (KT)
Acc# 86.33 (IOOF)
Acc# 88.24 (KofM)
Acc# 92.018 (KT)

Lipp, Rose
Boston, Massachusetts
c. 1914-1920 located at 74
Boylston St., then moved to 175
Tremont St. in 1915. Dealer and
manufacturer of Masonic regalia,
retail agent for Ames Sword Co.
Acc# 84.65 (KT)

Lucker, James
New York, New York
c. 1884-1889 located at 133 Grand
St. and 19 Crosby St. Regalia
dealer. Also maintained sales of-
fice in Philadelphia.

Macoy & Sickels
New York, New York
c, 1868. Dealers in regalia.
Advertised in *Voice of Masonry*
(Feb. 1868).

Manning, Charles G.
Cincinnati. Ohio
c. 1868. Dealer in regalia.
Advertised in *Voice of Masonry*
(Feb. 1868).

Marshall, Mrs. J.H.
Boston, Massachusetts
n.d. Regalia dealer. Sold swords
to Mt. Sinai Chapter, Lawrence,
Mass.
Acc# 80.66.2 (RAC)

Merrill, J. Ambrose
Portland, Maine
Established 1851. c. 1860 located
at 139 Middle St., moved to 503
Congress St. in 1895. Dealer in
Masonic and military regalia.
Albion Keith became manager c.
1900.

Masonic Furnishing Co.
New York, New York
c. 1871 located at 52 Bleeker St.
Dealer in regalia, banners, jewels,
swords, furniture, etc.

Milnor, William H.
New York, New York
1857 succeeded J.W. Leonard.
1859 located at 384 Broadway as
The American Masonic Agency.
Regalia manufacturer. Succeeded
by William Price.
William H. Milnor (n.d.-1862).
1846 raised: Holland Lodge No.
8 (New York), W.M. in 1847-49,
created KT: 1860 Palestine
Commandry No. 18.

Mintzer, William G.
Philadelphia, Pennsylvania
c. 1861 located at 131 North 3rd
St. "Military & theatrical trim-
mings, importer and
manufacturer of banners, flags,
Masonic, IOOF and other regalia
for lodges, encampments and So-
cieties generally...."

Mitchener, E.E.C.
Sheltonville, Georgia
c. 1859. Manufacturer of regalia
with agents Lewis Lawshe, At-
lanta; J.E. Wells, Macon; Hall &
Ford, Americus; S.S. Brooks, Co-
lumbus; Wm. Cox, Savannah;
W.R. Simms, LaGrange; Alfred
Bone, Alexandra, Tenn.; J.L.
Saulsbury, Montgomery, Ala-
bama.

Moller, Frederick
New York, New York
c. 1844 located at 200 Division St.
Cutler, made Odd Fellows sword
marked MOLLER/N.YORK.
Listed in Longworth's NYC Di-
rectory 1844-45.
Acc# 85.33 (IOOF)

Moore, Charles
Cincinnati, Ohio
c. 1868. Regalia dealer, adver-
tised regalia "without having to
go east for them...." Was also Edi-
tor of *Masonic Review*.

Moore, John K. & Co.
Cincinnati, Ohio
c. 1869. Dealer in KT outfits, op-
erated Masonic Emporium.

Morgan, Puhl & Morris
Detroit, Michigan
c. 1895 located at 102 Woodward
Ave. Relocated to 41-49 Grand
River in 1903. Manufacturers of
Masonic supplies, costumes, and
KT uniforms.

Moss, I.M. & Brothers
Philadelphia, Pennsylvania
c. 1855 located at 12 S. Fourth
St., then number changed to 16
S. Fourth St. Vendor in KT rega-
lia and Masonic paraphernalia.

Mustin, E.C.L.
Cincinnati, Ohio
c. 1868. Dealer in regalia.
Advertised in *Voice of Masonry*
(Feb. 1868).

Myers, George
St. Louis, Missouri
c. 1849 located at 23 Vine St. Re-
tail dealer in KT regalia.

Naylor, Charles
Philadelphia, Pennsylvania
c. 1890 located at 118 N. Fifth St.
Dealer in society regalia (see: Pa-
triotic Order Sons of America
catalog), paraphernalia, swords,
belts, etc. "called for by the New
Ritual [POSA]." Possibly retailed
swords made by Ames Sword Co.
Charles Naylor, member of Camp
No. 7, Pennsylvania POSA.

Norcross, Daniel & Co.
San Francisco, California
Established 1849. c. 1880 located
at 6 Post St. in the Masonic
Temple. Dealer in Masonic, mili-
tary, and naval goods.
Advertised in *Voice of Masonry*
(Feb. 1868).

Parson & Co.
St. Louis, Missouri
Established 1840. Located at 816
N. Fourth St., then moved to No.
710 in 1869/70, then No. 716 N.
Fourth St. in 1870. Dealers in
Masonic furnishings. Advertised
as being the oldest regalia manu-
facturer in the United States,
with 30 years experience (1869).
October 1870 opened a New York
agency at 132 Nassau St., moved
to 103 Duane St. in May 1871.
Advertised in *Voice of Masonry*
(Feb. 1868) and *The Freemason*
(Oct. 1873).

Parson & Co.
Louisville, Kentucky
Established 1840. c. 1880 located
at 716 Fourth St. Regalia dealer,
operated Masonic Furnishing
House providing regalia for all so-
cieties.

Pasquale, B. & Sons
San Francisco, California
c. 1900. Regalia and uniform out-
fitters.

Pettibone Brothers Mfg. Co.
Cincinnati, Ohio
Established 1871. c. 1883 located
at 165 Elm St. then moved to
626-632 Main St. until 1922.
Manufacturers of lodge furniture,
swords, and regalia. Used same
markings as M.C. Lilley, possibly
purchased their swords or blades
from Lilley. James Pettibone,
Pres. 1880-1889.
James Pettibone was a member
of Cincinnati Commandry No.3
in 1889.

Pettis, Julius R. & Co.
Troy, New York
c. 1867-1871 located at 374 River
St. Manufacturer of uniforms for
KT, and "swords hung with
Patent hangings...."

Phillips, E.C.
Boston, Massachusetts
c. 1901-1915 located at 202-203
Masonic Temple, Boston. Man-
ager of Henderson-Ames' New
England headquarters. Replaced
by L.C. Bruce in Sept. 1915.
Advertised in *Masonic Token* (Oct.
1901).

Pierce, B. Co.
Boston, Massachusetts
c. 1900 Knights of Pythias (Uni-
form Rank) sword marked
"Burton Pierce Co./Boston,
Mass."

Pilling, George P.
Philadelphia, Pennsylvania
c. 1870 located at 701 Chestnut
St. Manufacturer of Masonic,
IOOF/KT/KofM/SofT/TofH/
Am.Mech./IORM/KofP and other
jewels, R.A. Chapter breast
plates, emblems, marks, etc.; also
gold, silver, surgical and dental
instruments.
Advertised in *Masonic Library*
(July 1870).

Pinchin, William
Philadelphia, Pennsylvania
c. 1849 located at 16 Jacoby St.
Dealer in military goods.

Plate, A.J. & Co.
San Francisco, California
c. 1880 located at 325 Montgom-
ery St. and 510 Sacramento St.
Dealer and manufacturer of Ma-
sonic regalia and military goods.
Officers of company: H.A. Plate,
W.B. Cotrel, A.F. Plate, and John
Wolfe.

Platt, E.M.
Boston, Massachusetts
n.d. Regalia dealer, sold swords
marked "E.M. Platt/Boston."

Pollard, Abner W.
Boston, Massachusetts
c. 1845 located at 31 Merchants
Row, corner of N. Market St. Ad-
vertised as a draper and tailor
dealing in Masonic, IOOF, and
Rechabite regalia. 1855 located at
6 Court St. Merchant tailor, cos-
tumer and regalia manufacturer.
Entered partnership with Samuel
P. Leighton in 1868.
Abner W. Pollard. (n.d.-1886)
Raised: Mt. Lebanon Lodge, Jan.
1846. Advertised in *The Symbol*
(vol. 5, 1846); and *Masonic Review*
(June 1857).

Pollard & Leighton
Boston, Massachusetts
1867 located at 6 Court St. then
moved to 104 Tremont St. in
1868. Abner W. Pollard in part-
nership with Samuel P. Leighton
(see: Boston Regalia Co.). Fur-
nished swords and regalia for all
Masonic bodies.
Advertised in *Freemason's Monthly
Magazine* (Oct. 1867) and *Voice of
Masonry* (Jan. 1868).
Acc# 88.58.17 (Tyler)

Pollard & Alford
Boston, Massachusetts
c. 1878 located at 104 Tremont
St. Leighton appears to have left
Pollard and gone into business
for himself. Pollard then picked
up Alford as new partner.
Acc# 80.66.1 (Tyler)

Price, William H.
New York, new York
1859-1868 located at 424 Broad-
way. Regalia manufacturer,
operating The American Masonic
Agency, bought out by Wm. H.
Milnor in 1859. Price offered
swords made by his brother
Virgil. The firm succeeded by
D.B. Howell in 1868.
William H. Price was initiated in
Holland Lodge No. 8 in 1809.

Price, Virgil
New York, New York
1859 started as a sword maker for
brother William Price's American
Masonic Agency. Opened own
business located at 144 Green St.
as "manufacturer of Masonic ma-
terials, swords...." In 1871 moved
to 436 Broome St., then to 40
Great Jones St. Probably sup-
plied swords for D.B. Howell and
Redding & Company. Patented
designs for sword-hilt and scab-
bard (US Pat. 6,338 of Jan. 7,
1873; 6,953 of Oct. 7, 1873; and
6,763 of July 8, 1873), sword
hangings, and frog stud. Made
fine presentation Masonic and
military swords.
Virgil Price was a member of
Columbian Commandry No. 1,
New York in 1861.
Acc# 79.22.1 (K of P)
Acc# 80.6.1 (KT)

Raymold & Whitlock
New York, New York
c. 1882-1886 located at 39 W.
14th St., then moved in 1886 to
99/101 Fourth Ave. Dealer in Ma-
sonic goods for blue lodge,
chapter, and commandry. Adver-
tisements indicate an agent for
the Ames Sword Co. Succeeded
by W.A. Raymold in 1888.
Advertised in The Masonic Era
and Analectic (May 1886).
Acc# 81.14.2 (KofGE)

Raymold, W.A.
New York, New York
c. 1888 located at 99/101 Fourth
Av. In 1890 advertised a $40 KT
sword "of very light weight, with
narrow diamond blade, gold
etched, scabbard made of steel &
nickel-plated. Mountings of em-
blematical design. Ivory grip and
Monogram. A very neat sword."

Raynes, Joseph & Co.
Lowell, Massachusetts
c. 1862 located at 43 Central St.
Advertised "swords of half a
dozen different makers including
The Chelmsford Sword manufac-
tured by C. Roby & Co., W.
Chelmsford."
Advertised in Lowell Daily Citizen
& News (Apr. 2, 1862).

Redding, M.W. & Co.
New York, New York
Established 1859. Located at 212
Broadway then removed to 200
Fifth Ave. in 1885, then 731
Broadway in 1891. Remained in
business until 1923. Regalia
manufacturers advertising swords
probably made by D.B. Howell.

Reynolds, Harman G.
Springfield, Illinois
c. 1863 located at 25 South
Street. Dealer in regalia, swords
for KT and Chapter. 1867 adver-
tised KT swords with "rosewood
handles" (probably supplied by
D.B. Howell).
Advertised in The Masonic Trowel.

Rice, William M.
New York, New York
c. 1858 located at 424 Broadway.
Maker of Masonic regalia swords.
Patented a scabbard hanger ar-
rangement (Nov. 2, 1858).

Ridaback & Co.
New York, New York
Established 1847. Located at
149-151 W. 36th St. Remained in
business until 1925.

Roby, Christopher & Co.
West Chelmsford, Massachusetts
1853-1867. Manufacturer of mili-
tary and Masonic swords, Bowie
knives, and edged tools for agri-
culture and the textile industry.
Changed company name to Roby
Manufacturing Co. in 1868.
Christopher Roby (1814-1897).
Raised: Ancient York Lodge in
1862, Mt. Horeb Royal Arch
Chapter, Lowell. Postmaster, W.
Chelmsford (1852-1885), Captain
Troop F, MVM (1864-1877).
Acc# 79.24.1 (AASR)
Acc# 80.6.2 (KT)
Acc# 80.28 (KT)

Roby Manufacturing Co.
West Chelmsford, Massachusetts
1868 until 1875 when bought out.
Sword manufacturers of Masonic
KT, militia, and regulation mili-
tary uniforms.
Acc# 82.21.35 (KT)

Roundy Regalia Co.
Chicago, Illinois
1891-1925 located at 188 & 190-
S. Clark St. Moved to 312 Clark
St. in 1924. Manufacturers of Ma-
sonic goods and lodge supplies
for all societies. 1890-95 sales
representatives for the Ames
Sword Co.
Advertised in Voice of Masonry
(Mar. 1891).
David Curtis Roundy (d. 1907).
Knighted: Apollo Commandry,
1875, Elevated: AASR 1876.

Roundy & Son
Chicago, Illinois
1886-1891 located at 188-190 S.
Clark St. Dealer in regalia for
blue lodge, chapter, and
commandry.
Frank Curtis Roundy. Elevated:
AASR to 33rd degree in 1885.

Rowland, William C.
Philadelphia, Pennsylvania
Made swords for military societ-
ies.

Ruggles & Haskell
Boston, Massachusetts
c. 1846 located at 1 1/2 Tremont
St. Manufacturers (?) of regalia
for lodge, encampment,
Rechabite, and other societies.
Advertised in The Symbol (IOOF).

Sanborn, Amos & Co.
Lowell, Massachusetts
c. 1867 located at 25 Central St.
Dealer in swords (C. Roby) and
manufacturer of coin silver
masonic jewels, regalia,
chappeau, etc. Amos Sanborn in
partnership with H.B. Bacon.
Advertised in Massachusetts Regis-
ter (1867).

Schuyler, Hartley & Graham
New York, New York
c. 1856-1902 located at 17/19
Maiden Lane. Manufacturers of
military uniforms and accoutre-
ments, branching into fraternal
regalia and swords.

Seldner, L. & Co.
Washington, District of Columbia
c. 1865 located at 344 Pennsylva-
nia Ave. and 7th St. Emporium
for military equipments and Ma-
sonic goods.
Advertised in The National Free-
mason (Mar. 1865).

Sellew, Thomas
Providence, Rhode Island
(n.d.)

Seymour, Joseph
Syracuse, New York
Established 1846. Located at No.
36 Montgomery St. c. 1866.
Manufacturer of silver ware, Ma-
sonic, IOOF, Sons of
Temperence and other society
jewels and emblems. Seymour's
goods sold through Pratt &
Tomlinson (successors to Pratt &
Lombard, New York City),
Macoy & Sickels (New York),
Horstmann Bros. (Philadelphia),
A.W. Pollard & Co. (Boston),
M.S. Smith & Co. (Detroit),
Chas. G. Manning (Cincinnati),
Wm, Kendrick (Louisville), Par-
son & Co. (St. Louis) W.P.
Bingham (Indianapolis), D.
Norcorss (San Francisco), John
C.W. Bailey (Chicago) and
E.C.L. Mustin (Cincinnati).
Advertised in Voice of Masonry,
July, 1866.

Shannon, Miller & Crane
New York, New York
c. 1880-83 uniform outfitters.

Shuman, A.& Co.
Boston, Massachusetts
c. 1895 outfitters of KT.

Simmons, G.W. & Co.
Boston, Massachusetts
c. 1890-1900
Acc# 86.53 (Patriarchs Militant,
IOOF)

Sisco Brothers
Baltimore, Maryland
(n.d.) marked on 32nd Degree
Masonic sword.
Acc# 81.14.1 (KT)

Smith, M.S. & Co.
Detroit, Michigan
c. 1868. Dealer in regalia.
Advertised in Voice of Masonry
(Feb. 1868).

Spies, Adam W.
New York, New York
c. 1821-1851 located at 87
Maiden Lane, then moved to
Pearl St. until 1846, when re-
turned to Maiden Lane. Dealers
and importers of swords.

Stilz, Louis E. & Brothers Co.
Philadelphia, Pennsylvania
c. 1885-1915 located at 151-153-
155 North 4th St. "Manufacturers
of Society, Military, Naval and
Theatrical Goods." Louis E.
Stilz, Jr., Vice Pres.; James B.
Huston, Sec/Treas.; William H.
Stilz, Asst. Sec. 1915 published

"Catalog No. 8, Paraphernalia and Costumes, Knights of Malta," in which mentioned having supplied commanderies "during the past thirty years."

Teufel, J. Jacob
Philadelphia, Pennsylvania
c. 1850 located at 130 South 8th St. Purveyor of surgical instruments, sword maker. Known swords stamped "J. Teufel/Philada."

Tisdall, F.G.
New York, New York
c. 1858 located at 335 Broadway as Universal Masonic Agency. Regalia dealer, sold KT swords at $9 - $18.

Tomes, Son & Melvain
New York, New York
c. 1862 located at 6 Maiden Lane. Sold "Rich Presentation Swords." Advertised in *Leslie's Illustrated Weekly* (Aug. 30, 1862).

Tunnel City Regalia Co.
Port Huron, Michigan
Established 1881. Located at 502-508 Huron Ave. Published catalog for KOTM in 1886.

Wadhams, B.A. & A.S.
Chicago, Illinois
c. 1869 located at 101 Madison St. Regalia dealers. Became A.S. Wadhams in 1871.
Boyd Alexander Wadhams became a member of the Scottish Rite in 1868.

Wadhams, A.S. & Co.
Chicago, Illinois
c. 1870-1876 located at 139 Madison St. until the Great Chicago Fire (Oct.9, 1871), then relocated to 190-192 Clark St. Regalia manufacturers, importers, and jobbers. D.C. Roundy, who eventually became a partner, was mentioned in advertisements as early as 1875 (see: Wadhams & Roundy).
Alvin S. Wadhams, AASR 1872 (withdrew c. 1907).

Wadhams & Roundy
Chicago, Illinois
1876-1895 located at 190/192 S. Clark St. Regalia manufacturers, importers, and jobbers. Removed store to 192 S. Clark St. where, prior to 1895, became Roundy Regalia Co.
Acc# 81.23 (KT)

Ward, C.E. & Stilson, E.R.
New London, Ohio
Established 1888. Partnership split in 1905.

Ward-Stilson Co.
Anderson, Indiana
c. 1905-1953. Regalia and sword manufacturers. Bought out by C.E. Ward of New London in 1953.

Ward, C.E. Co.
New London, Ohio
1905-1967. Sword and regalia manufacturers, heir to Ames, Henderson, Lilley and Ward-Stilson. Became Macmillan, Ward, Ostwald Company in 1967.

Wilkes-Barre Regalia Factory
Wilkes-Barre, Pennsylvania
c. 1890. Mark on a regalia sword for Knights of Malta.
Acc# 86.3 (KofM)

Warnock Uniform Co.
New York, New York
c. 1875-1880.

Wilson & Hutchinson
Philadelphia, Pennsylvania
c. 1867 located at 418 Arch St. Dealers in blue lodge, chapter, and encampment regalia.

Wilson, J.H.
Philadelphia, Pennsylvania
c. 1865 located at 1106 Chestnut St. Supplier of military goods and regalia. Label appears on Royal Arch apron (Acc# 84.35).

Williamson, E.R. & Co.
Minneapolis, Minnesota
c. 1900-1920. Dealer in regalia.

Wilson & Stellwagen
Philadelphia, Pennsylvania
c. 1868 located at 1028 Chestnut St. Dealer in military goods and regalia. Importers, obtained goods from both American and European manufacturers. Advertised in *The Freemason*, St. Louis (Aug. 1871).

Young, A.E.
Rochester, New York
(n.d.), a KT sword marked "Monroe Commandry."

Young & Hosley
Springfield, Massachusetts
Established 1893. Regalia manufacturers. 1900 purchased by Joseph W. and W.M. Young. Incorporated in 1906 as the W.M. Young Regalia Company. Specialized in pins and badges.
Acc# 80.17.2 (KAEO)

Appendix II
Engravers of American Masonic Certificates & Aprons

(*Denotes a Freemason)
(a.w. - approximate working dates)

*Abernethie, Thomas (d. 1796) - engraver, Charleston, SC (a.w. 1785-1796).
cert. for lodges of SC.

Adams, D. - engraver, Nashville, TN (c.1886).
1845 cert. for G.L. of TN (bi-ling. Fr/Eng)

Anderson, Alexander (1775-1870) - engraver, New York City
cert. for G.L. of NH, [MSS 1815]

*Ames, Ezra (1768-1836) - artist/engraver, Albany, NY (a.w. 17983-1830).
R: 12/30/1794 in Union Lodge No. 1, Albany.
1793 charter member Temple Lodge No. 53
E: 2/14/1797 in Temple Chapter No. 5, Albany.
5/20/1795 engraved a "Mk. Meddel"
1796/7 engraved two Masonic certificates.
Advertisement: "Painting & Engraving - also Freemasons aprons, sashes, and ornamental paintings in general - Seals, Mk. Mr. Mason's Medals, &c. engraved neatly and elegantly." (*Albany Register.* Nov. 25, 1799).
5/3/1800 engraved a gilt Mark Master medal for Elijah H. Metcalf, Otsego M.M. Lodge No. 5.
6/27/1800 engraved a gilt Masonic medal.

*Annin, William B. - engraver, Boston, MA (a.w. 1813-1839).
R: 3/12/1819 in Massachusetts Lodge, Boston.
in partnership with G.G. Smith.

Aspinwall, Horatio G. - Charleston, SC, c. 1823.
Engraved plate for blue lodge apron (copied from O.T. Eddy design). Several aprons found in NH suggest Aspinwall worked there prior to going to Charleston.

Balch, Vistus (1799-1884) - Albany/Utica/New York City, c. 1825- 1833.
In partnership with Ralph Rawdon.

Bannerman, John (d. 1809) - engraver, Baltimore, MD (a.w. 1773- 1809).
cert. for K.T. Encampment No. 1 of MD.

Best, Samuel (1776-1859) - engraver, Cincinnati, OH c. 1802-1819.
In partnership with brother Robert (1790-1831)
"Will execute on shortest notice and in the best manner, all kinds of Masonic Jewels & Medals, Seals of office &c." (*Liberty Hall & Cincinnati Gazette.* May 5, 1817).

*Bettle, Samuel D. (d. 1833) - engraver, Wilkes-Barre, PA c. 1823.
Member of Lodge No. 61 from 1823 to 1833.
Copied Thomas Kensett's "four-decker" apron design

*Billings, Andrew (d. 1808) - engraver, NYC (a.w. 1750-1808).
Admitted: 6/24/1776 in American Union Lodge, listed on roster with "made Masters in other Lodges."
Master of Solomon Lodge, Poughkeepsie, NY 1780/82/85/90 and 1801.
1784 cert. for G.L. of NY [MSS 1786]

Boudier, J.J. - engraver, Philadephia, PA (a.w. 1796-1797) and NYC (c. 1816).
cert. for L.R.L. La Parfaite Union, Philadelphia [MSS 1798]

*Bowen, Abel (1790-1850) - engraver, Boston, MA (a.w. 1812-1850), Portland, ME (1822-23).
R: 5/26/1820 in Massachusetts Lodge, Boston.

Bowes, Joseph - engraver, Philadelphia, PA (a.w. 1796-1813).
cert. for Philadelphia Encampment No. 1, K.T.

Bruen, Robert C. - engraver, NYC (c. 1820).
apprenticed to Maverick, became deranged and drowned himself in Hudson River.
open cert. published by Comp. Luther Jackson, NYC

*Cerneau, Joseph (1763- n.d.) - jeweler/engraver, NYC (a.w. 1806-1825).
1807 estab. Sov. Grand Consistory of USA, declared spurious in 1813.
patent for Rose Croix Lafayette Chapter NYC [MSS 1824] used a cipher imprint.

*Clapham, (n.n.) - artist, NYC (a.w. 1800-1810).
in partnership with "Bro. Kettinger"
cert. for Hiram Lodge No. 7, New York, engraved by S. Rollinson.

*Coley, William (1758-1843) - engraver, Rupert, VT
charter member North Star Lodge
1794 cut seal for G.L. of VT
1798 cert. for Union Lodge, Middlebury, VT

*Coram, Thomas (1757-1811) - engraver, Charleston, SC
cert. for Grand R.A.Chapter of SC [MSS 1783]
advertised in the *Royal Gazette* (Charleston, SC, Oct. 24, 1781), "certificate plates engraved and printed."

*Dawkins, Henry (c. 1735-c. 1790) - engraver, NYC (a.w. 1753-1757 and 1774-1786), also Philadelphia (c. 1758-1774).
R: 9/11/1759 in Lodge No. 1, Philadelphia
12/27/1764 Jr. W. of Lodge No. 3, Philadelphia
summons printed by Br. S. Leacock
1757 open summons for Philadelphia Lodges
cert. for lodges in Province of PA [MSS 1779]

*DeBruls, Michelson Godhart - engraver, NYC and New Berne, NC (a.w. 1759-1773).
cert. for St. John's Lodge No. 2, New Berne [MSS 1772]

*Doolittle, Amos (1754-1832) engraver, New Haven, CT
R: 1802 Hiram Lodge No. 1, New Haven
E: 1795 Franklin R.A.Chapter No. 2, New Haven
open lodge cert. [MSS 1793]
open cert. for 3rd Deg. [MSS 1818]
open cert. for 4th Deg. (Mark Master) [MSS 1817]
cert. for G.L. of CT [MSS 1818]
open cert. for R.A. Chapters [MSS 1822]
open lodge cert. Sp. imprint
1812 open R.A. Chapter cert. Sp. imprint, adopted by CT cert. (ltr. of credence) for A&ASR, So. Jurisdiction [MSS 1825]

*Drown, Simeon DeWitt - engraver, NY and OH (a.w. 1815-1825).
1816 member of Genesee Lodge No. 138
1818 charter member of lodge in Bath, NY
1819 relocated to OH
1824 Wor. M. of Chester Lodge No. 71, Ripley, OH

Eddy, James (b. 1806) - engraver, Boston/New York c. 1827; Provi-
dence, RI c. 1830-40. Engraved plate for blue lodge apron (copied
from Penniman & Mills design engraved by Annin & Smith, Bos-
ton).

Eddy, Oliver Tarbell (1799-1868) - engraver, Wethersfield, VT, c. 1814-
1824. NYC c. 1826-31; Elizabeth/Newark, NJ, c. 1831- 50;
Philadelphia, c. 1850-68.
Engraved plates for blue lodge and Royal Arch aprons which were
"published" by Lewis Roberson (b. 1793) at Wethersfield and
Reading, VT, prior to 1824.

*Edwin, David (1776-1841) - engraver, Philadephia, PA (a.w.1797-
1817).
R: 3/1/1806 in Columbia Lodge No. 91, Philadelphia
1804 cert. for Columbia Lodge No. 91 (state II: pub by Wm. H.
Abbott).
cert. for Lodge No. 19 [MSS 1809] drawn by Barralet

*Fairman, Gideon (1774-1827) - engraver, Albany, NY c. 1790-1810.
Philadelphia 1810-1827. Apprenticed to Isaac Hutton and served
with him in the militia. 1796 commenced the engraving business in
Albany.
Raised: 12/1/1795 in Union Lodge No. 1, Albany.
1/11/1797 admitted to Temple Lodge, Albany (Mark Lodge).
1798 a Companion of the Royal Arch in Grand Chapter of NY. Served
with Ezra Ames.
1796 engraved a Mark medal for Oliver Riggles of Hiram Lodge No. 1,
Newtown, CT (Fairman born in Newtown), using imprint "Bror.
Fairman Sculpt." Probably also engraved Mark medal for Nathaniel
Butler of Temple Mark Lodge, dated 1796, and others in the Al-
bany/Schenectady area.

*Gimber, Stephen H. (c. 1810-1862) - engraver, NYC & Philadelphia
(a.w. 1842-1862).
Admitted to membership: 12/5/1856 in Lodge No. 9, Philadelphia.
open cert. F.& A.M. [MSS 1859]

Gridley, Enoch G. - engraver, NYC (a.w. 1803-1818).
cert. for G. Chapter of NY
open cert. for US of A

*Hamlin, William (1772-1869) - engraver, Providence, RI
R: 3/26/1804 in Mount Vernon Lodge No. 4, Providence
open cert. prior to 1849
open cert. with G.L. affidavit

Hawksworth, John - engraver, London, Eng. (a.w. 1819-1848).
open Past Master's cert. for G.L. of MA

*Hazen, Morse (d. 1840) - engraver, Boston, MA.
R: 12/26/1817 in Massachusetts Lodge, Boston
employed by Annin & Smith

*Higgins, M.B. - engraver, NYC c. 1800.
open cert. endorsed by G.L. of NY 9/1/1802

Hill, Samuel (d. c. 1803) - engraver, Boston, MA (a.w. 1789-1803).
cert. for Essex Lodge, Salem, drawn by J. Hiller, Jr. [MSS 1796]
open cert. drawn by D. Reynard [MSS 1812]
trade card for Bro. Robert Brookhouse of Salem

*Horsman, Edward (1775-1819) - engraver, Boston, MA (a.w. 1805-
1815).
Raised: 1802 in Mount Lebanon Lodge, Boston
plate for Mark Master cards, Grand R.A. Chapter of MA
cert. for Grand R.A. Chapter of MA, first design c. 1806

*Hurd, Nathaniel (1730-1777) - engraver, Boston, MA
Raised: 5/19/1762 in Second Lodge, Boston
open summons for MA lodges [MSS 1764]

*Hurd, Benjamin, Jr. (1750-1821) - engraver, Boston, MA
Raised: 12/12/1777 in St. Andrews Lodge, Boston
1794 Master of St. Andrew's Lodge, Boston
Exalted: 3/20/1789 St. Andrew's R.A. Chapter, Boston
High Priest 1791/92, 1794-98
summons for St. Andrew's R.A. Chapter [MSS 1790]
cert. for St. Andrew's R.A. Chapter [MSS 1796]

Hutchinson, Ebenezer - engraver/publisher, Hartford, VT. c.1820.
Copyrighted "Freemasons Heart supported by Justice and Liberty."
employed engraver Moody M. Peabody.

Hutton, Isaac (1767-1855) engraver, Albany, NY
open cert. "twin pillars" type [MSS 1796]

Jocelyn, Nathaniel - engraver, New Haven, CT (a.w. 1818-1843).
in partnership with brother, Simeon Smith Jocelyn.
cert. for R.A. Council (designed by Jeremy Cross).

Kearney, Francis (1785-1837) - engraver, NYC (a.w. 1798-1801) and
Philadelphia (a.w. 1810-1833).
apprenticed to Peter R. Maverick

Kendrick, D.T. - engraver, Boston, MA c. 1880.
cert. for Grand R.A. Chapter of MA [MSS 1886]
cert. for Grand Council Royal & Select Masters of MA [1900]

*Kensett, Thomas (1786-1829) - engraver, Cheshire, CT, (a.w. 1811-
1825).
Admitted: 1812 in Temple Lodge No. 16, Cheshire
Engraved plate for "four-decker" apron and cert. "T. Kensett Cheshire
Connect Sculpsit et edidit MCCCXII Copyright secured" design
(copied by Samuel D. Bettle of Wilkes-Barre, PA in 1823).

*Kettinger, (n.n.) - engraver, NYC, c. 1815.
in partnership with "Bro. Clapham"
cert. for Adelphi Lodge, New York [MSS 1815]

Kilburn, Samuel S. (n.d.-1903) - engraver, Boston c. 1830-1865.
R: 1864 in The Massachusetts Lodge, Boston.
In partnership with John S. Mallory as wood engravers.
Engraved plate for Craft apron c. 1865.

Kneass, William (1781-1840) - engraver, Philadelphia, PA
cert. for Hiram Lodge No. 81, Germantown, PA, drawn by Wm.
Strickland.
cert. for Grand R.A. Chapter of PA, in partnership with James H. Young
[MSS 1829]

*Lansing, Garret - wood engraver, Albany, Boston, NYC (a.w. 1808-
1819 & 1830s).
Son of Albany silversmith Jacob Geresitse Lansing.
1808 cert. for Jerusalem R.A. Chapter No. 8, NYC
summons for Jerusalem R.A. Chapter No. 8 (paid in 1819)

*Leney. William Satchwell (1769-1831) - engraver, NYC, emigrated to
NYC in 1805, retired to Montreal in 1820.
associated with Wm. Rollinson, but not a partner.

Longacre, James Barton (1794-1869) - engraver, Philadelphia.
cert. for G.L. of VA

*Lovett, Robert (1795-1875) - engraver, NYC.
Admitted: St. Andrew's Lodge No. 7 (old No. 169), NYC, Master in 1830.
1853 affiliated with St. John's Lodge No. 1

*Maverick, Peter Rushton (1755-1811) - engraver, NYC.
R: 1789 in Holland Lodge No. 8, NYC
cert. for Alexandria Lodge No. 22, Alexandria VA (drawn by A. Chevalier).
cert. for St. Simon & St. Jude's Lodge No. 12, Fishkill, NY
cert. for Lodge No. 1, Norfolk, VA [MSS 1802]
cert. for Harmony Lodge No. 31, Catskill, NY [MSS 1795]

*Maverick, Samuel (1789-1845) - engraver, NYC.
Admitted: St. John's Lodge No. 1
Companion K.T.
cert. for Phoenix R.A. Chapter No. 2, 7th Degree RAC [MSS 1810]
cert. for R.A.C.
open lodge cert. (Spanish imprint).

*Newcomb, Danforth (1799-1821) - engraver, Portland, ME (1820-21).
 R: 7/11/1821 in Portland Lodge No. 1
given Masonic funeral 10/5/1821
cert. for G.L. of ME [MSS 1822] (drawn by J.R. Penniman)

*Nutman, John C. - engraver, Cincinnati, OH
cert. for G.L. of OH, design adopted 12/14/1820.

*Pardee, Benjamin D. - engraver/artist, Ithaca, NY
A leather Craft apron c. 1814, "Drawn and Engraved by Brother Benjamin D. Pardee For Brother Moody Peabody Ithaca, N.Y."

*Peabody, Moody M. - engraver/artist, Ithaca, NY c. 1814; Hartford, VT c. 1820; Reading, VT c. 1823; Utica, NY c. 1830-35.
R: 6/1814 in Eagle Lodge No. 169, Ithaca, NY
Designed and engraved Masonic aprons and diplomas sold by Ebenezer Hutchinson of Quechee Village, Hartford, VT (*Vermont Republican*, Oct. 30, 1820)

*Pelham, Peter (c.1697-1751) - engraver, Boston, MA (a.w. 1727-51)
R: 11/8/1738 in First Lodge, Boston, MA
1743-44 Sec. of Lodge
June 28, 1741 - "directed to have a copper plate engraved for blank summonses."

Pollock, Thomas - engraver, Providence, RI (a.w. 1839-1849).
1849 cert. for G.L. of RI, paid $75 for work

*Porter, James T. - engraver, Middletown, CT, (a.w. 1810-1830).
Apron imprint "designed and engraved by a brother, Midd. Conn."

*Pursell, Henry D. - engraver, Philadelphia (a.w. 1774-1784).
cert. for Lodge No. 25, Bristol, PA [MSS 1791]

*Rawdon, Ralph (d. 1877) - engraver, Cheshire, CT 1813; Albany, NY c. 1815-1834; NYC 1835-1877.
Admitted on 10/5/1815 to Temple Lodge, Albany
open lodge cert. [MSS 1813]
open cert. for R. A. Chapter [MSS 1818]

Reed, Abner (1771-1866) - engraver, East Windsor, CT and Hartford, CT (c. 1803-11).
1798 printed "46 F.M. certs. for S. [Solomon ?] Lodge"
Engraved plates for blue lodge, Mark, and Royal Arch Chapter aprons. "for Bro. S. Dewey" of Willimantic, CT, and dated 1800.

*Revere, Paul II (1735-1818) - engraver, Boston
R: 1760 in Lodge of St. Andrew, Boston
Wor. M. in 1770/71, Grand Master 1795-97
1760s summons for Lodge No. 169, Boston [MSS 1775]
1760s summons for the Marblehead Lodge [MSS 1765]
1762 summons for St. Andrews Lodge, Boston [MSS 1767]
1762 summons for Philanthropic Lodge, Marblehead
1766 summons for lodge at Surinam (South America)
1772 summons for St. Peter's Lodge, Newburyport
1773 summons for Tyrian Lodge, Gloucester
(plate redated A.L. 58__)
open cert. (three Virtues type) [MSS 1790]
open cert. "Opposite Liberty Stump" imprint [MSS 1795]
open cert. (three Virtues type reversed, MB coffin)
1784/86 cert. for Rising States Lodge

Robinson, William - engraver, Philadelphia (c. 1815-1818). open
 A.Y.M. (Ancient York Mason) lodge cert.
State I: pub. by Bro. John B. Reynolds [MSS 1814]
State II: pub. by Bro. R. Desilver [MSS 1819]

*Rollinson, William (1762-1842) - engraver, NYC.
Master of Jerusalem Lodge No. 4 in 1794
Master of Phoenix Lodge No. 11 in 1795-97 and 1800
1796 open cert. for G.L. of NY (Eng. text)
1819 re-engraved open cert. for G.L. of NY (bilingual)
engraved private certificates for the following:
St. Andrews Lodge No. 3, NYC [MSS 1803]
Louisiana Lodge No. 1, New Orleans (chartered by G.L. of NY in 1807)
St. John's Lodge No. 1, Wilmington, NC [MSS 1815]
Phoenix Lodge No. 11, NYC [MSS 1803]
Independent R.A. Lodge No. 2, NYC [MSS 1795]
Washington R.A.C.
Hiram Lodge No. 7, NYC
West Chester Lodge No. 46
Suffolk Lodge No. 60, Smith Town, L.I.,NY
Morton Lodge No. 63, Hempsted, NY [MSS 1802]
Hampton Lodge No. 111, Sag Harbor, L.I. [MSS 1815]
lettter of credence A.A.S.R.
open cert. for New York A.Y.M. lodges [MSS 1793]
cert. for Lodge L'Amenite No. 73, Philadelphia [MSS 1811]

Sanford, Isaac (d. c.1842) - engraver, Hartford, CT 1785 and 1819- 21.
trade card printed in Hartford 3/8/1820: "Miniature Painter & Engraver - ... seals, medals, Masonic jewels & carpets."

Sartain, John (1808-1897) - engraver, Philadelphia
cert. for G.L. of PA (5 views of G.L. Temples each dated 1807, 1809, 1873, 1855, and 1835) [MSS 1910]

Savory, Thomas C. - engraver, Pitt Township, PA (c. 1824-40).
cert. for Hamilton Lodge No. 173, Lawrenceville, PA
(constituted 2/211/1820) [MSS 1828]
open cert. for PA A.Y.M. lodges [MSS 1841]

Scot, Robert - engraver, Philadelphia (c. 1781-1820).
teacher of Francis Shallus, engraved frontispiece for Masonic sermon by Wm. Smith (1783) and *Ahman Rezon* (Philadelphia, 1784). Appointed engraver to the U.S. Mint in 1793.
1780s cert.

Seymour, Joseph H. - engraver, Worcester, MA (c. 1791-1793). Philadelphia (c. 1793-1822), Utica, NY (c. 1835)
frontispiece for *Constitutions* (Worcester, 1792), printed by Bro. Isaiah Thomas.
summons for Rising States Lodge, Worcester

*Shallus, Francis (1773-1821) - engraver, Philadelphia (c. 1797).
Admitted: 8/13/1803 in Philadelphia Lodge No. 72,
served as Sr. Warden.
cert. for Washington Lodge No. 59 [MSS 1801]
cert. for R.A.C. No. 52, Philadelphia [MSS 1815]
cert. for Concordia Lodge No. 67 [MSS 1818]

Shipley, Henry H. (b. c. 1830) - engraver, Cincinnati, OH.
worked with brother William Shipley (1853-60)
cert. for G.L. of PA [MSS 1849]

Smith, Daniel W. - engraver, Charleston, SC (c. 1816-1818).
partnership with C.C. Wright in SC (c. 1820-23)

*Smith, George G. (1795-1878) - engraver, Boston, MA.
R: 11/13/1819 in Columbian Lodge, Boston
Wor.M. Columbian 1826/7, 1829, 1842-49
Deputy Grand Master 1838
Wor. M. Massachusetts Lodge 1842-45

*Smith, John Reubens (1775-1849) - engraver, Boston (c. 1811-1815)
NYC (c. 1816-26), Philadelphia (c. 1835-37), NYC (c. 1845).
R: 9/4/1810 in Mt. Lebanon Lodge, Boston
cert. for G.L. of MA, "A.L. 5812" [MSS 1812]

Smith, Knight & Tappan - engravers, Boston, MA.
cert. for Consistory c. 1860

*Sterry, Consider (1761-1817) - engraver, Norwich, CT
Admitted: 6/15/1796 in Somerset Lodge, Norwich
Master 1807, 1809, 1815/16.
1796 charter mbr. Franklin R.A.C. No. 4, Norwich
cert. for Mark Master [MSS 1801]

*Strickland, William (1787-1854) - artist/engraver, Philadelphia
R: 11/27/1809 in Columbia Lodge No. 91, Philadelphia
cert. for G.L. of PA
cert. "drawn & aquatinted" for Hiram Lodge No. 81

Stuart, F.T. - engraver, Boston, MA.
cert. for G.C. KT of MA & RI.

Thackara, James (1767-1848) - engraver, Philadelphia
partnership with John Vallance (c. 1791-97)
cert. for G.L. of MD
"the brethren of the Ineffable, as also of Ancient York Masons may be
supplied with aprons according to their different degrees, having
some excellent skins for that purpose." (*Charleston City Gazette*, Nov.
28, 1794)

*Thackara, William (1791-1839) - engraver, Philadelphia (c. 1818-
1824).
R: 1/3/1820 in Industry Lodge No. 131, Philadelphia

Thompson, William M. - engraver, NYC (c. 1833-1860).
cert. for K.T. designed by Jeremy Cross

Throop, Orramel Hinckley (b. 1798) - engraver, Portland, ME 1824,
NYC (c. 1825), New Orleans (c. 1831/32).
1824 cert. for Past Masters, G.L. of ME

Tisdale, Elkanah (1768-1835) - New York City, 1794-98; Albany 1798;
Hartford, 1798, Norwich, 1805, NYC 1809-10.
Engraved plate for Royal Arch apron, drawn by Consider Sterry (origi-
nal design drawn in 1790 by Benjamin Hurd, Jr. as a summons for
St. Andrews R.A.C., Boston).

Valdenuit, Thomas Bluget de (1763-1846) - artist/engraver, NYC 1795-
1797.
1797 open cert. with imprint "V ***N. York 1797".
Engraved plate for Craft apron with imprint "Valdenuit.. N. York 97."

Warr, John, Sr. - engraver, Philadelphia (c. 1821-1828).
1819 cert. for R.A.C. of PA, pub. by Comp. Robert Desilver (Desilver
& Muir)

Warr, John, Jr. - engraver, Philadelphia (c. 1825-1845)

*Wright, Charles Cushing (1796-1854) - engraver, Utica & Homer, NY;
SC (c. 1820-1823) in partnership with Daniel W. Smith.
Admitted: Homer Lodge No. 137
open lodge cert. pub. by William B. Whitney [MSS 1832]
open R.A.C. cert. [MSS 1818]
cert. for Grand R.A.C. of SC [MSS 1823]

Young, James H. - engraver, Philadelphia (c. 1817-1866).
cert. for Grand R.A.C. of PA [MSS 1820] in partnership with William
Kneass.

Appendix III
Artists of Masonic Aprons, Certificates, and Ornamental Paintings

(*Denotes a Freemason)

*Ames, Ezra (1768-1836) - Worcester, MA 1790-93; Albany, NY 1793-1836. Int: 12/30/1794 in Union Lodge No.1, Albany; 1795 charter member Temple Lodge No. 53. "Painting & Engraving - ...also Freemason's aprons, sashes, and ornamental paintings in general - Seals, Mk. Mr. Mason's Medals, &c. engraved neatly and elegantly." (*Albany Register*, Nov. 25, 1799).

> 1794 painted first apron.
> 1/1/1795 painted a carpet for Pittstown Lodge.
> 1796/97 painted five aprons.
> 5/20/1798 painted a "Sattan apron RA" for John Eames of Whitestown.
> 6/17/1800 painted an apron for Dr. Jonothan Eights.
> 1804 painted a Masonic apron.
> 1805 painted a Masonic "Piece" (Carpet ?).
> 1811 painted a Masonic carpet for Temple Lodge & Chapter for $70.00
> 1819 painted an "alegorical Painting" for Temple Lodge.

Ames, Julius Rubens (1801-1850) Albany, NY, son of Ezra Ames. apron painted for Jeremy L. Cross,(cotton with silk ribbon trim, metalic discs) Acc# 352-2 Gift of O.W. Niles, 1936

Barbier, Stephen B. - Philadelphia, PA c. 1818. At a meeting of the American Union Lodge No. 1, on 9/8/1818, it was reported that Mr. Stephen B. Barbier of Philadelphia would furnish a (Master's) carpet "3 feet 9 inches wide and 4 feet 6 inches in length, forming an oblong square, trimmed with gold leaf, for $28.00." The purchase was approved.

Barralet, John J. - Philadelphia (a.w. 1747-1815)
> drew cert. for Lodge No. 19 [MSS 1809]

Billings, Hammatt (1818-1874) - Boston, MA (a.w. 1840-1870)
> 1841 cert. for Grand Commandery K.T. of MA & RI, copyright renewed 1874.
> 1842 cert. for G.L. of MA
> cert. for AASR, No. Jurisdiction

Blunt, John Samuel - Portsmouth, NH c. 1825/26. Painted aprons for Samuel Neal, Nathaniel Dennet, Jr., and Sylvester Melcher.

Brown, Mandivilette Elihu Dearing (1810-1896) Portsmouth, NH until 1831; Philadelphia, PA 1831-34; Utica, NY 1849-96. Signed apron purchased by Samuel K. Hutchinson of Lowell, MA. in 1826.

Bush, (n.n.) Middletown, CT, c. 1824. Chaise and carriage painter, in partnership with Jones. Painted a Masonic carpet that was framed in 1824 by cabinetmaker Elizur Barnes of Middletown.

Chevalier, Alexander - NYC (a.w. 1793)
> cert. for Alexandria-Washington Lodge No. 22, Alexandria, VA, engraved by P.R. Maverick.

*Clapham, (n.n.) - NYC (a.w. 1800-1810) In partnership with "Bro. Kettinger."
> cert. for Hiram Lodge No. 7, NYC, engraved by S. Rollinson.

Codman, Charles (c.1800-1842) - Portland, ME. painted apron in pvt. coll.

Cox, James (1751-1834) - Philadelphia, PA
> cert. for Washington Lodge No. 59, Philadelphia [MSS 1801]

Crafft, R.B. - (fl. 1836-1866) IN, c. 1839.
> Painted a Craft apron for Walter Hamilton Hayes (1826-1894) of Bourbon County, KY.

*Cross, Jeremy L. (1783-1861) - New Haven, CT
> cert. for General Grand Encampment of USA, copyrighted 1848.

Darling, Martha (1806-1883) - Gorham, ME. Painted 2 aprons for Baxter family c. 1820-30, and perhaps others for local Masons.

Eaton, Charles Otis (n.d.-1903) - Boston c. 1854. Raised in Mt. Lebanon Lodge 5/10/1850. Advertised in the *Freemason's Monthly Magazine* (Feb. 1854): "(successor to T.C. Savory), Military Standard and Banner Painter, Banners, Aprons, Floorings, and every variety of Painting for Lodges, Chapters, Encampments, &c., executed to order with neatness and despatch [sic]."

Emmett, William Y. (1799-c.1860) Chillicothe, OH 1824-1838; Circleville, OH 1839-1840; Cincinnati, OH 1850-1853. Coach, house, sign and ornamental painter, and gilder in partnership with Joseph T. Moore; partnership dissolved in 1827. Advertised in the *Scioto Supporter and Scioto Gazette* (Dec. 7, 1826), "Fancy Sign & Ornamental Painter - prepared to execute in the neatest manner signs of every description, military standards and plates, Masonic carpets and aprons."

*Henry, Benjamin West - Lancaster, PA c. 1798. A symbolic floor cloth for Lodge No. 43, was "painted by the artist, Bro. Benj. West Henry, at an expense of L 11.5.0." Henry was Junior Warden of the lodge at that time.

Hiller, Joseph, Jr. (1777-1795) - Salem, MA. Drowned at sea in 1795, father was Master of Essex Lodge, Salem.
> cert. for Essex Lodge, [MSS 1796] engraved by S. Hill.

Hoppin, Davis Ward (1771-1822) - Providence, RI 1793-1822. Advertisement in the *Providence Gazette and Country Journal*, Nov. 30, 1793. In 1793 painted an apron for Daniel Stillwell (member of St. John's Lodge No. 2, and Royal Arch Chapter No. 2, Providence).

*Jackson, Luther - NYC (c. 1820s).
> Companion K.T.

Jones, (n.n.) - Middletown, CT. c. 1824. In partnership with Bush, as chaise and carriage painters. Painted a Masonic carpet in 1824.

Kemmelmeyer, Frederick - active from late 1780s to 1815, working in Baltimore, Alexandria, Georgetown, Frederick, Hagerstown, and possibly northern VA "in the art of Painting, Drawing Portraits in Oil and Crayons, Sign and Ornamental Painting, Free Masons Aprons...Also Stands of Colors for Regiments and Companies."

Lakeman, Nathaniel (b. 1756) - Salem, MA, c. 1820-1830.
> Portrait painter; a Craft apron with printed label painted for Charles Peabody, Middletown, MA, c. 1825.

Lawson, Charles - Medford, MA c. 1900. Painted a "mort" board (third degree) for a lodge in Medford, dated 1905.

Low & Damon - Concord, NH c. 1806-1816. Ornamental furniture, sign and house painters, advertised in the *New Hampshire Patriot*, February 6, 1816: " A few Masonic Aprons elegantly executed on white satin."

Martin, J. - MA or CT, c. 1792-1799. Painted leather aprons with Past Master's jewel and rainbow motif.

*Meer, John Sr. - Philadelphia, PA 1795-1830. Raised in Montogomery Lodge No. 19, Philadelphia, 4/18/1807. painted an apron for Lodge No. 19, Philadelphia; also Craft aprons, and Royal Arch aprons dated 1820. The flap on a Meer apron is invariably rectangular in shape.

Mills, (n.n.) - Boston, MA. In partnership with J.R. Penniman c. 1820.

Moore, Joseph Thoits (1796-1854) - Philadelphia, PA, c. 1825; Chillicothe, OH, 1816-1825; Philadelphia, PA c. 1825; ME (Freeport, Hollowell, Farmington, Chesterville) c. 1825-1826; Chillicothe, OH 1826-1830; Montgomery, AL 1830-1854. A Quaker, in partnership with William Y. Emmitt as house, sign & ornamental painters. Also painted many portraits in OH and ME. Partnership with Emmitt dissolved in 1827.

*Negus, Nathan (1801-1825) - Boston 1815-1825. Apprenticed to Penniman from 1815 to 1820. Made a Mark Master, Past Master and Most Excellent Master and Royal Arch Mason in Franklin Chapter No. 5, at Eatonton, GA, in April 1821.

*Peabody, Moody M. - Utica, NY; New York City; Hartford, VT.
> Raised: 6/1814 in Eagle Lodge No. 169, Utica, NY. "designed and engraved Masonic Aprons and diplomas sold by Ebenezer Hutchinson of Quechee Village, Hartford, VT." (*Vermont Republican*, Oct. 30, 1820)

*Penniman, John Ritto (1783-1841) - Boston, MA 1805-1837; Baltimore, MD 1837-1841.
> R: 1810 in St. John's Lodge, Boston (demitted 1822). In partnership with Mills c. 1820.
> cert. for G.L. of MA (Penniman & Mills)
> cert. for G.R.A.C. of ME (engraved by Annin & Smith)
> cert. for G.R.A.C. of MA, second "new design" of 1821, also engraved by Annin & Smith). In March 1816, Penniman completed a monumental emblematic painting for Columbian Lodge entitled "The Flooring," for which he was paid $330.00. In 1821 he decorated the interior of the new Masonic Hall in the Old State House. His Masonic trade card announced "Fancy Painting, Sign Painting, Transparencies, Designs for Diplomas, &C."

*Prentiss, Jonas (1777-1832) - West Cambridge, MA c. 1800-1832. Raised in 1809, member of Hiram Lodge, Menotomy (Arlington) in 1817.
> painted tracing boards for Hiram Lodge and Amicable Lodge, Cambridge.

Reynard, D. - MA c. 1803.
> cert. for G.L. of MA (engraved by Samuel Hill).

Robertson, Alexander (1772-1841) - NYC (w. 1815-1818).

*Savory, Thomas Collins (n.d.-1896) - Pittsburgh, PA c. 1824; Boston, MA c. 1841-1867. Initiated in St. John's Lodge, Boston 2/6/1843; Exhalted in St. Andrews Royal Arch Chapter 9/3/1845. Advertised in *Freemason's Monthly Magazine*, May, 1848: "Ornamental & Decorative Painter, Banner, Aprons, and every variety of painting for Lodges, Chapters, etc.executed to order, with neatness and despatch. A set of paintings in frames for Blue Degrees, including a Master's Carpet, on hand, and for sale."
Succeeded by Charles O. Eaton in 1854.

*Shaw, Asa L. - Buffalo, NY c. 1830
> probably Asa L. Shaw, a member of Union Lodge 261, Livingston, County. Painted a number of Mark Master aprons.

Soule, M.L.B. - painted an apron for W.R. Craigg of Abingdon, VA (coll. Rocky Mount Hist. Assoc., TN)

*Sterry, Consider - Norwich, CT. c. 1805
> member of Somerset Lodge, Norwich, CT, serving as Master 1807, 1809 and 1815-16.
> Designed and drew Royal Arch apron engraved by Elkanah Tisdale
> (copied from a summons drawn by Benjamin Hurd, Jr. in 1790 for St. Andrews R.A.C., Boston).

*Strickland, William (1787-1854) - Philadelphia, PA.
> R: 11/27/1809 in Columbia Lodge No. 91, Philadelphia.
> cert. for G.L. of PA
> cert. "drawn & aquatinted" for Hiram Lodge No. 81, Germantown, PA.

*Yates, Giles Fonda (1798-1859) - Schenectady, NY.
> Initiated: 1817, St. George's Lodge No. 6, Schenectady; 1821, Morton Lodge No. 87; York Rite; 1851, Sov. G.Com., AASR, No. Jur.
> Designed blue/Royal Arch apron based on lower two decks of Kensett's design with addition of the interlaced triangles.

Appendix IV
Masonic Eras & Dating, Definition and Conversion (Anno Domini) Dates

A.L. Anno Lucis (Year of Light)
Date used in the symbolic degrees, computed from supposed date of creation of the world in 4,000 B.C.

(to find common date subtract 4,000 from A.L. date, or 4,004 if computing by Bishop Usher's rule)

A. Dep. Anno Depositionis (Year of Deposit)
Era adopted by Royal Arch and Select Master Degrees, computed from legendary date when secrets were deposited in the First Temple of Solomon in 1,000 B.C.

(to find common date subtract 1,000 from A. Dep. date)

A. Inv. Anno Inventionis (Year of Discovery)
Era adopted by Royal Arch Masons, computed from date when secrets were discovered by the Craft at the building of the Second Temple of Zerrubbabel in 530 B.C.

(to find common date subtract 530 from A. Inv. date)

A.O. Anno Ordinis (Year of the Order)
Date used in Masonic Templarism, computed from establishment of the Order of Knights Templar in the year 1118 A.D.

(to find common date add 1118 to A.O. date)

A.M. Anno Mundi (Year of the World)
Date adopted by the Scottish Rite, computed from the Jewish date assigned to the creation, September, 3760 B.C.

(to find common date subtract 3,760 from A.M. date)

Appendix V
Sword Nomenclature

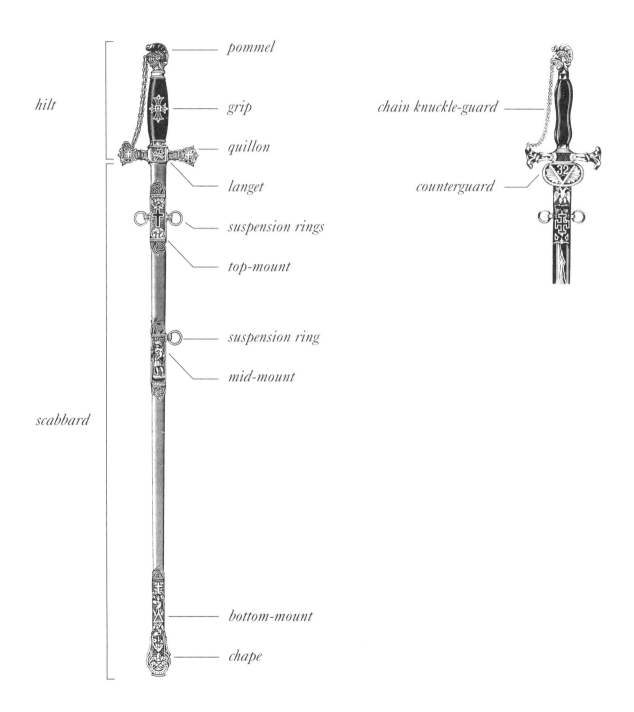

hilt

pommel

grip

quillon

langet

suspension rings

top-mount

suspension ring

mid-mount

scabbard

bottom-mount

chape

chain knuckle-guard

counterguard

Appendix VI
Crosses in Masonry

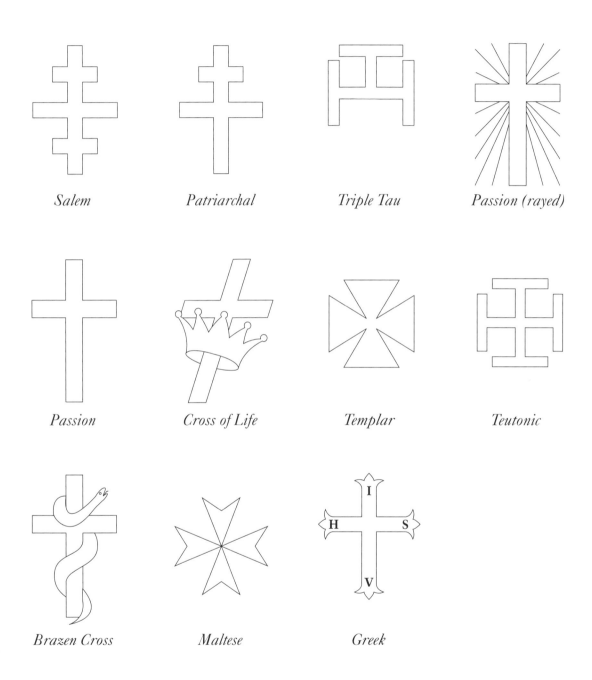

Salem

Patriarchal

Triple Tau

Passion (rayed)

Passion

Cross of Life

Templar

Teutonic

Brazen Cross

Maltese

Greek

References

PROCEEDINGS

Grand Lodge of New Hampshire. Concord, vol. 1 (1789-1841).

Grand Lodge of Maine. Portland, 1872. vol. 1 (1820-1847).

National Masonic Convention: Held at Baltimore, Md. May AL 5843 - AD 1843. Baltimore, 1843.

Sovereign Grand Council of the United States of America of Knights of the Red Cross of Constantine, Holy Sepulchre and St. John, 1876-1879. Philadelphia, 1879.

SERIES

Ars Quatuor Coronatorum, *Transactions of Quatuor Coronati Lodge No. 2076, London*. Margate, England, 102 vols. 1886-1989.

Nocalore. North Carolina Lodge of Research No. 666, A.F.& A.M., Monroe, North Carolina. Oxford, NC, 19 vols. 1931-1949.

Proceedings of the Chapter of Research, Grand Chapter of Royal Arch Masons of Ohio (O.C.R.). Columbus, 15 vols. 1949-1980.

Transactions of the American Lodge of Reserch, F.& A.M., New York. New York, 20 vols, 1930-1991.

Lodge of Research No. 2429, Leicester. Leicester, England, 67 vols. 1892-1978.

Digests of the Masonic Service Association, Washington, DC.

MASONIC BOOKS

Allyn, Avery. 1831. *A Ritual of Freemasonry, Illustrated by Numerous Engravings: With Notes and Remarks*. Boston.

Anderson, James, comp. 1723. *The Constitutions of the Free Masons*. London.

Barratt, Norris S. and Sachse, Julius F. *1909. Freemasonry in Pennsylvania 1727-1907*. 3 vols. Philadelphia.

Baynard, Samuel Harrison, Jr. 1938. *History of the Supreme Council, 33rd Degree Ancient Accepted Scottish Rite of Freemasonry Northern Masonic Jurisdiction of the United States of America and its Antecedents*. 2 vols. Boston.

Case, James Royal. 1972. *History of Royal Arch Masonry in Connecticut 1783-1972*. Grand Chapter of Connecticut.

Coil, Henry Wilson, et al. 1961. *Coil's Masonic Encyclopedia*. New York.

Dassigny, Fifield. 1744. *A Serious and Impartial Inquiry Into the Cause of the Present Decay of Freemasonry in Ireland*. Dublin.

Denslow, William R. 1959. *10,000 Famous Freemasons*. 4 vols. Trenton, Missouri.

Dermott, Lawrence, ed. 1756. *Ahiman Rezon or, A help to all that are or would be Free and Accepted Masons*. London.

Duncan, William J., comp. 1904. *History of Independent Royal Arch Lodge No. 2, F.& A.M. of the State of New York*. New York.

Egle, William H. and Lamberton, James M. 1901. *History of Perseverance Lodge No. 21, F.& A.M., Harrisburg*. Harrisburg.

Entick, John, comp. 1756. *The Constitutions of the Antient and Honourable Fraternity of Free and Accepted Masons*. London.

Franco, Barbara. 1976. *Masonic Symbols in American Decorative Arts*. Lexington: Museum of Our National Heritage.

— 1980. *Bespangled Painted & Embroidered: Decorated Masonic Aprons in America 1790-1850*. Lexington: Museum of Our National Heritage.

— 1986. *Fraternally Yours: A Decade of Collecting*. Lexington: Museum of Our National Heritage.

Hadley, Harold Pierce. 1979. *200 Years of Masonry in Essex Lodge 1779-1979*. Salem.

Hammond, William. 1917. *Masonic Emblems and Jewels: Treasures at Freemason's Hall, London*. London.

Harris, Ray Baker. 1955. *A Selection of the Rare Books of Freemasonry*. Washington, DC: Masonic Service Association.

Haunch, Terence O. 1982. *Freemasonry in England, The World's First Grand Lodge*. London: Exhibition catalog, Grand Lodge of England.

Heard, John T. 1856. *A Historic Account of Columbian Lodge*. Boston.

Hutchens, Rex R. 1988. *A Bridge To Light*. Washington, DC: The Supreme Council, 33rd Degree, Ancient and Accepted Scottish Rite of Freemasonry, Southern Jurisdiction of the United States of America.

Hutchinson, William. 1775. *The Spirit of Masonry, in Moral and Elucidatory Lectures*. London.

Jachin and Boaz, or an authentic key to the Door of Freemasonry.... London, 1762.

Jack, Harold W. 1976. *Mark Lodges of New England*. Massachusetts Chapter of Research. Boston.

Johnson, Melvin M. 1924. *The Beginnings of Freemasonry in America*. Kingsport, Tennessee.

Johnson, G.Y. and Bramwell, F.H. 1951. *A Catalog of Masonic Pottery, The Freemason's Hall, Duncombe Place, York*. York, England.

Jones, Bernard E. 1957. *Freemasons' Book of the Royal Arch*. London. Reprint with corr., 1969.

King, E.A. 1926. *Masonic Chapter Pennies: The Albert M. Hanauer Collection*. Pittsburg.

Lane, John. 1891. *Centenary Warrants and Jewels: Comprising an Account of all the Lodges under the Grand Lodge of England to which Centenary Warrants have been granted, together with Illustrations of all the Special Jewels*. London.

Les Costumes des Francs-Maçons dans leurs assembles, principalement pour la Reception des Apprentiss et des Maitres, tout nouvellement et sincerement decouvertes. 1744/1745. Paris.

Lyte, Joshua L., comp. 1895-1905. *Reprint of the Minutes of the Grand Lodge of Free and Accepted Masons of Pennsylvania 1779- 1858.* 9 vols. Philadelphia.

Mackey, Albert G. 1873. *Encyclopaedia of Freemasonry.* New York. Revised, 2 vols., New York, 1920.

Marvin, William T.R. 1880. *The Medals of the Masonic Fraternity.* Boston.

Massey, D.A. 1896. *History of Freemasonry in Danvers, Massachusetts from 1778 to 1896.* Peabody.

McFadden, James, ed. 1764. *The Pocket Companion And History of Free-Masons.* London (3rd ed.).

Neaulme, Jean. 1745. *L'Ordre Des Francs-Macons Trahi, Et Le Secret Des Mopes Revele.* Amsterdam.

Noorthouck, John, comp. 1784. *Constitutions of the Antient Fraternity of Free and Accepted Masons.* London (5th ed.).

Oliver, George. 1846. *The Historic Landmarks And Other Evidences of Free Masonry.* 2 vols. London.

Parramore, Thomas C. 1975. *Launching the Craft: The First Half- Century of Freemasonry in North Carolina.* Raleigh.

Perse, W.A.A. 1966. *History of Independent Royal Arch Lodge No. 2, F.& A.M.,* 2 vols. New York.

Poole, H. 1939. *A Catalogue of Masonic Medals in the Museum of the Provincial Grand Lodge of Worcester.* Worcester, England.

Preston, William. 1772. *Illustrations of Masonry.* London.

Reeves, John G. 1914. *History of Freemasonry in Ohio From 1791.* 2 vols. Cincinnati.

Reilly, Thomas E. 1901. *Centenary of Columbia Lodge No. 91, A.Y.M., 1801-1901.* Philadelphia.

Riley, J. Ramsden. 1890. *Masonic Certificates; Being Notes and Illustrations Descriptive of Those Engraved Documents of the Grand Lodge and Grand Chapter of England....*" Quatuor Coronatorum Antigrapha-Masonic Reprints of the Lodge Quatuor Coronatorum, No. 2076, London. Margate, England.

Sachse, Julius F. 1919. *The History of Masonic Knights Templar in Pennsylvania 1797-1919.* Philadelphia.

Schultz, Edward T. 1884. *History of Freemasonry in Maryland, Of All Rites Introduced Into Maryland, From the Earliest Time to the Present.* 4 vols. Baltimore.

Scully, Francis J. 1952. *History of the Grand Encampment of Knights Templar of the United States of America.* Greenfield, Indiana.

Shackles, George L. 1901. *The Medals (Commemorative or Historical) of British Freemasonry.* Hamburg, Germany.

The Complete Free Mason, or Multa Paucis for Lovers of Secrets. 1764. London.

Travenol, Louis G. [Leonard Gabanon]. 1744. *Nouveau Catechisme des Francs-Masons.* Paris. 3rd ed., Paris, 1749.

Tudor-Craig, Algernon. 1938. *Catalog of the Contents of the Museum at Freemason's Hall, in the Possession of the United Grand Lodge of England.* 3 vols. London.

Turnbull, Everett R., and Denslow, Ray V. 1956. *A History of Royal Arch Masonry.* 3 vols. Trenton, Missouri.

Upham, James H. 1877. *An Historical Sketch of Union Lodge, Dorchester from 1796 to 1876.* Boston.

Vernon, W.O. 1760. *The Three Distinct Knocks, or, the Door of the Most Ancient Free-Masonry, Opening to All Men, Neither Naked Nor Clothed, Bare-Footed Nor Shod.* London.

Vibert, Lionel. 1923. *The Rare Books of Freemasonry.* London.

Walker, Wendell K. 1956. *The Masonic Treasures of New York.* Washington, DC: The Masonic Service Association.

Webb, Thomas Smith. 1797. *The Freemason's Monitor; or Illustrations of Masonry.* Albany.

— 1816. *The Freemason's Monitor; or, Illustrations of Masonry.* Salem.

Wolfsteig, August. 1911. *Bibliographie der Freimaurerischen Literatur.* 4 vols., Burg. Reprint, Hildesheim, 1964.

GENERAL BOOKS

Adams, Elizabeth and Redstone, David. 1981. *Bow Porcelain.* London.

Bingham, Clarence S. 1954. *Paul Revere's Engravings.* Worcester.

Connell, E. Jane. 1984. *Made in Ohio: Furniture 1788-1888.* Columbus: Columbus Museum of Art.

Davis, Derek C. 1972. *English Bottles and Decanters 1650-1900.* New York.

Evans, Dorinda. 1982. *Mather Brown, Early American Artist in England.* Middletown.

Fabian, Monroe H. 1978. *The Pennsylvania-German Decorated Chest.* New York. Universe Books.

Flanigan, J. Michael. 1986. *American Furniture From the Kaufman Collection.* Washington, DC: National Gallery of Art.

Flayderman, F. Norman. 1972. *Scrimshaw and Scrimshanders, Whales and Whalemen.* New Bedford.

Fredrickson, N. Jaye. 1980. *The Covenant Chain: Indian Ceremonial And Trade Silver.* Ottawa.

Frizzell, Martha. 1955. *Second History of Charlestown, New Hampshire.* Charlestown.

Godden, Geoffrey A. 1965. *An Illustrated Encyclopaedia of British Pottery and Porcelain.* New York.

Gottesmann, Rita Susswein. 1954. *The Arts and Crafts in New York, 1777-1799.* New York: New York Historical Society.

Gusler, Wallace B. 1979. *Furniture of Williamsburg and Eastern Virginia 1710-1790.* Richmond: The Virginia Museum.

Hageman, Jane Sikes. 1984. *Ohio Furniture Makers: 1790 to 1845.* 2 vols. Private, vol. 1.

Hamilton, John D. 1983. *The Ames Sword Company 1829-1935.* Providence.

Howard, David S. 1984. *New York and the China Trade.* Frenchtown, New Jersey: Exhibition catalog, New York Historical Society.

Jobe, Brock and Kaye, Myrna. 1984. *New England Furniture-The Colonial Era.* Boston: Society for the Preservation of New England Antiquities.

Ketchum, William C. 1970. *Early Potters and Potteries of New York State.* New York.

Laidacker, Samuel H. 1951. *Part 2, Being a listing and description of other than American views appearing on transfer decorated wares produced by Staffordshire*. Bristol.

— 1954. *Anglo-American China, Part 1, Export China Made for the American Trade*. Bristol.

Lee, Jean Gordon. 1984. *Philadelphians and the China Trade 1784- 1844*. Philadelphia: Exhibition catalog, Philadelphia Museum of Art.

Lehner, Lois. 1988. *Lehner's Encyclopedia of U.S. Marks on Pottery, Porcelain, & Clay*. Paducah.

Little, Nina Fletcher. 1952. *American Decorative Wall Painting 1700-1850*. New York. Revised ed. 1972.

Little, W.L. 1969. *Staffordshire Blue, Underglaze Blue Transfer-printed Earthenware*. New York.

Mercer, Henry. 1961. *The Bible in Iron*. Doylestown: The Bucks County Historical Society.

McClinton, Katharine Morrison. 1968. *Collecting American 19th Century Silver*. New York.

Minor, John A. 1981. *Thomas Minor Descendants 1608-1981*. Trevett, Maine.

Munsel, Joel. 1859. *The Annals of Albany*. Albany. 10 vols.

O'Gorman, James F. 1983. *A Billings Bookshelf: An Annotated Bibliography of Works Illustrated by Hammatt Billings (1818- 1874)*. Wellesley: Wellesley College.

Opitz, Glenn B., ed., 1986. *Mantle Fielding's Dictionary of American Painters, Sculptors, and Engravers*. Poughkeepsie, 2nd new revised edition.

Parsons, Herbert C. 1937. *A Puritan Outpost, A History of the Town and People of Northfield, Massachusetts*. New York.

Picart, Bernard. 1737. *Ceremonies and Religious Customs of the Various Nations of the Known World*. 7 vols. London.

Romer, John L., ed. 1917. *Historical Sketches of the Romer, Van Tassel and Allied Families*. New York.

Ruggles-Brise, Sheelah. 1949. *Sealed Bottles*. New York.

Santore, Charles. 1981. *The Windsor Style in America*. 2 vols. Philadelphia.

Saunderson, Henry H. 1876. *History of Charlestown, New Hampshire, The Old No. 4, Enbracing the Part Borne By Its Inhabitants in the Indian, French and Revolutionary Wars, and the Vermont Controversy....* Claremont.

Schiffer, Herbert, Peter, and Nancy. 1980. *China for America, Export Porcelain of the 18th and 19th Century*. Exton.

Smith, H.P., ed. 1885. *History of Essex County*. Syracuse.

Stephenson, Sue H. 1979. *Rustic Furniture*. New York.

Sullivan, James, et al. comp. 1921-1962. *The Papers of Sir William Johnson*. 13 vols. Albany.

Towner, Donald. 1978. *Creamware*. London.

Watkins, Laura W. 1950. *Early New England Potters and Their Wares*. Boston.

Williams-Wood, Cyril. 1981. *English Transfer-Printed Pottery & Porcelain, A History of Over-Glaze Printing*. London.

Zannieri, Nina, ed. 1987. *Paul Revere - Artisan, Businessman, and Patriot; The Man Behind the Myth*. Boston: The Paul Revere Memorial Association.

ARTICLES

Adams, Cecil. "The Freemasons' Pocket Companions of the 18th Century." *Ars Quatuor Coronatorum (A.Q.C.)*, vol. 45, 1932.

— "Ahiman Rezon, The Book of Constitutions." *A.Q.C.*, vol. 46, 1933.

Andrews, Carol Damon. "John Ritto Penniman (1782-1841) an ingenious New England artist." *The Magazine Antiques*, July 1981.

Carr, Harry, ed. "Early French Exposures 1727-1751." *A.Q.C.*, vol. 84, 1971.

Conder, Edward. "The Hon. Miss St. Leger and Freemasonry." *A.Q.C.* vol. 8, 1895.

Copestake, Charles H. "Notes on Early Mark Jewels and Related Matters." *O.C.R.*, vol. 4, 1951.

Craven, J.B. "The Kirkwall Kilwinning Scroll." *A.Q.C.*, vol. 10, 1897.

Crawley, W. J. Chetwode. "Rabbi Jacob Jehudah Leon." *A.Q.C.*, vol. 12, 1899.

— "Notes on Irish Freemasonry." *A.Q.C.*, vol. 17, 1904.

Dring, E.H. "The Evolution and Development of the Tracing or Lodge Board." *A.Q.C.*, vol. 29, 1916.

Fennimore, Donald L. "Brass Hardware on American Furniture. Part II, Stamped Hardware, 1750-1850." *The Magazine Antiques*. July 1991.

Gould, R.F. "Masonic Celebrities: No.6, The Duke of Wharton, G.M. 1722-23." *A.Q.C.* vol. 8, 1895.

Hackett, F. Earl, comp. "E. Howard, The Man And The Company." *Bulletin of the National Association of Watch and Clock Collectors*. Supplement 1, Winter, 1962.

Hamilton, John D. "Swords of the Masonic Orders." *Man At Arms Magazine*. vol.1, no.3, May/June 1979.

— "Christopher Roby and the Chelmsford Sword." *Man At Arms Magazine*. vol.2, no.1, Jan/Feb 1980.

Harris, Reginald B. "Anderson's "Constitutions"." *The New Age*, 1947.

Haunch, T.O. "Tracing Boards, Their Development and Their Designers." *A.Q.C.*, vol 75, 1962.

— "English Craft Certificates." *A.Q.C.*, vol. 82, 1969.

Hawkins, Edward L. "Two Editions of the Book of Constitutions." *A.Q.C.*, vol. 21, 1908.

Horne, Alex. "King Solomon And His Temple in Masonic And Popular Legend." American Lodge of Research (*A.L.R.*), vol. 7, no. 2, 1958.

Lovegrove, Henry. "Batty Langley on Geometry." *A.Q.C.*, vol. 11, 1898.

Randall, Richard H., Jr. "The Finest American Masonic Senior Warden's Chair." *Connoisseur*. August, 1966.

Rauschenburg, Bradford L. "A Documented Bowl Made for Halifax-Lodge/NC." *Journal of Early Southern Decorative Art*. vol.1, no.1. May, 1975.

— "Two Outstanding Virginia Chairs." *Journal of the Museum of Early Southern Decorative Arts*. Winston Salem, November 1976.

Remennsnyder, John P. "The Potters of Poughkeepsie." *The Magazine Antiques*. July, 1966.

Reid, Robert W. "Some Early Masonic Engravers in America." *A.L.R.* vol. 3, no. 1, 1939.

Shettleworth, Earle, G., Jr.. "Portland, Maine, Engravers of the 1820s." *Old-Time New England.* vol 61, no.3, January-March 1971.

Smith, S.N. "The So-Called 'Exposures' of Freemasonry of the Mid-Eighteenth Century." *A.Q.C.,* vol. 56, 1943

Spencer, N.B. "Exposures And Their Effect on Freemsonry." *A.Q.C.,* vol. 74, 1961.

Stow, Charles M. "Paul Revere, Craftsman." *A.L.R.,* vol. 5, no. 1, 1949.

Thorp, J.T. "Freemasonry Parodied in 1754 by Slade's Freemason Examin'd." *A.Q.C.,* vol. 20, 1907.

Voorhis, Harold, V.B. "The First American Constitution." Masonic Outlook. New York, 1931.

— "The First American Masonic Book." *A.L.R.* 1953.

Winterburgh, E. "Masonic Ceramics." *A.Q.C.* vol. 70 (1957), 101-115.

Index

Index

A

Aaron, *See* Serpentine.
Acme Ritual Lamp, *See* Lamp, reading.
Adoption, Rite of, 5.
A.F. & A.M. (Ancient Free and Accepted Masons), 129.
"A Freemason Form'd Out of the Materials of His Lodge" (Slade), 29, 219; *See also* King, Samuel.
Ahiman Rezon (Dermott), 2, 12.
Alarm, *See* Knocker.
Aldworth, Elizabeth (nee St.Leger), 18, 33.
Alford, Frederick, *See* Pollard & Alford.
Alpha and Omega, 62.
Altar, 63, 198.
Ames, Ezra (engraver), 40.
Ames Manufacturing Co., regalia manufacturer, 95; sword, 156.
Ames, Nathan P., sword cutler, 163.
Ames Sword Co., *See also* Knocker.
Ammelung, John Frederick, 239, 242.
Ancient Accepted Scottish Rite, 4; Northern Jurisdiction; Southern Jurisdiction; *See also* Scottish Rite.
Ancients, 127.
Anderson, Alexander (engraver), "Solomon's Temple," 23; certificate, 183.
Anderson, James, 3, 31; *Constitutions*, 3, 7.
Andirons, 72.
Androgynous, degrees, *See* Mason's Wife; Knight and Heroine of Jericho; Good Samaritan; Order of Eastern Star.
Annin, William B., *See* Smith, George Girdler.
Arching, 98.
Ark, *See* Covenant, of the.
"*Armor Honor Et Justitia*," motto, operative stonemason's, 127, 212, 217, 219, 224.
Arms, Heraldic: Ancients, *iv.*, 3, 127, 181, 194, 196, 222; tetrarchial, 213; Maine, State of, 181; Massachusetts, Grand Lodge of, 43, 72, Provincial Grand Lodge of, 212; moderns, 3, 8, *8*, *219*, *223*; operative, *iv.*, 127, 212, 223, 227 crest, 217; Rhode Island, State of, 188; speculative, 127; England, United Grand Lodge of, 128; United States, 175; Weymouth, 21; Freemason's Arms, *See* Taverns.
Armstrong & Co., chromolithographers, 45.
Armstrong, Edwin A. & Co., 159.
Ars Quatuor Coronatorum, xii.
A Serious Enquiry... (D'Assigny); 12, 98.
Ashlar, *See* Symbols.
Athol, masons, 127.
"*Audi, Vide, Tace*," motto, United Grand Lodge of England, 128.
A.Y.M. (Ancient York Masons), 128.

B

Babcock, Samuel, 141.
Baldachino, 26, 194.
Ball, Jonathan; sword, 162; *See* Sword, suspension.
Balkam, Cyrus, 136.
Banner. Knights of Malta, *91; Labarum, 148*; Knights Templar, 160.
Bartolozzi, Francisco (engraver), 10.
Bascomb, Ezekiel, 141.
Baynes, James (artist), 126.
Beauseant, *See* Banner, Knights Templar.
Beinagle, Hugh (architect), 25.

Belcher, Jonathan, 206.
Bell, low twelve, 89.
Bettle, Samuel (engraver), 105.
Bideaud, Antoine, 172.
Billings, Hammatt (artist), 177, 196, 198.
Binning bottle, 240.
Bird, Benjamin Coolidge, 56.
Bird, Mark, 71, 73; *See also* Stove Plate.
Birkhead, Matthew, 17, 19, 216; funeral of, 249; *See also* Entered Apprentice's Song.
Blake, Alden Hathaway, 253.
Blindfold, *See* Hoodwink.
Boitard, Louis Peter, 8.
Bowen, Abel (engraver), 255.
Bowring, Josiah (artist), 40 n.
Brant, Joseph (*Thayendanegea*), 125.
Braxmor, C.G. & Co., 160.
Breastplate of Judgement, 43.
Breeches, 105.
Broached Thurnal, *See* Symbols: cubical ashlar.
Brooks, Capt. John, 134.
Browne, John (engraver), mentioned, 40 n.
Bufford, John H. (lithographer), 26, 47.
The Builder's Jewel (Langley), 222.
Bunch of Grapes Tavern, *See* Lutwych; First Lodge.
Bunker Hill Monument, 255.
Burdon, Rowland, 222, 226; *See also* Wear Bridge.
Butterfield, William (engraver), 226.

C

Cameron, John (artist), 33.
Candelabra. *See* Chapter, furniture of.
Cannon, fire a, 204; *See also* Firing Glass.
Cannon, Benjamin, 140.
Capitular, degrees, 4. *See* Mark Master, Past Master, Most Excellent Master, Royal Arch.
Carpet, textile, 91; printed, 44, 45; "Apprentice's", 37; "Master's", 40, 127; "Compleat", 35. 44, 45; "Knights of Malta", 47; "*Oriental Guide*", 45.
Cartwright, J. (engraver), first English certificate, 168, 169.
Catafalque, 251, 253.
"Cemented With Love," motto, 220.
Cerneau, Joseph, 172; engraver, 200.
Certificates, 168, 170, 171; Grand Chapters: Maine, 193; Massachusetts, 193, 194; Grand Lodges: Maine, 177, 180; Massachusetts, 177, 178, 180, 188; New Hampshire, 183; New York, 185; Rhode Island, 188; Scottish Rite, 198.
Chairs, passing the, 123, 124; *See* Seating.
Chamber of Reflection, 162.
Chapter (Royal Arch). Defined, 103n; degrees, 129; furniture of, 75; working tools, 148, 193.
Chapter Penny, 132.
Chapters: David's No. 34 (Auburn), 141, 190; Geneva No. 36 (Geneva), 141; King Hiram (Greenwich Village), 140; Mount Horeb (lowell), 163; Mount Moriah (Bangor), 145; Mt. Sinai (Lawrence), 156; St. Croix, 193; St. John's (S. Boston), 194; Temple No. 5 (Albany), 193; Washington No. 3 (Middletown), 137.
Charge. Toast, 203, 204; *See* Cannon.

G

G.A.O.T.U. (Great Architect of the Universe), 97, 148, 246.
Gardiner, H., 144.
Garfield, James A. (20th U.S. President), Sorrow Lodge, 251.
Gavel, 85, *85*.
George III (king of England), 73.
Gerrish, Timothy (silversmith), 134.
Gethen, William (silversmith), 123.
Getz, Peter (silversmith), Tyler's sword, 150.
Globes, 54, 128, 169, 172n, 185; certificate text on, 178, 180; *See also*
 Pillars.
Gloves, white, 97.
Goat. 86, 235.
Goodwin & Webster, pottery, 234.
Gormagons, 12, 31, *31*; *See also* Hogarth.
Gourgas, Joseph, 172.
Gnostic, *See* Ouroboros.
Grand Army of the Republic, 96.
Grand Mystery of Free-Masons Discover'd (Payne), xi.
Grand Parallels, 203.
Green Dragon tavern, 16. *See also* First Lodge.
Green, Joseph, 206.
Grice, J. (artist), 106.
Gridley, Col. Richard, military lodge, 167.
Grotto: *See* Veiled Prophets.

H

Haggi, 98.
Haigh, John, 236.
Hamborough, *See* Schott.
Harding, M.S. (artist), 140.
Harper, Thomas (engraver), 105.
Harris, John (artist), mentioned 40 n.
Harris, Richard, 104.
Harris, Thaddeus Mason, 12; *Discourses in Favor of Freemasonry, See
 also* Constitutions.
Hatch & Co., chromolithographers, 45.
Hatch, Thomas J., 56.
Hawksworth, John (engraver), certificate, 178.
Healy, Jesse, tavern, 28; See also Lodges: Faithful No. 12.
Heating, *See* Fireback; Mantle; Stove plate.
Hercules, 104, 169, 178, 185, 191, 213.
Hill, John (engraver), 25.
Hill, Samuel (engraver), certificate, 180, 189.
Hiller, Joseph, Jr. (artist), 189.
Hiram Abif, Grand Master, 12, 213, 242; Widow's son, 15; cinerary urn,
 199; *See* Symbols: acacia, coffin.
Hiram (king of Tyre), 15, 213; Grand Master, 12.
Hogarth, William (engraver), 18, 31, 32; *The Free Mason's Surpriz'd, 32*.
"Holiness To The Lord," motto, on ceramics, 220; *See* Royal Arch.
Hoodwink, 82; mechanical, *See* Fuller, Charles C.; Lindenberg, Carl R.
Horsman, Edward (artist), 43, 107, 193.
Horstmann, W.H., regalia manufacturer, 95.
Huber, Jacob, *See* Stiegel, Henry Wilhelm.
Houston, J.H.M., 56.
Howard, Albert, 67; E & Co. clock, 67.
Howell, David B., 159 ; *See* Sword, suspension.
H.T.W.S.S.T.K.S. *See* Mark Master, mnemonic.
Hull, J, 109.
Hurd, Benjamin, Jr. (engraver), 98; Mark Master's mark, 131.
Hutchinson, William, lecturer, 54.
Hutton, Isaac (engraver), 132, 170; certificate, 181; George, 132.

I

IHSV, on sword, 160. *See "In Hoc Signo Vinces."*
Illustrations of Masonry (Preston), 4.
Imposters, Masonic, 171.
Independent Order of Odd Fellows. Compatibility with Masons, 17;
 symbol of, 65; regalia swords, 153.
"In Hoc Signo Vinces," motto, *See* Knights Templar.
Installed Master degree, *See* Past Master.
Ireland, Grand Lodge of, 4, 105.
Iron Bridge, *See* Wear Bridge.

J

Jachin & Boaz..., exposé 22 ; frontispiece 19, 126, 139, 140, on ceramic,
 220; title page 14; *See* Pillars.
Jacobite, 12, 31, 98.
Jacobs, Abraham, 172.
Jesters, Royal Order of, 6.
Jewels, Office, insignia of, 121, 122; Immovable, 39, 121.
Job's Daughters, 6.
John, Saint (the Baptist), 203, festival, 206.
John, Saint (the Evangelist), festival, 167, 203.
Johnson, Andrew, 17th President, U.S., 26.
Johnson, Sir William, 125, 245.
Joshua, 98.
Justice, 228.

K

Kadosh, Council of, 199, 200.
Keith & Gibb (lithographers), 230.
Kendrick, D.T. (engraver), certificate, 194.
Kent, James D., 156.
King, Samuel (artist), 29, 30.
Kirk, John (engraver), certificate.
Kirkwell-Kilwinning Scroll, 35.
Knecht, Peter, 155.
Knights Templar. Apron described, 99; degree, first conferred in
America, 99; dirk, 159; insignia of rank described, 100; motto, 99, 148;
 parade, 99, 114, 115; swords, 156, 159, 160. *See also* Malta, Knights
 of; Red Cross Knights.
Knocker, door, 54, 68, 69.
"Kodes La Adonai," motto, 127, 213.
Kossuth, Lajos, 160.
Krimmell, John L. (artist), 25.

L

Labadie, Lean de, 22
Labidists, 22.
Lafayette, Marquis de., 107; Lafayette Chapter, 200.
Lakeman, Nathaniel (artist), 109.
Lamps, gas, 76, 78, 79; oil, 76, 78; reading, 79.
Langley, Batty. *The Builder's Jewel*, 222, 230; Thomas (engraver), 222.
Lantern, 78.
Larkin, Peter (engraver), 10.
Larudan, Abbe. *L'Orde de Franc-Masons Trahi*, 18.
Lebanon, Tall Cedars of, 6.
Leon, Rabbi Jacob Jehudah, 22.
Leney, William Satchwell (engraver), 185.
Les Secrets de L'Orde des Francs-Masons (Perau), 18.
Lewis, *See* Symbols.
Lights: great, 43, 75, 223; lodge, of the (fixed), 37, 75, 77, 155, 241. *See
 also* Floor Cloth.
Lilley, Mitchell C., 114; swords, 163, 164.
Lindenberg, Carl. L., hoodwink, 83, *83*.
Livingston, Robert R., 215.
Lodge: plan, 19, 22, 22; furniture, 51; inventories, 51, 52; Military, 167;
 seal, 52, 170; of Sorrow, 251; Table, 204, 206; *See* Emergent Lodge.
Lodges: Alexandria-Washington No. 22 (Alexandria), 184, 239;
 Amicable No. 36 (Herkimer), 178; Amity No. 5 (Zanesville), 122,
 123; Blazing Star No. 11 (Concord), 66, 174, 183; Charles River (W.
 Medway), 178; Columbia No. 91 (Philadelphia), 140, 185;
 Columbian (Boston), 39; Concordia No. 67 (Philadelphia);

V

Veiled Prophets, Mystic Order, Enchanted Realm of, 6.
Venus, 104, 178, 191, 214.
Vernon, W.O., *The Three Distinct Knocks...*, 42.
"*Vide, Aude, Tace,*" motto, 219, 220.
Vinton, David, 207.
"*Virtute Et Silentio,*" motto, 219, 222.

W

Warrants, 167.
Warren, Joseph. Mark Master's mark, 131, funeral of, 150; *See* Bunker
 Hill Monument.
Washington, George. *Constitutions* dedicated to, 12; initiated, 103n; 111;
 Past Master's jewel, 124; inauguration Bible, 175; lodge, 185; on
 ceramic, 228; on stoneware, 232, 235; funeral of, 250.
Waterford, glass, 241.
Wear Bridge, 211, 222, 224, 226.
Weaver, Emmor T. (silversmith), Past Master's jewel, 139; Tyler's
 sword, 150.
Webb, Joseph, 71, 72, 174.
Webb, Thomas Smith (ritualist), *Freemason's Monitor and Illustration of
 Freemasonry*, 4, 5, 249; Knights Templars, co-founder of, 99.
Wedgwood, Josiah, 217; Wedgwood & Sons, 236; Ralph, Wedgwood &
 Co., 217.
West Troy Pottery, 234.
Weymouth, second viscount, Thomas, 21; *See* Arms of, 21.
Working Tools, 36; *See* Entered Apprentice; Fellow-Craft; Master
 Mason; Mark Master; Royal Arch.
Wharton, Philip, Duke of, 7, 12.
Wheeler, Elijah, 141.
Wheelock, Merrill G. (artist), 26.
Whitney, William B., 176.
William, Prince of Orange, 23.
Williams, John, 145.
Willson, Carl D. (artist), 47.
Winding Staircase, *See* Symbols.
"Wisdom, Strength, Beauty," motto, 224.
Withington, Daniel, 136.
Wright, Charles Cushing (engraver), certificates, 176, 190, 191.

Z

Zerubbabel, 4, 98.